So Many
Brilliant Talents
Art & Craft *in*
the Age *of* Rubens

So Many Brilliant Talents
Art & Craft in the Age of Rubens

Ronni Baer

Michael C. Carlos Museum
Emory University

The publication of this catalogue was made possible through the generous support of the Forward Arts Foundation in honor of the Honorable Anne Cox Chambers.

LENDERS *to the* EXHIBITION

Royal Museums of Fine Arts of Belgium, Brussels

Royal Museums of Art and History, Brussels

Print Room, Royal Library Albert I, Brussels

King Baudouin Foundation, Brussels

High Museum of Art, Atlanta

Museum Plantin-Moretus, Antwerp

Musée Provincial des Arts Anciens du Namurois, Namur

Mildred and Paul Seydel Belgian Collection, Robert W. Woodruff Library Special Collections, Emory University

Private collection, Brussels

The exhibition *So Many Brilliant Talents: Art and Craft in the Age of Rubens* was organized by the Michael C. Carlos Museum, Emory University, in cooperation with the King Baudouin Foundation, U. S., and is presented under the patronage of His Excellency Alex Reyn, Belgian Ambassador to the United States, and the Honorable Paul Cejas, United States Ambassador to Belgium.

The exhibition has been made possible by Invesco; the Jim Cox, Jr. Foundation; the Katherine John Murphy Foundation; Sabena World Airlines; and the Helen Spence Lanier Foundation.

Additional support has been provided by Delhaize of America, Inc.; Mr. and Mrs. James C. Edenfield; KBC Bank; the Everett N. McDonnell Foundation; Jenny Pruitt & Associates Realtors; UBS AG; UCB Pharma, Inc.; Mr. and Mrs. William B. Astrop; Macy's East, Inc.; and Beaulieu of America.

The publication of the exhibition catalogue has been made possible through the generous support of the Forward Arts Foundation in honor of the Honorable Anne Cox Chambers.

Exhibition Schedule:
Michael C. Carlos Museum
Atlanta, Georgia
September 17, 1999–January 9, 2000

Catalogue design:
Times 3, Atlanta

Cats. 1–3, 5, 7–12, 14–15, 18–31 Photographs courtesy of the Royal Museums of Fine Arts of Belgium, Brussels
Cats. 4, 6 Photographs by Speltdoorn and Son, courtesy of the Galerie Jan de Maere, Brussels
Cats. 13, 16–17 Photographs courtesy of the High Museum of Art, Atlanta
Cats. 32–43 Photographs courtesy of the Print Room, Royal Library Albert I, Brussels
Cats. 44–46 Photographs by Michael McKelvey
Cats. 47, 49–50, 54, 56, 57, 61–63, 67, 74–75, 79–80, 83, 85, 91 Photographs courtesy of the Royal Museums of Art and History, Brussels
Cats. 48, 51–52, 55, 86 Photographs courtesy of the King Baudouin Foundation, Brussels
Cats. 53, 58–60, 64–66, 68–73, 76–78, 81–82, 84 Photographs by Speltdoorn and Son, Brussels
Cats. 87–88 Photographs courtesy of the Musée Provincial des Arts Anciens du Namurois, Namur
Cats. 89–90 Photographs courtesy of the Museum Plantin-Moretus, Antwerp

Cover

JACOB VAN OOST,
Bruges 1603–Bruges 1671,
The Music Party, 1667
Oil on canvas
64 ³⁄₁₆ x 74 ⁷⁄₁₆ inches (163 x 189 cm)
Royal Museums of Fine Arts of Belgium, Brussels, inv. 4322

CONTENTS

The King Baudouin Foundation United States (KBFUS) is particularly proud to present to you, in partnership with the Michael C. Carlos Museum, the exhibition *So Many Brilliant Talents: Art and Craft in the Age of Rubens*. The exhibition is both a first and a very concrete example of KBFUS' objective of sharing a wealth of knowledge between the United States and Europe, and is a reflection of the King Baudouin Foundation's long history of support for the preservation of Belgium's cultural heritage.

Dr. Ronni Baer, curator of the exhibition, has succeeded in organizing an exhibition that marvelously reflects the art and culture of the seventeenth century in the Southern Netherlands. This was an era of great wealth and extraordinary artistic achievement during which artists of the highest caliber worked for patrons of great sophistication.

Please join with us in experiencing these exquisite works selected primarily from the greatest museums of Brussels, Atlanta's sister city. Enjoy this fascinating exhibition and relive with us the compelling stories it tells of life in Rubens's time.

Baron Paul Buysse
President
King Baudouin Foundation United States

It is both a privilege and a pleasure for the Michael C. Carlos Museum to present *So Many Brilliant Talents: Art and Craft in the Age of Rubens*. This exhibition brings together superb seventeenth-century paintings, sculpture, drawings, prints, and decorative arts from the area we now know as Belgium. Representing one of the greatest periods in the history of European art, the exhibition includes material that has long been familiar to American audiences, including the work of Rubens, van Dyck, and Jordaens, as well as furniture, metalwork, glass, and examples of other media of the same extraordinary quality which have been seen but little in this country. It is difficult fully to express our gratitude to the Royal Museums of Art and History in Brussels, which, by closing for renovation, were able to lend some of their greatest works, and to the Royal Museums of Fine Arts, which agreed to part with key works, many from the walls of their galleries. To all of the lenders, we extend our profound thanks for their willingness to send significant treasures to Atlanta for several months.

The Carlos Museum has organized the exhibition in conjunction with the King Baudouin Foundation United States, the recently-established American branch of Belgium's largest and most prestigious foundation. When the Foundation first approached the Museum with a suggestion that an exhibition about art from Belgium would be an appropriate way to celebrate the opening of its office in Atlanta, there seemed only a modest chance that it would come to fruition. In short order, however, it became clear that an ambitious exhibition was indeed possible, one that we hope does ample credit to all of the participants. For the Foundation's consistent encouragement, financial support, and attention to an endless stream of requests for information and assistance coming from this side of the Atlantic, we are deeply grateful. We also must thank the Forward Arts Foundation of Atlanta, whose generous support, offered in honor of the Honorable Anne Cox Chambers, both a former president of that organization and the former Ambassador of the United States to Belgium, made the publication of this catalogue possible. This dedicated group of arts supporters has, over the years, assisted in presenting many of the most memorable visual arts events in the city. They receive less notice than they should for their multiple acts of generosity, and it is a pleasure to recognize them here. To them, and to all those corporations, foundations, and individuals whose contributions have allowed us to present the exhibition to the public, we express our thanks. And to the committee, led by Museum Board of Directors' member Jean Astrop, that did so much to raise awareness of the project and worked so hard to identify funding to support it, we can only express our grateful admiration.

The exhibition and catalogue offer ample testimony to the intelligence, dedication, perseverance, negotiating skills, and hard work of Ronni Baer, the Museum's Curator of European Art. From the moment we first discussed

the project, even before she officially began work for the Carlos Museum, Dr. Baer, a specialist in seventeenth-century Dutch and Flemish painting, became critical to its success. She has many friends and colleagues in and outside Atlanta who admire her work, and they will appreciate the significance of her contribution here.

Finally, it may be asked why the Carlos Museum undertook this project at all. For a museum best known for its holdings of antiquities, this exhibition may seem a bit far afield. Upon reflection, however, there is perfect logic to the choice to proceed. As part of an academic institution with a sophisticated audience of wide-ranging interests, the Museum often ventures into areas beyond those of its primary collections. The Carlos Museum also maintains a collection of prints, drawings, and photographs from the Renaissance to the present, and there is a considerable constituency for European art at Emory University and in the community beyond the campus. Finally, the people of the greater Atlanta area would have missed an opportunity that might never come their way again to see the complete spectrum of seventeenth-century Southern Netherlandish work of this quality. We could not let that opportunity slip away. It is our hope that our visitors will share the pleasure and pride we take in presenting *So Many Brilliant Talents: Art and Craft in the Age of Rubens*.

Anthony Hirschel
Director
Michael C. Carlos Museum

ACKNOWLEDGMENTS

My first debt of gratitude is to Anthony Hirschel, the director of the Carlos Museum, who invited me to mold this project and gave me the freedom to pursue it to the best of my ability. He was a critical editor, able negotiator, and enthusiastic supporter of the exhibition, which was not an obvious project for our institution. Despite her overloaded schedule, Virginia Henderson, who compiled the bibliography, was a dogged researcher; I could never have written the catalogue without her help. Our extraordinary exhibition design department—Nancy Roberts, Kipp McIntyre, and Stephen Bodnar—worked tirelessly and creatively on the design of the period room and the beautiful installation of the exhibition. Other members of the museum staff, especially our registrar Stacey Savatsky, and the curatorial assistant for special exhibitions Sheramy Bundrick, were invaluable in arranging the loans and attending to the numerous details that go into producing an exhibition and its catalogue respectively. Our director of development, David Curry, our coordinator of public affairs, Gail Habif, and our coordinator of marketing and public relations, Joy Bell, also contributed significantly to the realization of the project. Elizabeth Hornor and our small but dynamic education department dreamt up stimulating, informative, and appealing programming around this show. At the eleventh hour, Margaret Shufeldt graciously and ably drafted the label copy for the exhibition. Anna Bloomfield and Melissa Wargo were the diligent editors with whom it was an honor to work, and Robert Evans is responsible for the elegant design of the catalogue.

I must acknowledge the help and cooperation of my colleagues in the museums in Belgium who have lent so generously to this enterprise: Eliane de Wilde, Helena Bussers, Liesbeth de Belie, Stefaan Hautekeete, and Catherine Heesterbeek-Bert at the Royal Museums of Fine Arts, Brussels; Claire Dumortier, Sara de Coninck, Jeannette Lefrancq, Antoinette Huysmans, and Monique de Ruette at the Royal Museums of Art and History, Brussels; Nicole Walch at the Print Room of the Royal Library Albert I, Brussels; and Ronnie Dusoir and Dirk Imhof at the Museum Plantin-Moretus, Antwerp. They have answered innumerable questions about the objects in their care and made me feel most welcome at their institutions. The loans from the High Museum of Art were facilitated by David Brenneman, Phaedra Siebert, and Jody Cohen, to whom I am most grateful. It was a pleasure to work with Linda Matthews, Head of Special Collections at Woodruff Library at Emory University, who made the wonderful Flemish books from the Seydel Collection available to me.

Because of the scope of this exhibition and the variety of the objects on loan, I have had to rely for help on numerous friends and colleagues. The fact that the show and accompanying catalogue were assembled in just over a year's time makes my debt to them even greater. The expertise of the following people has been essential to my work: Susan Arensberg,

Ilse van den Bogaert, Karen Bowen, Luc Duerloo, Suzanne Guerlac, Quint Gregory, Danielle Grosheide, Egbert Haverkamp-Begemann, Wolfram Koeppe, Eloy Koldeweij, Eckhard Leuschner, Niria Levya-Gutierrez, Jan de Maere, Jesse McNab, Walter Melion, Jeffrey Muller, Nadine Orenstein, Elizabeth Pastan, Lynn Russell, Sarah Schroth, Virginia Tuttle, Eric Varner, Ilya Veldman, Claire Vincent, Arthur Wheelock, Rabbi Mark Zimmerman, and Shelley Zuraw.

My final debt is to the staff of the King Baudouin Foundation, who came to us with the seed of an idea to celebrate the opening of their United States office in Atlanta. Dominique Allard, Anne de Breuck, Luc Tayart, and especially Jean-Paul Warmoes shepherded the project on the European side and shouldered a significant portion of the financial responsibility. Such enlightened patronage does not often occur.

This catalogue is dedicated to Steven, Jake, and Jane Elmets with love.

Ronni Baer
Curator of European Art
Michael C. Carlos Museum

SO MANY BRILLIANT TALENTS:
ART *and* CRAFT *in the* AGE *of* RUBENS

The story of the art produced in the Southern Netherlands in the seventeenth century involves a complex web of politics, economics, religious imperatives, and individual and collective talent. This essay will examine Flemish artistic production in context, both by describing the impact of the Eighty Years' War and by focusing upon the prominent figures in the political and artistic life of the time. Any assessment of history is personal, but this one is particularly so, as it is told to help elucidate the character of the objects in the exhibition.

The towering figure of Peter Paul Rubens is at the core of seventeenth-century Flemish art, and it is from contemporary descriptions of him that the exhibition's title is drawn. The Abbé Scaglia, ambassador of Savoy, observed in tribute to Rubens's diplomatic ventures that the artist was "a person capable of things much greater than the composition of a design colored by the brush."[1] The bishop of Segovia, who had been confessor to Archduke Albert, wrote that Rubens "unites to his rare talent as a painter, literary gifts and a knowledge of history and languages; he has always lived in great style and has the means of supporting his rank."[2] The great Genoese military commander Ambrogio Spinola, who spoke of Rubens often, said that he saw so many beautiful talents shine in the soul of this great man that he believed that one of the least considerable was that of painting.[3]

The phrase "so many brilliant talents" refers, however, not only to Rubens's accomplishments but also to the range and quality of the art produced by the many artists active in the Southern Netherlands in the seventeenth century. While some are better known today than others, as Julius Held sensitively wrote, whoever "sees Flemish seventeenth-century painting only in terms of a few big names not only underrates the vigor and creative vitality of this school, but fails to do full justice to the great masters themselves."[4] Furthermore, many gifted craftsmen created masterpieces in a variety of materials that are generally grouped under the rubric of "decorative arts." These objects were appreciated both for their beauty and for their utility.

The careers of nearly all the artists represented in the exhibition intersected at some point. For example, Jan Brueghel the Elder, court painter to Archdukes Albert and Isabella from 1608 until his death in 1625, traveled and collaborated with Rubens, of whose final will and testament he was executor. He was also a friend of Frans Snyders and collaborator of Hendrik de Clerck. Paul Bril was friendly with Rubens during the latter's sojourn in Rome. Jan Boeckhorst, a pupil of Rubens and Jacob Jordaens, collaborated

1. White 1987, 180.
2. White 1987, 186.
3. de Piles 1970, 194. I am grateful to Frans Baudouin for this reference.
4. Held 1964, 272.

with Snyders; Snyders, in addition to Boeckhorst and Rubens, also col-
laborated with Jordaens, Abraham Janssens, Theodoor van Thulden, and
Anthony van Dyck. Lucas Faydherbe sculpted a portrait bust of Gaspar de
Crayer. Janssens was commissioned to paint an altarpiece for the new chapel
of the artists' guild in the Cathedral of St. Rombaut, Mechelen, for which
Faydherbe would later be commissioned to design an altar and choir screen;
the interior of the church, including Faydherbe's contributions, is the subject
of the painting in the exhibition by Wilhelm Schubert von Ehrenberg
(*cat. 18*). The list could go on; what it reveals are patterns of influence
and collaboration that help define the production of seventeenth-century
Flemish art.

Recurrent themes that surface in many of the different media in the
exhibition reflect contemporary preoccupations and modes of thought.
The aims of the newly re-energized Catholic Church and the tenets for art
production specified by the Council of Trent as a response to Protestant
challenges, for instance, clearly affected the nature of many commissions,
but they also influenced the choice of subject matter in works generated for
the market. Furthermore, as we shall see, religious themes, but also ostensibly
secular subjects, were given a moralizing gloss to drive home ethical lessons.
To understand more fully the nature of these creations, a synopsis of historical
events and an analysis of art production in light of prevailing cultural issues
is in order.

HISTORICAL OVERVIEW

In 1555–56, when the Holy Roman Emperor Charles v abdicated his
claims to the Netherlands and Spain in favor of his son, Philip ii, it was
obvious that the Netherlands was the ideal strategic base for Hapsburg
power in Europe. As the hub of European trade, Antwerp—Europe's fifth
largest city behind Paris, London, Venice, and Naples—saw increased indus-
trial activity, bringing with it new wealth and a sophisticated money market.
In sharp contrast to many other European countries, industrial production
in the Netherlands already equaled agricultural production.[5] Nevertheless,
despite this economic strength, there were strong local institutions and tradi-
tions, varying fiscal and legal systems, and separate languages that under-
mined the establishment of a unified country.[6]

Philip ii arrived in the Netherlands in September 1555, at which time
he was proclaimed the new ruler of the seventeen provinces that made up
that country. When he returned home to Spain four years later, he named
as regent his illegitimate half-sister, Margaret of Parma, to preside over the
central government in Brussels. Cardinal Granvelle, one of Philip ii's minis-
ters and Margaret's chief adviser, maintained control over decision-making
and administrative and ecclesiastical patronage. Prince William of Orange
was appointed Stadtholder (the equivalent of governor) of Holland, Zeeland,

5. van der Wee and Materné
1993, 23.
6. Parker 1977, 33–36.

12

and Utrecht, and the Count of Egmond Stadtholder of Flanders and Artois.

One of the most serious challenges to unity was the rise of Protestantism. William of Orange, who had married the niece of a German Lutheran prince, was committed to freedom of conscience and religious compromise. Granvelle, on the other hand, led Spain's anti-heresy campaign and strove to strengthen the central government's control over the provinces and towns. The resulting strain between these two camps produced an open split in 1561, which in turn led to the start of the Eighty Years' War, the longest war in modern European history.

The year 1566 saw one of the precipitating events of the war, called by contemporaries the "iconoclastic fury." In his writings, Calvin had railed against the Catholic practice of including images in churches; he regarded them as idols and urged their destruction. Only a "purged" church was deemed fit for Protestant worship. To the tension resulting from the promulgation of this attitude in a country ruled by stringent Catholics were added economic difficulties and a severe food shortage, conditions that led to bread riots in Breda, Mechelen, Ghent, and elsewhere in November and December 1565. Although the outbreak of iconoclastic violence in August 1566 in small towns in western Flanders was perpetrated by a small number of men—perhaps motivated by religious zeal and assuredly by the promise of a daily reward—it spread throughout the country, causing enormous artistic losses.[7]

Recognizing that the Protestant insurrection in the Netherlands had to be crushed, Philip II sent the Duke of Alba to subdue the rebels. Alba instituted the Council of Troubles (soon to be called the Council of Blood), a special judicial court established to try all those accused of heresy or rebellion. Over twelve thousand people stood trial, one thousand of whom were executed. Most of the nobles were tried *in absentia*, judged guilty of treason, and condemned to forfeit all of their goods and property in the Netherlands. The banished nobles understandably became Spain's enemies.

In 1576, the city of Antwerp was sacked by the unpaid and mutinous Spanish army, the most experienced and highly trained soldiers in Europe. The "Spanish Fury" lasted for several days, during which time eight thousand people died. The rampage was one of the worst atrocities of the sixteenth century, and one from which Antwerp did not quickly recover.

To help mollify the antagonism that developed against Spanish rule, Philip II appointed Alexander Farnese as Governor General of the Netherlands in 1578. Farnese, who had spent his youth in Brussels and trained as a soldier in Spain, possessed an intellectual flexibility and military acumen that proved invaluable in his new position. With the Treaty of Arras of 17 May 1579, in which the Walloon provinces recognized the full authority of Philip II, Farnese was able to restore a measure of peace in the Southern Netherlands by reconciling the people with the King of Spain. This treaty formed a counterpart to the Union of Utrecht of 23 January 1579, the

7. For a brief description of the havoc wreaked by the iconoclasts, see Parker 1977, 74–80. See also Freedberg 1988.

coalition of rebellious provinces in the North committed to resisting Spanish domination, that had laid the foundation for a formal split of the original seventeen provinces.

The mostly Protestant United Provinces established by the Union of Utrecht included the cities of Antwerp, Ghent, and Bruges. This was an unacceptable situation for Farnese, who took the offensive at the end of 1582 to regain control of Flanders and Brabant. His strategy was to limit the access of the major cities to the waterways on which they depended for trade and communication. Farnese pursued this course and, after a long and terrible siege, succeeded in retaking Antwerp in 1585. The long-term consequences, however, were almost more harmful to Antwerp's prosperity than the death and destruction that occurred during the siege. A great exodus ensued; merchants, bankers, scholars, artists, and craftsmen left the Southern Netherlands, taking with them their contacts, their expertise, and their capital.

In 1598, the year of his death, Philip II arranged for the marriage of his daughter Isabella Clara Eugenia to his nephew Albert, fifth son of the Holy Roman Emperor Maximilian II (ruled 1564–76). The marriage of Albert and Isabella was performed in Ferrara on 15 November 1598, with Isabella represented by proxy. The celebration of the consecration of their marriage (the "marriage solemnity") took place in Valencia on 18 April 1599. In June of that year, Albert, Isabella, and a large entourage undertook the two-month journey to the Netherlands.[8]

Isabella was Philip's favorite daughter. She was his constant companion and, as his health and eyesight deteriorated, his assistant in political affairs. By the time she left for the Netherlands, she was well versed in the complex matters of state. Albert, too, had grown up at the Spanish court under the tutelage of his uncle, Philip II. The boy was remarkably proficient at languages, loved music, and was ardently devoted to the Catholic faith. Philip appointed him cardinal in 1578, viceroy of Portugal in 1583, and archbishop of Toledo in 1595. Albert was frequently called upon to represent the king at state-related events and activities, and was even charged with educating the young Philip III on matters of political importance.[9]

Just before his death in 1598, Philip devolved upon Albert and Isabella, as full sovereigns for their joint lives, the government of the Netherlands.[10] Despite the appellation, however, their sovereignty was less than full because of measures Philip took to assure the continuity of Spanish and Catholic rule. The Act of Cession of 6 May 1598 stipulated that the Netherlands would be returned to Philip II or his legitimate successors if the archdukes were to die without an heir. While Albert was ostensibly supreme military commander, five garrisons stationed in the Netherlands remained under the direct command of the king of Spain, and military policies and strategy were decided in Madrid. Albert and Isabella were to promise to persecute heresy and to defend their country against it. These precautions assured that the

8. Israel 1997, 9.
9. See Francisco Caeiro, *O Arquiduque Alberto, Vice-Rei e Inquisidor-Mor de Portugal*, Lisbon, 1961, 353, as in Leyva-Gutierrez 1998, 5.
10. Trevor-Roper 1991, 130. Their predecessors were governors, not sovereign rulers, so they enjoyed an important distinction in the eyes of their "subjects" if not in reality.

new government would be virtually unable to negotiate independently with the rebel Dutch.[11]

The country the newly married couple entered in 1599 (see *cat. 45*) was completely exhausted by a war that continued through the first eleven years of their rule. But in 1609 Albert, aided by Ambrogio Spinola, the general in command of the Spanish army, convinced the Spanish government to agree to a truce with the North. The relative peace of the Twelve Years' Truce (1609–21) freed up large sums of money that allowed the archdukes to begin to rebuild the country—to restore prosperity, repair the churches, and attend to the needs of the towns. Furthermore, they set to work, from the moment of their arrival, to renovate the ducal palace in Brussels (Coudenberg Palace), to refurbish the hunting retreat at Tervuren, and to rebuild the archducal castle at Mariemont. Architects, painters, engravers, sculptors, and tapestry-makers received commissions from the archdukes not only for their court, but also for churches and for gifts to rulers and courtiers.

Both Albert and Isabella had had their own courts in Spain; when they came to the Netherlands, many of their attendants came with them. The court in Brussels—formal, sumptuous, and highly religious—had all the trappings and prestige of a sovereign court. After all, it represented Spain's military, financial, and diplomatic power in the Hapsburg Netherlands. Its structure and organization were directly modeled on the Spanish court; the parallel was deliberate in order to impress on the population the sovereignty of their leaders. Pomp and circumstance helped reinforce the elevated stature of the archdukes.[12]

According to the historian Jonathan Israel, "court ceremony, publicity, etiquette, formal announcements, and presenting of gifts to fellow rulers, as well as judicial and administrative supervision, were the domain of the archdukes' courtiers."[13] While many of them were Spanish, and those in the highest positions were required to be, the archdukes lured the Flemish nobility to court with the promise of other ceremonial roles. The resulting competition between these two groups was useful politically, as it both guaranteed Spanish control and garnered Flemish support for the archdukes. Furthermore, Flemish nobles competed among themselves for favor and position, enhancing the public image of the court in Brussels.[14] The seventeenth-century population of Brussels swelled not only because of the large number of courtiers, but also because of the number of people required to serve such a courtly society.[15]

The restoration of the primacy of the Catholic faith was an important factor in the archdukes' reordering of a war-ravaged population. Countless churches had been ransacked or destroyed, the archepiscopal seat in Mechelen had been unoccupied between 1589 and 1596, and the lack of priests, churches, and abbeys left much of the populace in ignorance.[16] Albert and Isabella committed themselves to revamping the ecclesiastical

11. Thomas 1998, 2–4.
12. Lanoye 1998, 116–17, discusses the political meaning of the court's structure.
13. Israel 1997, 7.
14. Lanoye 1998, 118.
15. Sutton 1993c, 115.
16. Baetens 1998, 145.

infrastructure. They contributed money for the reconstruction of religious buildings, attracted new religious orders, and stimulated the growth of those that already existed in the Southern Netherlands. The nature of their intervention was two-pronged. They gave substantial subventions (sometimes contributing the entire establishment) as well as privileges and tax exemptions to new religious houses. They also broke the resistance of local magistrates fearful of the costs involved in establishing such houses.[17] One of the archdukes' most significant challenges was to acknowledge the privileges of the nobility and city administrators while implementing their own ambitious program of reform.[18]

St. Ignatius of Loyola's Society of Jesus, known as the Jesuits, was the most powerful and dynamic of the new orders. The Jesuits amassed vast wealth, thanks in no small part to the archdukes.[19] They acquired enormous influence and, with their commitment to teaching, dominated the intellectual life of the country. The restoration of the educational infrastructure, which had suffered tremendously as a result of the war, was a priority for the archdukes. They focused their main support on Jesuit education, which Albert had enjoyed as a youth in Spain. The Jesuits, who came to be regarded as the principal agents of the Counter Reformation, were committed to ensuring the dissemination of the religious ideals of the Council of Trent.[20]

The Council of Trent, which met intermittently in twenty-five sessions between 1545 and 1563, was called in order to clarify Catholic doctrine and define the central articles of faith. Among other things, the Council was committed to the importance of the visual arts in the propagation of orthodoxy and decreed that religious imagery was not only admitted but truly welcome as a support to religious teaching. As such, art needed to be clear, simple, and intelligible, stimulating the faithful in their devotion.[21] Furthermore, it was the Catholic Church's responsibility to reassert through the visual arts many of the issues attacked by the Protestants, among them the cult of images and, above all, the cults of the Virgin and saints.

Historically, the Hapsburgs were particularly devoted to the Virgin Mary. Albert and Isabella were ardent supporters of the belief in the Immaculate Conception, that Mary had been conceived free of original sin rather than purified by God in the womb of her mother (compare *cat. 53*). On The Great Standard of Archduke Albert—the flag borne by his principal commanders—the Virgin was featured as the Immaculata, cloaked in the rays of the sun and standing on the crescent moon. To the champions of the Counter Reformation, the Mother of God came to symbolize the purity and primacy of Catholic belief as opposed to Protestant error.[22]

The archdukes were models of personal devotion. In addition to their extensive patronage, their appearance in processions and participation in pilgrimages made a profound impression on the populace and aided their cause of religious restoration.[23] Religious uniformity was deemed crucial to

17. Put 1998, 256.
18. Put 1998, 263.
19. According to Put 1998, 257, the Jesuits estimated that the total of gifts received from the archdukes in 1640 was more than 100,000 ducats. He partially attributes the archdukes' devotion to the order to its Spanish character.
20. Israel 1997, 10.
21. The archdukes recognized that art could fulfill a political function as well. It provided an ideal vehicle by which they could assert their own piety, being less ephemeral than private acts of devotion and readily accessible to the masses; see Duerloo 1998, 268.
22. Duerloo 1998, 271.
23. Put 1998, 260.

the preservation of the state. This belief was championed not only by the archdukes, but also by contemporary sovereigns, clergymen, and philosophers, among them Justus Lipsius.[24] Albert accepted the view that persuasion rather than inquisition would lead to conformity. As an effective tool of persuasion, he and Isabella performed an increasing number of public acts of devotion.[25] Thus, through religion, education, and contact with their subjects, the archdukes started a "civilization process" that led to a renewed ordering of society and the restoration of Hapsburg authority in the Southern Netherlands.[26] The emergence of a new political, religious, and cultural order would be intimately linked to the demographic and economic revival in the South.[27]

Compared with much of Europe, the Southern Netherlands continued to enjoy high crop yields and benefited from an industrious work force. The economic recovery was not confined to agrarian successes, however. Many industries revived, including the Flemish linen industry, and some expanded dramatically, as did religious book production (*cat. 46*).[28] The government encouraged the growth of new industries by granting patents that protected fledgling businesses against potential domestic competition. Many of these patents went to enterprises established by immigrants or run by foreigners. From the mid-sixteenth century, for example, the Antwerp glass-blowing works, set up and operated by Italians, was granted an exclusive patent by the government.[29] Glass blowing evolved into an important luxury industry there. With the restoration of peace and the growth of prosperity, the production of other luxury articles enjoyed a similar renaissance. Gold- and silversmiths, for instance, supplied a great deal of ornamental work both for secular (*cats. 81–84*) and sacred use.

Albert died in 1621, the year of renewed hostilities with the Dutch. According to the terms of his appointment, the Southern Netherlands now reverted to Spanish rule. Isabella had notified the king of her desire to resign her office and enter into a quiet and contemplative existence. Philip IV, however, wisely convinced her to remain as governor, realizing that her understanding of the country and its people was politically valuable. Philip knew that a transition of power in the Southern Netherlands could lead to discontent which might, in turn, compromise his plans to attack the Dutch.

RUBENS AND HIS SPHERE OF INFLUENCE

On his deathbed, Albert urged Isabella to rely on the advice of Peter Paul Rubens, "whose ideals were so similar to his own, whose diplomatic gifts had already been proven, and whose profession gave him access to so many of the art-loving statesmen and courtiers of the time."[30] Rubens had returned from Italy to Antwerp at the end of 1608. His arrival coincided with the many opportunities awaiting artists at the beginning of the truce that arose as a consequence of the iconoclastic devastation, the

24. Duerloo 1998, 270. The neo-stoic Lipsius, the most outstanding political thinker of his generation, advocated the avoidance of strife and the preservation of order as political moral imperatives, writing that economic well-being and stability are important cornerstones of a successful and good government; see Israel 1995, 411–12. Lipsius also warned that the political stability of the state is dependent in part on the conformity of the populace.
25. Duerloo 1998, 270–71.
26. Israel 1997, 10; Thomas 1998, 9.
27. Israel 1995, 411.
28. Israel 1995, 412–14.
29. Thijs 1993, 108. Despite government restrictions, however, the art of glass blowing spread to other centers. The city of Liège, for example, was soon producing goods of comparable quality.
30. Trevor-Roper 1991, 141.

newfound economic and political stability, and the requirements of the reformatory religious revival. Rubens was pressured immediately to enter the service of the archdukes, with whom he had probably been in contact prior to his departure for Italy.[31] He had served the ducal court in Mantua and been awarded prestigious ecclesiastical commissions in Rome, so he had the type of experience that would have been both desirable and useful to Albert and Isabella. Furthermore, Albert, a connoisseur and collector, came to appreciate Rubens not only as an artist but also as an urbane humanist. The archduke was reported to enjoy conversing after dinner with his court artists, who, in addition to Rubens, included Rubens's great friend and collaborator Jan Brueghel the Elder (*cats. 13* and *23*), Rubens's teacher Otto van Veen, and the architect Wenzel Cobergher.[32]

According to Rubens's nephew, Philip, Archduke "Albert had a particular fondness for Rubens" and "made him a member of his court and bound him with golden fetters."[33] The nature of Rubens's special position at court is described in a letter of patent of 23 September 1609. It specified that Rubens was not required to live in Brussels but could remain in Antwerp, where he would continue to work and teach without being subject to the regulations of the guild. In addition to his annual pension of five hundred livres, he was to be paid for any work done for the archdukes. One of his principal tasks was to paint portraits of Albert and Isabella, of which there are surprisingly few extant (*cats. 1–2* and *33–34*). His skills as a designer of tapestries, silver and gold vessels, ivory sculpture, and book title pages were also utilized by the archdukes.

Rubens's most important contribution at this time, however, was in the realm of religious art. Rubens became the Counter-Reformation artist *par excellence*. His prodigious talent was put to work producing altarpieces which communicated the Catholic Church's messianic zeal with energy, inventiveness, and great emotional power.

To keep up with the number of commissions that came his way, Rubens made use of pupils and well-trained assistants. As early as May 1611, Rubens wrote to Jacob de Bie that he could take no more pupils. In 1621, Dr. Otto Sperling visited the artist and saw in a room of his house "many young painters, who all worked at different pieces, which had been drawn in with chalk by Rubens."[34] Rubens himself made a clear distinction between work executed entirely by his hand and work that was painted by assistants but retouched by him.[35] Contracts with church administrators and princes occasionally stipulated that the work be by Rubens himself, while the artist is known to have requested permission to execute jobs with the help of his pupils.[36] This workshop turned out enormous altarpieces and historical, allegorical, and mythological cycles for the major royal courts of Europe, even while Rubens was carrying out other commissions on a smaller scale for private clients.

The education of professional painters took place in such studios.

31. This contact was presumably through Otto van Veen who had been charged with some of the decorations for the Triumphal Entry of Albert and Isabella into Antwerp in 1599 (compare *cat. 45*). Rubens was later to recall the event when planning his own suite of decorations for Ferdinand; see White 1987, 8 and p. 19–20 in this volume.

32. White 1987, 55.

33. Lind 1946, 38.

34. Gerson and ter Kuile 1960, 85–86.

35. The latter were also considered original works because of Rubens's finishing touches; see Vlieghe 1993, 159.

36. Gerson and ter Kuile 1960, 86.

The workshop was organized in an instructional hierarchy, with the master overseeing his assistants who, in turn, supervised the apprentices. The apprentice typically lodged for two or three years with his master and learned the technical aspects of his profession. He learned to grind paints and prime canvases and was set to work copying and imitating the style of his master. He was also expected to study in his own time, copying plaster casts and prints and drawing from life.[37]

Many artists trained with more than one master. Artists were often first pupils of their fathers. Despite the fact that art continued to be taught at an early age in this most traditional of ways, efforts began to be made to designate the work of "fine" artists as a liberal art rather than a manual craft (compare *cats. 37–39*).[38] This was to be a long and arduous process, because the system was not designed to encourage artistic originality but rather to insure the transmission of the principles and techniques of high-quality workmanship.

The most prominent painter in Rubens's studio was Anthony van Dyck, who came to work with the master after his apprenticeship with Hendrik van Balen.[39] Although van Dyck became a master in 1618, he continued to play a leading role in Rubens's workshop until his departure from Antwerp for England in 1620. During this time he collaborated with Rubens on large projects, while also painting a number of his own works for the private market. Unlike Rubens, who was reluctant to undertake portrait commissions except for personal or political reasons, van Dyck specialized in portraiture and developed a free and flowing touch that was quite different from the master's more polished modeling (*cat. 3*).

The other great artist associated with Rubens's studio was Jacob Jordaens, whose active work on Rubens's projects is documented only from the 1630s. However, Jordaens seems to have been so immersed in the grand heroic manner of Rubens that it appears likely that he worked with the master much earlier in his career (compare *cat. 6*).[40] Like Rubens, Jordaens received important princely and ecclesiastical commissions despite his Protestant convictions and bourgeois sympathies.

Rubens's influence did not extend merely to those who are recorded as working closely with him. Gaspar de Crayer, who was based in Brussels, adopted from Rubens's work particular motifs and compositional schemes as well as the plasticity and monumentality of his style (*cat. 7*). Although no archival evidence documents the relationship between these two artists, de Crayer's familiarity with Rubens's production, including the assimilation of details found only in works stored in the master's studio, implies some direct contact.[41]

Late in his life, Rubens was called upon to design and supervise one of the largest and most challenging commissions of his career: the decorations for the Triumphal Entry into Antwerp of the new governor of the Spanish

37. For a description of an apprentice's work, see Miedema 1989.
38. In this exhibition alone, the following artists were trained by their fathers: Bril, Brueghel, Cardon, Duquesnoy, Faydherbe, de Jode, Muller, Quellinus, Ryckaert, Sadeler, Veerendael, and probably also van Uden and de Vos. Sculptors and printmakers were also part of artistic "dynasties."
39. It is unclear precisely when van Dyck worked with Rubens, although he may have begun to frequent Rubens's studio as early as 1613; see Barnes 1990, 18–19.
40. Vlieghe 1993, 161.
41. De Crayer's composition for the *Triumph of Scipio Africanus*, despite the reduction in the number of people and the vertical format, is based on Rubens's oil sketch for the *Triumph of Henry* IV, which he could have seen only in Rubens's studio;. see Vlieghe 1993, 163–64.

Netherlands, the Cardinal-Infante Ferdinand (*cat. 43*). Triumphal Entries were public spectacles staged by cities to celebrate the visits of monarchs and nobles. They were "rare and costly events with elaborate and abstruse allegorical programs expressed with substantial albeit temporary decorations, murals, floats, performances, and above all, great pomp."[42] In early December 1633 the Archduchess Isabella died. She had failed to prevail upon the Dutch to reopen the Scheldt River, and the continued blockade was causing great economic hardship in the South. The King of Spain, Philip IV, chose his brother Ferdinand to succeed Isabella. On his way to Flanders from Milan, where he had been studying war and politics, Ferdinand successfully routed the Swedes at the Battle of Nördlingen. He was greeted as a hero on his arrival in Brussels in November 1634; at this time, he was also invited to make his solemn entry into the city of Antwerp.

The elaborate program for the Triumphal Entry of Ferdinand into Antwerp, scheduled for April 1635, was devised by Rubens along with his friends Nicolaas Rockox and Jan Caspar Gevaerts. It was conceived to welcome the new governor but also to make him aware of the ruinous state of the city because of the lack of access to the Scheldt River. Rubens pressed into service as many of his fellow Antwerp artists as were available to aid in the decoration. Numerous triumphal arches and stages were set up throughout the city. When Ferdinand reached one of these points, he was welcomed by performers and musicians. The ceremonial route took the Cardinal-Infante two hours on horseback to complete.

Among the artists who worked on these decorations were Jan Boeckhorst, Theodoor van Thulden, Jacob Jordaens, and Cornelis de Vos. They were all established masters by this time, well past the apprentice stage, and had developed artistic styles of their own. Nevertheless, they all made their work on the huge canvases for this monumental project, based on Rubens's *modelli*, look as Rubensian as possible. Van Thulden recorded the appearance of these temporary decorations in a series of prints published the following year as the *Pompa Introitus Honori Serenissimi Principis Ferdinandi* (*cat. 43*).

Prints were not only records of ephemeral projects but were used by Rubens much earlier in his career to disseminate his works, and hence his ideas, to a broader public. Raphael and Titian had done the same. Rubens felt strongly about the unity of his work and its importance, which were probably additional motivating factors in having his paintings recorded as prints.[43] Rather than contenting himself with the simple graphic transposition of the original, Rubens sought to translate the painterly qualities of his art into print. By compelling the printmakers who worked for him to adopt a pictorial style, he made them use their engraving tools in a new way.[44] After his return from Italy, he often relied on Dutch engravers, among them Jan Muller (*cats. 33* and *34*), to produce prints after his works. Gradually he found Flemish printmakers who could meet his requirements.

42. Sutton 1993c, 123.
43. Gerson and ter Kuile 1960, 83–85. By their calculation, there are more than seven hundred seventeenth-century engravings based on Rubens's compositions. Although his paintings were reproduced by other hands, his inventions remained his alone.
44. Baudouin, F. 1991a, 41.

Prints were also executed after Rubens's designs for book illustrations. These engravings after drawings by Rubens were made for publication either by his friend Balthasar Moretus of Ex Officina Plantiniana or by other Antwerp publishers. These detailed sheets, mostly executed in pen and brown ink over chalk, form a class of their own within Rubens's drawn oeuvre. Other of his drawings, made preparatory to paintings, for example, show how thoughtfully Rubens worked out his compositions and how tirelessly he repeated the same motifs, trying to perfect them.

Van Dyck and Jordaens were also prolific draftsmen. Drawings such as Jordaens's *Homage to Pomona* (*cat. 25*) were an essential part of working out the large, elaborate, multi-figured compositions that were the hallmark of much seventeenth-century Flemish art. They were also integral to studio practice, where the more assistants and pupils, the greater the need for and output of drawings.

Especially characteristic of Rubens's working method was his use of oil sketches on panel. They were original compositions by Rubens generally in preparation for paintings, tapestries, prints, or sculpture to be executed by others.[45] Some of the sketches belong to the trial-and-error phase of planning a composition, whereas others are more finished works, made primarily to demonstrate to patrons what the product would look like.[46] The "calculated spontaneity" of the oil sketches exhibited the *sprezzatura* that Castiglione— the influential Renaissance writer who defined the social manners and training of the accomplished gentleman—associated with the artist's genius. This characteristic played into the efforts of artists to distinguish themselves from artisans.[47] While the oil sketch had its roots in Italian practice and was used by Otto van Veen during Rubens's apprenticeship with him, Rubens "shaped it in a strikingly personal way, making it into a flexible and aesthetically significant tool for the vast and varied undertakings in which he was engaged."[48] Because of the virtuoso quality of these oil sketches, many artists in Rubens's circle adopted the technique.

Unlike Rubens, Jacob Jordaens frequently used canvas for his oil sketches (*cat. 5*). Jordaens's pupil Jan Boeckhorst also worked on canvas or paper, as in *Apollo and the Chariot of the Sun* (*cat. 28*), in which he used wash and bodycolor to achieve painterly effects. Although only a handful of oil sketches by Gaspar de Crayer are known, his *Saints Benedict, Bernard of Clairvaux, and Rupert of Molesme* (*cat. 27*) shows the stylistic and technical influence that Rubens had not only on his pupils but also on other Flemish artists.

45. Held 1980, 1:3.
46. Held 1980, 1:5.
47. Held 1980, 1:7.
48. Held 1980, 1:8.

SCULPTURE IN THE AGE OF RUBENS

The impact of Rubens's work was felt by sculptors as well as painters. Rubens had a profound interest in sculpture. He drew after antique and Renaissance masters while in Italy and eventually formed what was perhaps the most distinguished collection of antique sculpture in Northern Europe.[49] Rubens included quotations from sculpture in his painted work and conceived works of a sculptural nature, such as the temporary arches for the Triumphal Entry. Several of his oil sketches record his designs for relief sculpture and luxury decorative art to be made in ivory and silver.[50] He befriended sculptors, even interceding with the archdukes to support François Duquesnoy's initial stay in Rome.

While Duquesnoy's work does not reveal Rubens's influence (compare *cat. 47*), the early work of his distinguished student Artus Quellinus does. Before leaving for Rome in 1634, Quellinus apprenticed to his father in Antwerp at a time when Rubens's style was ascendant. His early works, not surprisingly, reveal a depth of feeling and sensuousness that owe a debt to Rubens. On his return to Antwerp in 1639, Quellinus reinvigorated the Flemish sculptural tradition by introducing works that balanced the expressiveness he learned from Rubens's example with great technical skill and classical vision. He was later called to Amsterdam to design the decoration for the new town hall (*cat. 48*). As with Duquesnoy, who spent his entire career in Italy, Quellinus's talents were recognized abroad. With the work of these two artists, Flemish sculpture became a truly international phenomenon.

Lucas Faydherbe was the only sculptor of his generation to have had close contact with Rubens. Beginning in 1636, Faydherbe worked in the master's studio for three years. His early work, such as the pair of *Tritons and Dolphins* (*cats. 49* and *50*), reveals Rubens's sensibility in the energetic, powerful, and fully plastic forms. It was largely because of his presence in Mechelen that an important school of sculpture flourished there in the second half of the century.

The sculpture in this exhibition shows a range of materials, techniques, and uses. Sculptors worked in bronze, terracotta, brass, and wood. The figures in the bronze group by Duquesnoy and Algardi (*cat. 47*) were individually cast and then meticulously polished and finished. The brass *Virgin with Child* (*cat. 53*) was cast from an alloy of zinc and copper.[51] Produced especially in the cities of the Meuse River, rich in beds of calamine (ore of zinc), this malleable metal was less expensive than silver, gold, or bronze and came to be used frequently for works intended for domestic settings.

As is evident in the carved *Madonna and Child* (*cat. 54*), the fine grain of boxwood makes it suitable for detailed work and conducive to virtuoso undercutting.[52] The carving is much different from that found on the coconut shell cup (*cat. 80*), the material of which is more recalcitrant (and the artist more naive and less talented than the artist of the boxwood

49. White 1987, 71.
50. Vlieghe 1997, 26; Held 1980, 1:355–61, cats. 265 and 266.
51. Bronze, by comparison, is an alloy of copper and tin.
52. Penny 1993, 146.

sculpture). Terracotta pieces such as those by Quellinus (*cat. 48*), Faydherbe (*cats. 49–52*), and Cardon (*cat. 55*) are freely modeled from clay. This pliable material enabled the artist to capture fleeting expressions and to work out ideas that could be easily and inexpensively altered.[53]

Because of its nature, terracotta was often used to make models for various types of projects. The final work might be in the same material, as in Faydherbe's bust of Hercules (*cat. 52*), or in a different material such as marble, as used by Faydherbe for the tomb monument of Archbishop Cruesen (*cat. 51*) and by Quellinus for the architectural plaque of *Apollo with the Dragon* for the Amsterdam Town Hall (*cat. 48*). The material could be used to complement the work's iconography and thereby affect both its meaning and visual impact. The graceful boxwood *Madonna and Child* (*cat. 54*) emphasizes the figures' humanity by capturing an intimate moment. Cardon stresses the Virgin's maternity in his elegant terracotta rendition of the theme (*cat. 55*). The *Virgin with Child* in brass (*cat. 53*) is a hieratic image of the Immaculata. Private devotional pieces such as these—whether executed in wood, plaster, ivory, brass, bronze, or silver—significantly strengthened the presence of religious art in Antwerp households.[54]

To fabricate the collar of the Archers' Guild of Mechelen (*cat. 86*) or the Boatmen's and Porters' pendants from Namur (*cats. 87 and 88*), the master silversmith first hammered sheets of silver that he then finished with chasing, chiseling, and engraving. These were ritual objects. The pendant was worn by the dean of a guild for processions and public ceremonies, while the guild collar was worn by the winner of the annual shooting match, the first to fell a leather bird-shaped target from its perch atop a high pole.

GUILDS

Guilds were religious, social, and commercial confraternities. They functioned as a kind of brotherhood or society of mutual help for people working in the same trade or craft. These professional groups, which were chartered by civil or ecclesiastical authorities, monitored the training, standards of production, and welfare of their members. Guilds established members' mutual rights and their obligations to patrons. They also monitored competition.[55]

The guilds played an important role in post-Tridentine Catholicism. They opposed iconoclasm and defended the veneration of the Virgin Mary. Practical work and religious devotion were completely integrated in these groups.[56] As Christian confraternities under the protection of a patron saint, guilds met regularly for Mass, for the celebration of their saint's day, and for annual feasts. In the grand processions held in Namur in the south-central part of the country, for example, archers led the way, followed by the twenty-four guilds, each behind its flag. The dean of each guild, accompanied by the statue of the guild's patron saint, was followed by dignitaries with torches and

53. Penny 1993, 201–09.
54. Muller, Jeffrey 1993, 197.
55. Namur 1998, 7; Efland 1990, 23.
56. Richard Mackenney, "Guild," in Dictionary of Art, 1996, 13:823.

the craftsmen with their pilgrims' staffs. Modest musical accompaniment depended on the finances of the guild.[57]

ART PRODUCTION

Guilds were not only involved in the production of art but were also important patrons. They decorated their guildhouses with images commemorating their history, commissioned portraits of themselves, and ordered works of art dedicated to their patron saints for chapels or altars.[58] Militia companies commissioned silversmiths to fabricate prizes for their competitions, gifts of honor for esteemed colleagues, and showpieces to add luster to their festive banquets.[59] The guilds thus joined the court, churches, and members of the middle class as significant art patrons. The expansion of the marketplace and the transformation of the bourgeois interior into a personalized space in need of decoration contributed to the development of artistic specialization so characteristic of this period. Artists began to focus on distinctive types of painting, whether architecture, landscapes, portraits, still lifes, or genre scenes. By specializing, they improved their skills so that they could also increase their productivity. Two or more painters, skilled in different areas, often worked on a single panel.[60]

Such collaborations, exceptional in European painting, are typical of seventeenth-century Flemish art. Rubens was known to call on established artists such as Jan Brueghel the Elder and Frans Snyders to paint the still-life components in his paintings, even as he was asked to furnish figures in the paintings of Brueghel and Hendrik van Balen. Specialization and collaboration were practices adopted not merely to expedite production but to achieve the closest imitation of nature, one of the goals of art.[61]

In mid-seventeenth-century Antwerp, there was a canon of "significant" painters. If the names of two of these painters could be attached to a single work of art, that work became doubly important. Such collaborations were considered the epitome of the city's art, but were not the only instance of two hands at work. Second- and third-rate artists joined together on "low-level" collaborations in which each painter executed a type of imagery that the other was simply unable to do.[62]

The size and subjects of most of the paintings in this exhibition suggest that they were meant to hang in private homes.[63] Pictures were collected avidly and used in many different ways: as wall decoration, signs of affluence, or devotional objects. Perhaps burghers collected art as an indication of social prestige or as an investment during a period of modest economic recovery. Or perhaps a system of production efficiently regulated by the guilds and an export trade controlled by merchants with a wide network for distribution provided Antwerp with an edge in the luxury goods market which included paintings. Whatever the explanation, there were an exceptionally large number of pictures in middle-class homes throughout the Netherlands in the seventeenth century.[64]

Paintings of historical themes, which included biblical, mythological,

57. Namur 1998, 59.
58. Muller, Jeffrey 1993, 195. For example, Hendrik de Clerck, court painter to both Archduke Ernest and his successors, Albert and Isabella, was commissioned to paint the triptych of *The Martyrdom of St. Sebastian* (*cat. 24*) for the St. Martinus Church on the occasion of the re-establishment of the Longbow Archers' Guild in Asse.
59. Silversmiths received similar commissions from civic authorities who desired beautifully crafted objects for their official banquet tables and to serve as gifts. See Amsterdam 1986b, 134.
60. Thijs 1993, 106.
61. Sutton 1993b, 58–59.
62. Honig 1995, 257. Examples of collaborations in this exhibition include the works by van der Baren and an unknown artist (*cat. 14*), d'Arthois and Bout (*cat. 20*), van Uden and Teniers (*cat. 19*), Ehrenberg and H. Janssens (*cat. 18*), and Jan Brueghel the Elder and an unknown collaborator (*cat. 13*).
63. The preponderance of smaller-scaled paintings in this exhibition does not necessarily reflect the size of the average work produced in the Southern Netherlands at the time. A great number of paintings, some of which are still *in situ* in the churches for which they were made, are simply too large to travel.

literary, or allegorical subjects, ranked highest in the hierarchy of subject matter. Abraham Janssens's allegorical personification of Lascivia, one of the Seven Deadly Sins, can be classified as such a history piece (*cat. 8*). Janssens was perhaps the most talented history painter active in Antwerp before Rubens returned from Italy. His manner of painting, a striking blend of classicism and realism, reveals the influence of the styles of his Italian contemporaries Caravaggio and the Carracci. The monumentality of the figure of Lascivia, her sculptural solidity, and the marked contrasts of light and dark are all characteristic of the artist's work. This painting might have been seen as a moral warning to the viewer as well as a seductive nude.[65] One of the most important reasons for the esteem history paintings enjoyed was that they offered the viewer guidelines for the proper conduct of his life.

History subjects could also contain political or religious meanings. Jordaens's *St. Paul and St. Barnabas at Lystra* (*cat. 6*), for example, has been interpreted as a Protestant critique of the Catholic practice of venerating saints. On the other hand, an image such as van Dyck's *St. Francis Receiving the Stigmata* (*cat. 4*) was intended to spur the Catholic faithful to imitate the exemplary nature of this humble and pious visionary.

Seventeenth-century Flemish portraits are quite varied in nature. The portraits of the archdukes by Rubens as recorded in the prints by Jan Muller (*cats. 33* and *34*) show Rubens's gift of enlivening the old, traditional schema of court portraiture, in which the sitter is placed in front of a schematic background.[66] Despite some idealization, Rubens has imbued these portraits with a directness of observation that seems at odds with the accessories and devices used to denote the archdukes' power and position.[67] The posthumous portraits of Albert and Isabella that appeared on one of the arches for the Triumphal Entry of Ferdinand into Antwerp were based on sketches made from life that Rubens kept in his studio (*cats. 1* and *2*). Although Cornelis de Vos most likely painted these images, they were probably extensively retouched by Rubens.[68]

Van Dyck's portrait of François Duquesnoy (*cat. 3*), a fellow countryman he came to know in Italy, is a tribute from one artist to another. It is a more personal statement, and is consequently less formal, than Rubens's portraits of the archduke and archduchess. This depiction shows van Dyck's concern with pictorial rather than structural values.[69] He captures the inner life of his sitter and creates a palpable atmosphere in which Duquesnoy seems to exist. The sculptor's sensitivity, his pride, and perhaps a certain melancholy is suggested by the painter's efforts to describe Duquesnoy's humanity and psychology.

The *Bust of an Apostle* by Jacob Jordaens (*cat. 5*) is not a true portrait but rather a *tronie*, or expressive head study, of Abraham de Graef. Jordaens used this type of study to give figures in his large narrative paintings immediacy and a touch of the quotidian.

The intersection of portraiture and genre painting is illustrated in

64. Muller, Jeffrey 1993, 203–04.
65. Seductive images often were used to warn viewers against succumbing to their appeal; see Sluijter 1991–92, 337–96. Carnal vices were seen to jeopardize both body and soul; see, for example, Armstrong 1990, 68.
66. Vlieghe 1987, 22.
67. White 1987, 188. A similar combination of traditional format and new acuity of observation is also apparent in Aegidius Sadeler's print of the Brandenburg nobleman Arnold de Reyger (*cat. 32*). Inscribed in the oval format traditionally used for portrait engravings, the sitter's shrewdness and vanity is suggested by Sadeler's virtuoso burin work.
68. Martin 1972, 95.
69. Sutton 1993b, 46.

The Music Party by Jacob van Oost (*cat. 9*). The painting exhibits the fluid technique, clear tonality, and local color accents that feature in the best of van Oost's works. Although the figures are involved in the ordinary communal activity characteristic of a genre scene, engagement with the viewer is one of the features of portraiture, and in this painting, three of the gentlemen look out at the spectator. Additionally, the faces are very specific and individual, strikingly different from the generalized visages typically encountered in genre scenes. It seems that the artist has included a portrait of himself behind the young servant entering at right. He looks over at his son, depicted in the center of the painting holding a wine glass by its foot. Such a genre portrait "synthesizes the formal traditions of bourgeois and aristocratic group portraiture with the compositional schemae, narrative informality, and popular connotations of genre painting."[70] The elegant musical party was, indeed, a favored theme in Southern Netherlandish genre painting. The popularity of this type of hybrid image could well be related to the aristocratization of the middle class that took place there during the course of the seventeenth century.[71]

Earlier in the century, the work of Adriaen Brouwer provided a new impetus to the tradition of low-life painting. His characterizations of the raw and brutal nature of contemporary peasants brought the sixteenth-century tradition of Pieter Bruegel the Elder up-to-date. Brouwer's own followers, notably David Teniers, presented less extreme figural types engaged in more harmonious activities. For example, Teniers's tempered peasants chat amiably and work industriously in the foreground of Lucas van Uden's expansive *Departure for Market* (*cat. 19*). Teniers's art embraced a far wider range of subjects than did Brouwer's. The paintings in this exhibition by David Ryckaert and Nicolaes van Veerendael are both derived from the work of Teniers.

Veerendael's use of monkeys to satirize the actions of men (*cat. 10*) is part of a long history of such images. His humorous depiction of simian high-life entertainment gently mocks the leisure activities of the aspirant middle class. Alchemists in their studios trying to turn base metals into gold, as in the painting by David Ryckaert (*cat. 11*), were frequently associated with vanity. That idea is made explicit in Cornelius Gysbrechts's *Vanitas* (*cat. 12*). The carefully crafted skull, spent candle, fragile soap bubble, and dog-eared almanac in the painting allude to the passing of time and the end that awaits us all. Gysbrechts placed great emphasis on illusionism to convey his message: the glass door of the cupboard protrudes beyond the picture plane, objects are haphazardly tucked into the letter racks, and nails and pins project convincingly from the surface of the fictive wall. The viewer is thus encouraged to contemplate the vanity of this world in both the objects depicted and the deceptiveness of the artist's illusionism.

The floral still life became an independent painting type only toward

70. Wieseman 1993, 184.
71. Wieseman 1993, 184.

the end of the sixteenth century. Jan Brueghel the Elder apparently turned to flower painting in 1605 after a visit to the court in Prague the previous year.[72] He was the first artist to paint the garland still lifes with a central religious image that subsequently became so popular. *Garland of Flowers with Holy Family* is a perfect example of the collaboration of a figure and still-life painter (*cat. 13*). Brueghel has meticulously described each individual bloom with the thinnest of brushes and layers of transparent glazes. In addition to the important religious connotations the garland carried, one of the most obvious attractions of the floral still life, according to the artist in a letter to his patron Cardinal Federigo Borromeo, is its permanence. Brueghel commended such a picture for the winter months when actual gardens lay dormant.[73]

Johannes van der Baren's *Flower Altar with the Mystic Marriage of St. Catherine* (*cat. 14*) combines a floral still life, a religious subject, and an architectural construction. The central depiction, by an unknown artist, represents a *sacra conversazione* organized on two levels.[74] Van der Baren painted the flower garlands and bouquets flanking the devotional image with a sure eye and skilled hand. Such a painting, in its virtuoso rendering of luxuriant flowers, was meant to delight. It was also used to edify; the bouquets allude in a general way to the marvelous and various nature of God's creation. Individually, certain of the flowers, specifically the iris in the place of honor at the left and the lily at the right, hold Marian associations, the former alluding to her suffering, the latter to her purity. Symbolism thus enriches the meaning of the image and illustrates an important way in which such an apparently decorative still life could aid the Counter Reformation's cause.

Although Jan van Kessel also painted flower garlands, most of his work focuses on small-scale, delicately wrought studies of flowers and insects painted on a cream-colored ground (*cats. 16* and *17*). He made whole series of these works that were mounted on cabinets into which collectors put precious objects for safekeeping.[75] He depicted each beetle, butterfly, caterpillar, and blossom precisely and accurately, making use of illustrated scientific texts but also frequently working directly from nature.[76] This latter procedure is clearly evident in his drawing, *The Belly of a Tree Frog* (*cat. 30*).

Of Jan Brueghel's contemporaries, only Frans Snyders matched his innovative powers in still-life painting. Snyders, a frequent collaborator with Rubens, revitalized the sixteenth-century tradition of market and kitchen still lifes with figures and invented the figureless, large-scale dead game, or "trophies of the hunt," still life.[77] His monumental images depicting elaborate arrangements of dead game on a table often include fruit and vegetables as well as a thieving cat or snarling dog. The drawing in the exhibition features many of these components, including a rabbit, peacock, peahen, partridges, a head of cauliflower, and a lively cat (*cat. 29*).

Adriaen van Utrecht was a follower of Snyders and, like him, executed

72. Sutton 1993b, 78. In Prague he could have seen works by Roelandt Savery and Jacques de Gheyn that influenced this choice of subject.
73. Sutton 1993b, 84. On Brueghel's working method, see Brenninkmeyer-de Rooij 1996, 235 and Freedberg 1981.
74. A *sacra conversazione* is an imaginary gathering of saints from different times and places paying homage to the Virgin and Child.
75. Amsterdam 1983, 67.
76. His working method, recorded by Jakob Weyerman, one of his son Ferdinand's pupils, is described in W. Laureyssens, "Jan van Kessel ii," in Dictionary of Art 1996, 17:920.
77. Sutton 1993b, 79.

large kitchen, market, and pantry pieces. His works are characterized by a somber palette of earth tones and strong chiaroscuro. His painting in this exhibition (*cat. 15*) represents a fruit festoon suspended from ribbons attached to brass rings. The painting's decorative aspect is heightened by the stems, branches, and leaves that break up the horizontality of the arrangement. The play of light and shade over the surface of the fruit further enlivens the picture surface.

Interior of the Church of St. Rombaut, Mechelen (*cat. 18*) depicts the Gothic cathedral of Mechelen, since 1559 the only see in Belgium. The cathedral was symbolically viewed as the religious center of the country. In the seventeenth century, this type of painting would have been known as a "perspective,"[78] and indeed the space of the building is the work's true subject. The rendering of depth, the play of light, and the mimetic possibilities of painting—concerns of a strictly pictorial nature—are explored in such depictions. While specialists in this type of painting could choose to paint fictive views, Wilhelm von Ehrenberg's rendition of the church is true-to-life. The artist has carefully depicted the church's identifying characteristics: the black-and-white marble rood screen and high altar; the lofty clerestory with its filigree carving; the two rows of foliage decorating the column capitals; and the sculpted images of apostles. Because of the structure's religious significance, such a painting might have been made as a "portrait" of this important landmark.[79]

One of the most popular of the genres in which artists chose to specialize was landscape. Landscapes, most of which were sold on the open market, were collected widely among middle-class patrons in large part because of their affordability. Paul Bril made a significant contribution to the field, imbuing the panoramic "world landscape" tradition of the mannerists with a greater naturalism. Although he most likely trained in Antwerp, Bril was chiefly active in Rome, where he influenced the Dutch and Flemish artists who came to work there as well as the Frenchman Claude Lorrain. His rich landscape drawings (*cat. 22*) exhibit a characteristic use of parallel lines and calligraphic, rounded foliage. Overall, his touch is powerful and expressive. The landscape itself becomes his subject rather than functioning, as it did earlier, merely as a backdrop for a narrative. The relative simplicity of composition, clarity of space, and fresh choice of themes mark a tendency toward greater realism in the depiction of landscape.

Jan Brueghel the Elder was not only renowned for his still lifes but was also one of the most prolific Flemish landscape painters of the seventeenth century. He adapted the "world view" approach to landscape of his father, Pieter Bruegel the Elder, into his own miniaturistic idiom, often retaining the high vantage point of the panoramic tradition. His landscapes are always peopled, and it is the activity of these figures that is the subject of the study sheet in the exhibition (*cat. 23*). The studies were made after life; Brueghel's

78. de Pauw-de Veen 1969, 163.
79. Giltaij 1991, 16.

incorporation of them into his paintings was his contribution to a more naturalistic landscape.

The landscapes of Lucas van Uden reveal a debt to Rubens in their broad brushwork and atmospheric palette. *Departure for Market (cat. 19)* illustrates the compositional formula van Uden used most frequently: a hillside with tall, slender trees to one side of the painting and a rolling plain stretching into the distance on the other.[80] The golden tonality, expansive sky, and ordered forms evoke a serenity in this lush world, in which man performs his daily tasks amid God's glorious creation.

More decorative, because of the strong value contrasts and striking use of color, is Jacques d'Arthois's *Winter Landscape (cat. 20)*. This depiction harks back to cycles of the months or seasons. By the seventeenth century, such images tended to focus on the peculiarities of weather conditions or winter pleasures rather than the arduousness of winter work. In a sense, d'Arthois, the leading figure of the Brussels school of landscape painting in the second half of the century, has opened up and populated Bril's forest view, so that the pool is now a frozen pond on the outskirts of what is probably the forest of Soignes, one of his favorite sites.

Both landscapes and city views required the painter to reproduce within a limited space a scene that often cannot be apprehended at a single glance. It is therefore not surprising that views of cities were primarily painted by trained or practicing landscape artists.[81] Jean-Baptiste Bonnecroy, painter of the *View of Brussels (cat. 21)*, was a pupil of van Uden's, and did, indeed, produce landscape paintings and etchings. However, as far as can be determined from his surviving oeuvre, he specialized in painting townscapes. The painting in the exhibition depicts the most important buildings of Brussels in enough detail to make them identifiable, while the houses are schematic and uniform. Had the archdukes been alive, an image such as this would have been deeply significant to them, as it shows the results of their architectural and urbanistic policy.[82]

THE USES OF PRINTS AND DRAWINGS

A map must have been the source of Bonnecroy's inspiration for *View of Brussels*. The majority of maps were printed from engraved copper plates and were frequently embellished through hand coloring. The abundance of cartographic material, including the great atlas published by Abraham Ortelius in 1570 (compare *cat. 44*), enabled a broad audience to learn about new geographic discoveries in this great age of exploration and to journey vicariously to faraway places. In addition to mapping the earth, cartographers also charted the heavens. The telescope, invented in 1609, led to more accurate recordings of the heavens and the discovery of many new celestial bodies. The results were detailed maps of the moon and an increased production of celestial globes.[83]

80. Sutton 1993b, 75.
81. Grieten 1993, 162.
82. Thomas and Duerloo 1998, 298.

Most commercially made globes consisted of engraved paper gores (tapering triangular forms) that were glued to a sphere made of plaster and paper. Once attached, the gores were often colored by hand and then varnished. Celestial and terrestrial globes were usually produced in pairs, as is the case with the examples by Arnold and Michael van Langren (*cats. 89* and *90*). They were rather costly items that ranged in size from an inch to several feet in diameter.[84]

Just as Galileo's telescope revealed the satellites of Jupiter and the richly textured surface of the moon, the newly invented microscope brought into view the tiniest details of the natural world.[85] Nature's handicraft, as revealed through the microscope, was seen as further proof of the infinite complexity and beauty of God's design.[86] In fact, the impulse to represent accurately every aspect of the visible world was grounded in a conviction that all of God's creations, both large and small, were worthy of representation. Furthermore, by closely observing and rendering the most ordinary and extraordinary natural forms (as did Jan van Kessel with frogs and insects [*cats. 16–17* and *30*] and Jan Brueghel with various blooms [*cat. 13*], for example), artists could come closer to understanding the underlying truths of nature.[87]

Drawing satisfied this need to record. Drawings were also used by artists to work out compositional ideas. Studies made early in the creative process often involve the disposition and grouping of figures and the laying-out of space. These might be followed by detailed analyses of individual forms, motifs, or portions of the whole. An elaborately finished compositional drawing could be shown to the client for approval or used by the artist as reference in the execution of the final work, which was invariably to be realized in a different medium.

Jordaens worked in chalk for his study for a religious history (*cat. 26*) and in pen, ink, and wash for his mythological subject (*cat. 25*). De Clerck's image in pen and ink is a fully worked-up presentational drawing (*cat. 24*). In all of these sheets, the figural groupings, spatial disposition, and distribution of light and shade have been fully established. Details have been included to a greater or lesser degree. Snyders, on the other hand, concentrated on only a portion of his still-life composition, studying the way in which the forms respond to and connect with one another (*cat. 29*). Sadeler's drawing (*cat. 31*) is a finished preparatory study for an engraving (*cat. 32*). Whereas draftsmen preparing such an image to be engraved by a professional printmaker would work carefully and painstakingly, usually in pen and ink, Sadeler worked more freely in ink and brush, as he was to engrave the image himself. Finally, as in Bril's *Pool in a Forest* (*cat. 22*), drawings could function as finished works of art in their own right. Many Flemish seventeenth-century landscape drawings were apparently made without a final painting in mind.[88]

There are preparatory oil sketches in this exhibition for a tapestry design (*cat. 28*) and an altarpiece (*cat. 27*). Boeckhorst stressed pictorial qualities in

83. Welu 1991, 105–09.
84. Welu 1991, 109.
85. Kenseth 1991, 29.
86. Kenseth 1991, 38.
87. Wheelock 1991, 183.
88. Logan 1993, 29.

the former while de Crayer concentrated on the arrangement and attitudes of the figures in the latter, which is related to several altarpieces that differ only slightly from one another.

During the seventeenth century, prints were collected for aesthetic reasons, but they also had a multitude of uses. They played an increasingly vital role in both educating the eye and, in the case of maps and globes, disseminating knowledge. Artists even used prints to teach their pupils how to draw. Painters also realized that the medium could be useful in spreading their achievements and fame. Muller's reproductive engravings of Rubens's portraits (*cats. 33* and *34*), for instance, spread not only the painter's fame, but also that of the archdukes. Politically they also served many functions, from expressions of loyalty to the Hapsburg government at home to impressive images of the regents in Spain and its dominions. Such prints began to be protected by privileges developed to regulate the copying of such images. Free reproduction had been tacitly sanctioned, or at least went unpunished, until that time, but the advent of the privilege signaled the new esteem in which prints and printmakers were held.

Painters, sculptors, printmakers, and architects studied engravings to absorb and occasionally to borrow from the works of their predecessors and contemporaries. Prints and model books provided examples of ornamentation that were used in the design of quite disparate objects, such as metalwork, architectural detailing, and stained-glass windows. In this exhibition, prints served as models for the central roundels of the stained-glass windows (*cats. 76* and *77*), for both the ivory (*cat. 63*) and painted (*cat. 62*) cabinets, and most likely for the brass clock (*cat. 64*) as well. While sketches intended as models for ornament designers were usually discarded after having served their purpose, prints, because of their cost, remained in use in the studios for several decades or longer.[89]

Artists delighted in adapting designs to novel contexts. Frieze configurations of vegetal garlands (rinceaux), for example, appear in the arch of the tapestry (*cat. 56*), around the rim of the silver beaker (*cat. 79*), on the silver basin and ewer (*cat. 84*), on the statue cupboard (*cat. 57*), and in the gilt leather wall covering (*cat. 91*). These twisting motifs were ideal for empty or subsidiary spaces such as frames, corners, and decorative borders, softening their angularity and regularity with curves and volutes.[90] Similarly, the sculptural framing elements of strapwork and cartouches adorn the statue cupboard (*cat. 57*), apothecary jars (*cats. 68* and *69*), and stained-glass windows (*cats. 76* and *77*) in the exhibition.

Printed imagery not only informed but also instructed. Antwerp continued to be the most important city for book printing in the Southern Netherlands, not least because of its importance as the primary center of the Counter Reformation. Printers such as the renowned Ex Officina Plantiniana, founded by Christopher Plantin and carried on by the Moretus family, produced both expensive liturgical and academic works intended for export, and popular

89. Gruber 1994, 16.
90. Bimbenet-Privat 1994, 115.

booklets, polemical tracts, and devotional works for the domestic market (compare *cats. 45* and *46*). The printmakers themselves produced not only costly works based on the designs of famous painters but also small devotional prints for the use of foreign missions and the attempt to win back errant Protestants organized by the priesthood after 1585.[91]

By 1617, there were at least ten firms in Antwerp producing numerous images of saints and biblical scenes to be put in the service of religious propaganda and approved edification. The Jesuits, for example, were committed to reaching as wide an audience as possible. Printed illustrations served this aim both expeditiously and in keeping with the character of the intensely visual principles on which the *Spiritual Exercises* of St. Ignatius were based.[92] Religious images were used throughout the home as a declaration of adherence to the Catholic faith or a reflection of personal devotion.[93]

The prints by Antonio Tempesta of Ovidian subjects (*cats. 40–42*) were a ready model for the cabinet painter (*cat. 62*) who needed to produce such cupboards quickly. On the most superficial level, these prints provided a fitting subject (love, in all its forms) for a domestic setting. However, prints, like paintings, often had a moralizing dimension.[94] Subjects from Ovid's *Metamorphoses* were frequently interpreted in an ethical light. For instance, the scene of *Jason Bewitching the Dragon* (*cat. 40*) might have been interpreted as pride, symbolized by the beast and considered the source of all evil, succumbing to reason. Jason's quest for the Golden Fleece was seen to correspond to man's quest for virtue.[95] The use of prints as source material in this example then both instructed and delighted.

Print series dealing with abstract concepts and the course of natural and human events were also popular during the sixteenth and seventeenth centuries. Through the use of personifications and allegories, serial subjects such as the seasons, times of day, temperaments, senses, elements, planets, and liberal arts—as they appear in the works by Crispijn van de Passe after Marten de Vos (*cats. 37–39*) that were used as models for the ebony and ivory cabinet (*cat. 63*)—provided the means of exploring various aspects of the natural and moral world.[96]

Heightened interest in texts, encouraged by the humanists in the sixteenth century, stimulated a proliferation of Old Testament narratives.[97] Such subjects were ideal for artists in search of engrossing, moving, and instructive tales. They were among the preferred themes of the collaborative team of van Heemskerck and Coornhert (*cats. 35* and *36*). Many of the stories featured characters embroiled in trials and tribulations with which viewers could readily identify; the central dramas raised issues that seemed relevant in the day. In the case of the story of Joseph, events are fraught with sibling rivalry and dramatic reversals of fortune, resulting in a complex saga that ultimately is resolved with the restoration of honor and family unity. Themes of love and revenge, loyalty and disobedience, vanity and

91. Thijs 1993, 112.
92. Freedberg 1993, 137–38.
93. Muller, Jeffrey 1993, 200.
94. The tendency to moralize and apprehend images and events in a multivalent way underlay the seventeenth-century view of the world.
95. Fabri 1993, 39–40.
96. See Stuttgart 1997, for a study of this print phenomenon.
97. New York 1995, 175.

humility, faith and inconstancy are at its core. The moral and didactic content of such stories came to be increasingly emphasized. The tales were looked on as guides to good and evil; they were considered a "fixed code of laws" from which one could learn proper conduct.[98]

Glass roundels, such as those illustrating the story of Joseph (*cats. 76* and *77*), generally were produced in narrative series rather than as individual scenes. These series were intended to convey some edifying, ethical, or cautionary lesson rather than to inspire devotion. "The finger raised in warning" served as a reminder to the viewer of the need for vigilance in the face of human frailty.[99]

THE DOMESTIC INTERIOR

Roundels graced the windows of public buildings and private living quarters.[100] Windows in the salon would have had shutters; the lower ones were often closed for privacy. The room would have been relatively empty and dark. Earth colors would have predominated, enlivened by accents of red, gold, and black. The floors would have been broad planks of dark wood and the ceilings, wood beams. The walls were often covered in gilt leather, with black-framed paintings hung symmetrically. The most prominent painting, in a gold frame, would have hung over the fireplace, which often occupied the wall at right angles to the windows.[101]

Gilt leather on walls came to replace tapestries in all but the most luxurious or largest houses.[102] *Scenes from Country Life*, Jordaens's series of eight tapestries (*cat. 56*), would have been appropriate to a domestic setting, albeit more likely a country villa than a city house.[103] Tapestries had been one of the more distinctive of the Southern Netherlandish luxury products, but despite the great demand and enormous output during the seventeenth century, the industry by this time had already begun to decline. Nevertheless, the role of the artists who painted tapestry cartoons became increasingly important as the role of the weavers grew less so. The latter restricted their work first to interpreting the designs of the artists and later to reproducing them as faithfully as possible. Rubens's innovation as a tapestry designer was to focus attention on the figures. His students and followers, including Jordaens, integrated these large figures into compositions that included a great deal of detail.

The Spanish chair, with or without arms (*cats. 60 and 61*), made of oak with leather seats and turned legs, was the dominant type of seating in a Southern Netherlandish interior. Armchairs were used by important or older people, while others sat in side chairs with similar features. In order to facilitate movement, the chairs were not always grouped around a table but were arranged along the walls of the room.

The statue cupboard (*cat. 57*) would have been best placed centrally against a wall, so that light fell directly onto it, making it easier to see inside

98. For the significance and interpretation of Old Testament subjects, see van der Coelen 1996, 8, and Veldman 1995, 19–20.
99. Husband 1995, 13.
100. These roundels came from the hospital of St. Elizabeth at Lierre, but such windows could also be found in guilds, mercantile buildings, courts, town halls, chapels, and glazed cloisters; see Husband 1995, 10.
101. For a thorough discussion of the appearance of such salons, see Vandenbroeck 1990.
102. d'Hulst 1982, 295.
103. Duverger 1988, 311.

when one of the doors was opened. According to archival and iconographic sources, cupboards such as these were used to store dishes, cutlery, and household linen such as tablecloths, napkins, and covers for the Spanish chairs. In this way, a direct relationship existed between the furniture in the room and the function of that room, whether it was for eating, sitting, or sleeping.[104]

The highly decorative cabinet, which would have been placed on a table, was a collaborative effort among ebony workers, silversmiths, coppersmiths, painters, carvers, turners, glaziers, and locksmiths. It frequently occupied a position of honor in the interior, against the short wall of the room and opposite the entrance, so that it would be immediately visible upon entering. The type of cabinet that incorporates small paintings on panels attached to the front of the drawers, door, shutters, and top was made only in Flanders (cat. 62). Another type of cabinet features drawers and doors fronted with thin ivory plates that are decorated with scenes drawn in black ink (cat. 63). For both types, artists found inspiration in graphic works by well-known designers.[105]

These cabinets served mainly for storing small valuables, such as collections of jewelry, silver, minerals, or shells. They also often hid secret compartments or false bottoms, so that they almost functioned like safes. Behind the central door of the cabinet there was almost always a prospect, a cube-shaped space covered with mirrors and decorated with columns and arcades. This construction created the optical illusion of infinite space and provided a source of amazement for the viewer. The presence of such sophisticated devices as the prospect and the secret compartment increased the attraction of these precious pieces and encouraged the designer to use his ingenuity to the full.[106]

The table (cat. 59) was often placed off the center line of the room in order to create a dynamic effect. It was used not only for displaying possessions but also for serving meals. The act of dining, as it evolved from court to bourgeois households, had developed into a ritual designed to demonstrate social status. The growth of a formal dining routine resulted in the establishment of individual place settings and the use of utensils, which in turn led to a specialization in tableware production and a demand for a greater choice of products to suit different incomes.

Stoneware containers were employed for a variety of purposes having to do with the dining ritual, from transportation, to storage, to serving. Among the primary functions of this material was its use as a drinking vessel. The fineness and plasticity of the clays enabled stoneware to be thrown or modeled into a wide range of forms suitable for the kitchen or table. Funnel-necked jugs were suitable for drinking wine, while beer was drunk from vessels with wider openings, more stable bases, and larger capacities. Either beverage would be decanted from larger jugs into smaller vessels on the table.

The development of applied relief technology that made use of molds

104. Fabri 1989, 218.
105. Fabri 1988, 449–51.
106. Fabri 1989, 216.

enabled the stoneware industry to transfer contemporary graphic designs onto the surface of domestic ceramics. At the same time, it allowed consumers to influence design, providing an opportunity for personal arms, badges, and merchants' marks to appear as decoration. The steady rise in the status of stoneware is also demonstrated by the fashion for embellishing drinking and decanting wares with silver-gilt or pewter lids and body mounts. This ornamentation and personalization allowed stoneware to compete with other luxury materials (such as metalware and glass) in the dining sphere. The thriving industry based in Raeren—a Belgian city in Limburg slightly south of Aix-la-Chapelle and southwest of Frechen, Cologne, and Siegburg—was particularly active during the second half of the sixteenth and the beginning of the seventeenth century in the production of ceramics for individual consumers.

Increasingly at the end of the sixteenth century, potters turned to stamped and incised decoration, although applied relief continued to be used for heraldic shields and portrait medallions. It was also used to apply text to the stoneware, from a caption clarifying an image to a moralizing aphorism urging piety and probity, as in the jug inscribed "Young man, keep your distance, do not give way to your fantasies; do not be too fond of the ladies, and you will be all right" (*cat. 71*). Applied to domestic drinking vessels, such inscriptions once again emphasize the penetration of moralistic concerns into everyday social rituals.

Sometimes the wares were designed to advertise political allegiance. The same jug that warns of the necessity for moderation and judgment features the Ducal arms of Brunswick and the Electoral arms of Saxony. From this homage to the German Protestant antagonists of the Hapsburg royal family, it can be inferred either that the jug was intended for the Protestant market or that the potter had Protestant sympathies. Often, this type of decoration was more commemorative than political.[107]

The main competitors of the stoneware manufacturers in the luxury tableware market were the glassmakers. Roughly speaking, two distinct types of glasses used at table can be distinguished. There were glass forms native to Germany and the Netherlands, among them the *roemer* and its variant, the *berkemeier* (*cat. 72*). These were generally made of greenish forest glass, used primarily for plain drinking vessels. On the other hand, more expensive, elegant glassware made of *cristallo*, or clear glass, was fashioned *à la façon de Venise* (in the Venetian manner) (*cat. 71*). Variety and ingenuity were highly prized at the time, in the number of dishes served at banquets and meals, and evidently in the forms of the glassware as well.[108]

The Italian Renaissance glass industry set the standard in Europe during the sixteenth and seventeenth centuries. The first glass-house in the Netherlands to produce glass *à la façon de Venise* was established in Antwerp in 1549. Workers, materials, and tools were all brought over from Italy. Italians kept control of the only glass manufacture in Antwerp for some

107. This discussion of stoneware is based primarily on Gaimster 1997, chapter 4, "Stoneware as a Utilitarian and Social Medium," and chapter 5, "Pots, Prints, and Propaganda."
108. Flandrin 1989, 292–94. See also Wheaton 1983.

seventy years.[109] After the first quarter of the seventeenth century, Antwerp's predominance succumbed to competition from Liège and Brussels, among other centers.

In paintings and prints of the period, such elegant glassware is rarely shown as part of the table setting. It is most often depicted either in the hands of a drinker or on a tray being carried by a servant. The great variety of types is also not represented. Apparently such delicate creations were used mostly on special occasions.

Even at the beginning of the seventeenth century, there were wealthy, enlightened people who still ate with their hands. Tableware was personal, in that it was not provided by the host, so travelers carried their own (*cat. 85*). Not until the last quarter of the century did the use of forks and spoons at table become customary practice in most households.[110] It was necessary, therefore, for guests to wash their hands several times during the course of a meal. For this reason, the ewer and basin (*cat. 84*) were a necessity at table. They, along with other precious vessels, are often quite visible on sideboards in representations of banquet scenes. Once forks became common, the ewer and basin, though still used in the dressing room, eventually became a standard type of display plate and honorary gift.

The silversmith's skill and virtuosity were highly prized. Covered cups in an amazing variety of sizes and shapes and ornamented in various techniques and with abundant decoration (*cats. 81* and *82*) were commissioned by civic and guild authorities and by prominent individuals. Silver vessels that ingeniously and wittily emulated other forms were also appreciated as examples of the silversmith's art, to be displayed and offered as tokens of honor and esteem. These costly silver objects, such as the cup in the shape of a *nef* of fortune (*cat. 83*), were only rarely used as drinking vessels (perhaps on special occasions or at banquets) and were almost exclusively put on display. The most common form of silver vessel from which people drank was the simple beaker (*cat. 79*). Even in this case, though, the elegant form and delicate, engraved ornamentation reveal a highly trained craftsman's sensibility.

Silversmiths also provided the settings for exotic objects or objects of curiosity, enhancing the value of the things themselves. Richly worked metal objects combined with products of nature were especially sought after by collectors in the Netherlands in the sixteenth and seventeenth centuries. They would have been part of the *kunst-* or *wunderkammer*, a collector's cabinet of works of art and artifacts, both natural and artificial, that captivated the eye and mind. Among the most popular of these expensive luxuries were mounted nautilus shells and coconut cups (*cat. 80*). The latter usually had carved representations, often biblical and frequently associated with drink, and were often worked by the silversmith who crafted the mount.[111]

Less expensive ornamental and utilitarian objects were made of brass. The center for brass production in the Southern Netherlands was Dinant;

109. Antwerp 1993a, 335–36, cat. 185. Similarly, Italian potters working in Antwerp were responsible for initiating local craftsmen in the techniques, colors, and ornamental motifs of their native ceramic tradition; see Chicorée 1972, 28.
110. Houart 1982, 71–72.

36

hence, objects of domestic or decorative function made of copper or brass, such as the platter with the Coronation of the Virgin (*cat. 65*) or the bottle cooler (*cat. 66*), became known as *dinanderie*. Its rich and luminous tones, reminiscent of gold, warmed many Flemish interiors.

The acquisition of luxury commodities on such a large scale was not only clearly acceptable in seventeenth-century Flanders, but was also deemed virtuous in some quarters. The emblem books by the Jesuit Adrianus Poirters, published in the 1640s, advocate "healthy spending on real, material goods." The export market was a significant outlet for these luxury goods. In fact, art was the only growth sector in Antwerp's industrial production for export. Even though the city no longer enjoyed all its former economic glory, the art market was its one area of indisputable strength, in which works of art functioned as symbols of civic prestige and sources of pride.[112]

111. For such coconut cups see Fritz 1979.
112. Honig 1998, 107–14.

CATALOGUE *of the* EXHIBITION

1.

PETER PAUL RUBENS
Siegen, Westphalia 1577–
Antwerp 1640

*Portrait of the
Archduke Albert,*

ca. 1634–35
Oil on canvas
54 ⅓ x 41 ⁹/₁₆ inches (138 x 105.5 cm)
Royal Museums of Fine Arts
of Belgium, Brussels, inv. 167
Inscription: on the rail of the
balustrade, ALBERTVS ARCHID.
AVSTRIAE BELG. ET BVRG. PRINC.

2.

PETER PAUL RUBENS
Siegen, Westphalia 1577–
Antwerp 1640

*Portrait of the
Archduchess Isabella,*

ca. 1634–35
Oil on canvas
54 ⅓ x 41 ⁹/₁₆ inches (138 x 105.5 cm)
Royal Museums of Fine Arts
of Belgium, Brussels, inv. 168
Inscription: on the rail of the
balustrade, ISABEL. CLARA EVG. HISP.
INF. BELG. ET BVRG. PRINC.

These posthumous portraits of Archduke Albert and Archduchess Isabella
were made for the rear face of the Arch of Philip (*cat. 43*), part of the deco-
rations for the Triumphal Entry of Ferdinand into Antwerp in 1635. As court
painter to the archdukes, Peter Paul Rubens would have had images on hand
from which he could take their likenesses.[1] The artist's choice of a profile
view for Albert has a practical explanation: on the arch, the archdukes were
separated by an engaged stone statue of Hymenaeus, god of marriage. He is
therefore depicted facing Isabella and doffing his hat. A profile view also
implies a sense of remove and majesty and evokes such portraits on medals,
coins, and tomb sculpture. By contrast, the archduchess, body turned to her
right, is seen full face. One of her hands rests on the parapet, the other holds
a fan. She wears a diadem, mill-stone lace collar and cuffs, many strands
of pearls, and an inlaid cross. From her bodice hangs a medallion with the
image of Our Lady. Her authority and sobriety are expressed by these accou-
trements, her posture, and her outward gaze. Rubens's images are direct and
carefully observed, avoiding the subtle forms of flattery and glamour that
are often features of royal and aristocratic portraiture.[2]

When the arch was dismantled and the paintings were being treated
for their exposure to the weather, it was decided to cut away the balustrade
and convert them into standard half-length portraits. While the portraits
that were originally placed on the arch were most likely executed by Cornelis
de Vos according to Rubens's designs, Rubens himself probably retouched
them extensively after they came down. This intervention may well have
been undertaken as a token of his esteem for the archdukes, and for the
Archduchess Isabella in particular.[3] Rubens became particularly close
to Isabella after Albert's death, serving as her diplomatic ambassador
and carrying out commissions at her request.

1. The last time Rubens painted both
the sovereigns from life was in
1616. It seems that the painting
of the archduke depends on this
1616 image, with the exception of
the position of his head. The profile
portrait of the archduke closely
resembles another on the left wing
of the Ildefonso altarpiece in Vienna
(ca. 1630–32); see Martin 1972, 95.
2. White 1987, 188.
3. Martin 1972, 95. The inscriptions
on the balustrade rails would have
been added at this later time.

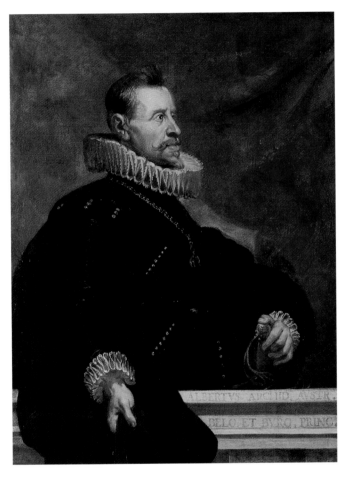 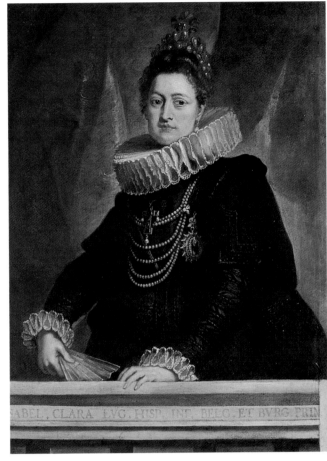

3.

ANTHONY VAN DYCK
Antwerp 1599–London 1641

*Portrait of the Sculptor
François Duquesnoy,*

ca. 1622–23
Oil on canvas
30 ½ x 24 inches (77.5 x 61 cm)
Royal Museums of Fine Arts of
Belgium, Brussels, inv. 3928

Anthony van Dyck was in Rome between February and August 1622, and again between March and October or November 1623. During that time he painted a small group of half- or near-three-quarter-length portraits of friends and associates in an almost monochromatic palette. Among them is this portrait, identified as sculptor François Duquesnoy in an engraving after the painting by Pieter van Bleeck from 1751.[1]

Since 1618 Duquesnoy had been active in Italy, where he went to study art with the financial support of the archdukes.[2] Van Dyck most likely made Duquesnoy's acquaintance through the group of artists from the Southern Netherlands who congregated at the Flemish hospice of San Giuliano dei Fiamminghi.[3] Duquesnoy's earliest protector in Rome was the rich Flemish merchant Pietro Pescatore, treasurer of the hospice of San Giuliano during van Dyck's Roman sojourn. It was through Pescatore that Duquesnoy received the orders for some of his most moving creations, among them the funeral monuments for two Flemish merchants buried in Santa Maria dell'Anima.[4]

Pentimenti in the painting indicate that van Dyck did not arrive at the composition without a struggle. An oil sketch in a private collection shows that Duquesnoy originally faced to his left and held out a sculptural group consisting of three putti.[5] In the finished work, the sculptor, wearing Flemish-style dress, faces to his right and holds an antique marble head of Silenus. This is the type of sculpture he would have produced during his early years in Italy when he was making small copies after well-known works from antiquity.[6] The head provides a foil to the sitter, its sightless immobility contrasting with his sharp-eyed vitality.[7]

Van Dyck was, above all, a painter of portraits. His sitters at once have an air of elegance and refinement and a psychological aspect, implying an inner life. Duquesnoy, proud of his craft, directs his steady gaze at the viewer. By allowing the head and hand of the sculptor to emerge from the dark background, van Dyck emphasizes the most expressive elements of his sitter.

1. Despite de Poorter's questioning of both the identity of the sitter and the date of the portrait's execution (de Poorter 1969), the traditional association of the portrait with Duquesnoy has recently been upheld by Freedberg 1994.
2. Rubens intervened to obtain this stipend from his patrons for Duquesnoy.
3. According to Freedberg 1994, 155, Passeri saw Duquesnoy in the company of his Flemish compatriots at the hospice.
4. Freedberg 1994, 156. These monuments date to the 1630s.
5. Jaffé 1967, 157, fig. 2.
6. Larsen 1988, 2:145, cat. 355. Rubens sketched a head similar, if not identical, to this one several times; Held 1959, 1:160–61, cat. 164.
7. Jaffé 1967, 159.

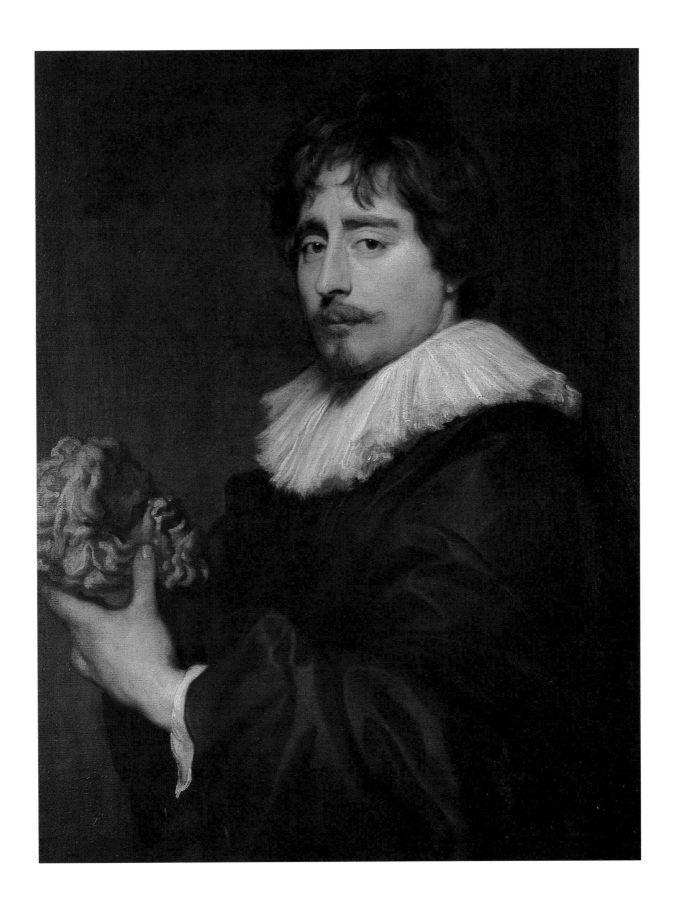

4.

ANTHONY VAN DYCK
Antwerp 1599–London 1641

*St. Francis Receiving
the Stigmata,* ca. 1630–31

Oil on canvas
85 ⅜ x 50 inches (217 x 127 cm)
Private collection

One of the most important dictates of the Council of Trent was that art should encourage the faithful to imitate the righteous lives it portrayed. Images of saints represented Christian heroes, exemplars intended to strengthen Catholics in their belief and spur them to emulation. Martyrs and ascetics were viewed as the most steadfast witnesses to the true faith.[1]

According to tradition, two years before his death St. Francis of Assisi had a vision of Christ on the cross in the form of a seraph with six wings. At that time, the saint miraculously received the five wounds of Christ— the stigmata—on his hands, feet, and side.

This painting dates from van Dyck's second Antwerp period (1627/8–32) when he enjoyed his greatest success as a history painter. In this depiction of St. Francis in ecstasy, the usually kneeling saint is standing upright, arms open in an embrace. The low vantage point emphasizes the saint's stature. The traditional image of Christ on the cross has been replaced by an intense beam of light that seems to envelop the figure of St. Francis. He looks upward, enraptured. Leafy branches from the tree behind him form a canopy above his head. For the most part, the landscape is sketchy and rapidly brushed; its luminosity and free rendering recall the work of the Venetians van Dyck so admired.[2]

The large dimensions of the painting indicate that it could have been made for one of the high niches that separated the choir from the nave in Franciscan churches of the seventeenth century.[3]

1. Vlieghe 1972a, 20–22.
2. A slightly smaller version of this painting with the saint placed on a parapet before an indeterminate background is in the Royal Museums of Fine Arts of Belgium, Brussels, inv. 214. It follows the traditional iconography more closely than does the present work by including an image of the crucified Christ, and it is not as freely executed. The pose of St. Francis shared by the two paintings is close to that chosen by van Dyck for the figure of St. Augustine in the altarpiece he painted for the Augustinian Church in Antwerp in 1628. According to Princeton 1979, 139, by using the posture associated with St. Francis for St. Augustine, van Dyck was drawing "a parallel between saints who received grace through the ardor of their love."
3. Metz 1993, 133, cat. 50.

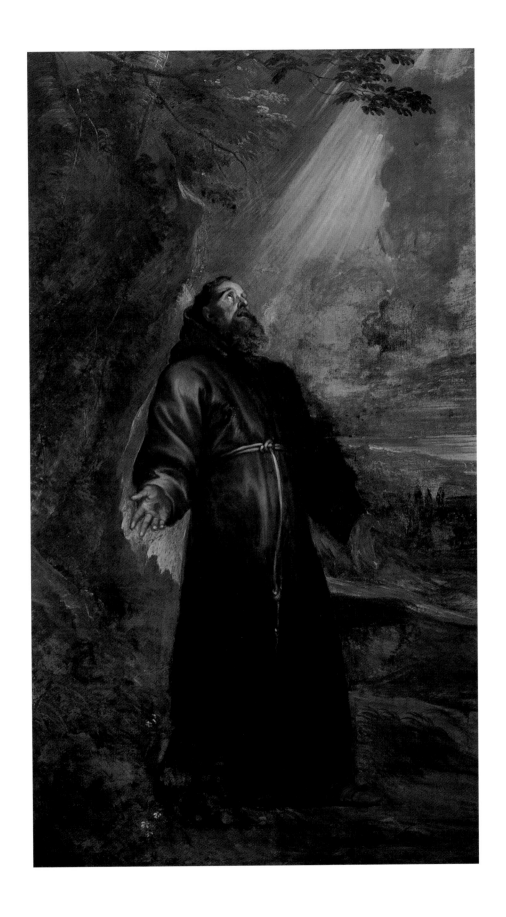

Jacob Jordaens
Antwerp 1593–Antwerp 1678

Bust of an Apostle,

ca. 1621
Oil on canvas
23 ¼ x 18 ⅞ inches (59 x 48 cm)
Royal Museums of Fine Arts
of Belgium, Brussels, inv. 121

The sitter in this fine oil sketch by Jacob Jordaens has been identified as Abraham de Graef, the factotum of the painters' Guild of St. Luke in Antwerp. Many artists with whom de Graef worked were struck by the craggy features and rugged physique of this man who kept the books, sold the work of his associates when they died, tended the guild's altar at religious ceremonies, waited on tables on the feast day of their patron saint, and worked behind the scenes on performances of the chamber of rhetoric connected with the guild. Until his death in 1624, de Graef sat for guild members regularly, among them Marten de Vos, Cornelis de Vos, and Anthony van Dyck. Some oil studies of de Graef by van Dyck and Jordaens are so closely related in composition and technique that the two artists must have been painting side by side.[1]

From about 1619 until about 1627, Jordaens was at the height of his creative powers. It was during this period that he began to produce for the first time figure studies from life in oils.[2] In this work, Jordaens used a heavily loaded brush and applied the paint with a firm, spirited touch. Like Rubens, Jordaens kept such oil paintings in his studio so he could use them for reference.

Jordaens repeatedly painted the head and bust of de Graef, which he incorporated into various paintings.[3] For example, the sitter apparently was the model for the satyr in Jordaens's *Homage to Pomona* (1623, Royal Museums of Fine Arts of Belgium, Brussels, compare *cat. 25*), for a background figure in *St. Peter Finding the Tribute Money in the Fish's Mouth* (ca. 1623, Statens Museum for Kunst, Copenhagen),[4] and for one of the *Four Evangelists* (ca. 1625–30, Louvre, Paris).[5]

1. Antwerp 1993b, 96, cat. A21.
2. Antwerp 1966, 28.
3. There are related oil studies in Ghent, Detroit, Douai, and Prague.
4. Antwerp 1993b, 102, cat. A23.
5. Antwerp 1993b, 96, cat. A21.

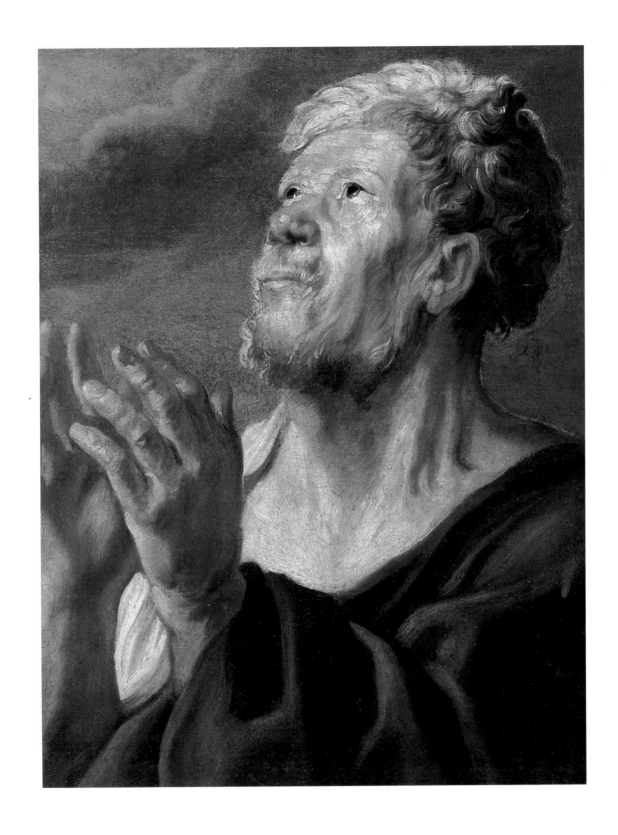

6.

Jacob Jordaens
Antwerp 1593–Antwerp 1678

*St. Paul and
St. Barnabas at Lystra,*

ca. 1655–60
Oil on canvas
45 ¼ x 53 ¹⁵⁄₁₆ inches (115 x 137 cm)
Private collection

The scene depicted is recounted in the New Testament, Acts 14: 11–15. After the people of Lystra had witnessed Paul healing the cripple, they considered Paul and Barnabas gods and prepared to sacrifice to them. The apostles "tore their garments" and reproached the people, saying, "we also are men, of like nature with you," and exhorted the crowd to "turn from these vain things to a living God."

Although the subject is rarely represented in the art of the Southern Netherlands, it appears more frequently in the North. The Protestants interpreted it as a critique of the veneration of saints as it was practiced by the Counter-Reformation Catholics.[1] Although it is tempting to connect this choice of subject with the fact that Jordaens had openly declared his adherence to Calvinism in the 1650s,[2] he had painted a version of *Paul and Barnabas at Lystra* as early as about 1616 (Hermitage, St. Petersburg). It was a subject he would have known from his teacher and father-in-law Adam van Noort.[3]

Jordaens represents Barnabas rending his cloak, sacrificial oxen being led in, the priest of Zeus ready to make the sacrifice on the burning altar, and numerous spectators jockeying for position. *Pentimenti* are visible in the area of the dog's legs and under the figure at the balcony at the upper left. These changes indicate modifications made in the course of the painting's execution but are also a function of the fact that, in his later works, Jordaens applied his paint very thinly.[4]

After Rubens's death in 1640, Jordaens began to rely more and more on studio help.[5] The execution and use of color indicate that this painting is a later repetition of a frequently depicted theme made with the aid of studio assistants.[6]

1. Antwerp 1978, 97, cat. 36.
2. d'Hulst 1982, 250.
3. d'Hulst 1958b, 93.
4. d'Hulst 1958b, 99.
5. According to d'Hulst 1982, 183, Jordaens's studio resembled that of Rubens and was run on the same principles but with less discernment. It turned out a flood of replicas, variants, and copies of Jordaens's most popular compositions.
6. Antwerp 1978, 97, cat. 36. There is a signed and dated painting of the subject (1645) in the Akademie der bildenden Künste, Vienna, and a version of it in the museum in Perm, Russia. Another rendition, of about 1640–45, is in the J.B. Speed Art Museum, Louisville, and a variant of it is in the Royal Museums of Fine Arts of Belgium, Brussels, inv. 6791. These works are all unthinkable without the example of Raphael's tapestry of the same subject.

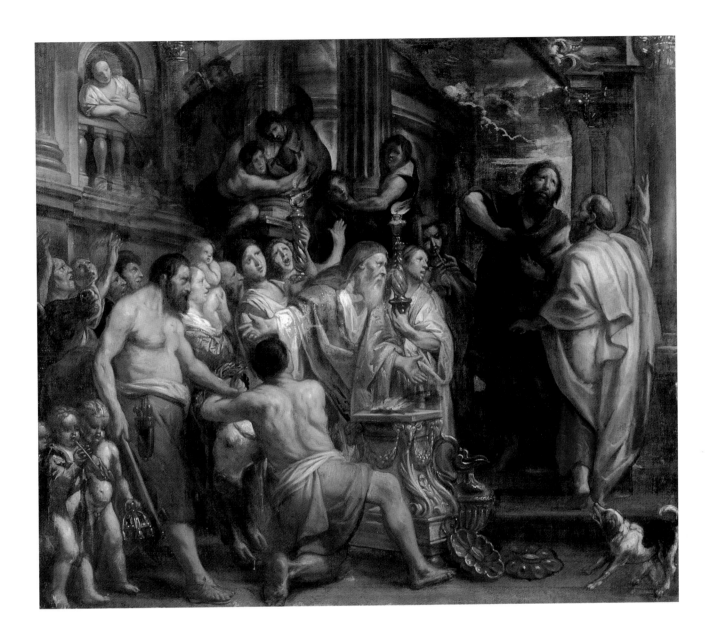

7.

Gaspar de Crayer
Antwerp 1584–Ghent 1669

The Adolescent Virgin Adorned by Angels in the Presence of Joachim and St. Anne,

early 1620s
Oil on canvas
61 x 43 ¹¹/₁₆ inches (155 x 111 cm)
Royal Museums of Fine Arts of Belgium, Brussels, inv. 66

Gaspar de Crayer's tender depiction of the young Virgin being adorned by angels and presented to God by her parents Anne and Joachim exemplifies the artist's style of the early 1620s.[1] The large, clear forms are not as robust as those of Rubens, but the palette of pale green, saturated red, and gold recalls that used by the great master in *The Last Judgment* of 1615 in Munich, for example. The delicacy of the figures' gestures and their refined features are characteristic of de Crayer's art, but are also symptomatic of the progressive sentimentalization of altarpieces that resulted from "a diet of sweetly exhortative or vigorously and graphically emotional imagery, disseminated in the form of everyday engravings."[2]

The assertion of the efficacy of the veneration of the Virgin and saints and an emphasis on the belief in the Immaculate Conception were important to the Counter Reformation's strategy for reclaiming the faithful. In focusing on the conception of Mary, there arose a concomitant interest in her parents and apocryphal tales of her youth. In de Crayer's oeuvre alone, there are four depictions of the present theme.[3] The large altarpiece in the Augustinian Church of St. Stephen, Ghent, is an expanded version of the Brussels painting in which the flower-bearing angel has been transformed into St. Dorothy,[4] the Virgin's family is placed on a dais, and the group has been joined by Saints Stephen, Barbara, and Clare of Montefalco.[5] St. Anne is enthroned, and the Virgin leans gently against her, standing between her knees. The central action in both paintings, the crowning of the Virgin with flowers, alludes to her future role as Queen of Heaven and Mother of God.

1. Boston 1993, 365, cat. 50.
2. Freedberg 1993, 138.
3. See Vlieghe 1972b, vol. 1, A90 (whereabouts unknown), A91 (Vestisches Museum, Recklinghausen), A142 (Church of St. Stephen, Ghent), and A214 (the present painting).
4. St. Dorothy refused to worship idols and was condemned to death. On her way to execution, the pagan lawyer Theophilus called to her to send him fruits from paradise. An angel appeared to her bearing roses and apples which she had sent to Theophilus, who was instantly converted. She is usually represented with an angel and flowers. See Murray and Murray 1996, 143.
5. St. Clare of Montefalco was a thirteenth-century abbess of a convent dedicated to the Rule of St. Augustine. It is said that her heart was impressed with symbols of the Passion of Christ. See <http://www.geocities.com/Athens/1534/saints/clare.htm> (13 April 1999).

8.

ABRAHAM JANSSENS
Antwerp ca. 1575–Antwerp 1632

Lascivia, ca. 1615–16

Oil on canvas
42 5/16 x 38 3/16 inches (107.5 x 97 cm)
Royal Museums of Fine Arts of
Belgium, Brussels, inv. 6592

1. Joost vander Auwera, "Janssen,"
(sic) in Dictionary of Art 1996,
17:5.
2. The other works, for example
Gaiety and Melancholy, tend to
depict at least two full-length
figures.
3. Compare, for example, Goltzius's
Venus in Half-Length (B. [Saenredam]
66; H.135, Strauss 337).
4. Joost vander Auwera, "Janssen,"
(sic) in Dictionary of Art 1996,
17:3.
5. See page 25, n. 65 in this volume.
It is interesting to note that this
painting was in the estate of
Janssens's widow in 1644.
6. This association is perhaps due in
part to the Dutch word for birds,
vogelen, a slang term for sexual
coupling; see de Jongh 1968–69,
22–27. Compare the engraving by
Jacob Matham after Hendrick
Goltzius of *Libido,* which shows
a barely robed strumpet striding
forward with a bird in her out-
stretched left hand.
7. Sluijter 1988, 146–63.

The two genres to which Abraham Janssens made a lasting contribution
are contemplative scenes of the Passion and allegorical scenes with a limited
number of figures in close-up.[1] Lascivia (Lust), identified on the band across
her chest, belongs to the latter category, despite her three-quarter-length
format.[2] Her languid pose, the idle, precious gesture of her right hand, and
the arrogance implied in the way she holds her head are posturings fitting
to the personification. Janssens's characteristic style is apparent in the strong
contrasts of dark and light that model her sculptural form. His experience of
Italy is reflected in the spotlight effect that he learned from the mature art
of Caravaggio. His use of color is idiosyncratic; the rich red robe and blue
curtain bracket and set off the flesh tones of her skin.

Janssens's statuesque nude reveals classicizing affinities both to the
work of Hendrick Goltzius[3] and to that of his Italian contemporaries, the
Carracci. In fact, it has been suggested that the erotic subject matter that
appears in Janssens's painted work as early as the middle of the first decade
of the century may have been inspired by Agostino Carracci's so-called
Lascivie, a series of prints of subjects with erotic content.[4] Janssens has
depicted the subject appropriately imbued with latent eroticism. The image
is at once a sculptural ideal and a sensuous nude, whose face is flushed and
whose body is displayed for the viewer's delectation. Such seductive images
ironically were intended to warn against carnal pleasures.[5]

Symbolic references give the painting a moralizing dimension. Lascivia
stares at a pair of mating sparrows on her left hand. Birds in general were
traditionally associated with the sexual act, but usually the allusion is not as
overt as it is here.[6] Her reflection in the mirror does not accurately reproduce
the angle of her face but is a frontal view, her eyes unfocused and her head
tilted coquettishly. The mirror, a symbol of vanity, warns that beauty and
youth (and sensual pleasures) are fleeting.[7]

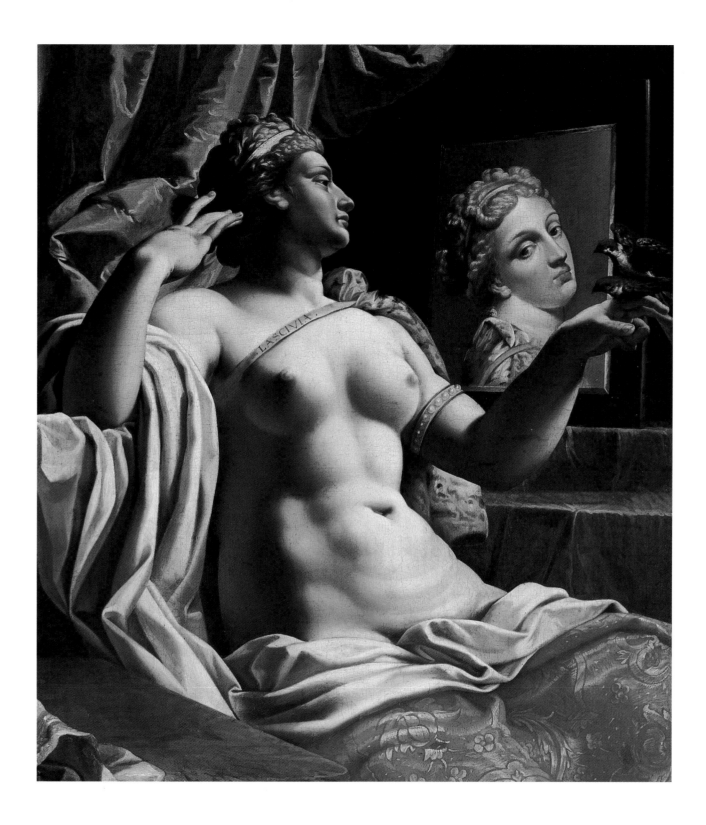

9.
Jacob van Oost
Bruges 1603–Bruges 1671

The Music Party, 1667

Oil on canvas
64 3/16 x 74 7/16 inches (163 x 189 cm)
Royal Museums of Fine Arts of
Belgium, Brussels, inv. 4322

Jacob van Oost's painting, a conflation of genre and portraiture, is remarkable on several counts. The size of the canvas, appropriate to a formal family portrait, distinguishes it from the typical seventeenth-century genre portrait on an intimate scale. Although the subject of a music party is familiar both in seventeenth-century genre painting and genre portraiture, it is rare to find such a depiction featuring only men.[1] In addition, self-portraits—if, as has been suggested, the painter is the man behind the servant at the right edge of the painting[2]—are usually not integrated into a composition including so many other figures.[3]

The setting of an outdoor garden or terrace is typical for genre portraits as a place of casual interaction for the figures.[4] Much of the iconography of this image, in fact, is derived specifically from genre family portraiture.[5] In this context, the garden is associated with the garden of love. Music-making is considered a symbol of familial harmony. The vine refers to the fecundity of marriage, the parrot to marital chastity (compare *cat. 56*). The seated man at the far left beating time to the music symbolizes moderation. Indeed, if the traditional identification is correct, there is a familial connection here to the artist. His son is portrayed standing near the center of the work, holding a wine glass by the foot.[6] The artist looks toward him and gestures as if presenting him to the viewer. Briefly in 1667, van Oost the Younger returned to Bruges between two sojourns in Lille. Perhaps the painting, with its connections to genre family portraiture, alludes to the happy reunion of father and son.[7]

Music, as one of the Seven Liberal Arts (compare *cat. 38*), was regarded as an intellectual activity, one with which a painter, wanting to dissociate himself from the practice of a mere manual craft, might want to be connected.[8] Furthermore, van Oost played the violin, so it has been suggested that the group represented is a *Collegium Musicum*, a group of upper-middle-class gentlemen who assembled regularly under the direction of a music master.[9]

The painting is a harmonious arrangement of black, white, and red. The artist successfully captures the sitters' specific physiognamies while simultaneously suggesting each man's personality. As the artist and his son exchange glances, three of the gentlemen address the viewer, underscoring the portrait character of the scene. The music-making, the activity of the dogs, the arrival of the servants, and the variety of poses enliven the gathering. It is not difficult to understand why this painting has been called van Oost's masterpiece.[10]

1. An exception to this generalization is Joos van Craesbeeck's *Gathering of Musicians*, Royal Museums of Fine Arts of Belgium, Brussels, inv. 3462. Usually such images represent domestic harmony or one or more of the five senses.
2. While both Bautier 1944, 4, and Meulemeester 1984, 363, cat. B64, identify this figure as the artist, neither author explains why.
3. Gonzales Coques's *Artists' Meal* (Musée du Petit Palais, Paris) is an exception if one of the figures can be identified with the artist.
4. Wieseman 1993, 189.
5. Brussels 1994a, 122.
6. This has been interpreted as an aristocratic gesture by Salomon 1998, 320.
7. Brussels 1994a, 123.
8. Brussels 1994a, 123.
9. Brussels 1995.
10. Bautier 1944, 4.

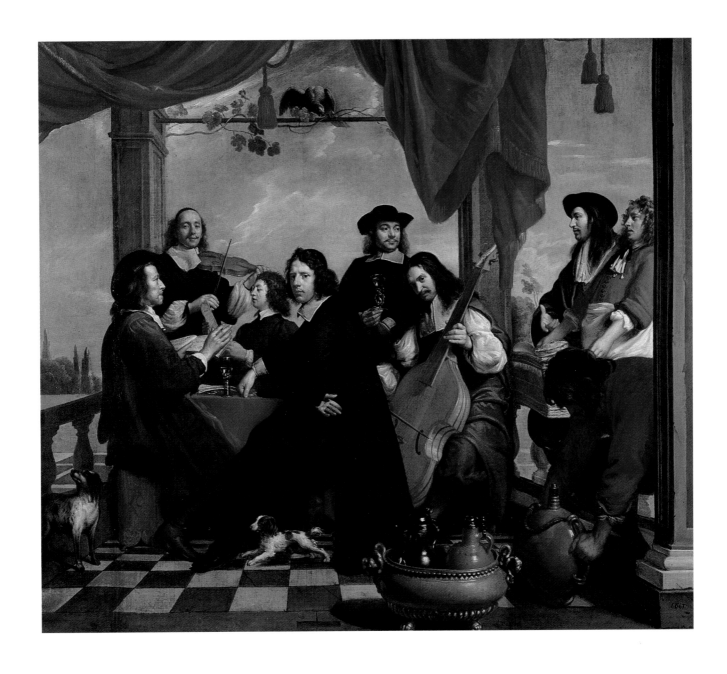

10.

Nicolaes van Veerendael
Antwerp 1640–Antwerp 1691

Singerie

Oil on canvas
11 ⁷⁄₁₆ x 16 ⁹⁄₁₆ inches (29 x 42 cm)
Royal Museums of Fine Arts of
Belgium, Brussels, inv. 4615

1. Janson 1952, 165. The ape's "uncomfortable" physical similarity to man and its marked instinct for imitation encourages its use as a symbol of man; see also Roscoe 1981, 96.
2. Janson 1952, 309.
3. Roscoe 1981, 97.
4. Nevertheless, the *mise-en-scène* of this painting appears more Dutch than Flemish.
5. It is apparent that van Veerendael did not base his depictions of the animals on a careful study of nature. His monkeys are charming creatures with legs resembling those of a chicken.
6. This is not to say that symbolism is absent: the plumed hats worn by three of the male monkeys in all likelihood allude to unchastity; see Amsterdam 1976, 59; Armstrong 1990, 62; Amsterdam 1997, 284.
7. Roscoe 1981, 97.
8. Janson 1952, 239. The mole or the wild boar represented hearing, the lynx sight, the vulture smell, and the spider touch.
9. Teniers also depicted this theme; see Janson 1952, 241. In the present painting, taste would be represented by the monkey drinking wine, touch by the embracing couple or "woman" caressing her companion's chin, and hearing by the violinist's fiddling. Sight is implied by the huge eyes of all the creatures. Only smell is without an overt reference.

The use of apes to parody humans can be traced back to classical and ancient Near Eastern art.[1] In the art of the sixteenth and seventeenth centuries, many of the satires featuring apes were meant to convey man's folly and idle ambition.[2] David Teniers, one of the great seventeenth-century Flemish genre painters (compare *cat. 19*), was responsible for extending the parameters of simian subject matter, depicting monkeys in the barber's shop, the tavern, and making music.[3]

This gallant company by Nicolaes van Veerendael, an artist better known as a flower painter, is dependent on a type popularized by Teniers.[4] Monkey couples embrace, food is prepared and presented by monkey servants, and a monkey fiddler saws his tunes.[5] As in Teniers's works, the parody is understated rather than derisive and seems more humorous than admonitory. The focus is on ordinary "people" at their leisure.[6] The cat was frequently the dupe in Dutch emblems; consequently he appeared in many of the *singerie* caricatures as the victim of the monkey's aggression.[7] Here, by contrast, the cat, avidly eyeing scraps on a plate, is included simply as a domestic detail.

The ape was traditionally regarded as possessing a keen sense of taste. He was therefore included in depictions of animals representing the five senses.[8] This painting might well have been intended as a representation of the five senses in the guise of a merry company *singerie*.[9]

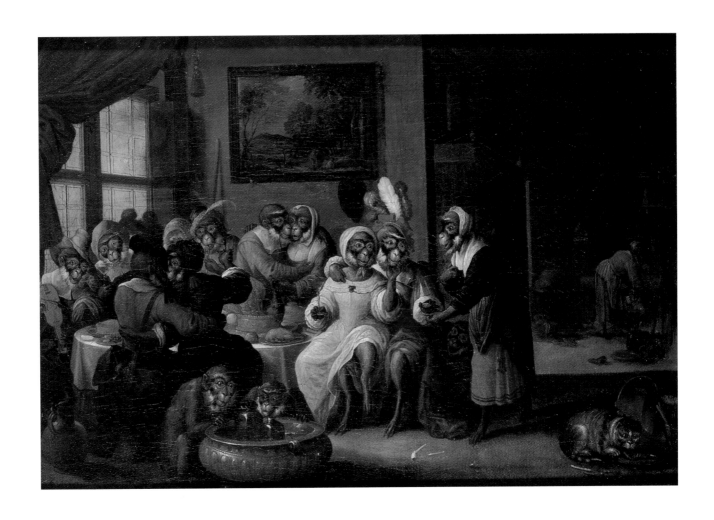

11.
DAVID RYCKAERT
Antwerp 1612–Antwerp 1661

*An Alchemist in
His Laboratory,* 1648

Oil on canvas
26 x 34 ⁷⁄₁₆ inches (66 x 87.5 cm)
Royal Museums of Fine Arts
of Belgium, Brussels, inv. 156

David Ryckaert was a painter of genre scenes, and his work was influenced by Adriaen Brouwer, David Teniers, and his pupil Gonzales Coques. In the present painting, the choice of subject, the simple but neatly dressed figures, the orderly jumble of the workshop, and the decorative colors reveal Ryckaert's debt to Teniers (compare *cat. 19*).[1]

The theme of the alchemist was depicted in an influential print by Hieronymous Cock (ca. 1510–1570) after Pieter Bruegel the Elder (1520/25–1569) that shows an obsessed pseudo-scientist in the midst of a chaotic and impoverished studio trying in vain to turn base metals into gold. The foolishness and wastefulness of the alchemist's mission is emphasized, and it was in these terms that the figure was usually described in contemporary literature.[2] Aside from the image of an owl on the chimney, however, there is little in Ryckaert's painting that carries such negative connotations.[3] The elderly man holding a carafe in one hand and tongs in the other looks over his shoulder at an old woman turned toward him indicating text in a book. Two assistants can be glimpsed in the background. Although something has shattered onto the ground below the alembic, the overall impression created is neither of chaos nor of poverty. While it is difficult to imagine that the artist meant to represent the wisdom of old age and the quiet mutual hard work of the couple,[4] it is equally hard to read it as a negatively moralizing picture.

Ryckaert tended to repeat figures and compositional elements in his paintings. The same elderly balding figure of the alchemist appears in other of his compositions, including variations of this painting and scenes with drinking peasants.[5]

1. Teniers painted the alchemist theme at least a dozen times; see Boston 1993, 422 n.7.
2. Boston 1993, 420, cat. 68.
3. The owl has been interpreted as a symbol of both folly and wisdom. It is possible that by this time, the owl was as standard an accoutrement of the alchemist's laboratory as the alligator was in the barber-surgeon's shop.
4. This is the interpretation offered in Cologne 1992, 428–30, cat. 77.2, in which the depiction is seen as illustrating the close connection of wisdom and folly in human existence.
5. Jetty E. van der Sterre, "David Ryckaert III," in Dictionary of Art 1996, 26:390.

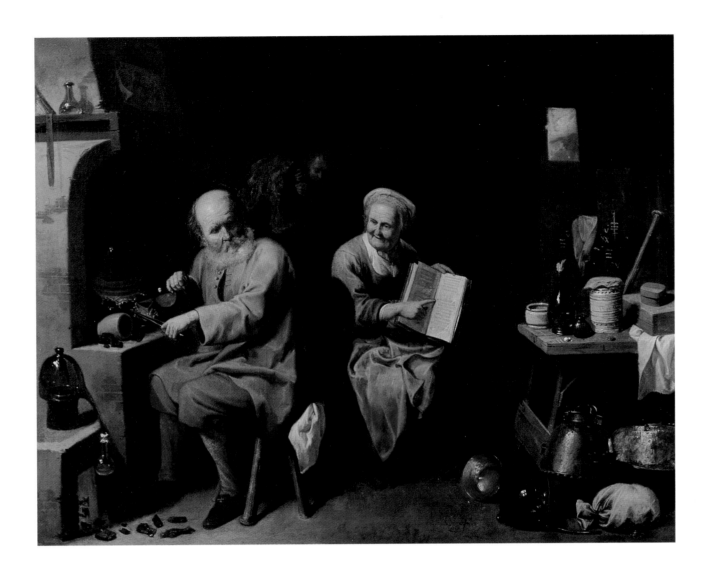

12.

CORNELIS GYSBRECHTS
possibly Antwerp ca. 1610–1678
or after

Vanitas, ca. 1678

Oil on canvas
25 x 18 ¹¹⁄₁₆ inches (63.5 x 47.5 cm)
Royal Museums of Fine Arts of
Belgium, Brussels, inv. 3905

This still life functions as both a *trompe l'oeil* and a *vanitas* painting. *Vanitas* means emptiness in Latin, and such works are concerned with the fragility of man and the inevitability of death. Objects such as the skull, snuffed-out candle, almanac, and soap bubble are traditional symbols of the passing of time and the transience of all things. References to the vanity of appearances—including the razor, curling-tongs, comb, lipstick, and ring—and of human endeavors—symbolized by the playing card, book, receipts, accounts, and letters—expound on the painting's obvious message.

The viewer is somewhat distracted from the moral, however, by the extraordinary virtuosity of the technique. *Trompe l'oeil,* French for "fool the eye," refers to a work of the greatest illusionism. Cornelis Gysbrechts has constructed this still life to suggest both depth (in the form of the cupboard recess) and the space in front of the painting. The latter is ingeniously suggested by the cupboard door, whose enframed glass panes swing into the viewer's implied space, and, more discreetly, by the ribbons of red leather and string stretched across the top of the feigned wooden planks. Objects are both tucked behind and placed in front of the ribbons and string.

The overt display of artistic skill evident in this painting raises the question of appearance versus reality and thereby reinforces the theme of vanity. The viewer thus is doubly encouraged to think about his end by admitting the meaning of the symbolic objects and by acknowledging that appearances themselves are deceiving. This type of image was also intended to amuse and delight the viewer. Gysbrechts, a native of Antwerp, was one of the favorite painters of Kings Frederick III (1609–1670) and Christian V (1646–1699) of Denmark. They accumulated a remarkable collection of still lifes and *trompe l'oeils* with which they entertained themselves by mystifying their guests.[1]

1. de Mirimonde 1971, 229. See, too, Marlier 1964.

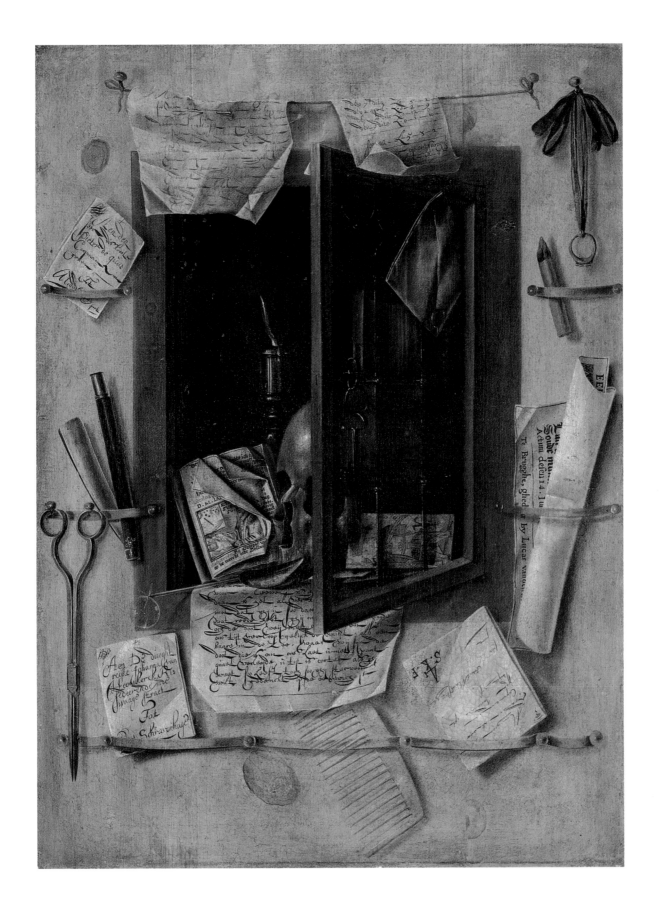

61

13.

Jan Brueghel the Elder
Brussels 1568–Antwerp 1625
(and unknown collaborator)

*Garland of Flowers
with Holy Family,*
ca. 1620
Oil on panel
28 ¼ x 23 ¼ inches (73 x 59 cm)
High Museum of Art, Atlanta,
Purchase with funds from
Alfred Austell Thornton in memory
of Leila Austell Thornton and
Albert Edward Thornton, Sr.,
and Sarah Miller Venable and
William Hoyt Venable, inv. 1989.113

Jan Brueghel was highly prized by patrons and collectors alike as a flower painter. From correspondence with his patron Cardinal Federigo Borromeo, it is clear that Brueghel not only traveled great distances to find unusual floral specimens but also that he waited entire seasons for flowers to grow.[1] The artist prided himself on working directly from nature and arranging the blossoms in his still lifes according to his own sensibility.

It was Cardinal Borromeo who initially suggested that Brueghel paint a garland of flowers around an image of the Virgin.[2] Such adornment enhanced the preciousness and worth of this type of image, which had been threatened and desecrated by the iconoclasts.[3] The garland also emphasized the religious image by focusing the viewer's eye on it.[4] Brueghel's skill as a still-life painter brought his paintings of flowers extremely high prices. Consequently, the flower garland added enormously to the actual value of the central religious image.[5]

Both the artist's extraordinarily delicate touch and his eye for the natural rhythms and color harmonies of the blossoms and foliage reveal why his flower pictures were so greatly appreciated. The garland contains over one hundred species and varieties of flowers, including a remarkably wide range of roses and a distinctive white lily at the top right.[6] These flowers traditionally had Marian associations; roses evoked the Passion of Christ, and lilies symbolized the Virgin's purity. Because of the voluminous three-dimensionality of the garland and the richness of the details in the painting, a late date of ca. 1620 has been posited for it.[7]

The painting seems to be an autograph copy of a work on panel of the same dimensions formerly in the collection of the Counts Schönborn.[8] The central octagonal image in that work is attributed to Rubens. The subject reflects Counter-Reformation ideology in general and Rubens's personal interest in the cult of Mary in particular.[9] The playful pose of the Christ Child, the warm and close interaction between Jesus and John the Baptist, the inclusion of John's attentive mother, Elizabeth, and the marginal placement of Joseph are also found in Rubens's *The Holy Family with St. Francis* in Windsor Castle, for example. In the present painting, the artist responsible for the religious image in Rubens's manner has not been identified.

1. Brenninkmeijer-de Rooij 1996,
 47–90, as in Washington 1998b,
 48–50.
2. Freedberg 1981, 116.
3. Freedberg 1981, 123. On the
 iconoclasts, see page 13 in this
 volume.
4. Freedberg 1981, 131.
5. Freedberg 1981, 125.
6. Osaka 1990, 181.
7. According to correspondence of
 20 June 1988 from Klaus Ertz in
 the High Museum of Art's files,
 Brueghel's earlier garlands are
 lighter and more oriented toward
 the two-dimensional surface of the
 picture plane. Osaka 1990, 181,
 dates the former Schönborn paint-
 ing ca. 1615–16.
8. Osaka 1990, 181, cat. 29.
9. Boston 1993, 293.

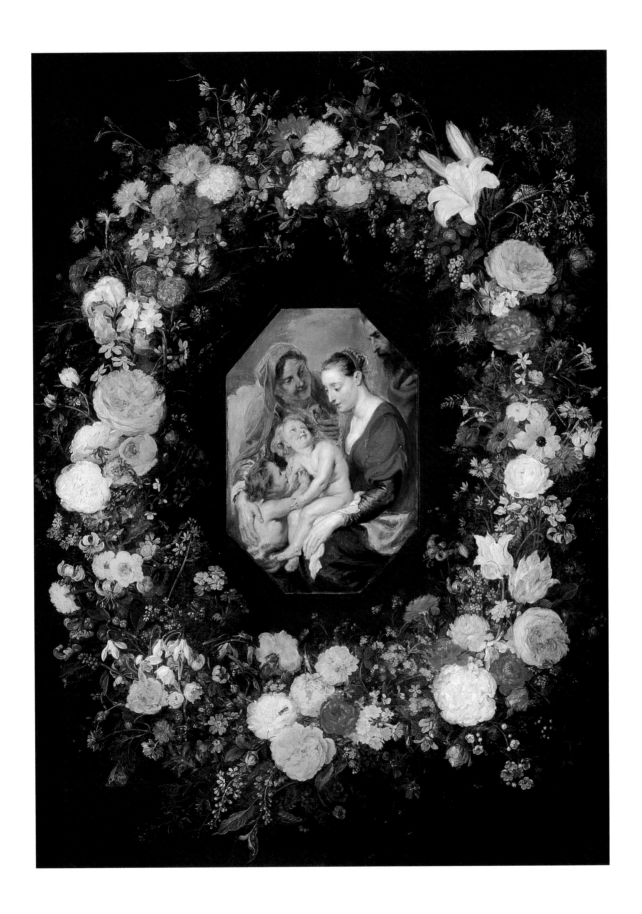

14.

Johannes Antonius
van der Baren
possibly Brussels 1615/16–Vienna 1686
(and unknown collaborator)

*Flower Altar with the
Mystic Marriage of
St. Catherine,* 1641

Oil on canvas
69 ⁹⁄₁₆ x 48 ⁷⁄₁₆ inches (176 x 123 cm)
Royal Museums of Fine Arts of
Belgium, Brussels, inv. 4197
Inscription: below the pediment,
D.O.M./ DEIPARÆ/ VIRRGINI/ DIVISQVE/
TVTELARIBVS/ AVTOR POSVIT./ M.DC.XLI.
(The author has erected [this monu-
ment] to the very good and very great
God, to the Virgin Mother of God,
and to the titular saints. 1641.)
Inscription: on the base of the altar,
AMICVS AMICO, FRATER FRATRI,/ SOG-
NIENSIS CANONICVS,/ MONTIS FRIGIDI
PRÆPOSITO,/D. IOES A. VAN DER
BAREN,/ IN SUI MEMORIAM MORIENS
ASSIGNAVIT./ OBIIT 31 DECEMBRIS
1686. R.I.P. (On his death bed,
Johannes A. van der Baren offered
[this painting] in memory, in friend-
ship to his friend, in fraternal love to
his brother and as canon of Soignies
to the provost of Coudenberg. He died
31 December 1686. May he rest in
peace.)

This is one of Johannes van der Baren's most significant works, both for the information it imparts and for the quality and complexity of the image itself. It was painted in collaboration with an unknown figure painter when van der Baren was about twenty-five years old. In addition to being a still-life painter, van der Baren was priest and canon of the convent church of St. Vincent de Soignies, chaplain at Coudenberg Palace in Brussels, and ultimately chaplain of the court of Emperor Leopold I in Vienna. As early as 1641, the date on this painting, he had found a way to give visual expression to his devotion to Counter-Reformation tenets.

An elaborate stone altar/portico enframes a *sacra conversazione.* The upper register of the enclosed scene depicts the Mystic Marriage of St. Catherine, attended by St. Agnes, St. Dominic, St. Francis of Assisi, and an unidentified young martyr. Below, at the left, are the two most important Jesuit saints, St. Francis Xavier and St. Ignatius Loyola, with the hermit St. Anthony in the center, and St. John the Evangelist and St. Cecilia at the right. On the floor, an open book is inscribed with the motto of the Society of Jesus: *Ad majorem Dei gloriam* (For the greater glory of God).

The altar, which recalls the altar of the Holy Trinity in the Church of St. Jacob in Antwerp,[1] is adorned with two flanking flower bouquets, abundant and symmetrical. A sumptuous ivy and flower garland is held above by two putti. All of the flowers are painted with such precision that they can be identified. The flowers are fresh and in full bloom with no trace of wilting or decay.[2] Van der Baren's gift for rendering botanical detail, his eye for balance and texture, and the warmth of his palette are superbly illustrated in this work.

Floral paintings were not unusual vehicles by which artists could evoke the variety and goodness of God's creation. However, with its explicit dedication to the Virgin and Child, this work is more than a simple homage to the Creator.[3] Two flowers occupy places of honor in the painting: the iris crowning the bouquet at the left and the white St. Bruno lily (*pardisea liliastrum*) surmounting the bouquet at the right. These both carry Marian associations. The iris, or sword lily, traditionally alludes to Mary's suffering, and the lily to her purity. Their inclusion draws our attention back to the central image of the enthroned Virgin and Child and underscores the importance of the Virgin to Counter-Reformation ideology.

1. Brussels 1996a, 96.
2. This is an unusual feature since many such paintings were intended to allude to life's transience. See Brussels 1989c, 58, cat. 10, for the species of each of the blooms.
3. Brussels 1996a, 98.

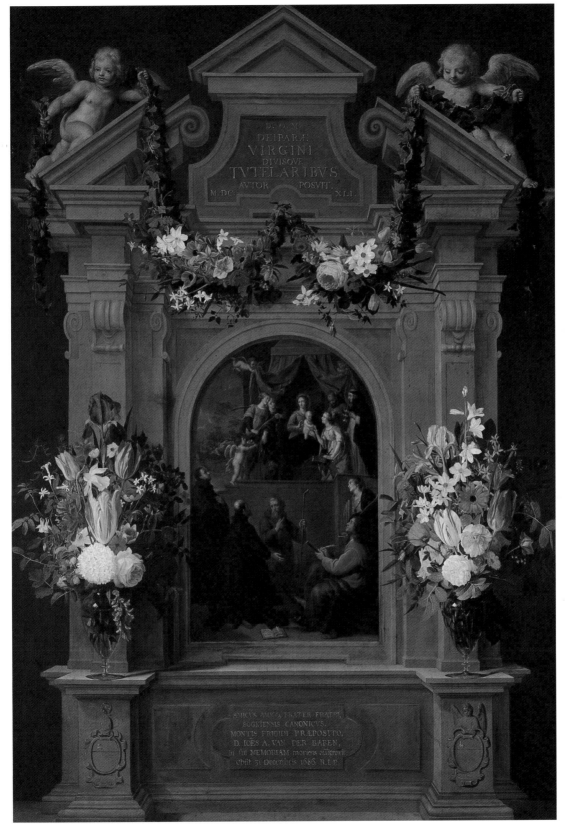

15.

Adriaen van Utrecht
Antwerp 1599–Antwerp 1652/53

Garland of Fruit, 1640

Oil on canvas
22 ¹³⁄₁₆ x 34 ⅞ inches (58 x 88.5 cm)
Royal Museums of Fine Arts of
Belgium, Brussels, inv. 3044

Although Adriaen van Utrecht painted pantry scenes and game pieces under the influence of Frans Snyders (compare *cat. 29*), he also painted more purely decorative pieces, such as this festoon of fruit. The device originated in classical antiquity, when festoons of real fruit were hung between the skulls of slaughtered animals and the instruments used for their sacrifice. It became a common classicizing decorative motif in the seventeenth century, appearing most frequently on textiles, pottery, and furniture (compare its use in *cat. 66*).[1]

Fruit in paintings often carried symbolic connotations. However, the lack of context for the fruit in this work and its very diversity argue against an emblematic interpretation. Rather, van Utrecht uses the fruit to explore contrasts of textures, degrees of translucency, and variations on the round and oval form. As in many of his still lifes, the fruit—grapes, peaches, plums, cherries, currants, gooseberries, medlars, chestnuts—is arranged primarily on a horizontal register, but he punctuates the composition with spiky stems and alternately limp and lively leaves to create dynamism.

The strong contrasts of light and dark, the slight halo effect distinguishing the space of the fruit from that of the background, and the palpable atmosphere created by modulations in the background contribute a sense of three-dimensionality to the image. The illusion is heightened by the apparent projection of the brass rings from the wall. The prominence of the central motif of a bunch of grapes, combined with this striking illusionism, makes the comparison to the celebrated competition between Zeuxis and Parrhasios unavoidable.[2] The present work, then, exhibits the painter's talent in keeping with the topos established by his ancient predecessors.

1. "Festoon," in Dictionary of Art 1996, 11:34.
2. The story, told in Pliny the Elder, *Naturalis historia*, recounts that the ancient Greek painter Zeuxis depicted some grapes so believably that birds flew up to peck at them. He was outdone by his competitor Parrhasios, however, who painted a linen curtain so convincingly that Zeuxis requested it be pulled back so that he could behold Parrhasios's painting. Zeuxis deceived the birds, but Parrhasios deceived the great Zeuxis. See Pollitt 1965, 154–55.

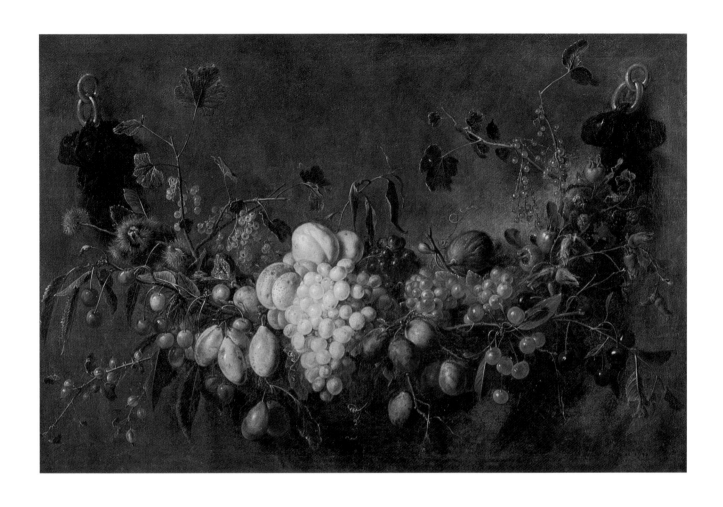

16.

JAN VAN KESSEL
Antwerp 1626–Antwerp 1679

Butterflies, Other Insects, and Flowers,
1659
Oil on copper
4 ½ x 5 ¼ inches (11.43 x 13.56 cm)
High Museum of Art, Atlanta,
Purchase in memory of Dr. and
Mrs. De Los Lemuel Hill, inv. 58.19

17.
JAN VAN KESSEL
Antwerp 1626–Antwerp 1679

Butterflies, Caterpillars, Other Insects, and Flowers,
1659
Oil on copper
4 ½ x 5 ⅝ inches (11.43 x 14.29 cm)
High Museum of Art, Atlanta,
Purchase in memory of Dr. and
Mrs. De Los Lemuel Hill, inv. 58.20

Jan van Kessel was the grandson of Jan Brueghel the Elder and seems to have shared his grandfather's predilection for the accurate, almost scientific, depiction of his subjects and their arrangement in a pleasing and artful way. He specialized in the representation of animals, birds, amphibians, and insects, often in very small format.[1] Sets of these works by van Kessel were occasionally used to decorate pieces of furniture.[2]

Placed against a light background, the various and colorful butterflies, insects, caterpillars, and flowers receive the viewer's full attention. The artist's faithful rendering of these creatures reveals an uncanny sense of detail and a subtle sensitivity to light and shade (apparent in the nuanced cast shadows on the ground). The choice of copper as a support, the meticulous rendering of the creatures, the small size of the paintings, and the very nature of the life depicted conjoin to evoke an impression of preciousness. This idea is reinforced by the strong element of display suggested in the compositions. Although in each picture life is implied by capturing a butterfly or caterpillar in movement, the type of collection assembled recalls those in actual cabinets of curiosity.[3] Here, rare and unusual specimens of *naturalia* were assembled, displayed, and studied.

1. Paintings such as these are reminiscent of the work of Joris Hoefnagel (1542–1600), who recorded the beauty and diversity of the natural world for the Hapsburg emperor Rudolf II (1552–1612) at his court in Prague.
2. Houston 1981, 86; Atlanta 1984, 111 (with an incorrect auction citation). Compare *The Allegory of Air and Water* in the Museum of Fine Arts, Quimper, which was also originally part of a cabinet; see Paris 1977, 120, cat. 81.
3. Compare Sterling 1952, 47, cat. 27, and Paris 1977, 119, cat. 79.

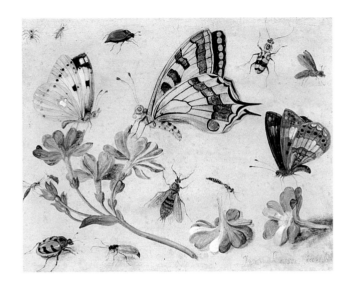 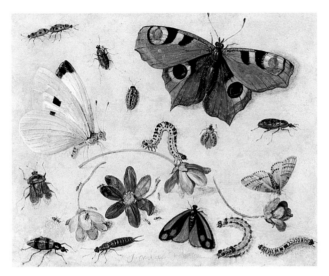

18.
WILHELM SCHUBERT
VON EHRENBERG
Ehrenberg, Germany 1637–
Antwerp ca. 1676
and HIERONYMUS JANSSENS
Antwerp 1624–Antwerp 1693

*Interior of the
Church of St. Rombaut,
Mechelen,* 1673

Oil on canvas
46 1/16 x 68 1/2 inches (117 x 174 cm)
Royal Museums of Fine Arts of Belgium,
Brussels, inv. 4162

Wilhelm von Ehrenberg[1] was a painter of architectural subjects who became a master in the St. Luke Guild of Antwerp in 1662/63. The figures in his paintings were often supplied by other artists, in this case most likely by Hieronymus Janssens (nicknamed "The Dancer"), with whom von Ehrenberg also collaborated on another painting in Brussels.[2] The well-dressed men and women are noticeably dwarfed by the immensity of the church setting.

The church of St. Rombaut, since 1559 the seat of the only see in the Southern Netherlands, is dedicated to the patron saint of Mechelen, an eighth-century Irish monk killed by workers whom he reproached for living dissolute lives. The construction of the church was begun in the twelfth century and finished early in the fourteenth century. Modifications were required after a fire in the fifteenth century and again after the Duke of Alba's troops sacked it at the end of the sixteenth. The church was gradually refitted during the course of the seventeenth century.[3]

In the painting, the viewer faces the choir as he would upon entering the church, although the viewpoint is elevated. Affixed to the columns of the nave are sculptures of the apostles by Robert de Nole (before ca. 1570–1636), his nephew Andries de Nole (1598–1638), and Hans van Mildert (1585/90–1638), dating from between 1629 and 1640. In the crossing of the church is the black-and-white marble high altar, visible beyond the rood screen. The altar is constructed in the form of a triumphal arch and crowned by a stone statue of St. Rombaut. Designed by Lucas Faydherbe (compare *cat. 51*), it was installed and the relics of the saint transferred to it in 1666.

The identity of the figures is unknown and their function in the painting unclear. The canon in the center seems to be addressing the viewer. He gestures toward the man in black, who stands in the light with a hand on his hip, a woman close behind him. An elegantly clad woman at the left points toward him as well. Nuns of three orders are present. It has been suggested that the painting might commemorate the familial establishment of a prebend for the canons.[4] It does seem likely that the designated man is some type of patron of this church.

Von Ehrenberg masterfully depicted the diffusion of light as it enters the church, playing off the columns and the graceful, delicate figures. The rhyming of the patterned floor and the black dress of many of the figures is punctuated by vibrant color notes of red and gold.

1. His name is also given the Dutch spelling Willem van Ehrenberg, and his birthdate is in some sources listed as 1630. See Baudouin, F. 1981, 8.

2. *Interior of the Church of St. Carlo Borromeo in Antwerp* (1667, Royal Museums of Fine Arts of Belgium, Brussels, inv. 3603).

3. For a history of the church, see Laenen 1919–20.

4. Brussels 1994a, 129, cat. 49. Formerly the painting was thought to represent a wedding, for which there is no evidence.

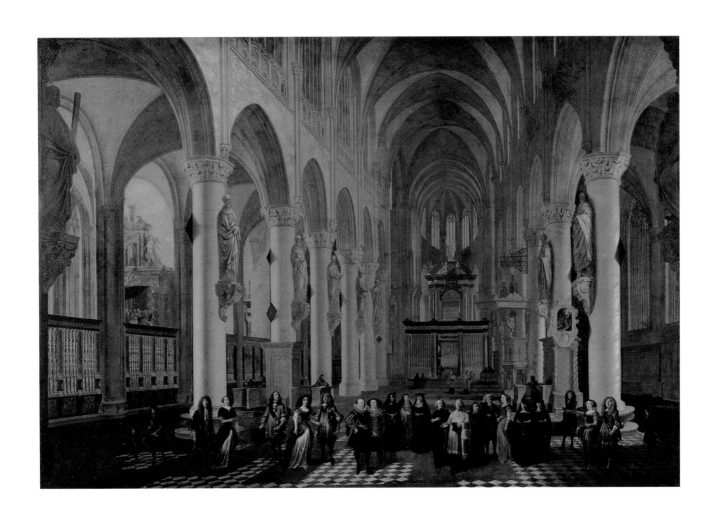

19.
LUCAS VAN UDEN
Antwerp 1595–Antwerp 1672/73
and possibly
DAVID TENIERS THE YOUNGER
Antwerp 1610–Brussels 1690

Departure for Market

Oil on canvas
37 7/16 x 50 inches (95 x 127 cm)
Royal Museums of Fine Arts
of Belgium, Brussels, inv. 193

Lucas van Uden's landscapes are notable for their decorative quality and for their characteristic construction. The latter is based on examples by Joos de Momper (1564–1635), a prodigious landscape painter from Antwerp of the preceding generation. Typically, van Uden's paintings show the remnants of a sixteenth-century *coulisse* to one side of the composition (as here, formed by the trees and the hillock to the left), a vast expanse of undulating land composed of parallel planes into which a farmhouse and/or chateau is nestled, an elevated horizon, and a body of water (note the river flowing through the foreground). Birch trees with slim trunks that intertwine are among his favorite motifs. The color scheme of warm brown, pale green, and a sky tinged with the yellow of the sun, perhaps inspired by the landscapes of Rubens, are also characteristic of his work. His touch is supple.[1]

Although van Uden often painted his own staffage, he sometimes enlisted other artists to people his landscapes. The peasants in the left foreground of the present painting are attributed to David Teniers, who collaborated with van Uden on landscapes that are now in Vienna, Dresden, and Dublin. Teniers's close observation of the manners and habits of his neat peasants allows him to depict them in characteristic attitudes around which a narrative can be constructed. The neighborly interest and mutual familiarity of the two figures in conversation in the foreground contrast to the industry exhibited by the peasants loading their produce for market behind them. These picturesque figures provide the only notes of local color in the painting.

Van Uden's serene and tranquil landscapes were greatly esteemed in his lifetime. Two of his paintings were in the inventory of Rubens's possessions at the time of the great painter's death.

1. Thiéry 1986, 169–72.

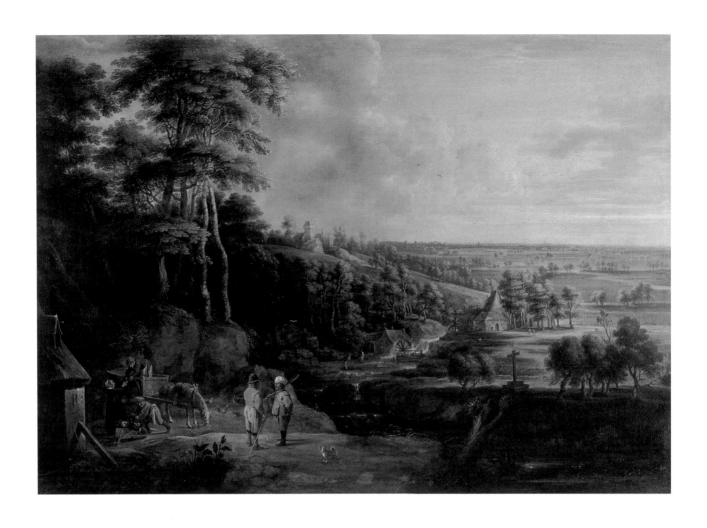

20.

JACQUES D'ARTHOIS
Brussels 1613–Brussels 1686
and possibly PIETER BOUT
Brussels, 1658–Brussels 1719

Winter Landscape,
ca. 1670–90
Oil on canvas
32 ½ x 47 ¹³⁄₁₆ inches
(82.5 x 121.5 cm)
Royal Museums of Fine Arts
of Belgium, Brussels, inv. 1

Jacques d'Arthois, best known as a muralist and tapestry designer, was the leading figure of the Brussels school of landscape painting of the second half of the seventeenth century. His work often features the forest of Soignes close to Brussels, where he had a home. The massing of the trees at the right edge of the painting and the suggestion of an expanse of trees in the left distance imply that this might be the setting of the present painting as well.

This type of image is rooted in depictions of the seasons or months of the year.[1] However, the construction of the landscape differs from sixteenth-century examples in its flatter, more naturalistic aspect and the greater prominence given to the middle ground.

The limited palette of gray, white, and pink effectively suggests the cold of winter and smoke curls from a chimney, but the bitter temperature is not the subject of the painting. Rather, the artist emphasizes the majesty of the landscape. Tiny birds fly in formation in the expansive sky, and small figures recede into the distance. The villagers, who give scale to the work, attend to their daily tasks (chopping wood, driving a cart to town, feeding a fire), visit among themselves, and enjoy leisure activities on the ice. The handling of the paint is broad and graceful.

The figures have been attributed to Pieter Bout, who is also known to have painted staffage for Adriaen Frans Boudewijns (1644–1711). The easy and lively character of the people at work and play and the precision of their rendering are characteristic of Bout's figure painting.[2] Bout enrolled in the Brussels painters' guild in 1671. If indeed he is responsible for the figures in the present painting, the work must date relatively late in d'Arthois's career.[3]

1. See van Straaten 1977, especially 70–93.
2. Manfred Sellink, "Pieter Bout," in Dictionary of Art 1996, 4:589.
3. Most of d'Arthois's landscapes are not dated, so no true chronology of his works has been established. A series of engravings dated 1648–52 by Wenzel Hollar (1607–1677) after d'Arthois's landscapes shows that d'Arthois's early style was influenced by the work of his slightly older compatriot Lodewijk de Vadder (1605–1655).

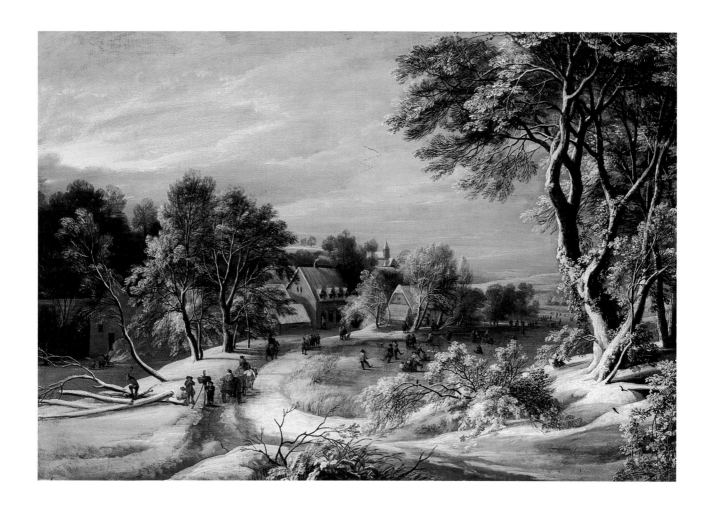

21.
JEAN-BAPTISTE BONNECROY
Antwerp 1618–Brussels 1676
View of Brussels,
ca. 1664–65
Oil on canvas
66 9/16 x 118 11/16 inches
(169 x 301.5 cm)
King Baudouin Foundation, deposited
at the Royal Museums of Fine Arts of
Belgium, Brussels, inv. P. 06

While Jean-Baptiste Bonnecroy was trained as and by a landscape artist, his surviving oeuvre consists primarily of townscapes.[1] This example is remarkable for the sparkling quality of the light and unpredictable play of shadow, the bird's-eye perspective, the animation of the sky, and the absence of a human presence.

The image of Brussels is a true panorama, somewhere between cartography and landscape. The view is depicted from an aerial perspective as seen from a point northwest of the city. In the foreground are the city walls erected between 1357 and 1383 and an arm of the river Senne. The ramparts and monuments are painted in great detail. By contrast, the houses and trees are systematically, almost abstractly, rendered.[2]

The tallest spire in the painting, near its center, is the fifteenth-century Hôtel de Ville. To the left is the belfry of the church of St. Nicolas. On axis with this tower and situated on the horizon is the Coudenberg Palace. More important for the dating of the painting is the presence of the new church of the Béguinage, constructed between 1657 and 1676. Because an altar in the church was already dedicated in 1663, it can be assumed that work on the church was well enough advanced at that time for it to have figured in this view of the city. Further, the tower of the church of St. Catherine was not yet finished in 1664; it is missing a roof in the present painting. The date of ca. 1664–65 for the work suggested by the appearance of the architecture coincides with Bonnecroy's inscription in the Brussels painters' guild.[3]

The city as it appears in this depiction is, at least in part, an homage to the archdukes. Not only are their palace, parish church, and park prominent landmarks in this image of Brussels, but so are the Cloister of the Annunciates and many of the other churches and cloisters that depended on their patronage and beneficence.[4]

In order to determine the precise position of the city gates and fortifications, Bonnecroy might have consulted a map, perhaps that by Joan Willemsz. Blaeu published in 1649. He might also have known the map engraved by Abraham Santvoort after a project by Martin de Tailly that was published in 1640. Bonnecroy might have used this map to construct the upper part of his panorama, although the point of view in the present painting is more elevated than in the de Tailly project, allowing more space in the foreground.[5]

1. Antwerp 1993, 162.
2. Bussers 1991, n.p.
3. Bussers 1991, n.p. See this article, too, for the identification of the rest of the prominent structures in Bonnecroy's painting.
4. Brussels 1998, 298. As Anthony Hirschel remarked in conversation, it simply could be that the archdukes' work of urban renewal was so pervasive that any such view would be a tacit homage to them.
5. Bussers 1991, n.p.

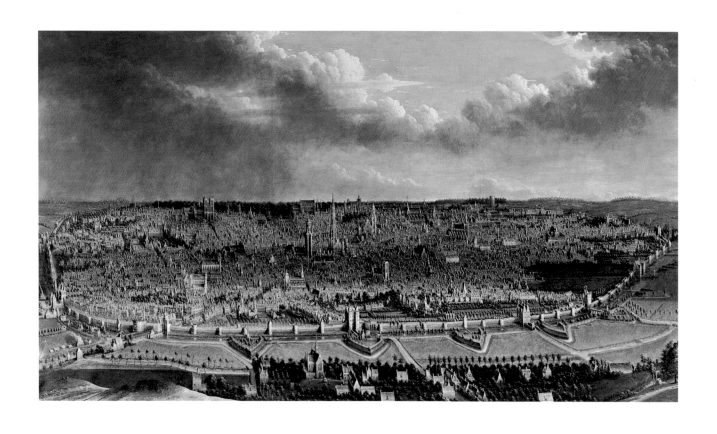

22.

PAUL BRIL
Antwerp 1554–Rome 1626

Pool in a Forest,

ca. 1596
Pen and brown ink, brown and gray
wash, tinges of blue watercolor, traces
of black chalk and white bodycolor
on paper
7 ¹⁵⁄₁₆ x 10 ⅝ inches (20.1 x 27 cm)
Royal Museums of Fine Arts
of Belgium, Brussels, inv. 4060/502

This drawing is a transitional work between Paul Bril's early landscapes, constructed according to mannerist "world-view" principles, and his later move toward greater realism. The flanking trees, the decorative impact of their gnarled trunks and ornamental foliage, and the effect of a funnel into depth in the middle distance are all characteristic of mannerist landscape construction. However, the focus on a particular aspect of nature (in this case a pool in the forest), the abandonment of a bird's-eye perspective for a close-up view, and a greater simplicity and unity in the composition as a whole point to a growth in naturalism in the depiction of landscape.[1]

The stylistic affinity of this drawing to one in Bremen and another in Dresden, both dated 1596, has led to its suggested dating.[2] It belongs to a group of drawings of enclosed wooded scenes that Bril apparently made between 1595 and 1600. Despite the small size of the sheet, the landscape has a majestic quality. The subtle use of wash heightens the contrast between dark and light that gives the wooded locale a feeling of intimacy. The human figure dwarfed by the trees suggests the grandeur of nature. The idea of nature undisturbed is suggested by the limpid reflections in the water and the lazily moving clouds in the sky. Despite the agitated forms of the trees, an air of tranquillity pervades the scene.

Because no print after this drawing is known, it may have been made either as an *aide-mémoire* for a painting or as an independent aesthetic creation.[3]

1. Hautekeete et al. 1991–92, 94. It has been suggested that Bril was a decisive influence on the development of landscape in the work of Jan Brueghel the Elder when the latter met him in Rome between 1593 and 1595; see Brussels 1963, 187, cat. 274, and compare *cat. 23* in this volume.
2. Cologne 1992, 486, cat. 107.1, and see Brussels 1963, 187, cat. 274.
3. Hautekeete et al. 1991–92, 94.

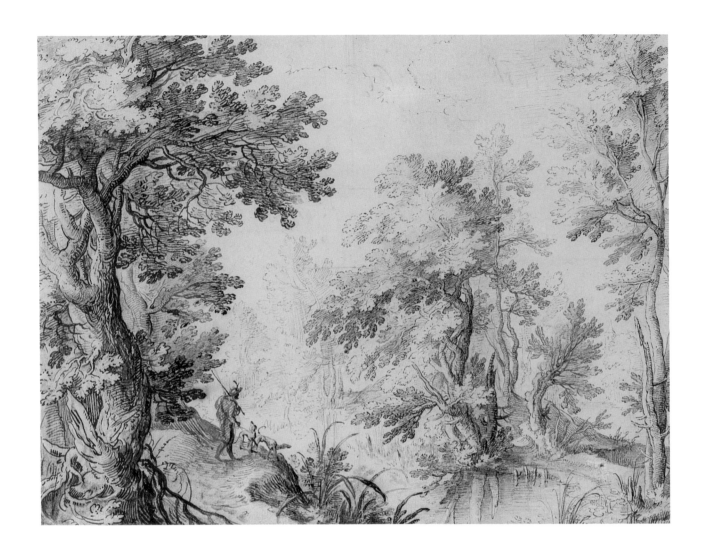

23.

Jan Brueghel the Elder
Brussels 1568–Antwerp 1625

*Study of People,
Horses, and Carts,* 1602

Pen and brown ink on paper
6 ¼ x 12 ¹⁄₁₆ inches (15.8 x 30.7 cm)
Royal Museums of Fine Arts
of Belgium, Brussels, inv. 4060/478
Inscription: 1 februwari 1602

This sheet, dated 1 February 1602, is an important marker in the graphic work of Jan Brueghel the Elder, as it helps define the loose, nervous handling typical of his early drawing style. The sketch features figure studies made after life, probably at a market. He captures the sense of bustling activity, the patience and resignation of the animals, and the drudgery and comradeship inherent in daily exchanges.

Brueghel has adopted a high vantage point, which accords with the panoramic approach to landscape in his early work. Around the turn of the century, however, he began to move away from the mannerist construction of the "world landscape" tradition (compare *cat. 22*)—characterized by marked contrasts in scale and perspective and stylized reproduction of trees and mountains—to increasing topographic specificity and close examination of detail.[1] His landscape paintings became simpler scenes with lower horizons that included vignettes of peasant life. Drawings such as this provided models for these vignettes.

The horse and cart in the upper right corner of the sheet are close to those in the foreground of the *River Landscape*, a contemporary painting by Brueghel in Aschaffenburg (inv. 829). The standing woman with a basket over her arm seen from the back and looking at the horse and cart reappears in reverse at the lower left of the painting.[2] The two women carrying a pail between them are transformed in the painting into less burdened peasants with rakes over their shoulders. In *Landscape with Windmill* in Madrid, attributed to Jan Brueghel the Younger and possibly after a lost painting by his father, the sketched horse and cart with a man loading sacks into it figures in reverse.[3]

1. Antwerp 1971, 27, cat. 5.
2. Brussels 1980, 220, cat. 159;
 Ertz 1979, 49, fig. 16.
3. Ertz 1979, 165, fig. 177.

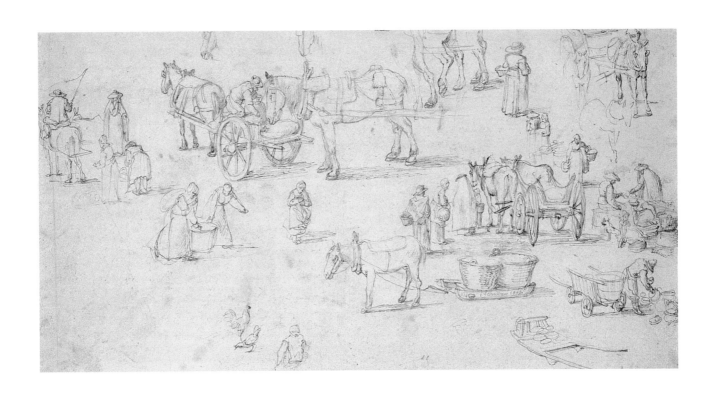

24.
HENDRIK DE CLERCK
Brussels ca. 1570–Brussels 1629

*St. Sebastian
Before the Emperor
Diocletian,* ca. 1617

Pen and brown ink, brown wash over
black chalk on paper
10 ⁷⁄₁₆ x 8 ¹³⁄₁₆ inches (26.5 x 22.4 cm)
Royal Museums of Fine Arts
of Belgium, Brussels, inv. 4060/877

Hendrik de Clerck was appointed court painter in Brussels, first to Archduke Ernest and then to his successors, Archdukes Albert and Isabella.

The artist's idiosyncratic drawing style, exemplified in this sheet, is characterized by a restless, agitated quality, with short curved strokes used to describe details. The exaggerated poses and responses of the participants, the contrived anatomical delineation, and the studied refinement of the forms reveal de Clerck's affinity with mannerism.

The subject of this drawing is rare in the history of art. It depicts St. Sebastian, brandishing the arrows with which he has been shot (compare *cat. 86*), confronting the Emperor Diocletian, who had ordered his execution. Sebastian was a threat not only because of his own Christianity but also because he supported other Christians in the Emperor's guard. This confrontation was intended to make the emperor repent. However, it had the opposite effect, and Diocletian ordered Sebastian to be beaten to death and his body thrown into the sewer near the Via Appia outside Rome.

This sheet is a compositional study for the inner side of the left wing of the *St. Sebastian Triptych* made for the church of Saint Martinus in Asse (eight miles northwest of Brussels). The triptych was probably commissioned in 1617 on the occasion of the re-establishment in Asse of the Longbow Archers' Guild, for which Sebastian was the patron saint.[1] De Clerck was responsible for the design of the triptych and for painting the central panel representing *The Martyrdom of St. Sebastian.*[2] Students were responsible for the side panels: on the left, *St. Sebastian Before the Emperor Diocletian* and on the right, *The Flogging of St. Sebastian.* The outside wings depict St. Sebastian as a member of the emperor's personal guard and St. Sebastian visiting imprisoned Christians.

Although the drawing functioned as a guide for de Clerck's studio, the format of the final painting of *St. Sebastian Before the Emperor Diocletian* is much more vertical, resulting in a compression of the composition. Most notably, the enthroned Diocletian is placed on a much higher plane than Sebastian. The reactions of the onlookers are also less theatrical than in the drawing, perhaps a sign of the student's inexperience or relative lack of talent.

1. For a full discussion of this commission, see Laureyssens 1989.
2. The martyrdom of St. Sebastian, the most frequently represented image from the story, is a depiction of St. Sebastian being shot with arrows; compare *cat. 86.*

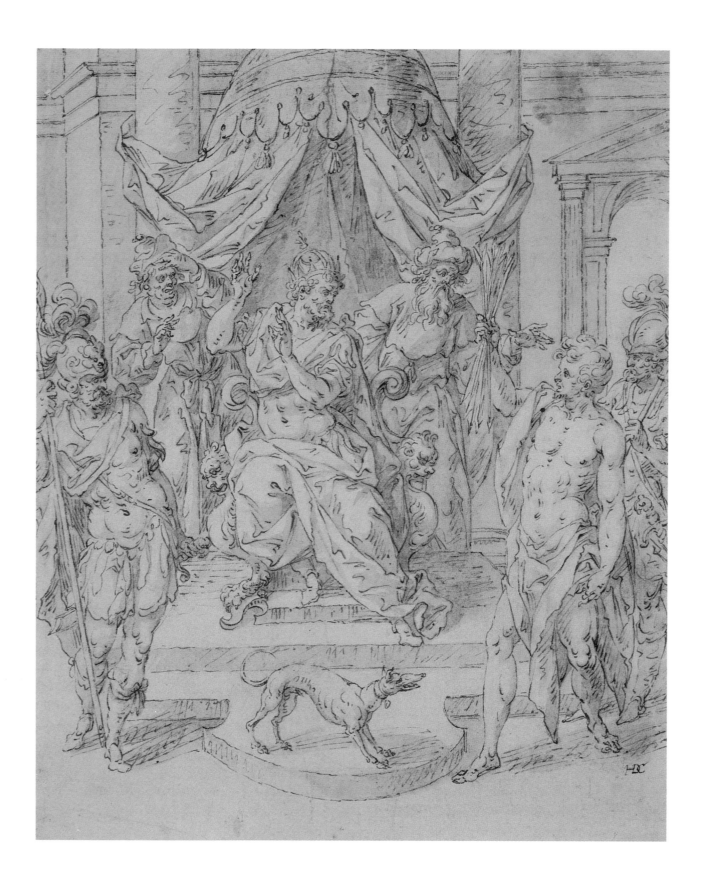

25.

Jacob Jordaens
Antwerp 1593–Antwerp 1678
Homage to Pomona,
ca. 1623
Brown ink and wash with
black chalk on paper
7 ½ x 10 ¼ inches (19 x 26 cm)
Royal Museums of Fine Arts
of Belgium, Brussels, inv. 6155

Drawing played an important role in the production of Southern Nether-landish painters. Jordaens, like Rubens and van Dyck, was an extraordinarily prolific draftsman. This drawing is a compositional sketch for the painting of the same name in the Royal Museums of Fine Arts of Belgium, Brussels. In the conception and preparation of the large figural composition, it apparently preceded another sketch, which is now in the Statens Museum for Kunst, Copenhagen.

The subject depicts Pomona, goddess of fruit and fertility, receiving the homage of nymphs, satyrs, and a woman who symbolizes humanity. This is a key work of an artist whose oeuvre is largely devoted to the idea of the fruitfulness and luxuriance of nature.[1]

There is a striking resemblance between this drawing and a sketch of *Diana and Callisto* by Hendrik Goudt (1583–1648) in the Städelsches Kunstinstitut in Frankfurt, on which Jordaens's image must be based. The similarities between the sheets include the strongly lit nymph seen from behind, the crouching satyr at left (which corresponds to a seated figure in the Goudt), and the crouching nymph facing right in the center of both compositions.[2]

Compositional changes are apparent between this sheet and Jordaens's final painting. For example, the space above the figures' heads is greater in the drawing than in the painting,[3] and the crouching nymph faces right in the drawing and left in the painting. The space that separates the group of nymphs from the satyr and his companions has been bridged in the painting.

The drawing is characterized by a loose and rapid style in which the artist is clearly more interested in suggesting than in analyzing the forms or exploring detail. The figures are arranged more or less statically in the foreground, with little or no sense of background. Jordaens has employed wide, spontaneous washes to suggest the distribution of light and shade. The use of this technique indicates an interest in the pictorial rather than the strictly linear and recalls the fact that the artist initially enrolled in Antwerp's Guild of St. Luke as a *waterschilder*, or watercolorist.

1. Brussels 1993, 46, cat. 6.
2. Goudt is most often associated with reproducing the designs of Adam Elsheimer in print, and his drawing style is based on Elsheimer's.
3. The height of the canvas was reduced when it was relined; see Antwerp 1993b, 2:20, cat. B10.

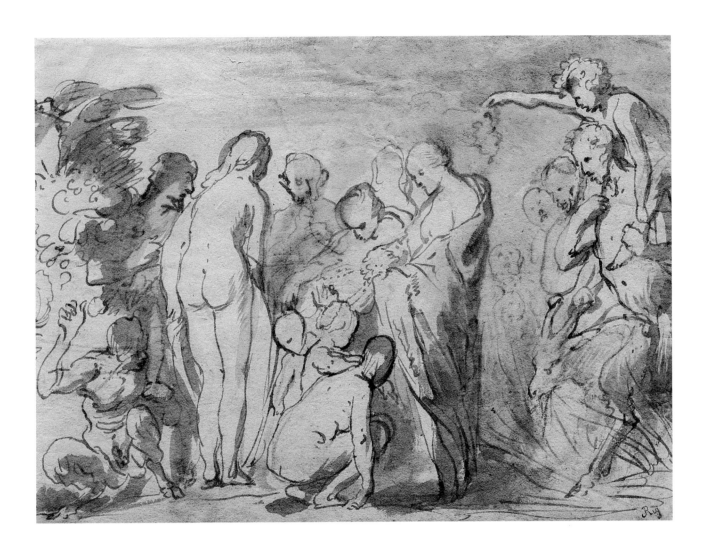

26.

JACOB JORDAENS
Antwerp 1593–Antwerp 1678

*Christ and the
Samaritan Woman,*

ca. 1655–60
Red and black chalk on paper
7 ¹¹⁄₁₆ x 7 ⁷⁄₁₆ inches (19.45 x 18.9 cm)
Royal Museums of Fine Arts
of Belgium, Brussels, inv. 4060/1945
Inscription: at bottom center, "Joe 4. 10
soo ghy wist wie hy was die u dit seyde/
geeft mij to drincken Ghy soudet van
hem/gegeeren/ Ende hij soude u lev-
ende waeter geven" ("John 4:10 [If you
knew the gift of God, and] who it is
that is saying to you, 'Give me a drink,'
you would have asked him and he
would have given you
living water.")

Christ is depicted seated at the well conversing with the Samaritan woman.
Three of his disciples have returned from town and are surprised to witness
the exchange, because Jesus should not have been speaking to her.[1] As a
narrator, Jordaens was able to make the stories from Scripture accessible
by bringing their human dimension to the fore. This accessibility is accentu-
ated by the use of a shallow stage setting. The viewer is thus brought both
psychologically and physically close to the scene.[2]

In his later years, Jordaens used red chalk frequently.[3] His line in this
drawing is firm, forceful, and simplified; the resulting forms are statuesque.
Broad parallel hatchings in both red and black chalk provide intimations
of depth and shadow. Black chalk is also used to reinforce outlines in
several places. The clear and direct style reflects an increasing classicism
in Jordaens's later works.

This drawing belongs to a small group of similar sheets, each bearing
Jordaens's written transcription of the biblical verse he was illustrating.
None of these works seem related to any known project. Such illustrations
of New Testament texts might reflect the artist's conversion to Protestantism,
which he openly embraced in the 1650s (compare *cat. 6*).[4] A variant of this
drawing is in the Staatliche Museen in Berlin.[5]

1. Jesus was forbidden to speak to her
both because she was a woman and
because she was a Samaritan; see
Moloney 1998, 116–17. Jewish men
did not speak to women in public,
and Jews viewed Samaritans with
distaste because they believed them
to be perpetually unclean. So Jesus
breaks both a cultural and ethnic
taboo and a religious prohibition;
see Thurston 1998, 83.
2. Sutton 1993b, 50.
3. Antwerp 1993b, 2:3.
4. Similar examples are in Stockholm,
Leningrad, Moscow, Warsaw, and
the Pierpont Morgan Library, New
York; see New York 1991, 132,
cat. 286. He has moved away here
from the images of the Virgin and
saints that were so much a part of
Counter-Reformation pedagogy.
5. Brussels 1993, 84, cat. 25.

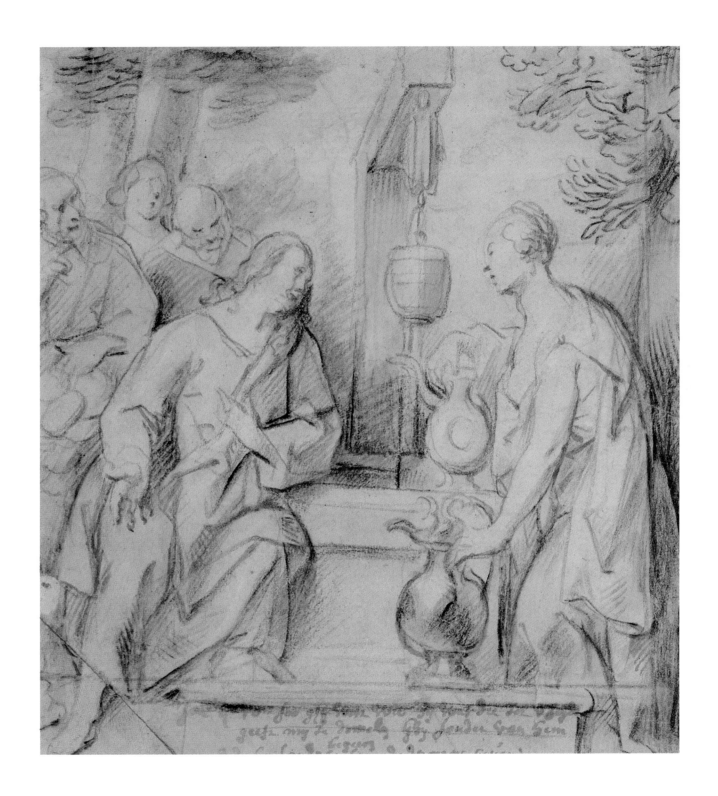

27.
GASPAR DE CRAYER
Antwerp 1584–Ghent 1669

Saints Benedict, Bernard of Clairvaux, and Rupert of Molesme, ca. 1668

Brown brush and white gouache on paper
6 ¹⁵⁄₁₆ x 8 ¼ inches (17.67 x 20.91 cm)
Royal Museums of Fine Arts of Belgium, Brussels, inv. 11.649

This sheet is probably a portion of a sketch for de Crayer's late painting *St. Bernard Nourished by the Virgin's Milk in the Presence of Other Saints* in Antwerp. It was commissioned for the high altar of the Cistercian abbey in Nazareth (near Lier, nine miles southeast of Antwerp) in 1668 or shortly thereafter by Edmunda of Ibarra, who was named abbess in that year.[1]

At the upper left, his figure only partially intact, is St. Benedict, the sixth-century founder of Western monasticism, with his attribute, a chalice resting on a prayer book. Below him is St. Bernard of Clairvaux, a twelfth-century reformer of the Cistercian order and fervent proponent of the cult of Mary. Across from him is St. Rupert of Molesme, one of the founders of the Cistercian order, who preached solitude, poverty, and simplicity. A small angel standing between St. Bernard and St. Rupert turns toward the Virgin, whose drapery folds can be seen along the upper edge at the center of the drawing.

There are a number of important differences between this sheet and the painting in Antwerp. In the drawing, St. Bernard's face is not turned upward to receive the Virgin's milk as it is in the painting. St. Benedict looks outward in the drawing, his crozier on the ground, whereas in the painting he looks down and cradles his crozier in the crook of his arm. The angel is absent in the painting.

The figures of St. Bernard and St. Rupert in the sketch are closest to the corresponding figures in de Crayer's altarpiece *The Virgin and Child Adored by Saints* in the Gymnasial Church, Meppen,[2] although they appear on different levels in the painted *sacra conversazione*. It is possible, therefore, that this sketch functioned as a model sheet on which de Crayer based components of various compositions.[3]

This oil sketch reveals the strong emotional character of de Crayer's later works. Ardent devotion and fervent supplication can be read in the attitude of the saints. The undulating brushstrokes and restrained use of white heightening and brown wash enliven this grisaille, a type of monochrome study popular in seventeenth-century Flanders.

1. Vlieghe 1972b, 1:230–31.
2. Vlieghe 1972b, 2:172, A188.
3. I am grateful to Stefaan Hautekeete for this convincing suggestion.

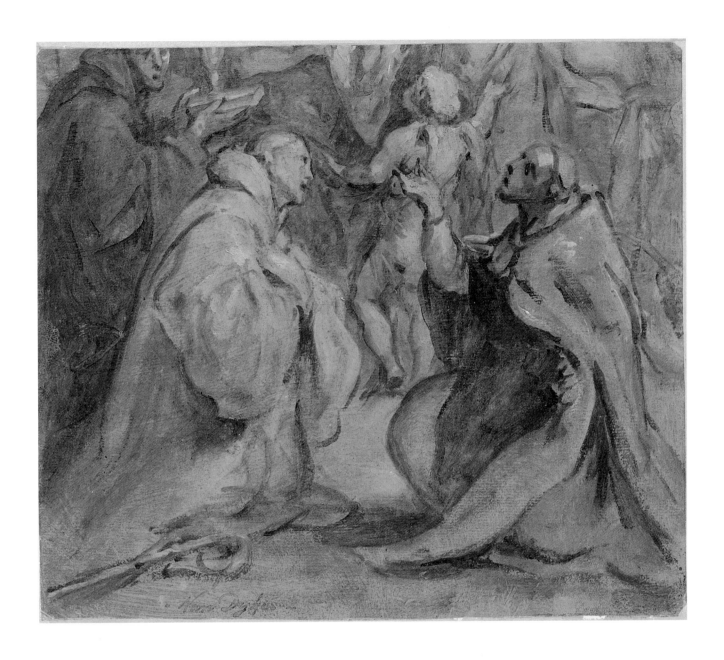

28.

Jan Boeckhorst
Münster 1605–Antwerp 1668

Apollo and the Chariot of the Sun,
ca. 1650–70
Brown ink and wash with white heightenings on paper
13 ⅜ x 21 ⁵⁄₁₆ inches (34 x 54.1 cm)
Royal Museums of Fine Arts of Belgium, Brussels, inv. 10.992

Jan Boeckhorst made this drawing in preparation for one of eight tapestries on the theme of Apollo he designed for the Antwerp collector and alderman Antoon van Leyden. It is one of several known works by Boeckhorst for this commission, including an oil sketch on canvas, two on panel, and another drawing on paper.[1] The tapestries differ, often substantially, from the preparatory works. For example, the horses in the present drawing are more uniformly arranged and less wild than the horses in the finished tapestry. It is therefore assumed that there were studies made between the known preparatory works and the finished tapestries.[2]

The composition shows the sun god Apollo driving his horses,[3] accompanied by the daughters of the Sun (the Heliades) and led by the evening star.[4] Its conception relies on the famous 1613 fresco of *Aurora* by Guido Reni in the Palazzo Rospigliosi, Rome.

This drawing is treated more or less as a grisaille. Boeckhorst has worked the sheet with a brush, varying the density and thickness of his strokes. He has also imaginatively used both the ground and passages of white heightening to define his forms.[5]

1. See van Tichelen and Vlieghe 1990, 113–16, and Logan 1990, 125. Similarities in some of the studies to the work of Jacob Jordaens are not surprising, given that Boeckhorst most likely trained in his workshop from about 1626; see Antwerp 1991b, 74. The tapestry of this subject is in the Spanish Embassy in Brussels.
2. Logan 1990, 126.
3. Pyrois, Eous, Aethon, and Phlegon are usually shown winged.
4. Antwerp 1990, 202, cat. 31.
5. For example, the daughters on the far side of the horses and the figure of Apollo himself are suggested by the artful placement of white strokes on the light brown ground.

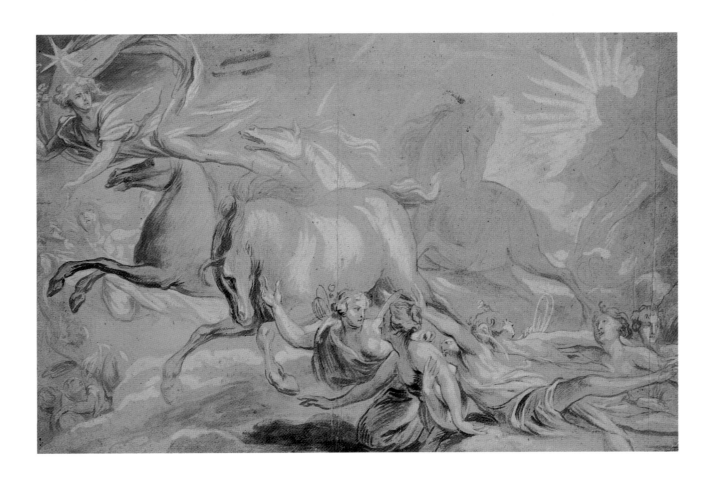

29.
FRANS SNYDERS
Antwerp 1579–Antwerp 1657
*Still Life with
Dead Game and
Vegetables,* ca. 1640
Pen and brown ink on paper
9 ½ x 12 ⅞ inches (24.2 x 32.7 cm)
Royal Museums of Fine Arts of
Belgium, Brussels, inv. 9979

Frans Snyders was the first specialist and most important seventeenth-century Flemish painter of still lifes and animal pictures. Because he enjoyed a long career, he produced an enormous body of work—by himself, with studio assistance, and in collaboration with some of the best-known artists of the day. Although for the most part drawings by still-life artists are rare, there are many such sheets by Snyders. They can be divided into five types: studies from life; copies after prints; preparatory studies, including individual motifs and compositions; presentation drawings; and *ricordi* and pattern sheets.[1]

This drawing is clearly a preparatory study. It was made for a painting featuring, on the left, a young man holding a boar's head. In front of him is a table that spans the width of the painting, laden with an elaborately arranged still life of dead game.[2] As here, the abundance of nature is often the true subject of Snyders's art. The drawing focuses on only a portion of the still life on the table and includes a pheasant, peacock, hare, and bowl of partridges, in addition to a head of cauliflower and a lunging cat. There is little deviation between the drawing and the corresponding parts of the finished painting.

Snyders understood the anatomy of animals extremely well, and his careful study of their forms from life is apparent in his drawings. However, despite the impression of spontaneity, Snyders's dynamic line emphasizes the overlapping curves that give structure to his composition.

The artist included living animals in his still lifes not only to contrast with the dead creatures from the hunt but also, perhaps, as symbolic elements. According to the artist and theorist Karel van Mander (1548–1606) in his *Wtbeldinghen der Figuren (The Representation of Figures)*, a supplement to his *Schilderboeck (Book of Painters)* of 1604, "The cat represents an unjust judge, as it often causes more harm in a household than the mice whose thievery it has been set to punish." By exposing the cat's true nature, the ubiquity of evil and the necessity for constant vigilance are implied.[3]

1. Koslow 1995, 60.
2. This painting (canvas, 142 x 208 cm) was last recorded in the Renesse sale, Sotheby's, London, 27 May 1938 (lot 18, to Sterne); Robels 1989, 216, cat. 54.
3. Koslow 1995, 131.

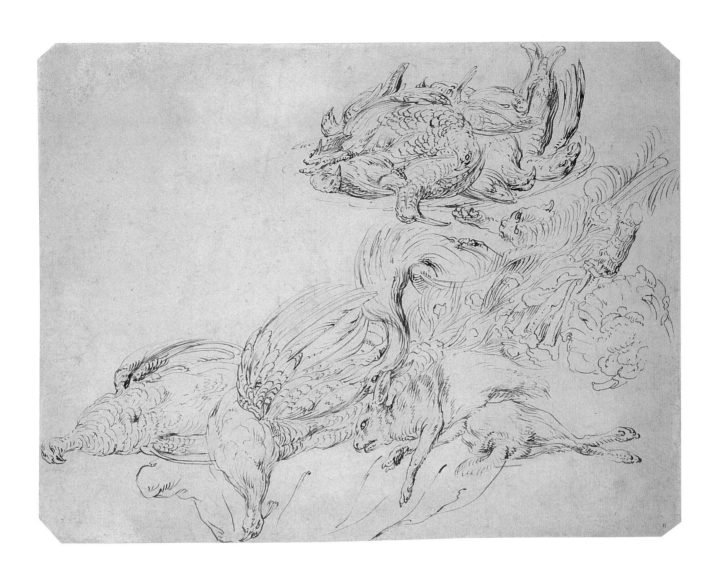

30.
Jan van Kessel
Antwerp 1626–Antwerp 1679
View of the Belly
of a Tree Frog
Pen and brown and gray ink, water-
color, and bodycolor on parchment
6 7/16 x 5 3/16 inches (16.3 x 13.2 cm)
Royal Museums of Fine Arts
of Belgium, Brussels, inv. 4060/1981

Tree frogs, from the family *Hylidae*, are small, slender, and long-legged amphibians, with sucker-like adhesive disks on the tips of their fingers and toes. The curious-looking suction cups are used for climbing trees. There are more than 550 species of hylids; found on all continents, they live primarily in North and South America.[1]

This work shows the artist's interest in rendering exotic creatures as accurately as possible. To achieve such exactitude, van Kessel regularly used illustrated scientific texts. According to Jakob Weyerman, a pupil of van Kessel's son Ferdinand, van Kessel also frequently worked from nature.[2]

Van Kessel made a drawing of this tree frog not only on its back but also on its stomach.[3] These works are on vellum, a relatively precious support that indicates that they were intended as independent and finished drawings.[4] It has been suggested that van Kessel made these images of the dead tree frog on commission for the owner of the specimen. Flemish artists were occasionally patronized by foreign princes to make representations of the animals in their collections in order to preserve the disparate creatures together in animal albums.[5]

1. "Tree frog" in *Encyclopedia Britannica Online* <http://www.eb. com: 180/bol/topic?thes_id = 465571&pm=1> (26 March 1999).
2. W. Laureyssens, "Jan van Kessel ii," in Dictionary of Art 1996, 17:920.
3. *View of the Back of a Tree Frog* is also in the Royal Museums of Fine Arts of Belgium, Brussels, inv. 4060/1979.
4. Paris 1972, 62, cat. 46.
5. Balis 1985, 13. Thanks to Stefaan Hautekeete for this reference.

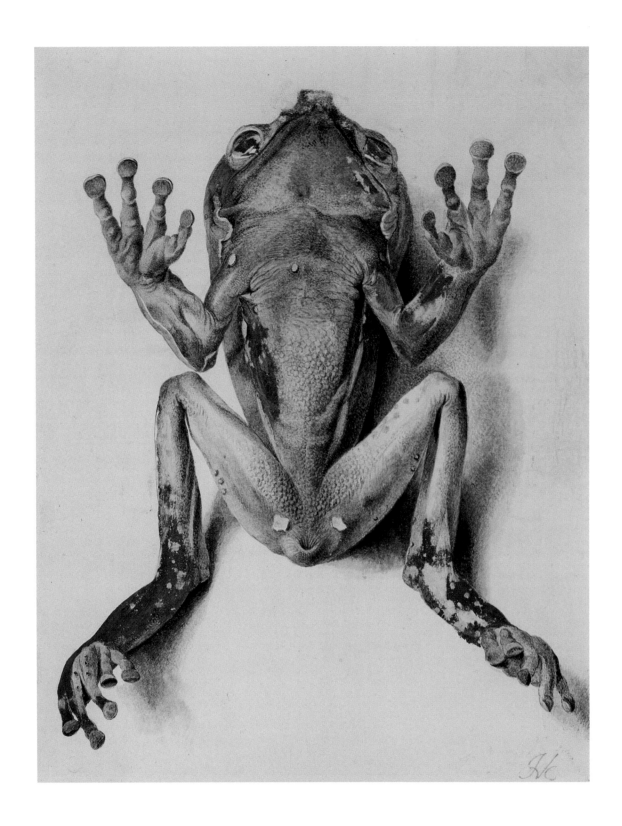

31.
Aegidius Sadeler
Antwerp 1570–Prague 1629
*Portrait of Arnold
de Reyger,* 1604
Black ink and brush with white
highlights on gray prepared paper
5 ¹⁵/₁₆ x 4 ⁹/₁₆ inches (15.1 x 11.6 cm)
Royal Museums of Fine Arts
of Belgium, Brussels, inv. 4060/3115

32.
Aegidius Sadeler
Antwerp 1570–Prague 1629
*Portrait of Arnold
de Reyger,* 1604
Engraving
4 ¼ x 6 ¾ inches (11.5 x 17.2 cm)
Print Room, Royal Library Albert I,
Brussels, inv. S. II 26518
Inscription: above oval, IN. MANV
DOMINE SORTES MEÆ (In the hand of
the Lord, my fate) Inscription: around
oval, ARNOLDVS DE REYGER IC. HEREDI-
TARIVS IN GLADBECK ET SERENISS.
ELECT. BRANDENBVRG. CONSILIARIVS
CONONIÆ AD SPREAM ETC (Likeness
of Arnold de Reyger, Hereditary in
Gladbeck and Most Serene Elector
Brandenberg Counselor of the
Colony at Spream, etc.)
Inscription: below oval, DUM RUIT
INFELIX FATALI BELGIA BELLO,/ EXCIPTI
OBIECTU TE THEMIS ALMA SUO,/
CONSILIISQ DUCUM MELIORIBUS INSER-
IT HOC EST/ VIRTUTI STIMULOS
ADDERE, NON RAPERE, H. TREUTLERUS.
F. (While unlucky Belgium was
destroyed by fatal war, dear Justice
rescues you by her protection, He
contributes to the better counsels of
leaders, that is, adding spurs to virtue,
rather than snatching them away.
H. Treutlerus.)
Inscription: at lower right of oval,
DE. FACIE FACIEM/ EXPRESSIT Æg.
SADEL:/ PRAGÆ. 1604. (From the face,
Aegidius Sadeler expressed the face in
Prague 1604.)

Aegidius Sadeler and his workshop engraved more than forty portraits of nobles and visiting dignitaries to Rudolf II's court between 1597, when the artist most likely arrived in Prague, and Rudolf's death in 1612.[1] The political and documentary interest of these prints may partially explain why Sadeler continued to work as imperial engraver for Rudolf's successors, Matthias (ruled 1612–19) and Ferdinand II (ruled 1619–37), despite their relative lack of interest in the arts.[2] Sadeler was greatly admired for his delicate representations of his sitters and his ability to penetrate their psychology.[3] His engraved portraits after his own inventions consequently make up a considerable portion of his total oeuvre, although only twelve drawings for these prints, of which this sheet is one, are extant.[4]

The use of a gray ground is typical of Sadeler's preparatory drawings for his portrait engravings.[5] This coating provided a medium tone against which he could build up a range of darks and lights. The use of such a preparation might have derived from the standard grisaille technique used in Sadeler's native Antwerp for drawings intended for print production.[6] He has used dense strokes to describe the details of the sitter's face. The costume is more summarily executed, although the highlights on and disposition of the ruff collar, which forms a frame for the penetrating glance and distinguished head of the Brandenburg nobleman, are given somewhat more thought than the fur-trimmed cloak.

Because the drawing of de Reyger is not the reverse of the engraving, it is possible that a second drawing was used to trace the image onto the engraving plate.[7] The existence of several Sadeler portraits in unfinished states suggests that he worked on the engravings in stages. The likeness would be completed and presented for the approval of the sitter. The surrounding border would then be filled in and the engraving finished.[8] The engraved portrait of de Reyger illustrates the formality of pose, tight control of burin line, and meticulous surface that were deemed fitting for Hapsburgian decorum.[9]

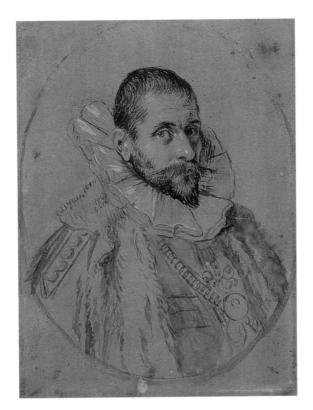

1. Limouze 1993, 168.
2. Limouze 1989, 15.
3. Christine van Mulders, "Aegidius Sadeler II," in Dictionary of Art 1996, 27:504.
4. Essen 1988, 376.
5. Sadeler arrived at his preferred oval format for portrait engravings around 1600. This format was also used by many of his Flemish contemporaries; see Limouze 1993, 170.
6. Prague 1997, 437, 1.230. Reznicek suggested that the technique might have been developed as a result of Sadeler's having engraved after Dürer drawings on colored grounds; see Limouze 1993, 162.
7. Compare Sadeler's drawing and print of Vincenz Muschinger facing in the same direction; see Limouze 1989, 18.
8. Limouze 1993, 163.
9. Limouze 1989, 15.

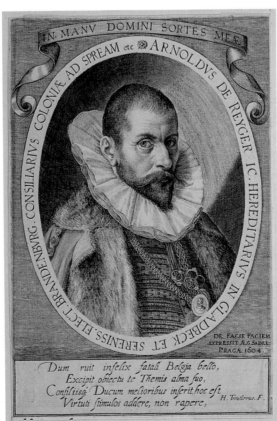

33.

JAN MULLER
Amsterdam 1571–Amsterdam 1628

after **PETER PAUL RUBENS**
Siegen, Westphalia 1577–
Antwerp 1640

Portrait of Archduke Albert, 1615

Engraving
15 ¼ x 20 ½ inches (38.8 x 54 cm)
Print Room, Royal Library Albert I,
Brussels, inv. S. I 29210
Inscription: in lower margin, SERENIS-
SIMO ET POTENTISSIMO ALBERTO/
AVSTRIÆ ARCHIDVCI, BVRGVNDIÆ
DVCI,/ PRINCIPI ET DOMINO BELGARVM./
Ioannes Muller Sculptor deuotionis
ergô D.D./Ex Archetypo Petri Pauli
Rubenij SERENITATIS SVÆ PICTORIS.
(Most serene and most powerful
Albert. Archduke of Austria, Duke
of Burgundy and Prince and Lord of
the Belgians. Jan Muller dedicated
this in token of his devotion. From
the archetype of Peter Paul Rubens,
Painter of His Serene Highness.)

34.

JAN MULLER
Amsterdam 1571–Amsterdam 1628

after **PETER PAUL RUBENS**
Siegen, Westphalia 1577–
Antwerp 1640

Portrait of Archduchess Isabella, 1615

Engraving
15 ¼ x 20 ½ inches (38.8 x 54 cm)
Print Room, Royal Library Albert I,
Brussels, inv. S. I 29211
Inscription: in lower margin, SERENIS-
SIMA ISABELLÆ CLARÆ EUGENIÆ/
INFANTI HISPANIARVM/ PRINCIPA ET
DOMINÆ BELGAVM/ Ioannes Muller
Sculptor deuotionis ergô DD./
Ex Archetypo Petri Pauli Rubenij
SERENITATISSVÆ PICTORIS. (Most
serene Isabella Clara Eugenia.
Infante of the Spaniards, Princess and
Mistress of the Belgians. Jan Muller
dedicated this in token of his devo-
tion. From the archetype of Peter
Paul Rubens, Painter of Her
Serene Highness.)

Peter Paul Rubens was appointed court painter by Albert and Isabella in 1609. In this capacity, one of his principal tasks was to create official likenesses of the archdukes. These compositions recorded by Jan Muller are based on the traditional international style of formal court portraits of the late sixteenth century, in which the sitters, with the accoutrements of their rank, are silhouetted against indeterminate backdrops.[1] Despite the formality of the portraits, Rubens has invested the figures with great plasticity and, by their direct gazes, has implied something of their humanity.[2]

The prints are apparently after paintings by Rubens which are no longer known, although they are clearly related to the portraits of Albert and Isabella in the National Gallery, London, and, to a lesser extent, to the pair in the Kunsthistorisches Museum, Vienna. The prints differ from the London paintings in details such as the age of the sitters and the jewel carrying the Golden Fleece on Albert's chest,[3] and from the Vienna works in the relative stoutness of the pair and the position of the archduke's hand. Rubens received payment of three hundred florins in October 1615 for a pair of portraits of the archdukes to be sent to Madrid to Rodrigo Calderón, the Marquis of Siete Ygliesias, the Duke of Lerma's closest administrator and one of Philip III's most important courtiers.[4] These are believed to be the images engraved by Muller in 1615.[5]

Rubens became interested in having his paintings reproduced as engrav-ings shortly after his return to Antwerp from Italy in 1608. He was evidently dissatisfied with the engravers working in Antwerp, so he called on artists working in Holland, among them Muller. Muller is best known as a repro-ductive engraver, although these are the only prints he made after Rubens's designs. Perhaps Muller's style, rooted in his Haarlem training and influenced by the work of Hendrik Goltzius, was too pronounced and idiosyncratic for Rubens, who was searching for a trained master still sufficiently malleable to adapt his skill to suit Rubens's wishes.[6] Nevertheless, as is evident in these extraordinary impressions, Muller was a master at rendering surfaces, textures, and the play of light in print.

The prints are inscribed CUM PRIVILEG [IO], which refers to the fact that Muller was granted a privilege of six years during which time no one else was free to reproduce his prints. This forerunner of copyright was meant to check irresponsible and unauthorized plagiarism, giving the printmaker the sole right to print the image.[7]

Proof impressions of some of Muller's reproductive engravings allow a glimpse of his working method. He began by scratching the composition into the plate in drypoint and then worked up the face in great detail. Proceeding section by section, he engraved the costume and background, often using middle tones behind the head. He employed a largely artisanal process, in which spontaneity was almost totally absent.[8]

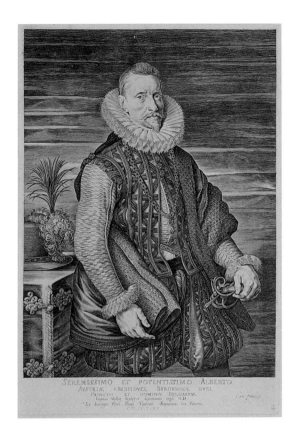

SERENISSIMO ET POTENTISSIMO ALBERTO
AVSTRIÆ ARCHIDVCI BVRGVNDIÆ DVCI,
PRINCIPI ET DOMINO BELGARVM.
Ioannes Muller Sculptor dinavtumis ergo D.D
Ex Archetypo Petri Pauli Rubenii Inuentoris hæc Pictura.
CIꝹ.IꝹ.C.XX.

1. Vlieghe 1987, 22 and 38.
2. White 1987, 55.
3. London 1970, 227, inv. 3818.
 Albert was made a knight of the
 Order of the Golden Fleece in
 1599.
4. When the Duke of Lerma fell out of
 favor, Calderón was tried for bribery
 and embezzlement and ultimately
 beheaded. For Calderón's collec-
 tion, see Martín Gonzalez 1988,
 267–92. I am grateful to Sarah
 Schroth for this information.
5. Brown 1998, 123; Göttingen 1977,
 69–70, cat. 40.
6. Rubens was searching for an
 engraver who could translate his
 paintings pictorially into prints,
 capturing color, light, and shade
 rather than merely line; see
 Baudouin, F. 1991a, 42–43.
7. The privilege was most likely
 granted by the States of Holland,
 which granted privileges for
 Muller's prints of 1608. In general,
 most Dutch printmakers applied for
 privileges from a single source; see
 Gerson and ter Kule 1960, and 85;
 Filedt Kok 1994, 256; Orenstein
 1996, 91.
8. Filedt Kok 1994, 259.

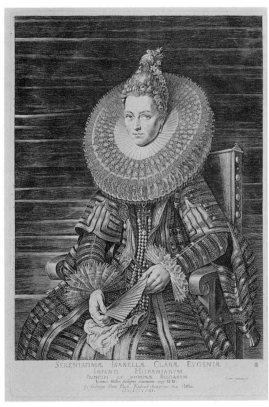

SERENISSIMÆ ISABELLÆ CLARÆ EVGENIÆ
INFANTI HISPANIARVM
PRINCIPI ET DOMINÆ BELGARVM
Ioannes Muller Sculptor dinavtumis ergo D.D.
Ex Archetypo Petri Pauli Rubenii chiagoteris fere Pictura
CIꝹ.IꝹ.C.XX.

35.
DIRCK VOLKERTSZ.
COORNHERT
Amsterdam 1522–Gouda 1590
after MAARTEN VAN
HEEMSKERCK
Heemskerck 1498–Haarlem 1574

*Joseph Seeking his
Brothers in the
Plain of Sichem,*
mid-16th century
Etching
9 ¼ x 7 ¼ inches (24.8 x 19.8 cm)
Print Room, Royal Library Albert I,
Brussels, inv. S. II 91709

36.
DIRCK VOLKERTSZ.
COORNHERT
Amsterdam 1522–Gouda 1590
after MAARTEN VAN
HEEMSKERCK
Heemskerck 1498–Haarlem 1574

*The Discovery of the
Golden Cup in the
Sack of Benjamin,*
mid-16th century
Etching
9 ½ x 7 ½ inches (24.2 x 19.1 cm)
Print Room, Royal Library Albert I,
Brussels, inv. S. II 91715

The relationship between Dirck Coornhert and Maarten van Heemskerck was unusually collaborative. Coornhert, not only an engraver but also a scholar and theologian, was van Heemskerck's intellectual partner rather than merely his reproductive printmaker,[1] and he played an active part in the creation of the images.[2] The prints they made are not reproductions of existing independent works of art, but rather etchings after drawings that were made specifically to be reproduced as prints. It was not the drawings but the prints that were intended to be the final product.[3]

After 1548 Coornhert and van Heemskerck began to illustrate large parts of the Bible, beginning with Genesis. They often, as here, chose the story of a single character as the theme of a series of etchings. These prints share a relatively large vertical format, with figures occupying almost the entire picture plane, and the backgrounds are summarily indicated. The muscular figures, with their energetic gestures and dynamic movements, betray the influence of Michelangelo, whose work van Heemskerck had come to know in Rome. Because of Coornhert's use of etching rather than engraving, the outlines of the forms are emphasized more than the hatching.[4]

In the mid-sixteenth century, Antwerp was the dominant center for publishing of all kinds, so it is not surprising that printmakers from Haarlem, such as Coornhert and van Heemskerck, were occasionally active there. Although it is not known where or by whom these series were published, Antwerp must have played an important role in the distribution of their prints for the international market.[5]

The fact that such Old Testament stories were narrated in print series indicates that they were less appreciated as prefigurations of the New Testament than as interesting tales in themselves (see p. 32–33 in this volume). *Joseph Seeking his Brothers in the Plain of Sichem* follows the earlier convention of successive narrative. In the foreground, Joseph asks a man wandering in the fields where he might find his brothers pasturing their flock (Gen. 37: 15–16). Behind the man in the middle ground, Joseph has been stripped of his robe and is being put into a dry well by his brothers (Gen. 37: 23–24). The Ishmaelites to whom Joseph was sold can be glimpsed in the background. By contrast, the incident of *The Discovery of the Golden Cup in the Sack of Benjamin* takes place entirely in the foreground of that print. The figures unloading goods in the background belong to the same moment of the story (Gen. 44: 12).

1. Silver 1993, 13.
2. Riggs 1993, 103.
3. van der Coelen 1996, 13.
4. van der Coelen 1996, 13–14.
5. van der Coelen 1996, 14.

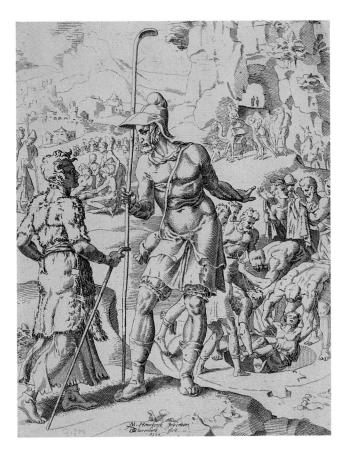

37.

CRISPIJN VAN DE PASSE
Arnemuiden 1564–Utrecht 1637
after MARTEN DE VOS
Antwerp 1532–Antwerp 1603

*Grammatica
(Grammar)*, ca. 1584

Engraving
3 ½ x 6 ⅝ inches (9 x 16.8 cm)
Print Room, Royal Library Albert I,
Brussels, inv. S. II 85322
Inscription: Prima fores Sophiœ,
recluso limite, pando:/Scibere quœ
puerum ritè, loquique volo. (I open
the doors of wisdom and make them
known throughout: while the children
as usual suckle, I speak with winged
words.)

38.

CRISPIJN VAN DE PASSE
Arnemuiden 1564–Utrecht 1637
after MARTEN DE VOS
Antwerp 1532–Antwerp 1603

Musica (Music), ca. 1584

Engraving
3 ½ x 6 ⅝ inches (9 x 16.8 cm)
Print Room, Royal Library Albert I,
Brussels, inv. S. II 85325
Inscription: Carminibus neruos aptans,
et carmina neruis:/ Dulcibus exhilaro
pectora moesta modis. (The strings
I point to the songs and the songs to
the strings: softly I tune the sad hearts
happy.)

39.

CRISPIJN VAN DE PASSE
Arnemuiden 1564–Utrecht 1637
after MARTEN DE VOS
Antwerp 1532–Antwerp 1603

Dialectica (Logic),
ca. 1584

Engraving
3 ½ x 6 ⅝ inches (9 x 16.8 cm)
Print Room, Royal Library Albert I,
Brussels, inv. S. II 85323
Inscription: A falso verum, à curuo
distermino rectum:/ Discenti dubiœ
duxque comesque viœ. (I distinguish
the true from the false, the crooked
from the straight: I am the leader and
the companion who removes you from
doubtful paths.)

These prints represent three of the Seven Liberal Arts from a series engraved by Crispijn van de Passe after drawings by Marten de Vos. The two met about the time van de Passe entered the Antwerp Guild of St. Luke in 1584–85. In addition to being one of the most important painters of altarpieces in Antwerp, de Vos was a prolific draftsman from whose designs some sixteen hundred prints were produced.[1] The drawings he made as designs for prints were worked largely in wash, with only the contours indicated in pen. He left it to the engraver to translate the shading into a network of lines.[2] Van de Passe often engraved prints after de Vos and published many of these prints himself.[3]

The use of personifications to represent allegorical concepts had both an aesthetic and an intellectual goal. By employing full-length, classically garbed female figures, de Vos emphasized the human body, the foundation of drawing itself.[4] At the same time, his choice of subject evoked the foundation of learning, as the liberal arts were viewed as man's access to knowledge of the world.[5] Furthermore, the subject and its allegorical figuration can be seen to reflect Renaissance humanist culture, responsible for the revival and study of classical learning.[6] On a more general level, the practice of producing series of prints of such abstract concepts illustrates the contemporary delight in compiling and classifying information.[7]

De Vos's conception of the liberal arts is different from the more narrative images of his contemporaries. Frans Floris (1519/20–1570) depicted full-length figures, joined by pupils or colleagues, in contextualized genre scenes.[8] Hendrik Goltzius (1558–1617), whose settings are not as detailed as those of Floris, nevertheless adopted Floris's approach while transforming his full-length figures into three-quarter-length women.[9] The allegorical intent is downplayed.[10]

By contrast, de Vos's figures stand before, rather than being integrated into, scenes alluding to their art. Music, playing her lute amid instruments and songbooks, dominates a cityscape at night, in which music-makers stroll. The accompanying inscription refers to music's ability to warm the heart. Logic gestures in a time-honored, expository way. On her head is perched a falcon, who "flies high and then swoops down on its prey, and thus does logic also move in the highest realms of thought to arrive at truth."[11] The snake wrapped around her arm is a symbol of wisdom and echoes the inscription's claim that Logic "distinguish[es] the true from the false." In the background are two scenes of men holding forth to their audiences. Grammar, "the first among the Seven Liberal Arts and the basis for all teaching,"[12] holds in her right hand the key to "the doors of wisdom" (as per the inscription) and in her left, one of several books that serve as her attributes.[13] In an arcaded space behind her, a schoolmaster conducts class.

By the late sixteenth and early seventeenth centuries, artists wanted to ally themselves with the liberal arts as a way of distancing themselves from the manual crafts. These prints would have had great appeal, therefore, not only to humanists but also to the artists themselves.

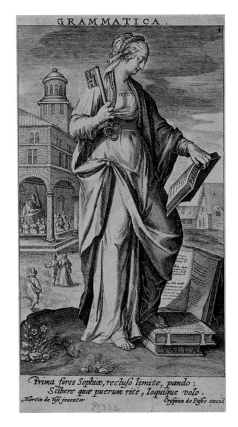

1. Christiaan Schuckman, "Marten de Vos," in Dictionary of Art 1996, 32:708.
2. Riggs 1993, 110.
3. Ilya M. Veldman, "Crispijn (van) de Passe (i)," in Dictionary of Art 1996, 24:235.
4. Compare Silver 1993, 12.
5. Stuttgart 1997, 63.
6. Silver 1993, 10.
7. Riggs 1993, 109.
8. Floris's drawings were engraved by Cornelis Cort (1533–1578) and published by Hieronymus Cock (1510–1570) in 1565.
9. Goltzius's drawings of the Seven Liberal Arts, which derived from the iconography and *mise-en-scène* of Floris's depictions, were engraved and published by Cornelis Drebbel (1572–1634). For the series by Floris and Goltzius, see Stuttgart 1997.
10. Only the inscriptions and conception as a series connect them to allegorical representations; see Stuttgart 1997, 70.
11. Ripa 1971, no. 184.
12. Ripa 1971, no. 191.
13. One of the books is inscribed VALLA, alluding to Lorenzo Valla (1407–1457), the Italian humanist, philosopher, and literary critic. The book Grammar holds, on which the letters PRISC can be deciphered, must, according to Walter Melion in correspondence of 28 May 1999, refer to Priscian (Priscianus), a famous sixth-century grammarian and author of the eighteen-volume *Institutiones Grammaticae*.

40.

Antonio Tempesta
Florence 1555–Rome 1630

*Jason Bewitching
the Dragon,* 1606

Etching
4 ¾ x 4 inches (12 x 10 cm)
Print Room, Royal Library Albert 1,
Brussels, inv. S. 1 32493
Inscription: Draconem velleris
excubitorem sopit Iason (Jason puts
to sleep the dragon, guardian of the
fleece)

41.

Antonio Tempesta
Florence 1555–Rome 1630

*The Race Between
Atalanta and
Hippomenes,* 1606

Etching
4 ¾ x 4 inches (12 x 10 cm)
Print Room, Royal Library Albert 1,
Brussels, inv. S. 1 32513
Inscription: Atalantam Veneris
ope vicit Hippomenes (Hippomenes
conquered Atalanta with the aid
of Venus)

42.

Antonio Tempesta
Florence 1555–Rome 1630

*Narcissus Adoring
His Own Image,* 1606

Etching
4 3/4 x 4 inches (12 x 10 cm)
Print Room, Royal Library Albert 1,
Brussels, inv. S. 1 32474
Inscription: Amore sui inardescens
Narcissus in florem transmutatur
(Narcissus, burning with love of him-
self, is transformed into a flower)

Between 1589 and 1627, Antonio Tempesta made over one thousand prints, which were widely circulated in Europe during his lifetime.[1] Many were conceived as series, among them the 150 etchings illustrating Ovid's *Metamorphoses* that were published in book form by Pieter de Jode (1570–1634) in Antwerp in 1606.[2] It is hard to overestimate how important these images became; the most famous and influential of the Ovidian iconologies, Tempesta's prints provided a standard repertoire of mythological pictorial narrative.[3]

The images are freely interpreted variants of woodcuts by Bernard Salomon (ca. 1508–1561), which were published in Lyon in 1557. Tempesta's prints are larger and the renditions of Ovid's stories more dramatic than in Salomon's woodcuts. Tempesta concentrated on Salomon's figures rather than on their environment and reduced the number of participants to the minimum required to tell the story.[4] The narratives were thereby easier to read, and the heightened sense of drama appealed greatly to both viewers and artists at the time.

The inscriptions identify the specific story from Ovid but do not always correspond to the exact moment depicted.[5] For example, although Narcissus is shown admiring himself in a pool of water, he has not yet been transformed into a flower.

Although there is little known about Pieter de Jode's printmaking activity, he traveled to Rome around 1595[6] and may well have become acquainted with Tempesta there. It appears that de Jode continued to collaborate with Tempesta after he returned to Antwerp.[7] Tempesta sold many of his not-yet-published plates to publishers active in Antwerp, perhaps because they paid better than their Italian counterparts.[8]

62. *Draconem velleris excubitorem sopit Iason.*

1. C. Höper, "Tempesta," in Dictionary of Art 1996, 30:428.
2. Amsterdam 1980, 12. The second state of the frontispiece carries the name of the Amsterdam-based publisher Wilhelmus Janssonius, which might account for the confusion in some of the literature about the place of publication (see, for example, Boston 1989, 217 n.6, which gives the place of publication as Amsterdam). Thanks to Eckhard Leuschner who, in correspondence of 29 May 1999, confirmed Antwerp as the initial place of publication of Tempesta's book.
3. Tempesta 1976.
4. Amsterdam 1980, 12, 36. Ironically, the figures were greatly reduced and the environment enlarged again when Tempesta's prints were used as models for the painted cabinet later in the century (*cat. 62*).
5. Amsterdam 1980, 36.
6. Christine van Mulders, "Pieter de Jode (i)," in Dictionary of Art 1996, 17:598.
7. Leuschner in correspondence, 29 May 1999. Pieter de Jode was admitted to the Antwerp Guild of St. Luke "as a master's son" in 1599–1600; see Christine van Mulders, "Pieter de Jode (i)," in Dictionary of Art 1996, 17:598.
8. According to Leuschner in correspondence of 29 May and 1 June 1999, Tempesta's *Deeds of Alexander the Great* was published in Antwerp in 1608 by Johannes Baptista Vrients. Furthermore, Tempesta made thirty-six etchings based on drawings by Otto van Veen of *The War of the Romans Against the Batavians*, which was published in Antwerp in 1612.

97. *Atalantam Veneris ope vincit Hippomenes.*

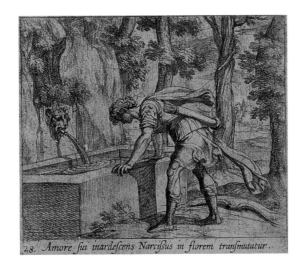

28. *Amore sui inardescens Narcissus in florem transmutatur.*

43.

THEODOOR VAN THULDEN
s'Hertogenbosch 1606–
s'Hertogenbosch 1669

after PETER PAUL RUBENS
Siegen, Westphalia 1577–
Antwerp 1640

Rear Face of the
Arch of Philip, from
*Pompa Introitus
Honori Serenissimi
Principis Ferdinandi*,

ca. 1635
Etching
14 ⅜ x 21 ⅞ inches (36.5 x 55.5 cm)
Print Room, Royal Library Albert I,
Brussels, inv. S. II 57194

Theodoor van Thulden was part of the team of artists who worked under Rubens's direction on the decorations for the Triumphal Entry of Ferdinand into Antwerp in 1635. He was subsequently commissioned by the city of Antwerp to produce a book of prints commemorating the event. Rubens made oil sketches for the designs of the individual elements of decoration,[1] which were then redrawn by another hand to be used by van Thulden for the etchings. The book, delayed for several years until the commentary by Jan Caspar Gevaerts was ready, was finally published in 1643 by Jan van Meurs, a former partner in the esteemed Plantin printing house, for whom Rubens had also designed a printer's trademark.[2]

This etching preserves the appearance of the rear face of the Arch of Philip, the largest and most splendid of the arches in the decorative ensemble. Dedicated to Ferdinand's brother King Philip IV of Spain, the arch most likely filled the entire street.[3] The rear face, or north facade, looked onto the wide avenue called the Meir. The central field of the arch's tympanum represents the historic marriage in 1496 of Philip the Fair, son of Maximilian I of Hapsburg and Mary of Burgundy, to Joanna the Mad, daughter of Ferdinand II of Aragon and Isabella I of Castile. This union joined the Austrian monarchy to the kingdoms of Spain. To either side of the marriage scene is a triton seated on a dolphin (compare *cats. 49* and 50). Their function, according to Gevaerts, was to "promulgate this most splendid marriage with their shell-trumpets." The lower story of the triumphal arch shows Ferdinand and Isabella flanking Archdukes Albert and Isabella on the gallery over the arch. Archduke Ernest, the predecessor of Albert and Isabella as governor of the Netherlands, appears at the lower right, and the Cardinal-Infante Ferdinand himself is at the lower left.

On top of the pediment is the personification of the Austrian Monarchy. She sits in majesty surrounded by the circle of the zodiac, representing the eternity of her power. Above her head is Hesperus, the brightest of the stars and emblem of the Spanish empire. The figure of the Austrian Monarchy is offered a globe, symbol of the terrestrial world of her rule, into which she inserts the cross-scepter of Christianity.

The Apollo-like figure on her right is Sol Oriens, the rising sun. He holds the sun's face in one hand and the banner of Portugal, leader in trade with and exploration of the Far East, in the other. Below him is India Orientalis holding a cornucopia filled with spices and pearls associated with the riches of the East. To the proper left of the Austrian Monarchy is Luna, displaying the crescent moon and the banner of Castile. Below her is India Occidentalis, personifying the West Indies. She empties gold coins from her cornucopia, symbolizing the enormous wealth acquired by Spain through the conquest of Peru. Together the Sun and the Moon signify the vast extent and eternal power of the Austrian Monarchy. The inscription on her pedestal, taken from the passage in the *Aeneid* in which Jupiter foretells the glory of the Roman race, reads: "HIS EGO NEC METAS RERUM, NEC TEMPORA PONO: IMPERIVM SINE FINE DEDI" ("For these I set no boundary nor periods of time: I have granted them empire without end.")[4]

1. The oil sketch for the *Rear Face of the Arch of Philip* is in the Rubenshuis, Antwerp.
2. See Gerson and ter Kuile 1960, 84; Boston 1993, 361; and compare *cat. 46*.
3. The arch measured over 68 x 36 x 18 feet (21 x 11 x 5.74 m).
4. The information in this entry is mostly based on Martin 1972, 87–89.

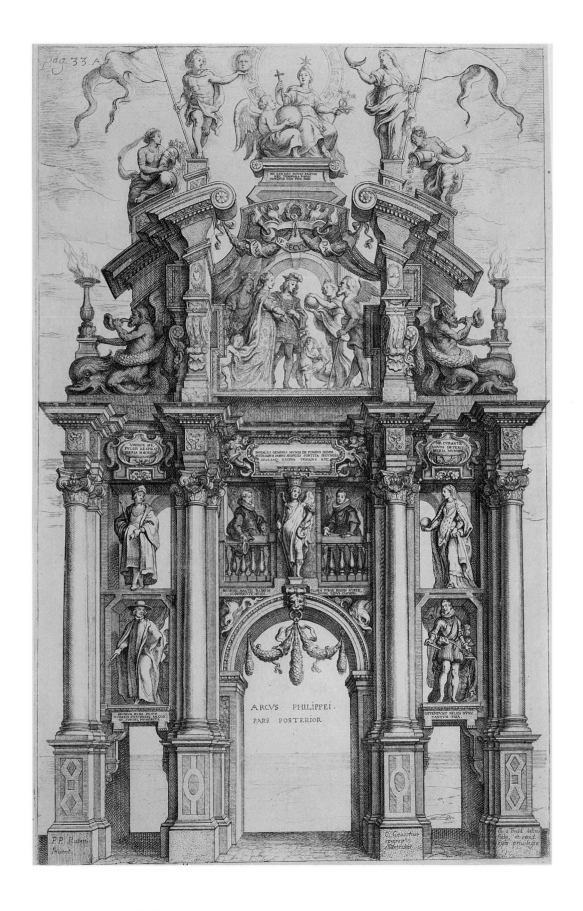

44.

ABRAHAM ORTELIUS
Antwerp 1527–Antwerp 1598

Theatrum Orbis Terrarum, 1574
Antwerp, printed by ANTONIUS
COPPENS VAN DIEST (died 1574)
17 x 12 inches (43.2 x 30.5 cm)
Mildred and Paul Seydel Belgian
Collection, Robert W. Woodruff
Library Special Collections,
Emory University

First published in 1570, Abraham Ortelius's collection of maps was the earliest attempt to assemble contemporary knowledge of the entire world in maps of uniform style and format. Ortelius was among the most important sixteenth-century geographers but was not, strictly speaking, a scientific cartographer. Rather, he was a compiler of the best cartographic work of his time. Printed maps of almost the whole of Europe existed by the sixteenth century, but they were extremely large and expensive and were often hung on walls as decoration. Ortelius carefully selected the best examples and had copper plates made of the maps so that they could all be printed in the same size. The maps were probably engraved by Frans Hogenberg (ca. 1540–ca. 1590). Ortelius called this first systematically compiled atlas *Theatrum Orbis Terrarum*, or theater of the world.

As was the usual practice, the text of the volume was printed before the illustrations. Gillis Coppens van Diest was the printer of the texts until 1572; his son, Antonius Coppens van Diest, took over until he died in 1574. The text of the 1575 edition was printed by Gillis van den Rade.

In the first edition, which included fifty-three double pages with maps, Ortelius solicited new and better maps from his readers. This appeal resulted in an increase to seventy maps in the editions of 1573, 1574, and 1575. Not surprisingly, as the number of maps in the volume increased, so did the price.[1] Ortelius's atlas was intended not only for the wealthy but also for the educated, who would have been able to read the Latin text.[2] Despite these factors, the *Theatrum* enjoyed great success, and new editions followed one another rapidly.

In the front of the volume, Ortelius acknowledged the individual mapmakers whose work appears in the atlas. This list, called the *Catalogus auctorum*, included eighty-seven names in the first edition of 1570. By 1574, 103 names are given. Similarly, in each successive edition of the atlas, Ortelius augmented the text with new information as it became available to him.[3]

Ortelius's atlas reflects the range and breadth of discoveries being made in the Age of Exploration. For example, the map of the "New World" reflects its accurate position with respect to Europe, and the East coast is for the most part correctly depicted. The West coast, on the other hand, is not yet completely understood. In inland North America, only the area around the St. Lawrence River appears to be known, thanks to Jacques Cartier's explorations of 1534, 1535, and 1541–42.

1. According to Koeman 1964, 38, people who wished to own the book, despite its high price, paid in installments.

2. As early as 1571, editions of the atlas appeared in Dutch, German, and French. These vernacular editions are written in a less formal style and contain more information of popular interest. They do not include the short bibliographies that appear after the Latin text for each map, nor do they include the *Catalogus auctorum* in the front or the list of historical place names in the back of the Latin editions. See Antwerp 1998, 34.

3. The above information is taken from Imhof 1998 and Antwerp 1998, in which Ortelius and the various editions of his atlas are discussed in detail.

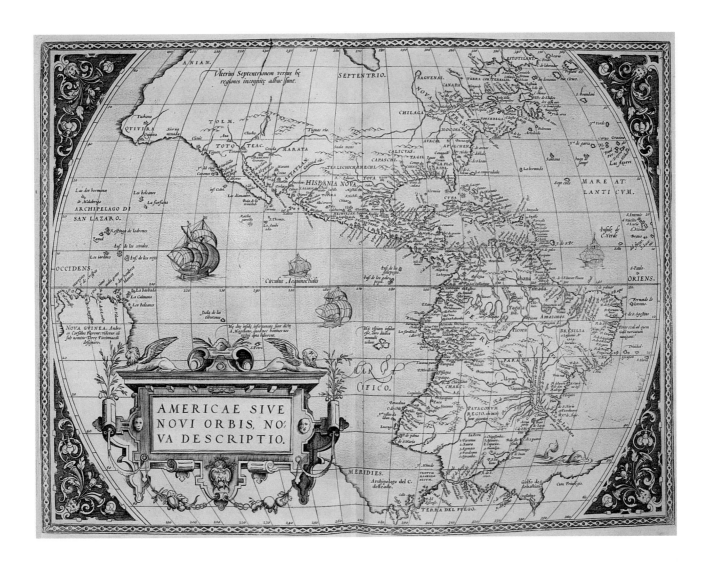

45.

JOANNES BOCHIUS
Brussels 1555–Antwerp 1609

Historica Narratio Profectionis et Inaugurationis Serenissimorum Belgii Principum Alberti et Isabellae Austriae Archiducum…,
1602
Antwerp, printed by EX OFFICINA PLANTINIANA, JAN MORETUS I (1543–1610)
16 ½ x 10 ¾ inches (41.9 x 27.3 cm)
Mildred and Paul Seydel Belgian Collection, Robert W. Woodruff Library Special Collections, Emory University

This Latin text, dedicated to Albert and Isabella, describes a series of events in the lives of the archdukes between 1595 and 1602. It traces Albert's appointment as governor of the Southern Netherlands and his acceptance of rule, his trips to Italy and Spain, and his marriage to Isabella. Most detailed is the description of fifteen of their Joyous Entries into the most important cities of the Southern Netherlands at the end of 1599 and the beginning of 1600.[1] Aside from engraved title pages that divide the book into four parts, the description of the Joyous Entry into Antwerp is the only section of the book that is illustrated. Twenty-eight etchings, most likely by the Antwerp printmaker Pieter van der Borcht (1545–1608) after paintings by Joos de Momper, record the appearance of the festival architecture erected in the city, the ceremonial processions of the archdukes (they entered Antwerp on 8 December 1599), and the special events planned.[2] The size of the volume confirms that the arrival of the archdukes was regarded as an event of great political and symbolic importance.[3]

The humanist Joannes Bochius, secretary of Antwerp, was asked by the city to compile a commemorative book of the occasion. Jan Moretus I, official printer of the city and owner of Ex Officina Plantiniana, the largest printing-publishing house in the Southern Netherlands, produced the volume with subsidies from Antwerp. A limited edition of 775 copies was printed. The small edition size, the Latin text, and the sumptuousness of this true gem of typographical craftsmanship[4] indicate that the volume was produced for an elite segment of the population. Given its preciousness, it is surprising that Albert and Isabella did not own a copy.[5]

1. For a detailed account of the events described in the book, see Brussels 1998, 51–52, cat. 49 and Thøfner 1998.
2. De Momper was paid by the city of Antwerp "for twenty-seven paintings…for the book of the entries of Their Highnesses." See Antwerp 1998, 106, cat. 17a. Etchings were not as regularly employed for such work as engravings because a significantly smaller number of good impressions could be taken before the plate became worn. Nevertheless, the famous printer-publisher Christophe Plantin (1520–1589) and his successor, his son-in-law Jan Moretus I, sometimes used etchings for the illustration of works, presumably because of their close relationship with van der Borcht. See Sellink 1996, 35.
3. Brussels 1998, 51, cat. 49.
4. de Nave 1996, 19.
5. The book does not appear in the inventories of the archdukes' libraries; see Brussels 1998, 52, cat. 49.

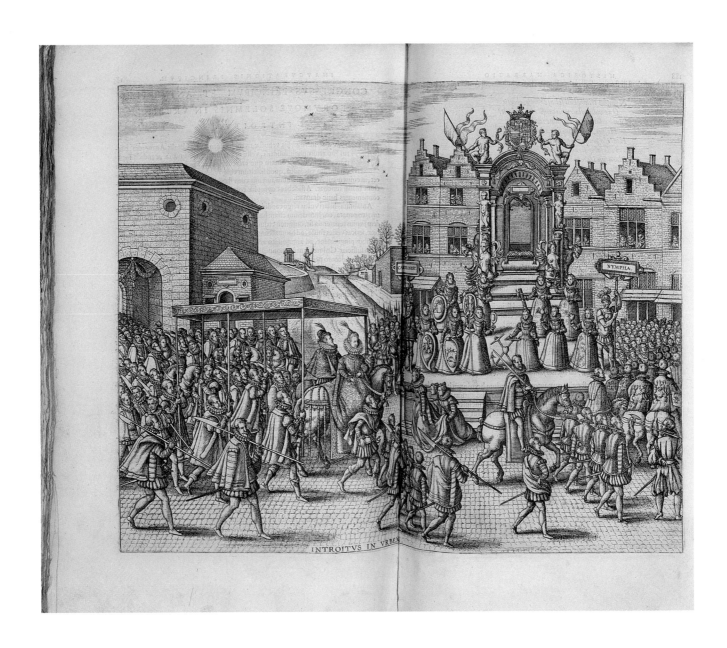

INTROITVS IN VRBEM

46.

Officium Beatae Mariae Virginis, 1622

Antwerp, printed by Ex Officina Plantiniana, Balthasar Moretus I (1574–1641), Maria de Sweert (1588–1655), and Jan van Meurs (1583–1652)
7 x 9 ¼ inches (17.8 x 24.1 cm)
Mildred and Paul Seydel Belgian Collection, Robert W. Woodruff Library Special Collections, Emory University

1. de Nave 1996, 15.
2. Bowen 1996, 43.
3. Duerloo 1998, 271. A Book of Hours is a popular prayerbook for laymen. The title of the book, *Officium beatae Mariae virginis…. Nunc mandato serenissimorum Belgij principum hac augustiori forma excusum* (Office of the Blessed Virgin Mary….Executed now by the order of our exalted Belgian sovereigns in this majestic form), underlines the archdukes' intent to commission an exceptional volume.
4. Antwerp 1996, 98, cat. 11b.
5. The selling price was fifteen guilders a volume. The coats of arms of Albert and Isabella appear on the title page. See Antwerp 1996, 98–99, cat. 11b.
6. I am grateful to Karen Bowen and Dirk Imhof, who explained the vetting process to me.
7. Antwerp 1996, 99, cat. 11b.
8. Antwerp 1996, 99, cat. 11b.
9. Such images are most common in Spanish Books of Hours from around 1400; see Antwerp 1996, 99, cat. 11b.
10. In Latin in Aubertus Miraeus, *De vita Alberti pii, sapientis Belgarvm principis commentarivs*, Antwerp, 1622, as quoted and translated in Antwerp 1996, 100, cat. 11b.

Ex Officina Plantiniana, the most important printing-publishing house in the Southern Netherlands, was known for the production of luxury books in which the design of the volume was at least as important as the content.[1] Their liturgical publications were routinely illustrated with a greater number of prints than the books of their potential competitors.[2] It is therefore not surprising that Archdukes Albert and Isabella commissioned Jan Moretus I of that establishment to produce a sumptuous Book of Hours "in commemoration of their marriage and as a means of dedicating their reign to the Virgin Mary."[3] The composition and printing of the text took place from July 1600 to February 1601, and the engraving and printing of the illustrations lasted from September 1600 until July 1601.[4] Albert paid 750 guilders in advance, for which he received fifty copies of the completed volume.[5]

Both the format of the volume and the letter type used are unusually large for a Book of Hours. There are also many more prints than one would expect to find in such a publication. The number and choice of illustrations for liturgical books were normally governed by tradition. Books of Hours almost always contained seventeen or eighteen illustrations. This exceptional volume features forty-one full-page engravings and twenty-five decorative tail pieces. Some of the engravings were based on old compositions; others were created specifically for this commission. The illustrations were submitted for approval to Albert's secretary, Blasius Heuterus, who required the artists to make changes based on his interpretation of decorum and orthodox readings of the texts.[6]

The success of the first edition of the *Officium* led to a new printing of another *quarto* Book of Hours in 1609, with even more illustrations and a special dedication to Albert and Isabella.[7] A new edition of this finely tuned version, of which this is an example, was published in 1622, attesting to its popularity.

This book, like the others in the exhibition (*cats. 44* and *45*), anticipated a wealthy buying public. To keep costs down, most liturgical editions from this period would have had a certain portion of the copies illustrated with woodcuts. By contrast, the *Officium* was illustrated only with engravings.[8] However, the engraving plates were reworked and re-used until they showed signs of wear, so the freshness of the impressions in a single volume varies.

Furthermore, this Book of Hours was meant to appeal specifically to the Spanish court and those either affiliated with or aspiring to it. On the page facing the *Commendatio ad Virginem Mariam*, an engraving shows the Virgin and Child seated on a bank of clouds and surrounded by angels. They are adored by bishops and royalty with their retinues, all dressed in contemporary garb.[9] At right among them, Albert and Isabella are depicted next to the King of Spain.

According to Aubert le Mire, a scholar, humanist, and Antwerp cleric, "Every day before he went to bed, [Albert] read the *Officium* of the Virgin with great care, which he, with this goal in mind, had printed with large letters at the Plantin Press, together with the seven penitential psalms and the litanies."[10]

COMMENDATIO AD VIRGINEM MARIAM.

 Dómina mea sancta María, me in tuam benedíctam fidem, ac singulàrem custódiam, & in sinum misericórdiæ tuæ, hódie, & quotídie, & in hora éxitus mei, & ánimam meam & corpus meum tibi comméndo, omnem spem meam & consolatiónem meam, omnes angústias & misérias meas, vitam & finem vitæ meæ tibi commítto; vt per tuam sanctíssimam intercessiónem, & per tua mérita, ómnia mea dirigántur & dispónántur ópera, secúndùm tuam tuíque filij voluntátem. Amen.

Alia Oratio ad Virginem.

O Marìa Dei génitrix & virgo gratiósa, ómnium desolatórum ad te clamánrium consolátrix vera, per illud magnum gáudium, quo consolàta es, quando cognouísti Dóminum Iesum die tértia à mórtuis impassíbilem resurrexísse, sis consolátrix ánimæ meæ: & apud eúmdem tuum &

F f Dei

47.

FRANÇOIS DUQUESNOY
Brussels 1597–Livorno 1643
and ALESSANDRO ALGARDI
Bologna 1598–Rome 1654

Flagellation of Christ,
ca. 1635–45
Gilt bronze, marble, ebony, stones
23 ⅛ x 17 ¹¹⁄₁₆ inches (58.8 x 45 cm)
Royal Museums of Art and History,
Brussels, inv. 8507

Admiration for the art of ancient Rome led to the revival of a taste for bronze statuettes. By the mid-sixteenth century, such works were being made with a precision equal to that of the best Roman examples. By the end of the century, these bronzes were often meticulously polished and finished.[1]

In the seventeenth and eighteenth centuries, this type of work functioned as a private devotional piece.[2] Given that thirty replicas and variants of this particular group are extant, it seems clear that this image was an extremely popular model of the type.[3]

The sculptural group is a collaborative effort between François Duquesnoy (compare *cat. 3*), whose practice of copying classical and modern works in Roman collections profoundly influenced his classicizing approach to the human figure, and Alessandro Algardi, who would later become Bernini's chief rival in Rome.[4] The work consists of three separate figures: Christ, tied to a Corinthian column and standing on a socle, is flanked by two tormentors. The invention of the group (derived from a print by Willem Danielsz. van Tetrode [born ca. 1505–1510]) and the figure of Christ have been attributed to Algardi, and Duquesnoy was apparently responsible for the pair of flagellators. Their graceful poses are designed as demonstrations of balance and twisting movement. Their musculature is very detailed, with each element clearly articulated. By contrast, the modeling of the broad chest and shoulders of Christ reveals the fluid, less analytical treatment of anatomy typical of Algardi's sculpture of the later 1630s.[5]

1. Penny 1993, 244. Duquesnoy was known as a slow and meticulous worker who paid great attention to the finish of his sculptures; see Lydie Hadermann-Misguich, "François Du Quesnoy," (sic) in Dictionary of Art 1996, 9:411. According to Penny 1993, 247–52, the assumption that it was the sculptors themselves who were responsible for the casting and finishing of their models can be erroneous; these roles were often assumed by the goldsmith-founders.
2. Berlin 1995, 486, cat. 175.
3. Some of the pieces are silver and some, such as this example, are bronze.
4. After Duquesnoy's death, Algardi's work came to represent the classicizing stylistic antithesis to the High Baroque sculpture of Bernini; see Rudolf Preimsberger, "Alessandro Algardi," in Dictionary of Art 1996, 1:625.
5. Montagu 1985, 315–16.

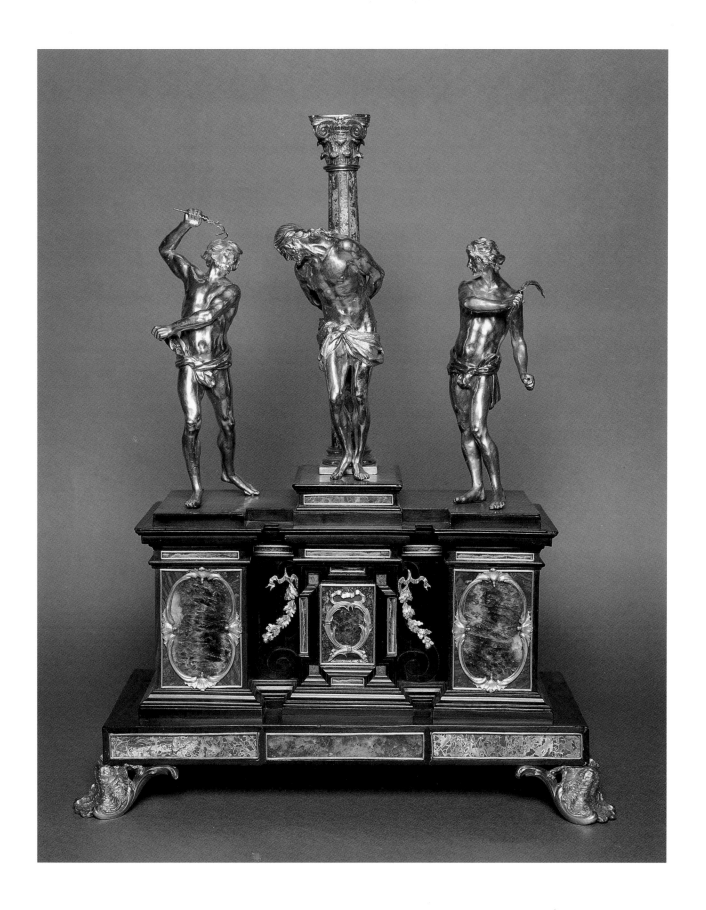

48.

ARTUS QUELLINUS THE ELDER
Antwerp ca. 1609–Antwerp 1668
Apollo with the Dragon,
ca. 1650
Terracotta
24 ⁷⁄₁₆ x 13 ⅜ inches (62 x 34 cm)
King Baudouin Foundation, Brussels

The painter, theorist, and artists' biographer Joachim von Sandrart reported that Artus Quellinus, after studying with his sculptor father, went to Rome to perfect his craft under François Duquesnoy (compare *cat. 47*). While there, he also carefully studied classical art.[1] He was back in Antwerp by 1639, where he worked for more than a decade. In 1650, Quellinus was called to Amsterdam to direct the extensive and programmatic sculptural decoration of the new Town Hall, designed by Jacob van Campen. The city of Amsterdam provided him with a workshop; with the help of assistants, he worked on this commission for fourteen years.

This terracotta is related to the decoration of the *Burgerzaal*, or Citizens' Hall. This vast room, modeled on the public halls of Roman antiquity, was intended to represent a miniature universe in which the prosperous and powerful city of Amsterdam played a central role. Marble reliefs of figures of the planets occupy the ends of the galleries opening out of the hall. Seen from the ground, these figures give the impression of sculpture in the round. They are positioned by doors or stairs that formerly led to departments of the city government.[2]

Apollo, god of the sun, is one of four celestial bodies in the south gallery. He is depicted by Quellinus as a muscled youth, standing in *contrapposto* with Python, the serpent of darkness, at his feet and his lyre at his side. He holds his bow and reaches behind him into his quiver for an arrow. As a "maker of harmony," it is fitting that Apollo was guardian of the adjoining Chamber of Petty Affairs, "where minor squabbles were settled by arbitration."[3]

This work has been called a reduction of the marble relief, a studio replica copied from the original sketch, and the original from which Quellinus and his studio worked.[4] The most significant change between the terracotta and the marble relief, and an argument against the first proposal, is that in the final relief the figure of Apollo looks out rather than down.

1. Vlieghe 1998, 243. Although it is unclear when Quellinus left for Italy, he was reported in Rome in 1636.
2. Amsterdam 1977, 39.
3. Amsterdam 1977, 41.
4. Brussels 1977a, 145.

49–50.

LUCAS FAYDHERBE
Mechelen 1617–Mechelen 1697

Tritons and Dolphins,
ca. 1640
Terracotta
25 x 24 ³⁄₁₆ inches (63.5 x 61.5 cm)
Royal Museums of Art and History,
Brussels, inv. R.2 and R.3

The three stylistic periods of Lucas Faydherbe's career as a sculptor are represented in this exhibition. These playful tritons and dolphins exemplify his early work, produced under the influence of Rubens. After training with his father and stepfather, both of whom were sculptors, Faydherbe moved to Antwerp around 1636–37 and entered Rubens's studio, where he stayed for over three years. Letters by Rubens document how warmly the teacher admired his pupil and his work.[1]

The terracottas depict chubby, childlike tritons with full round cheeks, dimpled hands, and big bellies. The figures are reminiscent of the children in the reliefs for which Duquesnoy was famous (compare *cat. 47*)[2] as well as the putti that populate numerous paintings by Rubens. The energetic posturing of the tritons recalls the Baroque theatricality of Rubens's work. Their ponderousness and monumentality are typical of Faydherbe's early style. He worked the surfaces quickly and assuredly, with broad, expressive modeling that evinces his artistic promise.

Triton was the son of the sea god Poseidon and his wife, Amphitrite. In depictions of him, Triton eventually lost his individuality and became generalized as a human boy or man with the tail of a fish. His attribute is a twisted seashell, which he blows to calm the water or raise the waves. Tritons blowing into conch shells were common iconographic motifs for fountains.[3] Although it is not known why these terracottas were made, they may have been preparatory models for an undocumented fountain project.

1. For the three letters by Rubens that allude to Faydherbe's training and tasks in Rubens's studio and the value Rubens placed on Faydherbe's artistry, see Vlieghe 1997, 24. Faydherbe apparently executed a number of ivory carvings for Rubens. As Vlieghe 1997, 25 points out, a sculptor training in Rubens's studio is not as strange as it first appears. Rubens thought of the arts of painting and sculpture as interconnected and, more than most painters, conceived of his art in plastic terms. Furthermore, he designed the architectural settings for his altarpieces much as he developed the allegorical borders on his tapestries, thinking in terms of the totality of the commission and the integrated form of the product.
2. Duquesnoy would directly influence Faydherbe in his design for the tomb monument for Andreas Cruesen (compare *cat. 51*).
3. Brussels 1977a, 102, cat. 66. See, for example, Bernini's Triton Fountain in the Piazza Barberini, Rome.

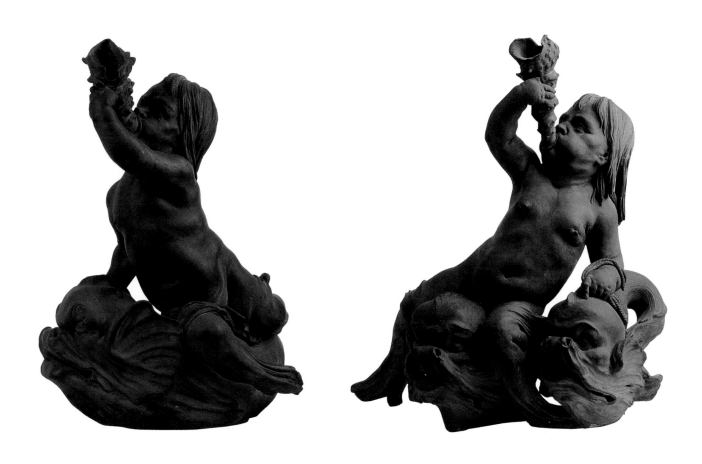

51.
LUCAS FAYDHERBE
Mechelen 1617–Mechelen 1697
Archbishop Cruesen,
ca. 1659–62
Terracotta
H: 13 ¾ inches (35 cm)
King Baudouin Foundation, Brussels

1. van Riet and Kockelbergh 1997, 40. Jérôme Duquesnoy was François Duquesnoy's younger brother. They worked together in Rome, and after François's death, Jérôme brought the contents of his brother's studio back to Brussels. François's models and drawings served Jérôme as points of reference for the rest of his life. See Lydie Hadermann-Misguich, "Jérôme Duquesnoy II," in Dictionary of Art 1996, 9:412. According to eighteenth-century tradition, François conceived the Triest monument while in Rome; see van Riet and Kockelbergh 1997, 40.
2. Vlieghe 1998, 242.
3. For example, TEMPVS MISERENDI EIVS QVIA VENIT TEMPVS PS. CI ([Thou wilt arise and have pity on Zion;] it is the time to favor her; the appointed time has come; Psalm 101) appears under the figure of Time, and EGO SVM RESVRRECTIO ET VITA IO. XI (I am the Resurrection and the Life; John 11) appears under the figure of Christ.
4. This entry is based on Mechelen 1997, 164–66, cats. 40–41.

This terracotta, dating from Lucas Faydherbe's mature period, is a preparatory study for one of his largest and most important works, the white marble tomb monument for Andreas Cruesen in the choir of the Cathedral of St. Rombaut in Mechelen (compare *cat. 18*). Although Cruesen, fifth archbishop of Mechelen, did not die until 1666, he became sick and commissioned his monument as early as 1659. Faydherbe worked on it for three years.

The design of the monument is based on one of 1654 by Jérôme Duquesnoy (1602–1654) for Bishop Antoine Triest in St. Bavo's Cathedral, Ghent.[1] Based in turn on Italian models, the figure of the deceased bishop is "the most important part of a more grandly staged allegorical scheme. The tripartite arrangement of this monument determined the direction of the future evolution of episcopal tombs in the Southern Netherlands."[2]

For his figural grouping, Faydherbe placed Archbishop Cruesen with his back to the winged figure of Time and facing the powerful figure of the Risen Christ. Metaphorically, the archbishop occupies a realm between the transience of earthly life and the hope of resurrection. These concepts are underlined by the carved inscriptions that accompany each figure on the monument.[3] Descendants of Faydherbe's tritons (*cats. 49* and *50*) appear as cherubs.

The terracotta study differs from the final marble figure of the archbishop in several respects. In the monument, the mitre rests on the ground before him rather than on his head. He holds his left hand to his breast rather than his right hand, which in the finished work supports the heavy folds of his mantle. Although the figure's left hand is missing in the terracotta, it was clearly originally outstretched, perhaps in a gesture of supplication toward Christ. Lacking, too, are the many details captured in the marble, including the elaborate border of Cruesen's garment and the refined and realistic features of his face.[4] The terracotta, then, was Faydherbe's first, raw sketch, a way of working out his conception for the figure of the archbishop and exploring the emotions he wanted to express in the context of the monument.

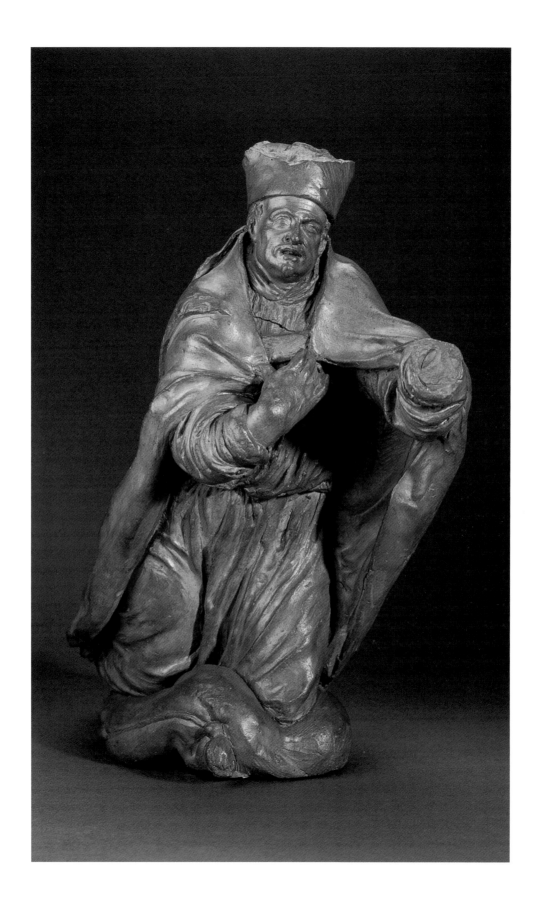

52.

LUCAS FAYDHERBE
Mechelen 1617–Mechelen 1697

Hercules, ca. 1675–80

Terracotta
H: 16 ⅛ inches (41 cm)
King Baudouin Foundation, Brussels

Lucas Faydherbe's late style is represented by this terracotta bust of Hercules.[1] The Baroque nature of the image, evident in the turn of the head and shoulders and the dramatic arrangement of the lion head and skin, is somewhat counteracted by the heightened realism and attention to detail in the face. His expression suggests an inner life. The artist's skill in modeling is evident in the curly locks of hair and the liveliness of the drapery pulled across Hercules's chest. Faydherbe here achieves a nuanced expression through his handling of the material.

There are several other, larger terracotta busts of Hercules by Faydherbe, each paired with a bust of Omphale.[2] These busts differ from one another only in the smallest details. The original function of the terracottas is unknown, although it seems they were made to be seen from below. In each, Hercules looks to the left toward Omphale, who looks to the right.

Hercules, son of Zeus, was famed for his superhuman strength. According to Greek legend, Hercules was sold in slavery for three years to Omphale, Queen of Lydia, as punishment for his murder of Iphitos, son of King Eurytos of Thessaly. While at the Lydian court, he performed many feats of courage and fell in love with Omphale, who forced him to do women's chores and wear women's clothes as signs of his subservience.

The first bust of Hercules by Faydherbe, perhaps commissioned for a collector or civic institution, might have been widely known, leading to other requests for similar works. The present bust might have served as a preparatory model, at least for the busts now in Mechelen and Duffel, or for presentation to a prospective client. Alternately, perhaps a patron asked for a copy of the terracotta maquette so that he had in hand the image he had agreed upon with the artist.[3]

1. According to Mechelen 1997, 187, cat. 59, the late date that had originally been determined on stylistic grounds has been confirmed through thermoluminescence tests.
2. Terracotta busts of Hercules are in the Museum Hof van Busleyden, Mechelen (1675–80; 78.5 cm. high), the Victoria and Albert Museum, London (ca. 1640–50; 87 cm. high), and a private collection in Duffel near Mechelen (after 1680; 77.5 cm. high). See Mechelen 1997, 60 and 67, cat. 21.
3. van Riet and Kockelbergh 1997, 55.

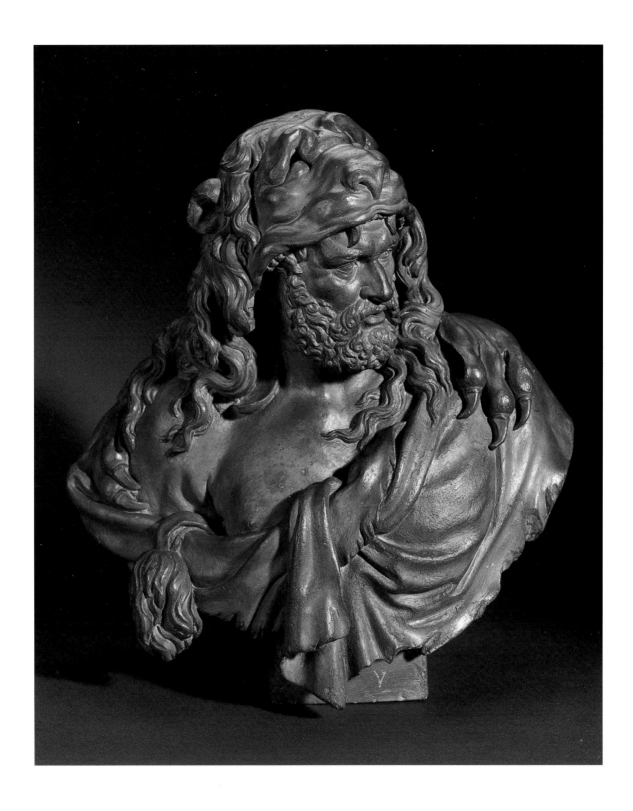

53.
Virgin with Child, 1629
Dinant
Brass
H: 9 7/16 inches (24 cm)
Royal Museums of Art and History,
Brussels, inv. v 2362
Inscription: on the base,
S. MERE DES ORPHELINS 1629

The inscription on the base of this hieratic brass figural group, Holy Mother of the Orphans, conjures up images of the Madonna of the Misericordia, who harbors members of a group—usually a religious order, confraternity, guild, or family—under her all-encompassing mantle. The intercession of the Mother of God was considered by the faithful to be the most efficacious of all.[1] However, the iconography of this image has nothing to do with the protective Virgin. Rather, it clearly belongs to that of the Immaculate Conception. The Virgin, depicted frontally with a crown on her head and a scepter in her right hand, holds the Christ Child in her left. At her feet are a crescent moon[2] and an anthropomorphic serpent, both symbols of the Immaculate Conception.

The Immaculate Conception refers to the conception of Mary in the womb of her mother, St. Anne. According to Catholic tradition, since the Virgin was chosen to be the vessel of Christ's Incarnation, she, too, had to have been conceived "without concupiscence."[3] Mary's triumph over Satan, in the guise of a serpent, represents her triumph over Original Sin. The Christ Child provided the means of her preservation from sin. According to Pius v, pope from 1566 to 1572, "The Holy Virgin crushed the head of the serpent thanks to the child that was born to her."[4] For the proponents of the Counter Reformation, the serpent trampled by the victorious Virgin was the image of heresy overcome by the Church triumphant.[5] The Virgin Immaculate thus represented the purity of Catholic belief.[6]

The inexpensive material chosen for this depiction of the Virgin and Child, its size, and its somewhat worn appearance indicate that it was at one time a common and beloved domestic devotional object.

1. Réau 1957, 2:111.
2. According to Ostrow 1996, 225, "the moon's supposed purity, its unblemished nature, corresponded to Mary as being both immaculate and a virgin."
3. Hall 1974, 326.
4. de Bruyn 1985, 291.
5. Knipping 1974, 2:245.
6. Duerloo 1998, 278.

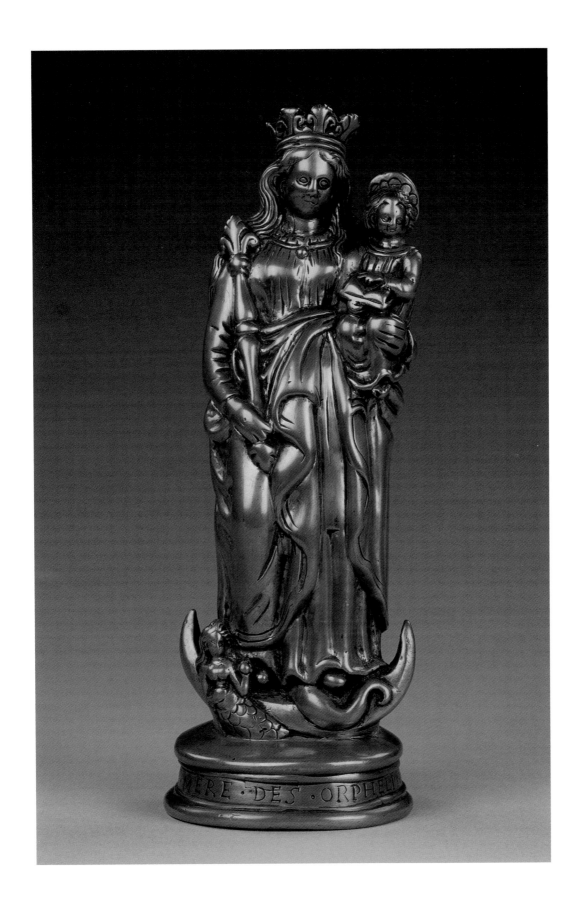

54.
Virgin and Child,

ca. 1640–60
Antwerp or Mechelen
Boxwood
H: 11 15/16 inches (30.3 cm)
Royal Museums of Art and History,
Brussels, inv. 6546

This engaging and tender sculpture of the Virgin and Child is much less iconic and hieratic than the comparable image in brass (*cat. 53*). Depictions of Mary and the infant Jesus were important in bringing the Virgin into the hearts of the faithful.[1] Statuettes such as this, that were not products of the great innovative workshops, were objects of private devotion.[2]

In representations of this subject, the standing Virgin does not often look at the child in her arms and is rarely shown engaged in play.[3] Here, however, the realistically active baby in his mother's embrace reaches out for her chin as she smiles down at him. The emphasis is on grace and sensibility. Similar statuettes are in the Museum Mayer van den Bergh in Antwerp and the Abbey of Heiligenkreuz in Austria.[4]

Boxwood, repellent to the woodworm beetle, has an exceptionally fine grain that makes it suitable for working in great detail.[5] This piece shows a simplicity and harmony of execution that accords well with its subject.[6]

1. Réau 1957, 2:99.
2. Brussels 1977a, 300.
3. Réau 1957, 2:99.
4. Brussels 1977a, 300.
5. Penny 1993, 146.
6. Brussels 1977a, 300.

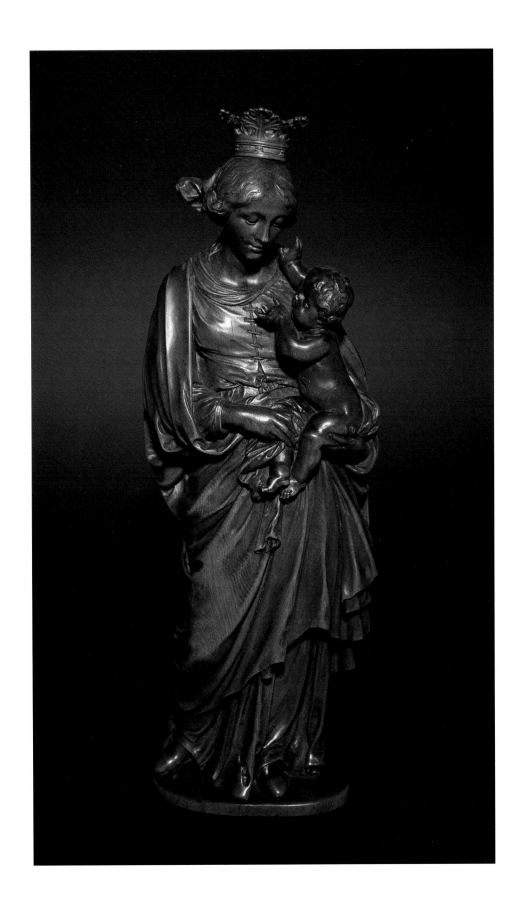

55.

JOANNES CARDON
Antwerp 1614–possibly Antwerp 1656

Seated Virgin, 1643

Terracotta
H: 16 ¹⁵/₁₆ inches (43 cm)
King Baudouin Foundation, Brussels
Inscription: Joannes Cardon fecit 1643

This work is one of two terracotta statuettes signed and dated by Joannes Cardon. The identity of the artist, however, is problematic, as there is another sculptor called Jan Cardon who was born in Douai in 1605 or 1612 and was also active in Antwerp.[1]

Unlike the other two small sculptures of the Virgin and Child in this exhibition (*cats.* 53 and 54), Mary is shown here seated, nursing the Christ Child.[2] This intimate view of motherhood and the elegance and sophistication of the figure of the Virgin contrast both to the majestic image in brass and the playful one in boxwood. Realistic touches, such as the child's right hand clinging to his mother's bodice and the Virgin's right hand cradling the child's back, heighten the tenderness of the depiction. Mary's graceful pose and voluminous, swirling drapery, typical of the High Baroque, are successfully captured in terracotta, a medium most conducive to recording fleeting expressions and details.[3] Because of the careful treatment of the drapery, this was probably not a preparatory work but was a work of art in its own right.

1. Helena Bussers, "Joannes Cardon," in Dictionary of Art 1996, 5:733.
2. According to Réau 1957, 2:99, there are far fewer images of the Virgin nursing than standing with the child in her arms.
3. Penny 1993, 209.

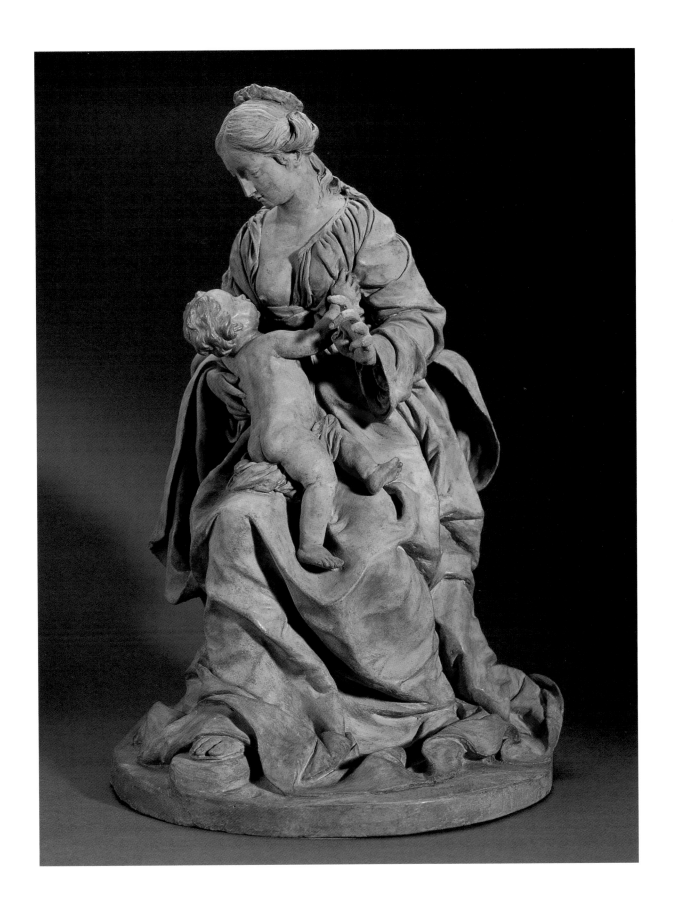

56.

Jacob Jordaens
Antwerp 1593–Antwerp 1678

Lute Player and Woman on a Balcony,

ca. 1635
Brussels, woven by
Conrad van der Bruggen
Wool and silk
147 ¼ x 126 inches (374 x 320 cm)
Royal Museums of Art and History,
Brussels, inv. 6300

1. d'Hulst 1982, 142.
2. The other option for a tapestry series was to illustrate a succession of scenes designed to give a comprehensive view of a particular activity; see d'Hulst 1982, 296.
3. According to d'Hulst 1982, 299, these genre images are more than mere representations of country pursuits; there are also secondary meanings—not equally prominent among the scenes—that had moral implications.
4. Haarlem 1986, 145. Compare the similar meaning of these elements in *cat. 9*.
5. The form of the architectural border is the same for each tapestry in the series, although the decoration of it differs from piece to piece.
6. The city mark of Brussels is its coat of arms flanked by two "B"'s standing for Brabant and Brussels. Marking was made compulsory in Brussels from May 1528 to discourage fraud. See Delmarcel and Volckaert 1995, 15–16.
7. See Brussels 1994b, 61. The poses of the figures are somewhat different, and the parrot appears above the figures' heads in the drawing (as in Jordaens's famous *Portrait of a Couple* in the National Gallery, London) rather than on the balustrade as in the tapestry. The draped carpet does not figure in the drawing. For further information on the tapestry series, see Nelson 1986, 214–28.
8. Brussels 1977b, 28, cat. 4.

The period between about 1628 and 1641 was enormously productive for Jacob Jordaens. It is not clear exactly when he began to execute tapestry designs, although they are so numerous in his oeuvre that he must be regarded as one of the chief practitioners of this art at the time.[1] All the tapestries executed to his designs formed part of sets or ensembles. In *Scenes of Life in the Country*, of which this is the fourth of eight subjects, various aspects of rustic life are illustrated.[2] This scene of an elegantly clad couple in plumed hats is an image of the ideal marital state.[3] The making of music traditionally stands for marital or familial harmony. The presence of the dog symbolizes fidelity ("Fido"). The parrot appears in several paintings of couples by Rubens and Jordaens and had come to represent marital purity.[4] The tapestry's illusionistic border functions both as a frame for the scene and as its architectural enclosure.[5]

Many of Jordaens's tapestries were woven in Brussels. This one bears the Brussels city mark[6] and the weaver's mark of Conrad van der Bruggen, who worked as a master tapestry maker there beginning in 1622.

The middle section of a drawing in the British Museum by a collaborator of Jordaens's shows this composition and might have served as the model for the tapestry.[7] Replicas of the tapestry are in the Czech Republic (Castle Nachod), Venice (Palazzo Labia), Paris (the Embassy of Belgium), and Madrid (Palace Hotel). The whole series is at Hardwick Hall, Derbyshire, and in the Kunsthistorisches Museum, Vienna.[8] Because the different versions do not vary except in small details, it seems clear that they were either all executed after the same cartoon or after an exact copy of the original tapestry.

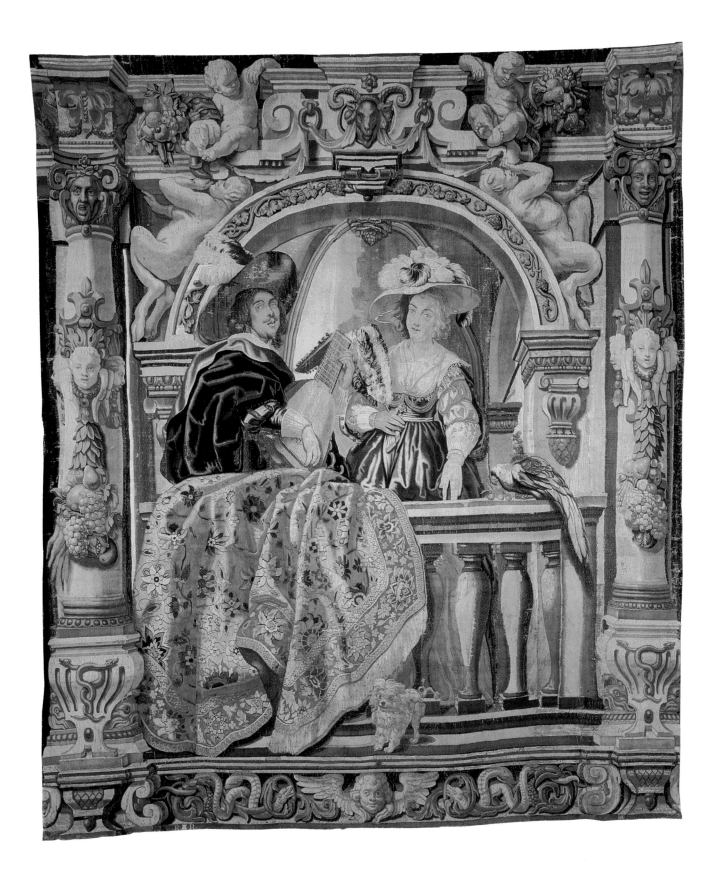

57.

Beeldenkast, ca. 1620

Walnut
75 ⁹⁄₁₆ x 57 ⅞ inches (191 x 147 cm)
Royal Museums of Art and History,
Brussels, inv. 424

This type of two-story, four-door cupboard is known as a *troonkast,* or throne cupboard. The fact that it is decorated with caryatids also makes it a *beeldenkast,* a modern Dutch appellation translated as "statue cupboard." The first term refers to its form, the second to its decoration. Probably a dowry item or wedding present, this highly ornate piece of furniture was likely used to store valuable household linen. In many homes these cupboards were perhaps the most important articles of furniture. Together with their contents they indicated the household's prosperity.[1]

The cabinetmaker was responsible for the construction of the piece, while a carver made the figures and scenes. The three figurines in the upper part supporting the cornice, from which the cupboard takes its name, symbolize the theological virtues. Hope (who originally probably held her attribute, the anchor) and Charity (nursing her infants) flank Faith in the center niche (holding a cross and book).[2] The carved scene at the left represents Christ and the Samaritan woman; to the right is Christ with Nicodemus. These panels correspond to doors.

The sculpted scenes, both from the Gospel of John (Christ and the Samaritan woman is told in John 4: 1–30, and the rarely represented scene of Christ with Nicodemus is from John 3: 1–21), deal with intimate conversations between representatives of heaven and earth. Each encounter tells of Jesus' self-revelation and the response of others to that revelation.[3] The reactions of the two—one from inside and one from outside Israel— contrast to one another. Whereas Nicodemus remains unenlightened through his encounter with Christ, the Samaritan woman eventually recognizes him as the Living God. The purpose of using this type of iconographic program on such a cupboard, however, is not clear.[4]

Between the upper and lower sections of the cupboard, running the full width of the piece, is a drawer with a convex profile. It is decorated with strapwork and lions in silhouette and is punctuated with projecting lion heads at either end and in the middle. The doors of the lower part are decorated with coats of arms.[5] Two female herms bracketing a male support the cornice below the drawer. Elaborate shell and vine motifs border the panels. The sides of the cupboard are decorated with a lion head and a female grotesque head framed in strapwork. As is common with *beeldenkasten,* the cupboard is lifted from the floor on bun feet.[6]

1. Amsterdam 1993b, 24, cat. 9.
2. The majority of *beeldenkasten* have only three statuettes; see Amsterdam 1993a, 416, cat. 73. These statuettes are frequently, as here, of the theological virtues; compare the statue cupboards in The Metropolitan Museum of Art (Amsterdam 1993a, cat. 73) and the Rijksmuseum (inv. N.M. 11448).
3. See Knipping 1974, 1:204, and Moloney 1998, 64.
4. The scenes usually depicted on such cupboards—Solomon and the Queen of Sheba, scenes from the life of Joseph, St. George slaying the dragon, Marcus Curtius sacrificing himself to save the people of Rome, depictions of Susanna—are generally images of virtue (compare the statue cupboards mentioned in n. 2 above). I am grateful to Danielle Grosheide for this observation.
5. Notes by Mme. G. Dervaux-van Ussel in the files of the Royal Museums of Art and History, Brussels, suggest that the coats of arms could belong to the Van Barneveld or Van Oldenbarneveld family or to the Bardet family.
6. Amsterdam 1993a, 416, cat. 73.

133

58.

Ribbank,

second half of 17th century
Walnut, ebonized wood, and oak
49 ⅝ x 67 ½ x 28 inches
(126 x 171.5 x 72 cm)
Royal Museums of Art and History,
Brussels, inv. V 78

This low cupboard or sideboard is known as a *ribbank.* It is not clear whether in its original form this particular piece had an upper section or not, although many did.[1] The single deep drawer at the top is decorated with rinceaux (featuring fruits, flowers, and birds) and playful figures of Pan and Syrinx. In the center is a lion head; two more lion heads with rings in their mouths grace the upper corners. The lion heads and metal mounts were standard decoration for this type of furniture.

The interior encloses a single shelf. On the exterior, the doors are decorated with moldings of ebonized wood forming intricate geometrical patterns. In the center of each door is another lion head with a brass ring that functioned as a pull. The same ebonized wood is used for the columns that adorn the corners and center of the low cupboard. Along the base are more rinceaux composed of scrolling tendrils; a bird that resembles a swan has replaced Pan and Syrinx here. Unlike this *ribbank,* which lacks feet, other examples feature ball or ball-and-claw feet.[2]

The *ribbank* would have held table and household linen, metal and wood service, silverware, and glassware. This type of cupboard would most often have been found in the salon or reception room of the house.[3]

1. Amsterdam 1993b, 14, cat. 4. If it had, it would have been a *troonkast (cat. 57).*
2. See Antwerp 1977, 43, cat. 103, and Brussels 1991, 467, cat. 233.
3. Compare, for example, the armoire described in Brussels 1991, 467, cat. 233.

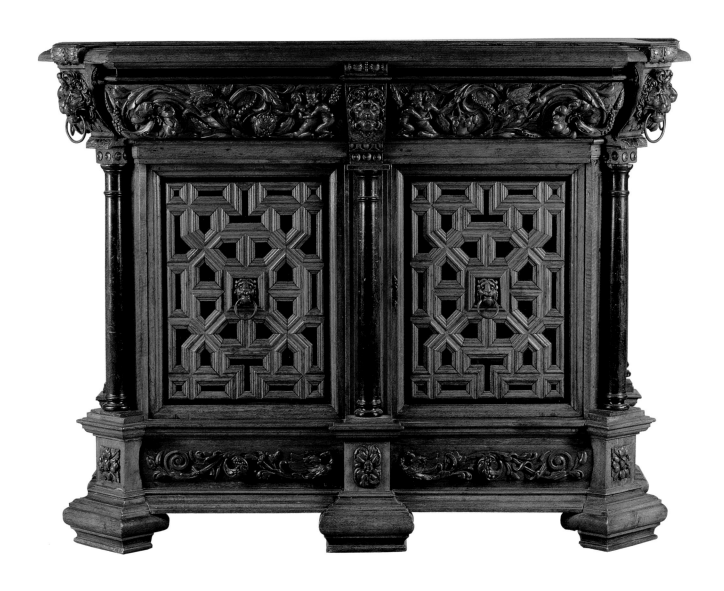

59.

Draw-leaf Table,

17th century
Oak
52 ¼ x 31 ⅞ x 32 ⁵⁄₁₆ inches
(134 x 81 x 82 cm)
Royal Museums of Art and History,
Brussels, inv. V 79

This type of table was called a *trektafel* in seventeenth-century sources. The extension leaves are under the table top. To extend the table to its full length, the leaf on either side would be pulled out and up. When open, the profile of the table has a gently tapering shape. To judge from paintings of interiors from this period, however, the tables were seldom open. They are usually shown in the closed position, covered with a table carpet generally of Turkish origin.[1]

The simple yet elegant table has a solid, straightforward aspect, its minimal decoration determined primarily by the harmony of the discrete forms. Each leg of the table is articulated by a baluster; an upright member above the baluster is echoed by a square form below. The legs, connected by a double Y-shaped stretcher, terminate in bulb feet. The small scrolled brackets bridging the top of the table and the legs are subtly decorated with contrasting wood strips.

1. Brussels 1996c, 71, cat. 61.

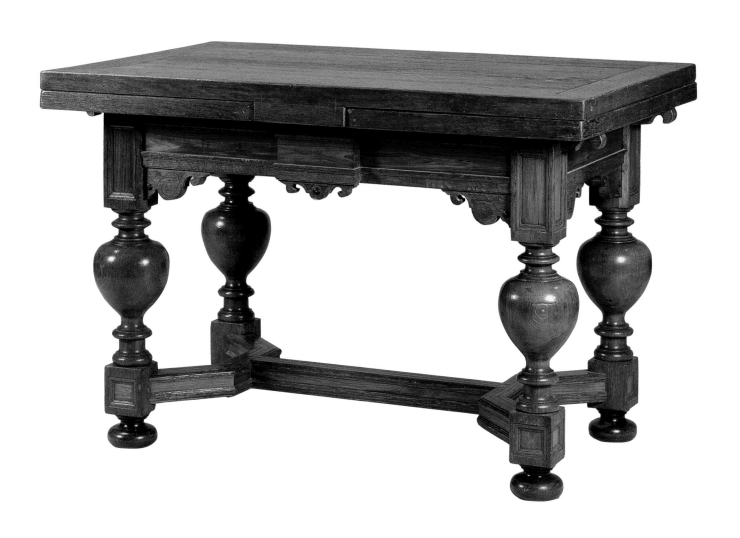

60.

Armchair, after 1640

Oak, Italian leather
35 ¹³⁄₁₆ x 24 x 18 ⅛ inches
(91 x 61 x 46 cm)
Royal Museums of Art and History,
Brussels, inv. VDP 746

61.

Side Chair,

second half of 17th century
Oak, leather
34 ¼ x 18 ⅛ x 16 ½ inches
(87 x 46 x 42 cm)
Royal Museums of Art and History,
Brussels, inv. V94A

The dominant type of seating in the Southern Netherlands, beginning in the early sixteenth century and coinciding with the period of Spanish rule, was the Spanish chair. Originally imported from the Iberian peninsula and eventually made in Flemish towns by "Spanish chair-makers," it was made of oak and had a seat and back upholstered in black, brown, or red leather. The arms of the chair were covered in the same material. As with the side chair exhibited here, the feet and legs were turned and worked in the form of vases, balusters, and blocks, then joined with four paired stretchers. After 1640, as with the armchair in this exhibition, the legs and stretchers were mainly spirally turned, the legs joined by H-shaped stretchers.[1] The copper nails that fasten the leather to the wooden frame bring luster to the furniture. Often the posts are decorated with lion or angel heads. The outside back of the chair was not covered, because the chairs generally stood against the wall when not in use.[2]

1. Ria Fabri, "Belgium: Furniture,"
 in Dictionary of Art 1996, 3:582.
2. Thornton 1978, 188.

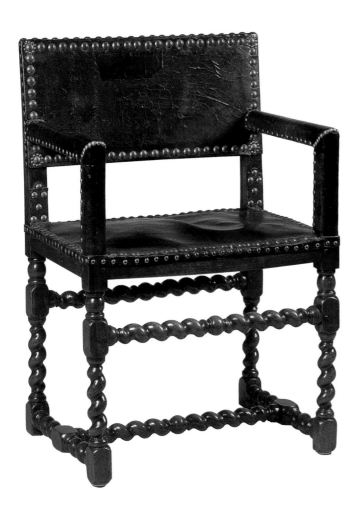
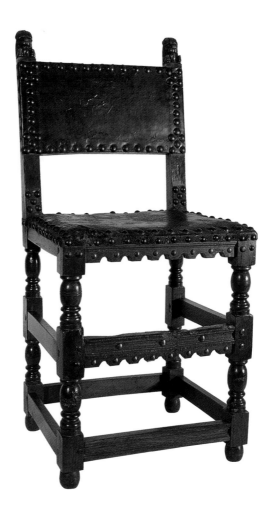

62.
Cabinet, mid-17th century
Antwerp
Ebony and oil on panel
63 ¼ x 38 ³⁄₁₆ inches (162 x 97 cm)
Royal Museums of Art and History,
Brussels, inv. 1904

1. Fabri 1993, 210.
2. Fabri 1993, 109. Cornelis is
 mentioned in sources as cabinet
 painter in the Forschondt work-
 shop.
3. The disposition of figures is similar
 to that in the painting of *Paris and
 Oenone* by Pieter Lastman in the
 High Museum of Art, Atlanta.
4. The identification of Tempesta as
 the source of the cabinet paintings
 and of the individual scenes repre-
 sented is in Derveaux-van Ussel
 1971–72, 99–123.
5. For van Mander's *Wtleggingh op den
 metamorphosis Pub. Ovidii Nasonis,*
 published as an appendix to *Het
 Schilderboeck* in Haarlem in 1604
 (as well as to the editions of 1618
 and 1662) and the moralizing
 interpretations contained therein,
 see Fabri 1993, 32ff.
6. Fabri 1991b, 52–54.
7. See p. 34 in this volume.

The production of collector's cabinets such as this one began around 1620 in Antwerp. The painters who worked on them usually borrowed compositions from other works of art, most frequently from prints. It was often a collaborative effort: in some cases, one artist painted the doors and the hinged top panel while a second one executed the small horizontal panels to be fixed on the drawers; in others, one artist painted the figures and another the landscapes.[1] Considering the style and prominence of the landscapes, the painter of the Brussels cabinet might have been either Cornelis Huysmans (1648–1727) or his brother and pupil, Jan-Baptist Huysmans (1654–1716).[2]

The subjects and compositions of the paintings are based on Antonio Tempesta's prints for Ovid's *Metamorphoses,* published in Antwerp in 1606 by Pieter de Jode (*cats. 40–42*). The figures in the prints are much more prominent than they are in the paintings; the cabinet painter has integrated tiny figures into extensive landscapes.

The representations follow neither the sequence of Ovid's text nor any other apparent order. On the left door is the scene of Mercury falling in love with Herse, and on the right is Diana's departure for the hunt. On the inside cover is the musical contest between Pan and Apollo. The small door in the center of the cabinet depicts a shepherd's idyll;[3] below it Ocyrhoe withholds the secrets of fate and is transformed into a mare. The left side of the cabinet, from top to bottom, depicts Cadmus slaying the dragon, Mercury lulling Argus to sleep, Atalanta and Meleager hunting the Calydonian boar, and Jason bewitching the dragon who guards the Golden Fleece. On the right side of the cabinet is the race between Atalanta and Hippomenes, Aurora and Cephalus, Narcissus enamored of his own reflection, and Pyramus and Thisbe.[4]

In the seventeenth century, the tales recounted in Ovid's *Metamorphoses* were given a moral gloss. These stories warned, for example, against corruption in the case of Atalanta and Hippomenes, or pride in the case of Jason. There were also lessons to be learned about love: the undesirability of blind love, as in the case of Procris; that children and parents should be in accord so as to avoid a tragic end like Thisbe's; that true faithfulness, as in the Aurora and Cephalus story, is rewarded. General moral principles, such as the practice of virtue or the triumph of reason, were also extolled.[5]

The subject of the *Metamorphoses* is known to have been requested in certain instances by those commissioning such cabinets, and sometimes desired scenes are even specifically described. It is not clear whether such images were chosen to indicate the literary leanings of the patron, whether the fantastic and often erotic character of the stories appealed to his sensibilities, or whether the moralizing exhortations were a motivating factor of this request. The landscapes were also most likely an important component.[6]

Behind the center door is a mirrored compartment, the so-called prospect or *perspectiefje.*[7] The floor of the chamber is covered in black and white tiles, and gilt arches springing from slender engaged columns frame the mirrored walls. The receding tiles and repeating arches enhance the perspective effect.

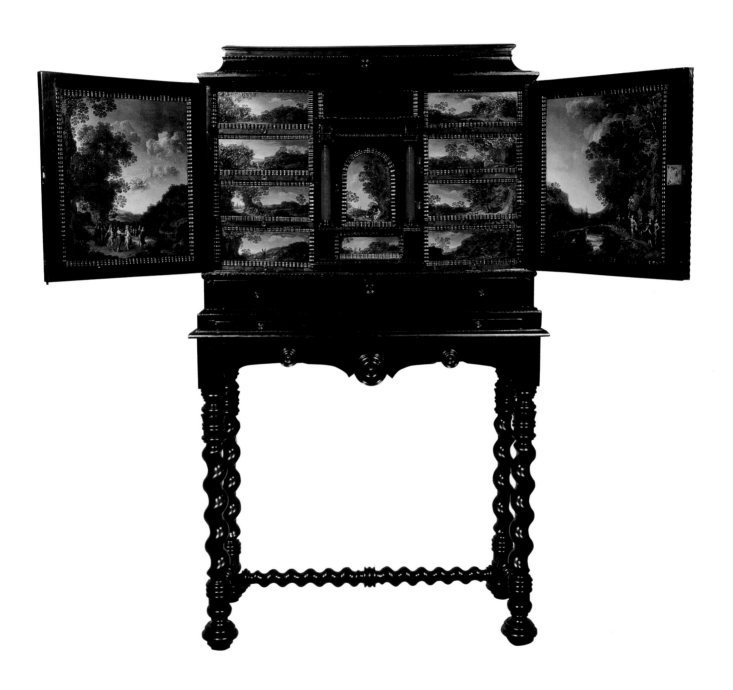

63.
Cabinet,

first half of 17th century
Antwerp
Ebony and ivory
21 ⅝ x 25 ⁹⁄₁₆ inches (55 x 65 cm)
Royal Museums of Art and History,
Brussels, inv. 3023

This ebony cabinet has inlaid ivory panels decorated with drawings in black ink.[1] The drawings of standing female figures that grace the doors are taken, if not traced,[2] from the series of prints of the Seven Liberal Arts engraved by Crispijn van de Passe around 1584 after drawings by Marten de Vos (*cats. 37–39*). When the cabinet is closed, Arithmetic on the left door faces Rhetoric on the right. When open, Grammar occupies the left door, Music is on the right, and Logic stands in the center. The grouping of these last three arts is unusual; normally the *trivium* of Grammar, Logic, and Arithmetic are placed together.[3] It seems that the artist was primarily concerned with their formal arrangement; the figures have been chosen so that they turn toward one another, both on the inside and the outside of the cabinet.

The artist made use of other print series for the decoration of the cabinet as well. The putti in the ivory border surrounding Music, for example, derive from prints attributed to H.J. Wierix (1549–after 1615) in the book *De rervm vsv et abvsv* by Bernardo Furmero (ca. 1540–1616), published in Antwerp in 1575 by Christopher Plantin. The fishing scenes that decorate the cabinet's drawers, depicting various types of fishing,[4] are taken from the book *Venationis, piscationis et avcvpi typii*, published in Antwerp in 1582, with prints by Philips Galle (1537–1612) after Hans Bol (1534–1593). The draftsman has imaginatively combined details from one or more prints for the scenes on each drawer.

This type of cabinet was produced in Antwerp for the luxury market. The prints used for the design are also of Antwerp origin. It is not clear whether the artist himself was responsible for choosing the illustrative material, whether the studio arranged for such sources or models, or whether it was the patron who determined the iconography.

When the central door of the interior of the cabinet is open, a cubic compartment is revealed. This chamber was originally probably a prospect lined with mirrors. Behind this small chamber, now empty, is a secret space consisting of drawers of various sizes and depths.[5]

1. The designs are not grooved. Given oxidation in some places, they were probably drawn first with silverpoint and then gone over with black ink; see Fabri 1982, 46.
2. The dimensions of the women in both print and drawing are the same; see Fabri 1982, 32.
3. Only five of the Seven Liberal Arts are represented on this cabinet; Geometry and Astronomy are missing.
4. For example, the cabinet shows deep sea fishing for mollusks, turbot fishing with nets, fishing for rays with lines, and carps trapped in flexible wickerwork; see Fabri 1982, 80.
5. The information in this entry is drawn almost entirely from Fabri 1982.

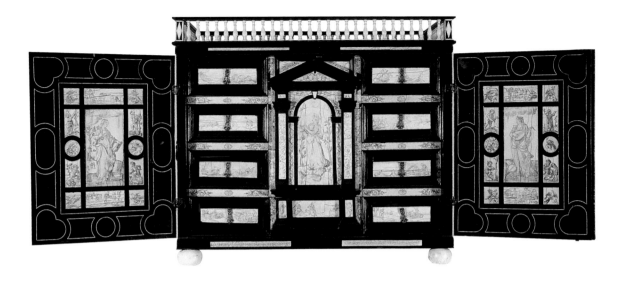

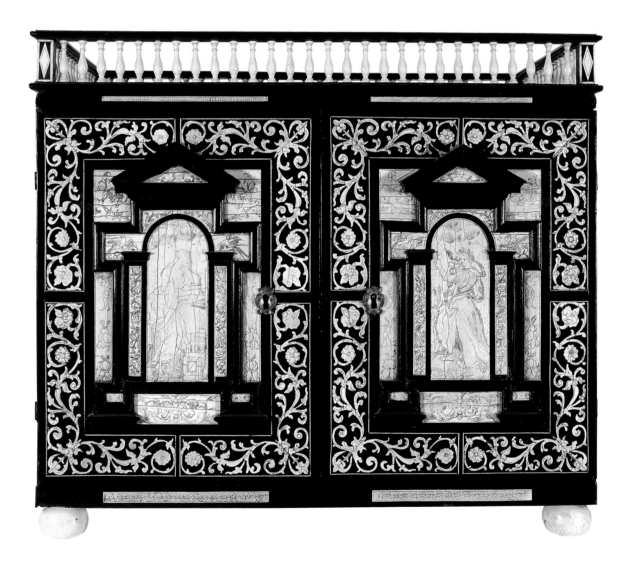

143

64.
Table Clock,
second half of 16th century
Copper
10 1/16 x 4 7/8 x 4 5/16 inches
(25.5 x 12.3 x 10.9 cm)
Royal Museums of Art and History,
Brussels, inv. G 1059

The earliest portable clocks still extant date from the beginning of the sixteenth century. With the invention of the mainspring, the weights that had made it necessary for clocks to remain stationary were no longer necessary. This innovation introduced the first "golden age" of mechanical horology, lasting from about 1550 to 1650 (until Christiaan Huygens's application of the pendulum to the clock). In addition to the wheelwork needed to measure time, a supplementary wheeltrain could be added for hour and half-hour chimes. Furthermore, additional indications—the date, the day of the week, the month, the phases of the moon—could also be incorporated into the mechanisms.[1] These portable clocks have been credited with precipitating a new consciousness of time, leading to more efficient ways of conducting business. For this reason, the mechanical clock has been called the key invention in Europe's evolution toward industrialization and modern technology.[2]

The form of table clocks varied, although they frequently assumed the shape of round, square, or hexagonal towers. Most often, they were made of gilt brass, sometimes with the addition of rock crystal. The case was often engraved with images inspired by contemporary prints. Secondary decoration—rinceaux of leaves and flowers, for example—would be derived from the ornamental vocabulary of the day. Because of the different talents required, the clock was a collaboration between the case decorator and the clockmaker.[3]

This clock, in the shape of a rectangular tower surmounted by a dome and made of gilt copper, shows the ingenuity and talent of both metalworker and clockmaker. The dome, which is capped by a Roman figure armed with a lance and a shield, contains the bell. The main dial of the clock has twelve Roman numerals and hands of steel; in the center is a little alarm dial. Above are small dials for the phases of the moon and days of the month; below, the dial adjusts for the number of days in a month.

The whole is engraved with ornamental motifs and figures, both inside and out. On the back, in a medallion surrounded by floral motifs of rinceaux and birds, is an image of Charlemagne crowned, holding a sword and accompanied by two church towers. On the front, flanking the lower dial, are the figures of Grammar and Arithmetic, above whom are music-making angels. Other female personifications of the Liberal Arts adorn the side panels. On the inside at left is the figure of Logic, and on the outside is Geometry; on the inside at right is Rhetoric, and on the outside is Music. These figures are accompanied by Latin texts that explain their significance. For example, the benefit of Music, shown here playing her viol, is that "the voice, to whom the flute and lyre lend their cooperation, caresses the spirit by a varying melody" ("Multiplici mentes modulanime mulcet cui proebent operam vox fistule tibia chordoe"). Geometry, placing a compass on a terrestrial globe, "determines the extent of the earth and its limits, distinguishes the plains from the mountains, and considers the course of rivers" ("Terrarum spatia et metas Geometria ponit distinguitque plagas montesque ac flumin, lustrat"). Brilliant Rhetoric, holding in her right hand the caduceus, "likes the

1. Ecouen 1989, 7–9.
2. For the effect of timekeeping on society, see Dohrn-van Rossum 1996 and Landes 1983. Thanks to Virginia Tuttle Clayton for these references.
3. Ecouen 1989, 11.
4. Berryer and Dresse de Lébioles 1974, 39.
5. Berryer and Dresse de Lébioles 1974, 39–40.

florid style and adds to words ornament and sharp colors" ("Rhetorica vario delectat splendida cultu. Ornatumque adhibet dictes vinosque colores").[4]

Such depictions of the Liberal Arts were popular for print series (compare *cats. 37–39*); these prints, in turn, provided the model for countless decorative projects (*cat. 63*). The engravings on the clock are signed with the monogram I⁴H, but the artist has not been identified. The style, the fashion of the hair and dress of the figures, and the interpretation of the subject have much in common with prints by Jost Amman (1539–1591) of around 1580.[5]

WORKSHOP OF
LEONART DUSART

Platter, ca. 1670

Dinant
Brass
Diameter: 31⅞ inches (81 cm)
Royal Museums of Art and History,
Brussels, inv. 1957
Inscription, on the molding near the
gadrooning: F/P. LEONART DVSART A
DINNANT

Despite continual recasting and melting down of metal objects, changes in taste, and the expansion of the production of ceramics and silver, there are still extant a number of brass platters and bottle coolers from sixteenth- and seventeenth-century Dinant.[1] The platter form, which left room for a choice in ornamentation, reflects the aesthetic preoccupations of the brass workers. The artisan would trace his subject on the form and then transfer his compositions into the metal by repoussé, chasing, and other techniques.[2] The embossed decoration of such platters, executed with large stamps, falls primarily into two principal categories: religious and allegorical subjects, and stylized decorative patterns.[3]

This platter depicting the Coronation of the Virgin clearly falls into the former category. In the four medallions are the evangelists with their symbols: St. John with an eagle; St. Luke with a bull; St. Matthew with an angel on a cloud; and St. Mark with a winged lion. Between the medallions on the broad rim are rinceaux—frieze configurations of vegetal garlands—that terminate in half-length female forms. The rinceaux at the top include a helmet and two coats of arms. The central medallion depicts the Virgin flanked by God the Father and Christ, holding a crown above her head. The dove of the Holy Spirit surmounts the crown. The Virgin is seated on a bank of clouds with a cherub to either side. The artist's signature appears on the molding near the gadrooning, the ornamental border around the platter's central scene.

The same artist's name appears on the bottle cooler in the exhibition (*cat. 66*). Because of the stylistic variety of the work attributed to Dusart, there might have been more than one brass worker by that name active in Dinant. Much of the repoussé work associated with his name shows the influence of Venetian examples, giving his production a hybrid character that is truly original. However, the artist did not merely imitate his Italian models. He interpreted them, adding his own ideas and elements reminiscent of the local tradition.[4]

1. Remacle 1992. See, too, p. 36–37 in this volume.
2. Collon-Gevaert 1951, 309.
3. "Dinanderie," in *Britannica Online* <http://www.eb.com:180/cgi-bin/g?DocF=micro/170/90.html> (4 January 1999).
4. Collon-Gevaert 1951, 310.

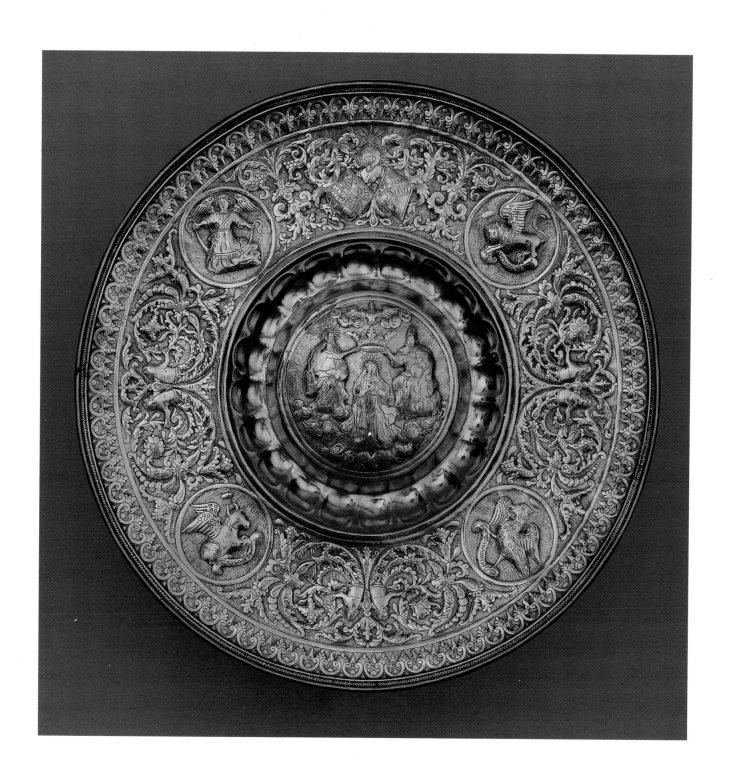

66.
WORKSHOP OF
LEONART DUSART

Bottle-Cooler, 1668

Dinant
Copper
24 7/16 x 11 13/16 inches (62 x 30 cm)
Royal Museums of Art and History,
Brussels, inv. 1092
Inscription: in the medallion,
A. DINANT/ PAR DVSART/1668

Bottle coolers, made of brass or more rarely of copper, were a standard feature in well-to-do Flemish households. They were used to keep flagons of wine and flasks of water cool and appear in many seventeenth-century paintings of interiors (*cats. 9 and 10*).

Bottle coolers resemble each other by their oval form, their iconographic repertoire of classical motifs, and the techniques employed in their ornamentation. This cooler is worked in repoussé, then chased and engraved. The feet and handles are cast, fitted, and chiselled. The decoration is separated into several registers. The center of the principal tier features a medallion bearing the artist's name and the place and date of execution.

The form of the artist's signature differs from that on the platter with the Coronation of the Virgin (*cat. 65*); this discrepancy might point to more than one hand being associated with Dusart's name in Dinant.[1] The Dusart responsible for the bottle cooler—with its pleasing proportions and spare and harmonious use of decorative motifs—was clearly an accomplished master. The ornamental ovulo border, swags (comparable to the painted festoon in *cat. 15*), stylized flowers, ball-and-claw feet, and winged female busts are motifs familiar from Renaissance art. Through his use of balance, symmetry, and rhythm of motifs, the artist of the bottle cooler incorporates into his craft the Renaissance ideal of harmony.[2]

1. For a further dscussion of this point, see *cat. 65*.
2. Remacle 1992.

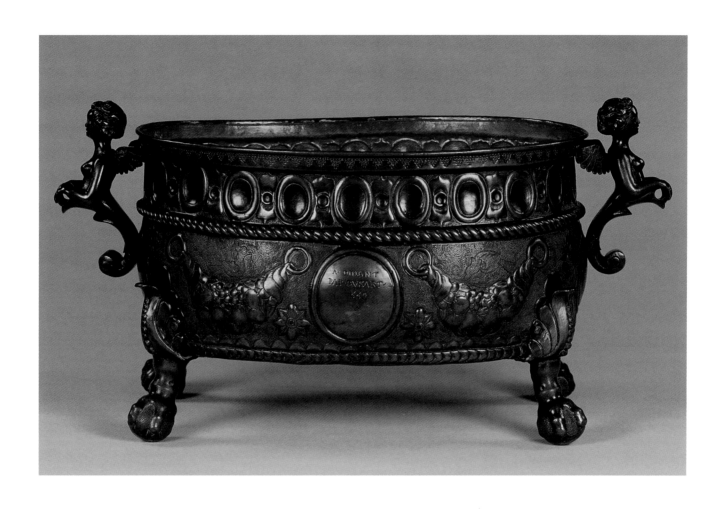

67.
Apothecary's or Surgeon's Chest,

mid-17th century
Ebony, oak, tin, gilt copper, red satin,
paint, glass, and paste
18 ⅛ x 14 ¹⁵⁄₁₆ x 11 ¹³⁄₁₆ inches
(46 x 38 x 30 cm)
Royal Museums of Art and History,
Brussels, inv. 5898

In the seventeenth century, the boundary between surgeon and apothecary was unclear. Apothecaries sold medicines that they had either prepared in their own laboratories or purchased from druggists; they dispensed prescriptions written by physicians or based on their own diagnoses; they gave medical advice and carried out minor surgical operations, such as drawing teeth, lancing boils, and bandaging wounds.[1]

It is not evident, therefore, whether this chest belonged to an apothecary or a surgeon. It is constructed like a small cabinet, with two doors and a lid that lifts up. The painting on the inside of the lid depicts the interior of a pharmacy, in which an apothecary stands behind a counter, working with his mortar and pestle. He is surrounded by a variety of drawers, bottles, and measuring devices necessary to his profession. On the tin plates surrounding the painting are engraved medicinal plants, such as the foxglove and the poppy.

Beneath the lid is a satin-lined compartment that holds a variety of copper containers, a mortar and pestle with an accompanying steel bowl and sieve, and numerous glass bottles, which were probably used for storing pharmaceuticals. Below this compartment is a series of drawers, which may have held the raw ingredients for the preparation of medicines. A wide partitioned drawer at the bottom of the chest holds various gilt copper instruments, including scalpels, spatulas, spoons, and a syringe.

Such a chest was most likely used by a surgeon or apothecary on journeys or house calls. With all his necessities at his disposal, the practitioner could immediately administer a preparation to the patient after making a diagnosis.[2]

1. Burnby 1983, 53.
2. This entry is based on Antwerp 1993a, 346, cat. 192. The chest might have belonged to a man named Nicholas; two discs with a picture of St. Nicholas and the inscription s. NICOL/DEOLENT/ are found in another drawer, along with a drop-counter, sand-sprinkler, and hook. St. Nicholas of Tolentino was patron saint of Antwerp; see Murray and Murray 1996, 352.

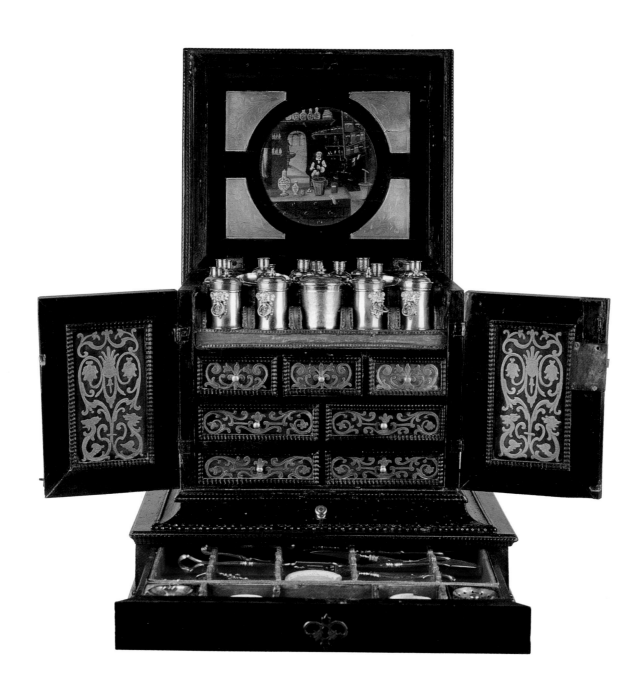

68.

Apothecary Jar, ca. 1600

Antwerp
Ceramic, majolica
H: 9 ¹⁄₁₆ inches (23 cm)
Royal Museums of Art and History,
Brussels, inv. CR 420
Inscription: on a label in reserve,
S.DE.CICHORIOC/ RABAR

From the inscription on the vessel, it is clear that this apothecary jar
was made to hold chicory syrup with rhubarb.[1] In ancient times, the juice
from the chicory plant was mixed with rose oil and vinegar as a remedy for
headaches. Chicory root has been used as a tonic for the liver and stomach;
an infusion of the leaves and flowers is said to aid digestion. The plant has
also been claimed to help rheumatic conditions, gout, and constipation.[2]
It seems likely that rhubarb was eventually added to the mixture to counter-
act the bitterness of the chicory; it was also used to alleviate constipation.

This apothecary jar has the usual form—bulbous body on a foot with
a spout and handle—for pots that held liquid preparations or syrups.[3] The
ornamentation is typical for late-sixteenth-century apothecary jars: *a-foglie*
decoration[4] was often combined, as here, with gadroons (below the lip and
on the foot) and strapwork (framing the cartouche). The soft blue color
against a white ground, rather than a deeper blue in Dutch examples, is
characteristic of Antwerp pieces.[5]

1. Chicorée 1972, 20–21; see, too,
 Drey 1978, 195.
2. Chevallier 1996, 187.
3. Chicorée 1972, 21.
4. A-*foglie*, leafy in Italian, refers to
 the stylized leaves on slender stems
 derived from Venetian models.
5. Korf 1981, 161–62.

69.
Apothecary Bottle,

ca. 1600
Antwerp
Ceramic, majolica
H: 10 ¹¹⁄₁₆ inches (27.1 cm)
Royal Museums of Art and History,
Brussels, inv. CR 421
Inscription: on a label in reserve,
A.PETORSELINI

This apothecary bottle held parsley water,[1] long used as a diuretic and digestive tonic. It was also used to treat gout, rheumatism, and arthritis, as it was thought to encourage the flushing out of waste products from inflamed joints, and the waste's subsequent elimination by the kidneys. The plant was also valued as a promoter of menstruation, helpful both in stimulating a delayed period and in relieving menstrual pain.[2]

The form of the bottle is associated with distilled aromatic waters.[3] Like the apothecary jar (*cat.* 68), it is decorated in typical fashion both as an apothecary vessel and as a product of Antwerp.

1. Drey 1978, 182 and 222.
2. Chevallier 1996, 244.
3. Wittop Koning 1991, 14.

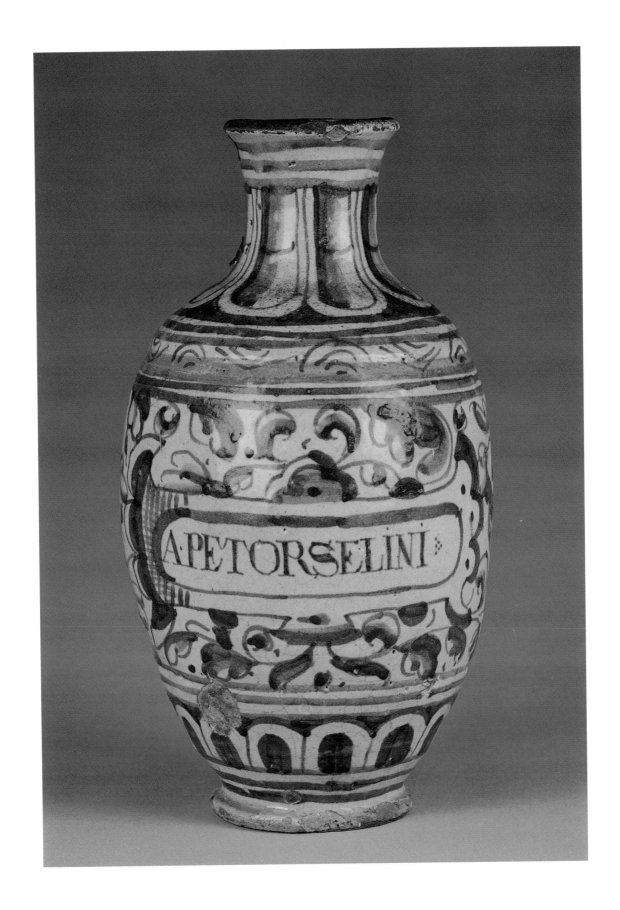

70.

Jug, early 17th century
Raeren
Stoneware
H: 8 1/16 inches (20.5 cm)
Royal Museums of Art and History,
Brussels, inv. 1465

This bulbous jug is made of dark gray stoneware, the surface a dark brown wash under a salt glaze. It has a partially cordoned, cylindrical neck decorated with a frieze of grotesques and medallions and a strap handle. The body has three large applied oval medallions, two of which are decorated with lions and include the date 1600 and the initials "WE." The third contains a shield bearing a merchant's mark (including a stoneware jug and goblet) and the initials "WE." The motto ESPOIR ME CONFORT 1599 (hope comforts me 1599) encircles the rim of this medallion. While the dates on the molds used to make these decorative reliefs provide an earliest possible date for the jug, molds were typically used for many years, so the dates are not reliable indicators of the actual year of production (compare *cat. 71*).

The monogram is that of the Raeren potter and stoneware dealer Winand Emonts. Emonts came from a family of potters, including his brothers, Emont and Gilles; his second wife was Margarete Mennicken, daughter of Balduin Mennicken, another distinguished Raeren potter.[1]

The lid, with its decorative lion head, is attached to the jug with a single-pin hinge. A stamp on the underside of the silver cover indicates that it dates from the nineteenth century, despite the inset gold carolus from 1553.

Such a jug was too large to drink from and too small for transport; it was most likely a pouring vessel, used at table as decanting ware.

1. See Hellebrandt 1977, 53 and 59.

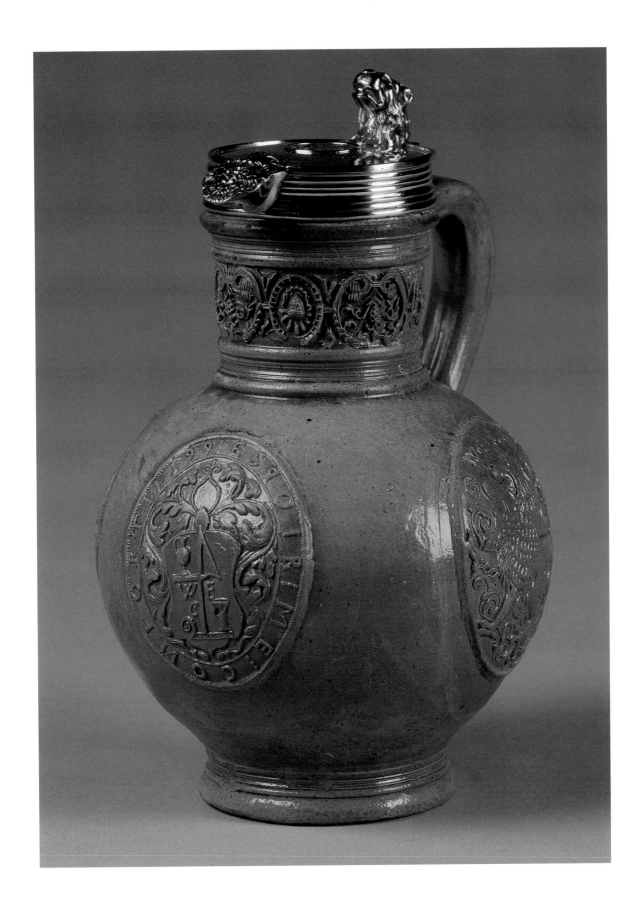

71.

Jug, ca. 1600

Raeren
Stoneware
H: 12 inches (30.5 cm)
Royal Museums of Art and History,
Brussels, inv. 778

Around the middle of the sixteenth century, the stoneware industry of Raeren, led by various members of the Mennicken family (see *cat. 70*), entered a golden age that lasted well into the seventeenth century. It was characterized by the production of a new range of forms, among them the barrel-shaped jug with a cylindrical neck and body designed to take rectangular strips or friezes of ornament in relief.[1] The shape of the vessel was developed by Jan Emens Mennicken around 1568. The form continued to be used for some time although the decoration varied.[2]

In this example, the neck of the brown-slipped jug is decorated with medallions alternating with the imperial double eagle. The shoulder has vertical gadrooning with stamped decoration in the interstices. The vertical gadrooning reappears in the lower part. The frieze on the body includes an oval medallion of a pelican nourishing its young supported by two griffins.[3] On one side of this central motif are the Ducal arms of Brunswick, and on the other, the Electoral arms of Saxony, German Protestant antagonists of the Hapsburg imperial line. It can be inferred, then, that the jug was made for a Protestant market or that the potter had Protestant sympathies.[4]

The frieze carries the date 1599 and is inscribed with an admonition to the young drinker: JVNGER. GESEL. HALT. DICH. WERM. // VERFVL. NIT. DEINEN. DRIM // BIST. DEN. FRVWEN. NIT. ZV. HVLT. // SO STET. DU. WVL // (Young man, keep your distance, do not give way to your fantasies; do not be too fond of the ladies, and you will be all right).

This same decoration appears on a jug in the Wallace Collection, London,[5] one in the British Museum,[6] and one in the Rijksmuseum.[7] Although the mold is dated 1599, the jug itself could have been made later (compare *cat. 70*).

1. Gaimster 1997, 225.
2. Amsterdam 1996b, 74, cat. 32.
3. The pelican symbolized charity, as it was believed to feed its young from the blood of its own breast. It was also the Christian symbol of redemption or the Resurrection, as it was seen as entirely consumed with love for its children.
4. Gaimster 1997, 153.
5. London 1976, cat. C185.
6. Gaimster 1997, cat. 95.
7. Amsterdam 1996b, cat. 32.

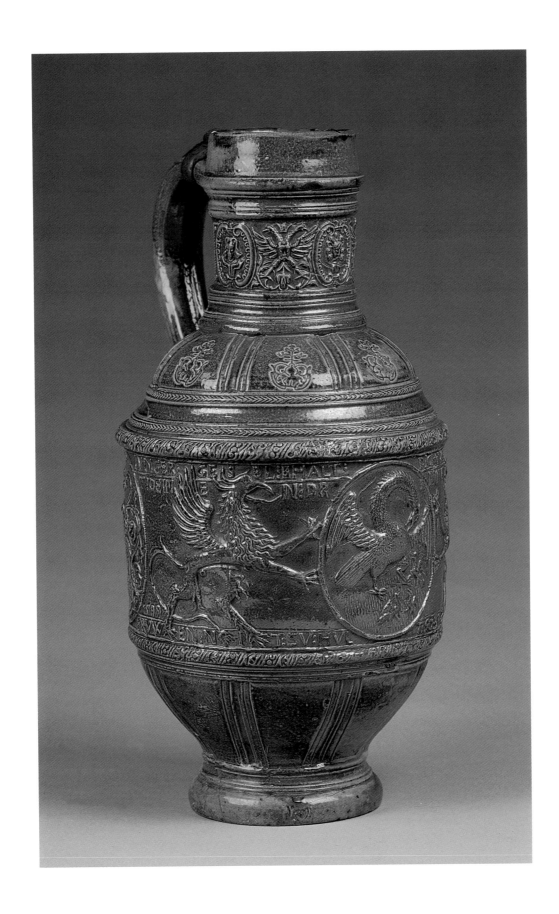

72.

Berkemeier,

first half of 17th century
Glass
4 ¹¹/₁₆ x 5 ⅛ inches (11.9 x 13 cm)
Royal Museums of Art and History,
Brussels, inv. 6377

Among the most frequently used vessels for drinking wine in the seventeenth century were the *roemer* and the *berkemeier*.[1] Whereas the *roemer* has a slightly convex bowl, the *berkemeier* has a funnel-shaped bowl opening onto a cylindrical stem. Unlike the *roemer*, the *berkemeier* does not show a distinct separation of the bowl from the stem. The *berkemeier* was the shape of drinking glass found most frequently in Flanders from the second quarter of the sixteenth century well into the seventeenth. Dating the glasses is difficult, because there is a great deal of variation among contemporaneous examples.

The stem of this *berkemeier* is ornamented with two staggered horizontal rows of prunts. The prunts are sometimes smooth and flat as they are here; often they are pulled up into little points, and occasionally they are imprinted with a die to form a raspberry or checked design. The low foot was made by closely winding a glass thread around a wood form that was then removed.

The raw ingredients for making glass include alkali (either potash or soda), lime, and silica (sand or, occasionally, flint). The alkali reduces the temperature at which the silica fuses; the lime has a stabilizing function. In forest glass, of which most *roemers* and *berkemeiers* were made, the alkali is obtained from the ashes of burnt wood or ferns. The green tint is caused by iron alloys from the impure potash. Although most *roemers* and *berkemeiers* dating between 1600 and 1650 were made of potash-lime glass, potash was eventually replaced by soda (sodium carbonate) to produce a better-quality vessel.

1. Henkes 1994, 192. He also traces the evolution of the form on pages 71 and 189.

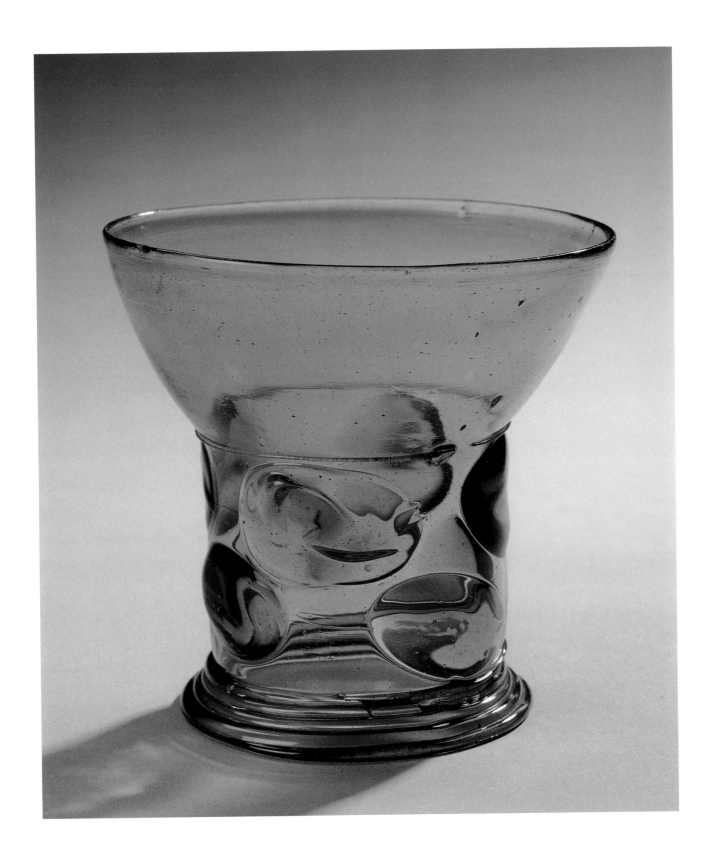

73.
Cup,
late 16th–first half of 17th century
Glass and gilt bronze
4 $^{13}/_{16}$ x 4 $^{1}/_{16}$ inches
(12.2 x 10.3 cm)
Royal Museums of Art and History,
Brussels, inv. 188

Different decorative techniques have been applied to this small cup. Its edge has been stretched for a highly original ovoid form. The everted rim has an applied, translucent blue trail; a second blue trail, about a third of the way down the cup, marks the end of the smooth glass zone. At each side are clear pinched scroll handles. The cup has been mounted on a gilt-bronze support with three shell feet, enhancing its precious character. Such mounts for glass in the Southern Netherlands were typically used only for the *roemer*;[1] perhaps it was thought that the fantastic inventions of other glass forms did not need to be further embellished.

The lower portion of the cup is made of ice glass, which was created either by plunging the hot glass into water for a moment and immediately reheating it, or by marvering a glass gather onto glass fragments. The rough appearance of ice glass became popular in Venice in the sixteenth century and spread to Northern Europe, where it remained in vogue into the seventeenth century.

Very refined forms such as this might have been used at table other than as drinking vessels. The shape has been thought to evoke a ship; fittingly it has been suggested that this mounted cup could have been used as a salt cellar (compare *cat. 83*).[2]

1. Klesse and Mayr 1987, n.p., cat. 20.
2. J. Lefrancq in correspondence of 8 December 1998. Salt cellars were generally mounted. The traditional *nef* in silver was originally a drinking vessel, but it was also used as a salt cellar. This was appropriate, as salt came from the sea; see Oman 1963, 2–5.

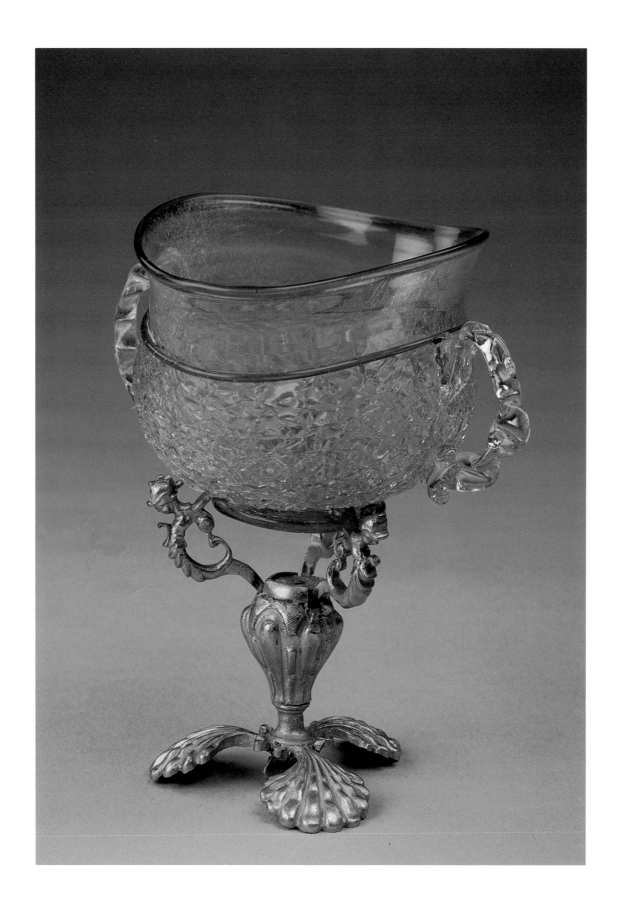

74.
Serpent-stem Goblet,

17th century
Antwerp, Brussels, or Liège
Glass
H: 10 ⅝ inches (27 cm)
Royal Museums of Art and History,
Brussels, inv. 255

Soda glass had been blown in Antwerp since the second half of the sixteenth century, in imitation of the famous Venetian *cristallo*. The glass, which was initially not very pure and clear, was often decorated with threads of white or colored glass. By the end of the century, this filigree glass went out of fashion, partly because it became easier to make clear, pure, and thin glass. Artisans were then free to concentrate on developing new forms of vessels made *à la façon de Venise* (in the Venetian fashion).[1]

The richly decorated serpent-stem goblet—one of the novel forms (compare *cat. 75*)—best represents the new tendency to stretch the possibilities of the material. In this marvel of craftsmanship, the clear glass of the cup is contrasted with the opaque colored threads in the stem. Although many were produced throughout the seventeenth century, the serpent-stem goblet, characteristic of luxury tableware, was considered a showpiece.

The tall wine goblet stands on a wide round foot with a curled edge. The cone of the cup, which became larger with time to accommodate the drinking of beer,[2] rests on the stem on a small collar. An important development in the *façon de Venise* glassmaking of the seventeenth century was an increasingly complex stem treatment.[3] The openwork stem—consisting of a convoluted glass rod enclosing opaque red and white threads, with ribbed blue glass wings nipped onto the sides—was formed on a marver (a polished slab of marble or iron upon which the glass is rolled and shaped while still on the blowpipe) and joined to bowl and foot. Because the effect created by this stem was of two coiled and intertwined serpents, such glasses were referred to as *verres à serpents* (snake glasses) in seventeenth-century documents.

1. Antwerp 1993a, 335, cat. 185.
2. Engen 1989, 144.
3. Charleston 1980, 124.

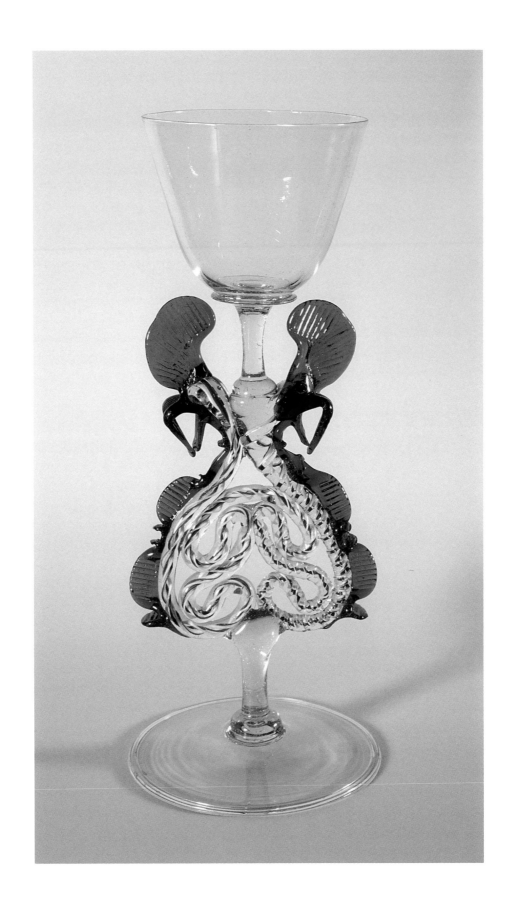

75.
Possibly workshop of
the Bonhomme Family

Cup with
Knobbed Stem,
second half of the 17th century
Probably from Liège
Glass
H: 8⅞ inches (22.5 cm)
Royal Museums of Art and History,
Brussels, inv. 220

The stem of this elegant *cristallo* wine glass has four hollow knops (or knobs) and a flat foot. Because of its shape, the cup is thought to come from the workshop of the Bonhomme family in Liège. Henri (1608–1679) and Léonard (1612–1668) Bonhomme, the two elder sons of Jean Bonhomme, were businessmen, not glassworkers, who built up a commercially successful enterprise. They diversified, making not only luxury glassware such as this example but also inexpensive glassware for everyday use in sturdier forest glass (compare *cat. 72*). Their workshop dominated production in Liège; thanks to their dynamism and to a privilege granted by the Cathedral Chapter Jurisdiction, the Bonhommes were able to eliminate local rivals almost completely.[1] In large part because of this workshop, Liège rivaled Antwerp as a quality glass-blowing center. The Bonhommes also opened branches in other cities.[2]

In February 1645, Paulo Matzalo, from Murano, was engaged to work for Henri Bonhomme for five years. In his work contract, he agreed to produce forty-five glasses with four knobs *à la façon de Lille*. Nine months later, the Venetians Jean Rigo and Antoine Meringo were hired for two years to produce similar glasses (although these had two rather than four knobs). When Rigo renewed his contract, the explicit terms were to continue making glasses with knobs destined for Lille. These were the first specific glasses that are mentioned in contracts.[3]

In the beginning of the seventeenth century, glass blowers began to abandon traditional Renaissance forms and create a new repertoire of shapes. The glass with four knobs *à la façon de Lille* was one of the new forms that enjoyed a long popularity. By mid-century, such glasses were no longer exclusively produced in the Bonhomme workshop, nor were they all intended for the city of Lille.[4]

1. Engen 1989, 137–40.
2. Phillips 1981, 122.
3. "...arrivant qu'il convien travailler pour Lisle et faire vers à quattre bouttons" ("...arriving that he agrees to work for Lille and make glasses with four knobs"); see Engen 1989, 143.
4. Engen 1989, 144.

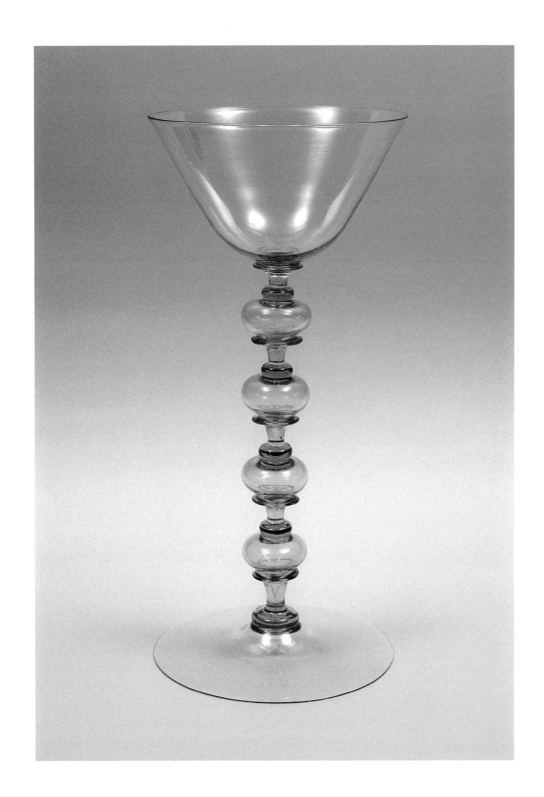

76.

*Joseph Seeking his
Brothers in the
Plain of Sichem,*

mid-16th century
Antwerp
Stained glass
33 ⅞ x 18 ½ inches (86 x 47 cm)
Royal Museums of Art and History,
Brussels, inv. 2017.III
Inscription: DEES BRODRES MIDTS DEN
DROEM ZYN MET HAET BESMEDT
HEBBEN HEM DUS IN EENEN DROOGHEN
PUT GHESEDT (Because of the dream
these brothers are tainted with hatred
and therefore have put him in a dry
well)

77.

*The Discovery of the
Golden Cup in the
Sack of Benjamin,*

mid-16th century
Antwerp
Stained glass
33 ⅞ x 18 ½ inches (86 x 47 cm)
Royal Museums of Art and History,
Brussels, inv. 2017.XI
Inscription: JACOP OM SPYZE ZYN
KINDEREN GHEZONDEN HEEFT DOER
JOSEPHS RAEDT TSCONNAP BY HAER
GEVONDEN HEEFT (Jacob has sent
his children for food and because
of Joseph's advice has found the
precious cup with (her?))

1. Sanguine is a pigment used from the
late fifteenth century on, which con-
tains hematite, iron sulphite, or sienna
and which takes on a rose to red-brown
tint on firing; see Caviness 1978, 98.
2. The original coat of arms above *Joseph
Seeking his Brothers in the Plain of Sichem*
has disappeared and has been replaced
by a contemporary fragment represent-
ing four nuns accompanied by St. Anne
at right and St. Colette of Corbie at
left. See Helbig and vanden Bemden
1974, 155.
3. Helbig and vanden Bemden 1974, 156.
4. Helbig and vanden Bemden 1974, 148.
5. The painted images are in the same
direction as the prints, which are
mirror images of the drawings.

These stained-glass roundels have been set into rectilinear windows glazed
with elaborate ornamentation of strapwork and cartouches characteristic
of the so-called Floris style. This manner of decoration distinguished the
decorative arts in Antwerp around the middle of the sixteenth century.
This date is confirmed by the date of 1544 on one of the panels in the
series and is supported by the use of sanguine red.[1] Above each roundel
was originally a coat of arms identifying the donor of the window;[2] below
is a cartouche inscribed with a biblical text in Dutch identifying the scene.
The fact that several of the panels have incomplete coats of arms indicates
that the series was executed all at one time, with the intention of filling in
the arms as donations were made.[3]

These panels come from a series of at least eight windows that adorned
the convent hospital of St. Elizabeth at Lierre. By the sixteenth century, the
original twelfth-century hospital included, in addition to wards for the sick,
the house of the sisters, that of the almsman, places reserved for paying
pensionaries, and a separate wing for people with the plague. The hospital
was demolished toward the end of the nineteenth century.[4]

The scenes in the roundels are based on prints of 1549–50 by Dirck
Volkertsz. Coornhert after drawings by Maarten van Heemskerck (*cats. 35
and 36*).[5] The glass painter adapted his models to a circular form and varied
the details naturally and with facility. Most liberally copied are the secondary
elements, with, for example, figures added to or removed from the back-
ground, landscape features minimized or changed, and insignificant details
suppressed.[6] The Musée de la Biloque in Ghent owns seven rectangular
paintings on glass by a less assured hand that were copied from the same
models.[7]

The roundel featuring Joseph seeking his brothers in the Plain of
Sichem retains the earlier tradition of showing numerous episodes in one
narrative panel.[8] In the middle ground, he is being put into the dry well by
his brothers, while in the background he is being sold to the Ishmaelites.
The other panel illustrates the episode in which Joseph's golden cup is found
in the sack of his youngest brother, Benjamin.[9] Joseph's turbaned servants
are shown at the right; his brothers, in their traveling cloaks, are on the left.

In both panels, the grisaille is very pale, with large expanses of glass
left unpainted; the artist has used stickwork extensively for highlighting.
An unusual green enamel is employed judiciously for the ground on which
Joseph's brothers stand in the scene where they discover the golden cup.[10]

It is not clear whether van Heemskerck or his publishers provided
glass painters with sets of prints, or whether the painters simply chose
compositions to their liking. In either case, such prints after van
Heemskerck proved extremely popular among glass painters.[11]

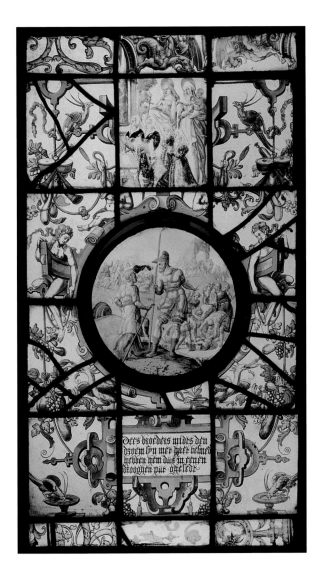

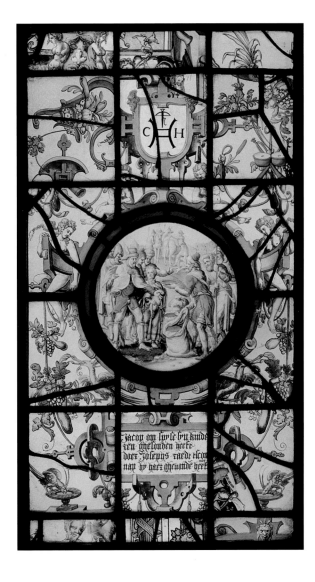

6. In *Joseph Seeking his Brothers in the Plain of Sichem*, for example, differences between the glass painting and the print include the addition of secondary elements such as the vaulted bridge and two more figures at the left, and less imposing rocks in the background.
 In *The Discovery of the Golden Cup in the Sack of Benjamin*, the background has been simplified: classical buildings replace rocks and ruins, and the number of figures has been reduced. See vanden Bemden 1976, 87–88.

7. vanden Bemden 1976, 85.

8. Gen. 37: 14–28.

9. Gen. 44: 12.

10. vanden Bemden 1976, 88–89; New York 1995, 188.

11. New York 1995, 188.

78.

LOYS VAN NIEUKERKE
THE YOUNGER

Basin, 1631–32

Bruges
Gilt silver
Diameter: 21 ⅞ inches (55.5 cm)
Royal Museums of Art and History,
Brussels, inv. 112

In the middle of the central boss of this elaborate basin is a summary representation, in bird's-eye perspective, of the walled city of Bruges, recognizable by its towers and city gates. The well of the platter is divided at the bottom by the Reie River and at the top by the canals that lead to the towns of Damme and Sluis. The right half of the well shows the troops of Prince Frederik Hendrik of Orange, who raised the siege of Bruges on 4 June 1631. To the left is the victorious Spanish army, with their standards bearing the cross of St. Andrew. The border of the basin is decorated with war weapons.

The siege of Bruges failed in the first place thanks to the efficient military precautions of Paul Bernard de Fontaine (ca. 1576–1643). The Count of Fontaine had been charged by Archduke Albert already in 1621 with the military defense of the region of Bruges and Franc. This was a huge responsibility in the face of renewed hostilities with the Northern Netherlands on the expiration of the Twelve Years' Truce. The military organization in the South was lamentable; Fontaine was faced with irregular pay for the troops, poor sanitary conditions, lack of munitions, and diminution of the ranks due to sickness, death, and desertions. Despite these conditions, he remained vigilant, learning from his spies of the plans of the Northern troops to take Bruges and invade Flanders in order to take Dunkerque. He was therefore able to dispatch reinforcements to the most threatened places and allow the new general, the Marquis of Santa Cruz, to concentrate troops where necessary. Thanks to his judicious advice and swift action, and to the dual system of control of the Northern army—which resulted in a fierce split between Frederik Hendrik, who wanted to press on with the siege, and the deputies of the States General, who opposed what they claimed was a "dubious and risky enterprise"[1]—the Northern troops withdrew.[2]

The States of Flanders expressed their satisfaction with Fontaine with a payment of forty écus and a gift. That gift was probably this silver platter,[3] which most likely originally carried his coat of arms in place of those presently there.[4] This is not the only time a military exploit was honored in this fashion; the city of Amsterdam, for instance, commissioned a ewer and basin from Adam van Vianen in 1614 to commemorate Prince Maurits's victory at the Battle of Nieuwpoort.[5]

The platter was made by Loys van Nieukerke the Younger, who belonged to a family of Bruges gold- and silversmiths. His father became a member of the silversmiths' guild in 1573; Loys the Younger entered as master in 1607. He was prolific, and many of his works are still extant (cats. 81 and 83). The platter bears his mark, a cross from his family coat of arms.[6]

This basin was originally called the Alexander Farnese Platter, mistakenly named after the man who was governor general of the Netherlands from 1578 until 1592.

1. Israel 1982, 183.
2. This account of the siege of Bruges and of the administration of the Count of Fontaine is based on van Meerbeeck 1965.
3. van Meerbeeck 1965, 314 and n. 44.
4. This coat of arms, inscribed SICVT AQVILA, belonged to Augustinus Wichmans, abbot of Tongerlo from 1644 to 1661.
5. See Amsterdam 1993a, 451.
6. This was actually his second mark. The first, a small church, relates to his name, which in Dutch translates as "new church." The platter also has two hallmarks, a crowned lion head and a crowned "b," which both indicate it was made in Bruges. The information about van Nieukerke's marks was kindly communicated to me by Sara de Coninck, who is responsible for silver at the Royal Museums of Art and History, Brussels.

79.

Master of the Cherub[1]

Beaker, 1631–32

Antwerp
Silver
H: 5 ³⁄₁₆ inches (13.1 cm)
Royal Museums of Art and History,
Brussels, inv. 4089

This type of beaker, the most common silver drinking vessel, was used throughout the Netherlands in the seventeenth century. It is probably what was referred to in contemporary inventories as a *bierbeker* (beer beaker).[2] Because of its simple form, it remained in use longer than any other type of silver vessel. Beakers such as this were often given as prizes in competitions and lotteries.[3]

A band of rinceaux is engraved under the rim. Below, hanging tendrils encircle a stylized flower alternating with bunches of fruit suspended from a ribbon. The engravings above the foot include birds alternating with flowers around the cup. The forms are somewhat naive and quite freely engraved.

On the bottom of the foot are the initials "GDM," probably belonging to a former owner. Under the lip is the control mark "E," for *étranger* (foreigner). This revision mark, placed on objects in Belgium between 1832 and 1869, was meant to indicate work either made in Belgium before 1814 or produced outside of the country.

1. The name of the unknown maker is derived from the maker's mark of a cherub in a shield on the underside of the beaker. The hallmark is a crowned hand, the mark of Antwerp.
2. Amsterdam 1993a, 434, cat. 92.
3. Baudouin, P. et al. 1988a, 35, cat. 19. I am grateful to Sara de Coninck for drawing my attention to this reference.

173

80.
MASTER OF THE SAINT
ANDREW'S CROSS

Coconut Cup, 1615–16

Antwerp[1]
Coconut, silver
H: 14 11/16 inches (37.3 cm);
diameter of base: 3 ¾ inches (9.5 cm)
Royal Museums of Art and History,
Brussels, inv. 103

Carved and mounted coconut cups would have been a prized feature of a collector's cabinet because of their rarity and exoticism. Among the oldest drinking vessels known, the coconut cup began to be mounted in precious metal in the fifteenth century. Silver, sometimes gilt, was usually used for the mount.

In this example, three vertical bands of the mount link the stem and neck. The bands, which begin and terminate in acanthus leaves, are hinged so that the coconut can be removed from the mount. The vault of the cup's cover is chased with images of fruit clusters alternating with sea monsters. A cast figure of an Indian with bow and arrow stands on a small base above. He probably alludes to the Americas, the most plentiful source of coconuts.[2] The elaborate stem of the mount is a baluster shape onto which three female herm volutes are transversally placed. It is further adorned with lion heads alternating with fruit clusters on ribbons. On the base of the baluster are transverse dolphin volutes that echo those on the Indian's base. The sloping foot is chased with three cherubs alternating with fruit swags. The rim of the foot is stamped with a plant motif that reappears on the edges of the shoulder and cover.

The fields between the mount's bands contain carved pairs of Old and New Testament scenes. The Creation of Eve is paired with the Annunciation, the Fall with the Nativity, and the Expulsion from Paradise with the Adoration of the Magi. Each of the fields is, in turn, partitioned by carved Y-shaped bands: the band separating the Creation from the Annunciation has an angel above it; the one separating the Fall from the Nativity has a shield; and the one separating the Expulsion from the Adoration has a crowned heart pierced by two arrows. A segment band with rinceaux is carved below each field, linking the two scenes. The carving is unsophisticated and appears to date earlier than the silver setting.

Often the carved images on such cups were Old Testament scenes, used as prefigurations of the New Order or as admonitions concerning the evil resulting from overindulgence in drink. Here, the pairing calls to mind the role of Mary as the new Eve and the idea that the fall from grace by Adam and Eve necessitated the Incarnation.[3]

1. The Antwerp hallmark of the crowned hand appears on the lip of the cup. The control mark "E" also appears; see cat. 79.
2. According to Fritz 1979, 673, they were rare and costly in Europe.
3. Thanks to Sheramy Bundrick and Bryan Small, who framed this last connection.

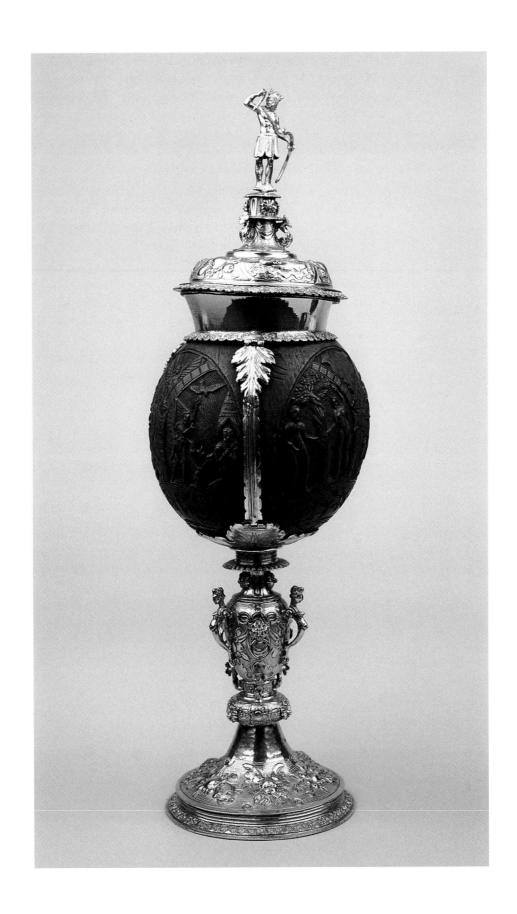

81.
LOYS VAN NIEUKERKE
THE YOUNGER

**Standing Cup
and Cover,** 1615–16

Bruges[1]
Gilt silver
H: 9 ¾ inches (24.8 cm); diameter
of base: 2 ½ inches (6.4 cm)
Royal Museums of Art and History,
Brussels, inv. 579 A

This refined covered cup was made by Loys van Nieukerke the Younger (*cats. 78* and *83*). Commissions for such standing cups were among the most prominent given to silversmiths. The great variety of forms and ornamental decoration on the cups attests to the craftsman's inventiveness and skill. Covered cups were prized as collectors' pieces, offered as gifts of honor, displayed on sideboards in elegant dining rooms, and only rarely put to use. Costly objects, they had the same alloy as coins and were often melted down at times of crisis for their silver content.

Unlike early Renaissance examples, which could be apprehended in one glance, these cups were meant to be studied from all sides.[2] This example is engraved throughout with scrollwork and festoons of fruit. Volutes on the lower part of the cup may originally have had ornaments. Volutes also are components of the open-worked stem. A cast lance-bearer holding a shield on which a tower is emblazoned crowns the lid. Such figures were applied only to pieces intended as special gifts, reflecting the honoree's high social status and accomplishments.[3]

1. On the lip of the cup are the crowned lion head and crowned "b" hallmarks of Bruges. The control mark "E" also appears; see *cat. 79*.
2. Amsterdam 1986, 395, cat. 279.
3. Koeppe 1992, 477, cat. GO 18.

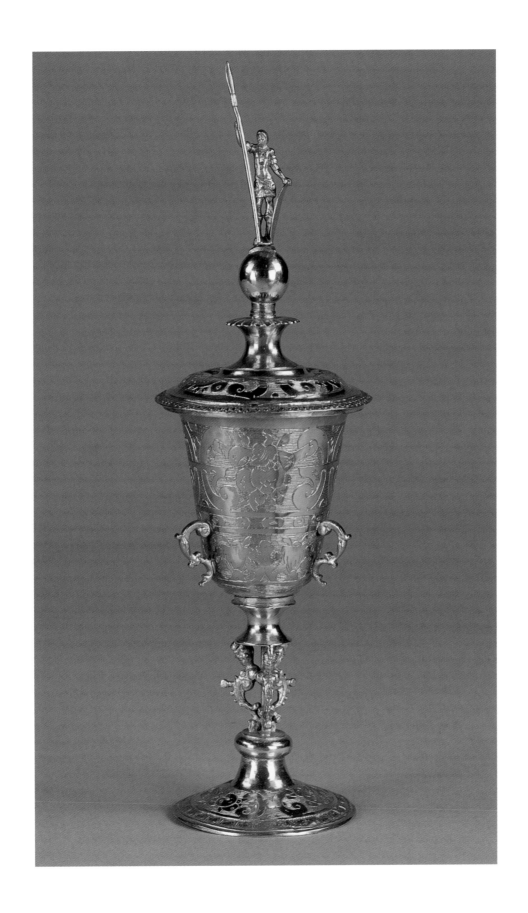

JAN BRAEM
Standing Cup and Cover, ca. 1630

Ypres[1]
Gilt silver
H: 17 ⅛ inches (43.5 cm); diameter
of base: 4 3/16 inches (10.7 cm)
Royal Museums of Art and History,
Brussels, inv. Ag 10

Silver vessels had been commissioned by civic authorities since the Middle Ages. Town councils ordered silver both to grace their official banquets and to serve as gifts or a commemoration on the death of a councilor. These significant works were a source of civic pride. Guilds, too, gave important commissions to the silversmiths; for example, militia companies ordered prizes and marks of honor to be made for their competitions. The appreciation of richly worked vessels in precious metals was also shared by prominent people who competed to possess fine examples of the silversmith's art. Among these, the covered cup was particularly highly regarded. All the great silversmiths of Europe produced this type of object; consequently, a great variety of shapes and decorative schemes was created. These cups served mainly to be displayed and admired and were offered as tokens of honor (compare *cat. 81*).[2]

This cup is a relatively large and ornate example of the type. The chased decoration includes scrollwork, fruit, and sea creatures around the lip and foot. Tiny human heads protrude from the cover and body of the cup. Grotesque scrolls with projecting annulets, some of which originally had pendants, adorn the bulbous lower part of the cup and the baluster stem. Such scrolls are particularly associated with silverwork created in Bruges,[3] one of the most important centers for metalwork in the early seventeenth century and the nearest big city to Ypres.[4] The cast male figure surmounting the cover holds a shield engraved with an unidentified coat of arms. He is placed on an unusual vase shape with ornate handles.

1. There are two Ypres hallmarks on the lip of the cup: a crowned Lorraine's cross (*Lorreins Kruis*, a cross with two horizontal lines, the lower one a bit shorter than the upper one), and a crowned "Y." The control mark "E" also appears; compare *cat. 79*.
2. Amsterdam 1986a, 136–37.
3. Baudouin, P. et al. 1988b, 67.
4. As Sara de Coninck kindly pointed out in correspondence, there were probably examples of Bruges silverwork available in Ypres, or it might be that the patron of the standing cup and cover asked Braem for a piece in the Bruges manner. Ypres, home of Jan Braem, was the only city in which he could work.

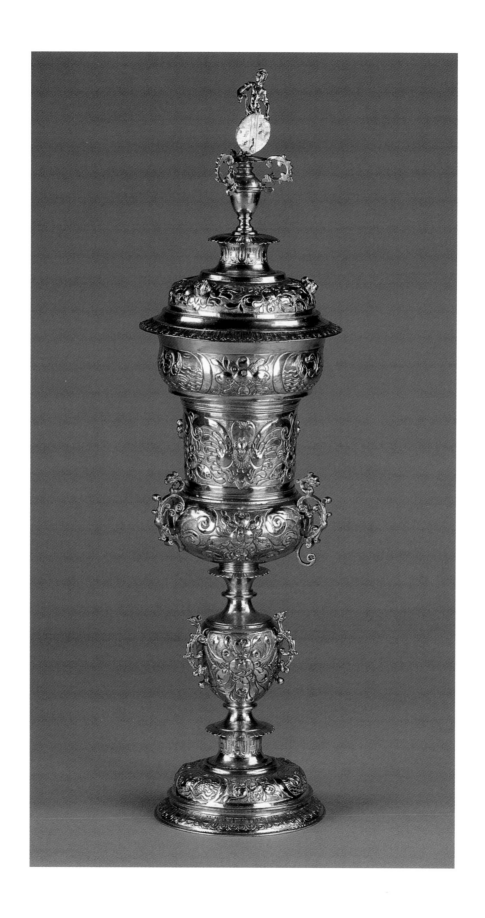

83.

LOYS VAN NIEUKERKE
THE YOUNGER[1]

Standing Cup in the Shape of a *Nef* of Fortune,

1623–24
Bruges
Gilt silver
H: 8 1/16 inches (20.5 cm); diameter
of base: 2 13/16 inches (7.1 cm)
Royal Museums of Art and History,
Brussels, inv. V2111

Loys van Nieukerke the Younger employed all manner of decorative techniques on this silver vessel. The six-lobed shell bowl of the cup is partly smooth and partly decorated with repoussé punchwork. Typical of Bruges metalwork (compare *cats. 81* and *82*) are the openwork stem of volutes and the scrolls with projecting annulets that adorn the handle. The foot is ornamented with chased flower and fruit clusters. The flat area between handle and standing figure (evoking the stern of the ship) is engraved with scrollwork. The whole is a wonderful example of the craftsman's ability to create an exquisite display object that cleverly and humorously emulates a natural form—here, a ship or *nef*.

In the fifteenth and sixteenth centuries, *nefs* were elaborately crafted silver vessels in the shape of large ships, with small figures populating the decks. Filled with wine or used as containers for salt[2] or spices, they were traditionally used to mark the place of the master of the house at the head of the table.[3]

This wine shell represents a ship of fortune. Fortune is usually depicted as a graceful female figure holding a sail above her head and balancing on a sphere. She is mistress of her own fate, responsible for catching the wind and controlling the ball. Here, however, is a rare example of Fortune personified by a nude male. He holds a pennant blown by the wind, which is represented by the small head with bulging cheeks and pointed bonnet perched on the handle's volute. Given the position of the wind's head and direction of his breath, the sail is blowing in the wrong direction.[4] Similar *nef* cups were intended as wedding gifts.[5] In this case, the male figure could represent a playful warning to the groom that the "wind of his life" should not be taken over by his wife.[6]

1. On the lip of the cup are the crowned lion head and crowned "b" hallmarks of Bruges and the cross in a shield that is van Nieukerke's mark; compare *cat. 78*.
2. According to Jesse McNab in conversation, salt was mined by evaporating sea water, making a ship an appropriate vessel to hold it at table.
3. See Oman 1963, and Washington 1998a, 48.
4. It is uncertain if this man of fortune with the sail going the wrong way was intended as a joke or whether, in fact, there a tradition of humor in such display vessels at all. It is possible that the object has suffered from improper restoration.
5. Koeppe 1992, 468–69, cat. GO 11.
6. This interpretation was proposed by Wolfram Koeppe in the Department of European Sculpture and Decorative Arts at The Metropolitan Museum of Art, who graciously read a draft of this entry.

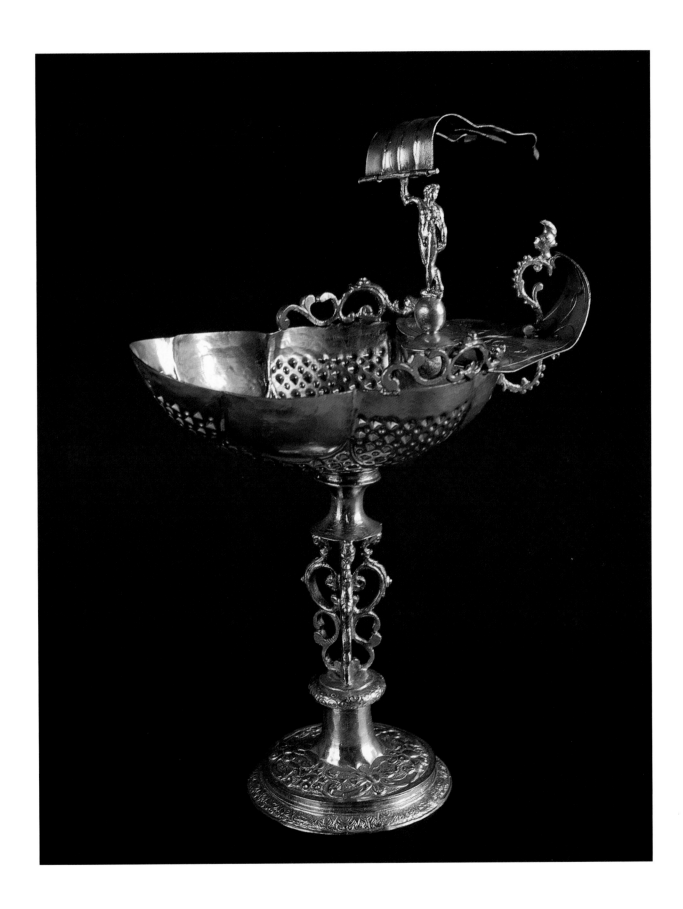

Ewer and Basin,

early 17th century
Possibly Antwerp[1]
Silver
Height of ewer: 13 ½ inches (34.3 cm);
diameter of basin: 15 ¹³⁄₁₆ inches
(40.2 cm)
Royal Museums of Art and History,
Brussels, inv. 1589 a, b

Such a monumental and elaborate ewer and basin would have had pride of place on the sideboard when not being used for washing the fingers between courses at table. The decoration of such pieces, appropriately enough, often featured water themes. Only the dolphin's head that forms the mouth of the ewer alludes to water in this pair, however. The overarching theme here is one of bacchic celebration.

The repoussé work—the most elaborate in this exhibition—is extremely complex and of the highest quality. The central medallion of the basin features an unidentified subject of a young woman and child with a scepter (perhaps the young Jupiter, accompanied by his eagle, with his mother Rhea). The hollow features a bacchanal in repoussé asymmetrically disposed; cupids and satyrs offer sacrifices, pull at a goat, and dance and frolic around a wreathed herm. Swags are draped above their heads. The rim of the basin is decorated with elaborate repoussé grotesque work, including acanthus leaves, volutes, birds, flowers, and satyr heads. Four medallions are placed axially, each containing a seated female personification of one of the Four Seasons. At the top, Autumn reclines, her drapery strategically placed, while two putti offer her bunches of grapes. Winter is fully swathed and huddles while putti tend the fire. At the bottom, Spring gathers in her drapery the flowers tossed to her by her attendants. Summer, personified by Ceres and shown in side view, holds shafts of wheat and watches over the putti's harvest.

The ewer has a small circular base that fits over the umbo of the basin. The foot is decorated in high relief with swags that echo those in the basin's hollow. Protruding heads of satyrs encircle the top of the base. The belly of the ewer also features a bacchanal: the god Pan is seated next to a sacrificial altar while fauns, nymphs, and ephebes bring offerings of fruit. Above the scene on the upper part of the body are regularly disposed motifs of stylized acanthus leaves, volutes, and cow heads, surmounted by a register of more volutes, flowers, and satyr torsos. Silver beading articulates the division between body and neck. On the neck, ribbons and bouquets form garlands. Below the ewer's dolphin spout is a female face crowned with vine leaves. Another face is placed opposite her, below the scroll of the handle. The handle, in the form of a large volute, features a young woman resting her head on a satyr's, her hands on his shoulders. The satyr supports the woman with one arm; the other hand holds a large flower.

1. The only mark on the silver is the control mark "E;" compare cat. 79.

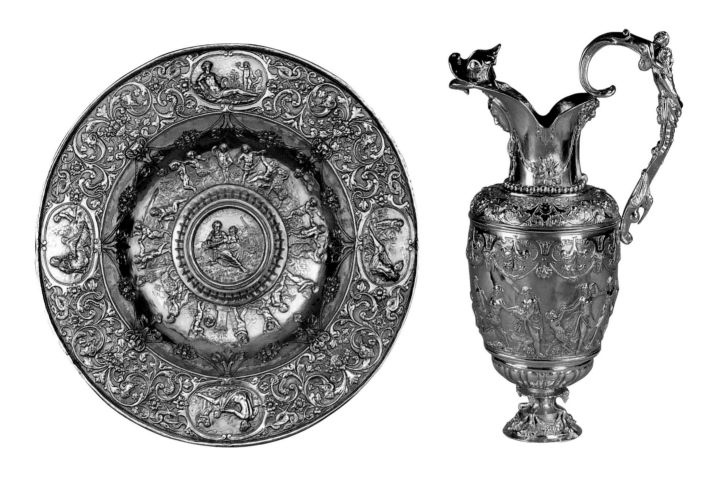

85 a.

MASTER OF THE CROWNED
HAMMER[1]

Fork and Spoon Set,

1616–17
Antwerp
Silver
fork: 5 ½ inches (14 cm); spoon:
1 ⅞ x 2 ⁷⁄₁₆ inches (4.7 x 6.2 cm)
Royal Museums of Art and History,
Brussels, inv. 6296

85 b.

MASTER OF THE RUNNING FOX[2]

Portable Fork and Spoon Set with Case,

1627–28
Antwerp
Silver
fork: 5 ⅝ inches (14.3 cm); spoon:
1 ⅞ x 2 ⁹⁄₁₆ inches (4.8 x 6.5 cm)
Royal Museums of Art and History,
Brussels, inv. 5249

Whereas knives and spoons had a long history of use in Europe, forks were employed primarily for carving meats until the late sixteenth century. Only gradually did they appear at table. It was not until the last quarter of the seventeenth century that the use of forks and spoons by diners became usual in most households.[3]

The elaborately ornamented implements exhibited here, made to be stored and carried in the leather case, are typical of the Netherlands.[4] They were used by guests invited to dinner and by travelers. The fork has three evenly bent tines at the end of a rectangular handle that is square in section. The hinges on the handle would be secured by the sliding ring on which a cast putto appears. The cast figure of a Roman soldier at the end of the handle is also the grip of the toothpick that is screwed into the hollow stem.

The oval spoons, whose bowls are engraved with a bunch of fruit hanging from a ribbon (compare similar swags of fruit in *cats. 15* and 66), were not made with handles. Rather, on their backs are soldered five little loops into which the fork tines would be slid.

The leather case is decorated with gold tooling. Although the case was likely an integral part of these travel sets, many have disappeared with time.

1. On the back of the bowl of the spoon is the crowned-hand hallmark of Antwerp and the maker's mark of a crowned hammer in a shield.
2. On the back of the bowl of the spoon is the crowned-hand hallmark of Antwerp and the maker's mark of a running fox in a shield.
3. Houart 1982, 71.
4. The form was also used in France and Germany. In Britain, a simpler implement (the sucket fork) was designed that had a spoon bowl at one end and a two-pronged fork at the other end of the stem. See Houart 1982, 73.

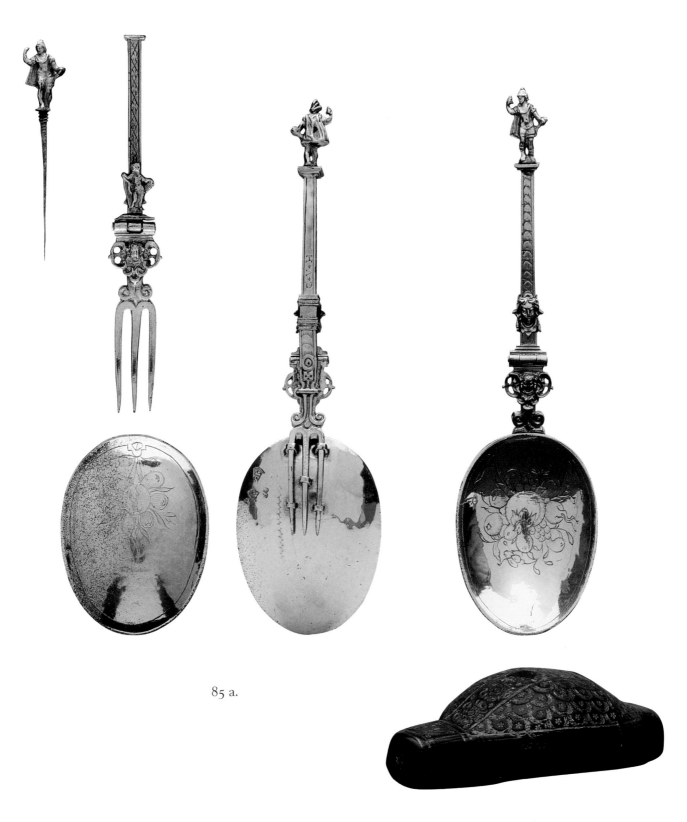

85 a.

85 b.

Collar of the Archers' Guild of Mechelen,

17th century
Gilt silver
8 ¼ x 7 ½ inches (21 x 19 cm)
King Baudouin Foundation, Brussels

Although the military role of the guilds had become virtually obsolete by the seventeenth century, the guilds were so deeply anchored in the life of the community that they assumed other functions.[1] Among the activities of the archery guild were annual shooting matches, the most important of which was *le tir au roi*. The reigning king of the guild was the first to attempt to fell a bird from his perch; if he was unsuccessful, the first to prevail earned the title of king. The king organized the shoot and was required to add to the guild collar a silver escutcheon bearing his name and the date(s) of his reign.

Guild collars, generally modeled on the collar of the Order of the Golden Fleece, are composed of a chain of medals that depict the patron saint of the guild and commemorate its successive kings. A pendant representing a bird is suspended from the chain.

This specific collar is composed of a series of links interrupted by medallions: four fire steels (two volutes on one side and an elongated handle on the other) flanked on either side by a flint (with flames shooting from both sides) make up the links. The flint was hit against the fire steel to make sparks. These instruments of fire are symbols of the Golden Fleece, the main chivalric order of the duchy of Burgundy. From each of the steels and the medallions hangs a crossbow, symbol of the guild.

The oval medallion at the back features St. Libert, who had been baptized and raised by St. Rombaut and later became abbot of the monastery of St. Rombaut in Mechelen (compare *cat. 18*). He was killed by barbarians before the altar of St. Trond during the Norman invasions of ca. 835. Around the figure of the venerated saint of Mechelen is the inscription IOES FRANS IPS DE COCK HOOFTMAN DESER GUILDE 13 JUNY …6… (Frans de Cock, master of the guild 13 June …6…). Each side of the collar has a medallion bearing a shield. The medallion at right is inscribed IO PHLVPS DE HAYNIN HEER VAN LEGIES BORGEMESTER DER STADT MECHLEN. CONINCK DESER GUILDE. 1615." (Philippe de Haynin, seigneur of Legies, burgomaster of the city of Mechelen, king of the guild, 1615). The coat of arms of the Haynin family appears in the center. The medallion at left has no inscription, but only the coat of arms of the van Laethem family.

In the center of the collar is a large gilt pectoral bordered with acanthus leaves and shell motifs framing a representation of the Martyrdom of St. Sebastian (compare *cat. 24*). Sebastian, the patron saint of archers, was a guard in Diocletian's army. When he became a Christian, Diocletian ordered him killed, so he was tied to a tree and shot with arrows. This is the scene represented on the pectoral.[2] The figures of the saint and two archers are in high relief, fully plastic forms that contrast to the engraved view of a city whose cathedral and houses are evident in the background. Based on traditional depictions of the scene, this representation is an example of superb craftsmanship. A smaller silver oval medallion is suspended from the pectoral. Also framed by acanthus leaves are two crossed arrows tied with a knot with points facing down. This is the emblem of the Archers' Guild of Mechelen.[3]

1. According to Thomas 1998, 12, the support of the archdukes for the archery guilds was militarily motivated; the archers were one of the few nuclei of national defense under the archdukes' auspices while the entire army of the Southern Netherlands remained under Spanish control.
2. A subsequent episode from the life of St. Sebastian is depicted in the drawing by Hendrik de Clerck in this exhibition (*cat. 24*).
3. This entry is largely based on van der Elst 1994.

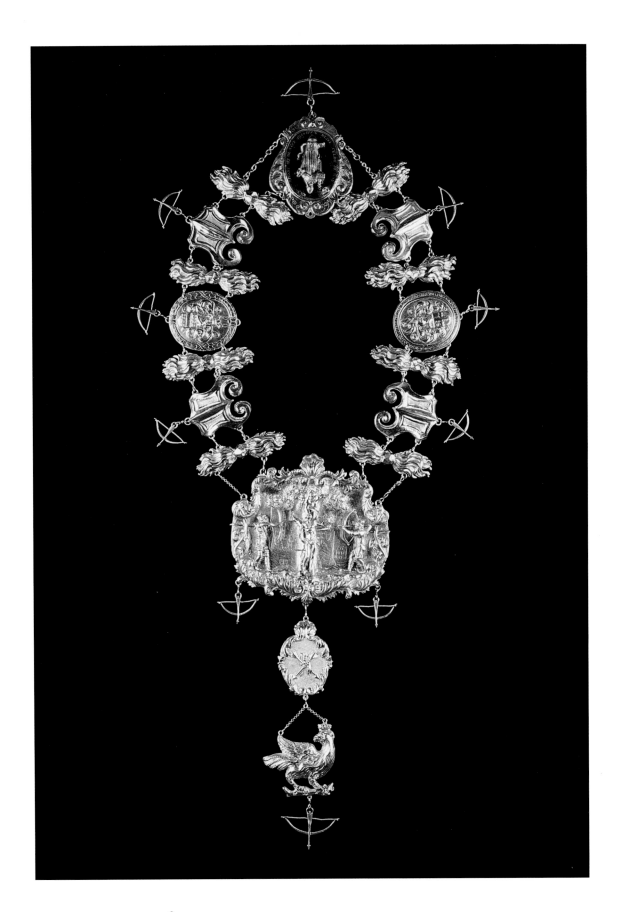

WORKSHOP OF PAUL WANSON

Porters' Pendant, 1659

Silver
Diameter: 9 1/16 inches (23 cm)
Musée Provincial des Arts
Anciens du Namurois,
Collection of the
Archaeological Society of Namur

88.

WORKSHOP OF PAUL WANSON

Boatmen's Pendant, 1667

Silver
Diameter: 9 13/16 inches (25 cm)
Musée Provincial des Arts
Anciens du Namurois,
Collection of the
Archaeological Society of Namur

Guilds were not only professional groups who guaranteed the quality of a particular type of production, but also a kind of hierarchical brotherhood, with the master supervising journeymen and apprentices. Each profession was placed under the aegis of a patron saint; each craft had its place of liturgical celebration. The guilds had distinctive signs of trade and made for themselves ritual objects, including pendants (*affliges*), silverwork worn by the dean of the guild for processions and public ceremonies.

Each of the trades had different needs and characters dictated by their activities. Brewers or tanners needed costly establishments, making them effectively heads of a business, and silversmiths working with precious metal needed capital to guarantee their operations. Other guilds had nothing to do with production but were centered on sale and transport and tied to commercial movements.[1]

The porters' patron saint was the Virgin Mary, although the reason for her association with this profession is obscure. This pendant depicts her with scepter in hand and arcades at her feet, recalling the church of Notre-Dame-de-Foy. A sanctuary dedicated to Notre-Dame-de-Foy was built in 1622; in 1659, the date on this pendant, her cult was in full bloom.[2]

The patron saint of boatmen was St. Nicholas of Bari who, according to legend, saved a boat in the middle of the ocean from sinking. Patron of sailors, he also became, by extension, patron of those who navigate rivers. Consequently, many churches under his patronage were erected close to water, where merchandise was loaded and unloaded.[3] The collegiate church of Notre Dame in Namur was adopted by the boatmen.

These pendants, stamped "w," are associated with the workshop of Paul Wanson. Wanson, a silversmith recorded as working for the city of Namur in 1608, produced a chalice for the church of Wartet in 1617.[4]

1. Namur 1998, 7–8.
2. It has been suggested that the choice of the Virgin might be the expression of a localized Marian devotion. See Namur 1998, 57.
3. Namur 1998, 52.
4. Poskin and Stokart 1982, 220.

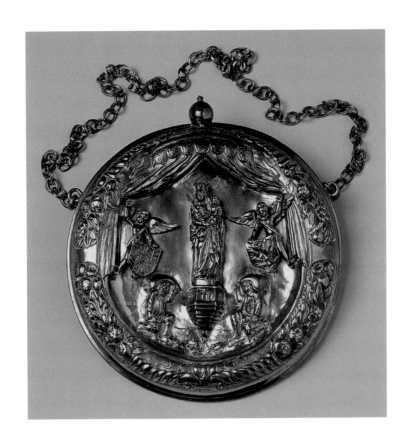

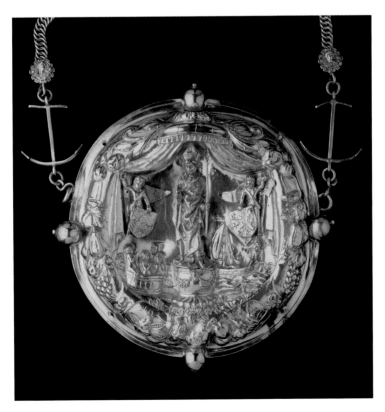

89.
ARNOLD FLORIS VAN LANGREN
died probably between 1628 and 1635
and MICHAEL FLORENT
VAN LANGREN 1598–1675

Celestial Globe, ca. 1630
Brussels
Diameter: 20 ¹¹/₁₆ inches (52.5 cm)
Museum Plantin-Moretus, Antwerp

90.
ARNOLD FLORIS VAN LANGREN
died probably between 1628 and 1635
and MICHAEL FLORENT
VAN LANGREN 1598–1675

Terrestrial Globe, ca. 1645
Brussels
Diameter: 20 ¹¹/₁₆ inches (52.5 cm)
Museum Plantin-Moretus, Antwerp

1. van der Krogt 1993, 259.
2. Tycho Brahe was a Danish astronomer who is most noted for his remarkably accurate measurements of the positions of stars and the movements of the planets.
3. Tasman had gone on a Dutch East India expedition to find a route to South America and discovered Australia instead.
4. This entry is based on van der Krogt 1993, 257–71 and 454–59.

Arnold Floris van Langren fled to the Southern Netherlands from Amsterdam to escape his creditors in late 1607 or early 1608. He was forced to leave behind all of his goods, including "instruments of spherography, many prepared globes, maps, suitcases, boxes, and such household things which he needed very much."[1] The copper plates he used for his globes remained in the possession of his brother, Hendrik Floris van Langen, who remained in the North. Arnold may have lived in Antwerp when he first moved to the South. He was named spherographer to Archdukes Albert and Isabella in September 1609. After Albert's death in 1621, he served the King of Spain in the same capacity.

The date of ca. 1630 for this celestial globe is based on the position of the stars. The legend on the globe records that van Langren had participated in Tycho Brahe's (1546–1601) observations of celestial bodies.[2] In addition to the stars from Brahe's catalogue, the globe-maker included three hundred stars taken from Frederik de Houtman's (1571–1627) studies. The constellations on the globe, represented as mythical figures, are accompanied by their names in Latin and extensive notes in other languages, including Greek. A portrait of Brahe appears near the title, close to Gemini. Included, too, are the path of a comet from the year 1618 and, in Sagittarius, the novas of 1577 and 1604–05.

The style is close to that of the famous Dutch globes by Hondius and Blaeu, which van Langren clearly used as models. Missing, however, in the northern examples are the explanation of the symbols used on the globe and information about the size of the stars (both included in the table on the magnitude of the stars), and a survey of the planets in the solar system with data on their size and distance (next to the table). These important additions were in all likelihood the work of Arnold's son, Michael Florent van Langren. He and his friend the humanist Erycius Puteanus (1574–1645), on whom the van Langrens relied for the Latin notes on the globe, were both closely involved in the construction of the celestial globe and the new edition of the terrestrial globe.

The fourteen extant copies of the van Langrens' terrestrial globe are all different. Because the pasting process could easily damage the gores (the tapering or triangular engraved pieces pasted onto the sphere), the supply of printed gores decreased irregularly. Consequently, some of the globes are composed of both old gores (brought by Arnold from Amsterdam) and gores he printed in the Southern Netherlands from newly engraved plates. Eventually, van Langren's globes were composed entirely of new gores, although even these gores would not have all been made at the same time. The present terrestrial globe is an example of this type.

Michael's changes to this globe include modifications achieved by trimming old gores or pasting on new fragments and adding notes in manuscript (among them, new discoveries in North America, Japan, and Australia). The loxodromes were removed; these curves, cutting the meridians at a

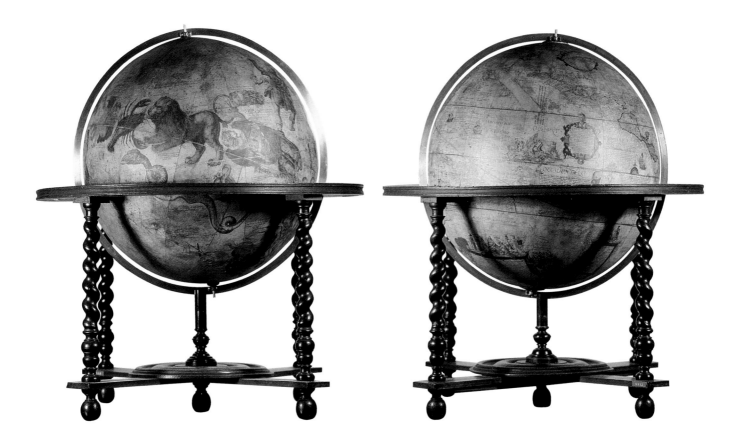

constant non-right angle, were originally applied to globes to indicate the path of a ship. In Brussels, however, Michael had no connection with seafaring and tended to view his globe as an aid to cosmographic research rather than as a navigational tool. The most remarkable change to the globe was Puteanus's addition of a date line. This drawn circle indicating the "beginning of the civil day" and located at 217° longitude ran through Rome and was called a *Circulus Urbanianus* after Urban VIII, pope from 1623 until 1644. Of note, too, are Australia and New Zealand, drawn as they were known at the time of Abel Tasman's (ca. 1603–possibly before 1659) discoveries in 1644.[3]

Globes such as these are relatively rare. Their production in the Southern Netherlands was limited, partly because of the time-consuming process (both the manual labor and the necessity of incorporating new discoveries) and partly because of competition from the North in international commerce.[4]

91.

Two panels and two matching borders from a wall hanging,

1670–90
Mechelen
Printing mold made by the engraver
JOHANNES VAN HATTEM (died 1691)
Gilt leather
Each panel: 30 x 23 ½ inches
(76.2 x 60 cm)
Each border: 9 x 24 ¼ inches
(22.9 x 61.6 cm)
Royal Museums of Art and History,
Brussels, inv. 1042

1. The border of the wall hanging
 in Wiston House, very close to
 those in the exhibition, is signed
 "Johannes van Hattem," an
 engraver working in the Southern
 Netherlands known for his coins
 and medals. He made the molds
 used for the panels and borders
 and might also have designed the
 patterns on them. My thanks to Dr.
 Eloy Koldeweij of the Rijksdienst
 voor de Monumentenzorg, Zeist,
 for this information and other
 pertinent data contained in this
 entry.
2. Koldeweij in correspondence with
 the author, 26 May 1999.
3. The basic technique for making gilt
 leather is described in Koldeweij
 1991a, 5. The new printing method,
 invented by Jacob Dircxz de Swart
 (before 1594–1641) in The Hague
 in 1628, made it possible to produce
 numerous identical gilt leather
 sheets with fine, raised patterns.
 The embossing gave a completely
 new appearance to an old and
 established product. See Koldeweij
 1991b, 10. According to Koldeweij
 in correspondence of 24 May 1999,
 painters and silversmiths were hired
 by the Northern gilt leather makers
 to design the patterns (which
 is different than the practice of
 Spanish and Italian gilt leather
 makers).
4. Koldeweij in correspondence with
 the author, 24 May 1999.

The whimsical decoration on these leather panels features mythical creatures amid spirals of fruit and foliage. The panels are almost mirror images of each other, yet they exhibit significant variations. For example, the central griffin on the left panel eats berries, while the griffin on the right holds a snake in its beak. The left panel features a ram and monster with a tufted mane and whiskers, while the right depicts a unicorn and rampant lion in comparable positions. The forms of the vegetation in the two panels do not conform exactly either.

These patterns, with different borders, are found on wall hangings in the Musée National de la Renaissance (Château de Ecouen, France), Wiston House, Sussex,[1] and the Swedish castles Skokloster and Sövdeborg. Identical borders to the ones exhibited here, featuring a central stylized leaf flanked by variant dragons emerging from small spirals of fruit and foliage, are in the Castle Beauvoorde, Belgium, and the Castle Vollrads, Germany. They are hung with panels of different patterns. The mixing of panels and borders in various combinations was not at all unusual.[2]

In order to make embossed gilt leather, a piece of calfskin was covered with a thin layer of silver foil, which in turn was covered with parchment glue or albumen to prevent the silver from oxidizing. A layer or two of yellow-brown varnish was applied over the covered foil which created a "golden surface." The skin was then turned over and pressed into a metal printing mold containing a cut-out pattern.[3] It was subsequently painted with one or several colors according to the client's wishes.

Gilt leather was an extremely expensive type of wall hanging because of the costs of the material (calfskins, silver foil), equipment (press, molds, tools), labor, and design. Despite the high prices commanded for such decoration, however, probate inventories reveal that they existed in great quantities in the mid-seventeenth century, in both the Northern and Southern Netherlands. Inventories from Antwerp indicate that it was not unusual for the wealthy to have had two or three gilt leather wall hangings in their homes.[4]

BIBLIOGRAPHY

Abbott 1984
Abbott, David. *The Biographical Dictionary of Scientists: Astronomers*. New York, 1984.

Allgemeines Künstler-Lexikon 1992
Allgemeines Künstler-Lexikon: Die bilden-den Künstler aller Zeiten und Völker. Edited by Günster Meissner. Munich, 1992.

Amsterdam 1976
Amsterdam, Rijksmuseum. *Tot lering en vermaak*. Amsterdam, 1976.

Amsterdam 1977
Amsterdam, Royal Palace. *Beelden kijken: De kunst van Quellien in het Paleis op de Dam /Focus on Sculpture: Quellien's Art in the Palace on the Dam*. Catalogue by Katharine Freemantle. Amsterdam, 1977.

Amsterdam 1980
Amsterdam, Rijksmuseum. *Ovidius Herschapen: Geïllustreerde uitgaven van de Metamorphosen in de Nederlanden uit de zestiende, zeventiende, en achttiende eeuw*. Catalogue by A.W.A. Boschloo et al. 's Gravenhage, 1980.

Amsterdam 1983
Amsterdam, Gallery P. de Boer. *A Fruitful Past: A Survey of the Fruit Still Lifes of the Northern and Southern Netherlands from Brueghel till Van Gogh*. Catalogue by Sam Segal. Translated by Mrs. P.M. van Tongeren-Woodland. Mijdrecht, 1983.

Amsterdam 1986a
Amsterdam, Rijksmuseum. *Art Before the Iconoclasm: Northern Netherlandish Art 1525–1580*. Edited by W. Th. Kloek et al. Translated by Patricia Wardle. 's Gravenhage, 1986.

Amsterdam 1986b
Amsterdam, Rijksmuseum. *Kunst voor de beeldenstorm: Noordnederlandse kunst 1525–1580*. Edited by J.P. Filedt Kok et al. 's Gravenhage, 1986.

Amsterdam 1992
Amsterdam, Historisch Museum. *De wereld binnen handbereik: Nederlandse kunst- en rariteitenverzamelingen, 1585–1735. Catalogus*. Edited by Ellinoor Bergevelt and Renée Kistemaker. Amsterdam, 1992.

Amsterdam 1993a
Amsterdam, Rijksmuseum. *Dawn of the Golden Age: Northern Netherlandish Art, 1580–1620*. Edited by Ger Luijten and Ariane van Suchtelen. Translated by Michael Hoyle. Amsterdam, 1993.

Amsterdam 1993b
Amsterdam, Rijksmuseum. *Nederlandse meubelen, 1600–1800/ Dutch Furniture, 1600–1800*. Catalogue by Reinier Baarsen. Amsterdam, 1993.

Amsterdam 1996a
Amsterdam, Museum het Rembrandthuis. *Patriarchs, Angels, & Prophets: The Old Testament in Netherlandish Printmaking from Lucas van Leyden to Rembrandt*. Catalogue by Peter van der Coelen. Studies in Dutch Graphic Art, vol. 2. Amsterdam, 1996.

Amsterdam 1996b
Amsterdam, Rijksmuseum. *Duits steen-goed/German Stoneware*. Catalogue by Ekkart Klinge. Translated by David McLintock. Aspects of the Collection, vol. 7: Sculpture and Decorative Arts. Amsterdam, 1996.

Amsterdam 1997
Amsterdam, Rijksmuseum. *Mirror of Everyday Life: Genre Prints in the Netherlands, 1550–1700*. Catalogue by Eddy de Jongh and Ger Luijten. Translated by Michael Hoyle. Amsterdam, 1997.

Anthony van Dyck 1975
"Anthony van Dyck: Portrait du sculp-teur Frans Duquesnoy. Manuscrit inédit des Archives du Louvre (auteur anonyme)." In *La vie, les ouvrages, et les élèves de van Dyck*, 53–54, Palais des Académies, Classe des Beaux-Arts, vol. 2. Brussels, 1975.

Antwerp 1966
Antwerp, Rubenshuis. *Tekeningen van Jacob Jordaens*. Catalogue by R.-A. d'Hulst. Antwerp, 1966.

Antwerp 1971
Antwerp, Rubenshuis. *Rubens en zijn tijd: Tekeningen uit Belgische verzamelingen.* Antwerp, 1971.

Antwerp 1977
Antwerp, Volkskundemuseum. *De huisvesting in Rubens' tijd.* Brussels, 1977.

Antwerp 1978
Antwerp, Koninklijk Museum voor Schone Kunsten. *Jordaens in Belgisch bezit.* Antwerp, 1978.

Antwerp 1988a
Antwerp, Rockoxhuis. *Zilver uit de gouden eeuw van Antwerpen.* Catalogue by Heinrich Hellebrandt. Antwerp, 1988.

Antwerp 1988b
Antwerp, Rubenshuis. *Antwerps huiszilver uit de 17de en 18de eeuw.* Catalogue by G. van Hemeldonck and Piet Baudouin. Antwerp, 1988.

Antwerp 1990
Antwerp, Rubenshuis. *Jan Boeckhorst, 1604–1668: Maler der Rubenszeit.* Freren, 1990.

Antwerp 1991a
Antwerp, Museum Plantin-Moretus en het Stedelijk Prentenkabinet. *Antoon Van Dyck (1599–1641) & Antwerpen.* Catalogue by Alfred Moir et al. Antwerp, 1991.

Antwerp 1991b
Antwerp, Stedelijk Prentenkabinet. *Rondom Rubens: Tekeningen en prenten uit eigen verzameling/Around Rubens: Prints and Drawings from the Stedelijk Prentenkabinet.* Edited by Francine de Nave. Antwerp, 1991.

Antwerp 1993a
Antwerp, Hessenhuis. *Antwerp: Story of a Metropolis, 16th–17th Century.* Edited by Jan van der Stock. Ghent, 1993.

Antwerp 1993b
Antwerp, Koninklijk Museum voor Schone Kunsten. *Jacob Jordaens (1593–1678).* Catalogue by R.-A. d'Hulst et al. Vol. 1: *Schilderijen en Wandtapijten*; vol. 2: *Tekeningen en Prenten.* Edited by Hans Devisscher and Nora de Poorter. Brussels, 1993.

Antwerp 1996
Antwerp, Museum Plantin-Moretus. *The Illustration of Books Published by the Moretuses.* Edited by Dirk Imhof. Antwerp, 1996.

Antwerp 1998
Antwerp, Museum Plantin-Moretus. *De wereld in kaart: Abraham Ortelius (1527–1598) en de eerste atlas.* Catalogue by Dirk Imhof. Antwerp, 1998.

Armstrong 1990
Armstrong, Christine Megan. *The Moralizing Prints of Cornelis Antonisz.* Princeton, N.J., 1990.

Atlanta 1984
Atlanta, High Museum of Art. *European Art in the High Museum.* Catalogue by Eric M. Zafran. Atlanta, Ga., 1984.

Aurell et al. 1992
Aurell, Martin, Olivier Dumoulin, and Françoise Thelamon, eds. *La sociabilité à table: Commensalité et convivialité à travers les âges.* Publications de l'Université de Rouen, no. 178. Rouen, 1992.

vander Auwera 1989
vander Auwera, Joost. "Conservatieve tendensen in de contrareformatorische kunst: Het geval Abraham Janssen." *De Zeventiende Eeuw: Cultuur in de Nederlanden in interdisciplinair perspectief* 5 (1989): 32–43.

Baetens 1998
Baetens, Roland. "Le relance d'une dynamique culturelle sous le règne des archiducs." In *Albert & Isabella: Essays,* ed. Werner Thomas and Luc Duerloo, 145–50. Brussels, 1998.

Balis 1985
Balis, Arnout. "Dieren als model. Het dier in de Vlaamse schilder- en beeldhouwkunst." *Openbaar Kunstbezit in Vlaanderen* 23 (1985): 13.

Balis 1991
_____. "De nieuwe genres en het burgerlijk mecenaat." In *Stad in Vlaanderen: Cultuur en maatschappij 1477–1787,* ed. Jan van der Stock, 237–54. Brussels, 1991.

Barber et al. 1976
Barber, A., L.V. Lockwood, and Hollis French. *The Ceramic, Furniture, and Silver Collector's Glossary.* New York, 1976.

Barnes 1990
Barnes, Susan. "The Young Van Dyck and Rubens." In *Anthony van Dyck,* cat. Arthur K. Wheelock, Jr. et al., 17–26. Washington, D.C., 1990.

Barnes and Wheelock 1994
Barnes, Susan J., and Arthur K. Wheelock, Jr., eds. *Van Dyck 350.* Studies in the History of Art, vol. 46. Washington, D.C., 1994.

Battie and Cottle 1991
Battie, David, and Simon Cottle, eds. *Sotheby's Concise Encyclopedia of Glass.* Boston, 1991.

Baudouin, F. 1981
Baudouin, Frans. *Het interieur van de Sint-Carolus Borromeuskerk te Antwerpen: Een schilderij op marmer van Willem van Ehrenberg.* Antwerp, [1981].

Baudouin, F. 1984
_____. "Jacob van Oost de Oudere: Een meester van het tweede plan," review of *Jacob van Oost de Oudere en het zeventiende-eeuwse Brugge,* by J.L. Meulemeester. In *Het Standaard,* 25 November 1984.

Baudouin, F. 1989
_____. *P.P. Rubens.* Translated by Elsie Callander. New York, 1989.

Baudouin, F. 1991a
_____. "Prenten naar Rubens/Prints After Rubens." In *Rondom Rubens: Tekeningen en prenten uit eigen verzameling/Around Rubens: Prints and Drawings from the Stedelijk Prentenkabinet,* ed. Francine de Nave, 41–47. Antwerp, 1991.

Baudouin, F. 1991b
_____. "Rondom Rubens: Tekeningen en prenten uit Rubens' omgeving/Around Rubens' Entourage." In *Rondom Rubens: Tekeningen en prenten uit eigen verzameling,* ed. Francine de Nave, 23–39. Antwerp, 1991.

Baudouin, F. et al. 1995
Baudouin, Frans et al. *The Rockox House, Antwerp.* Antwerp, 1995.

Baudouin, P. 1985
Baudouin, Piet. "Profaan zilverwerk in de Zuidelijke Nederlanden en het Prinsbisdom Luik van de 16de tot en met de 18de eeuw." In *Meesterwerken in zilver. Burgerlijk zilver van de 16de, 17de, en 18de eeuw uit de Zuidelijke Nederlanden en het Prinsbisdom Luik uit privé verzamelingen*, 15–24. Ghent, 1985.

Baudouin, P. et al. 1988a
Baudouin, Piet, Pierre Colman, and Dorsan Goethals. *Edelsmeedkunst in België. Profaan zilver XVIde–XVIIde–XVIIIde eeuw.* Tielt, 1988.

Baudouin, P. et al. 1988b
_____. *Orfèvrerie en Belgique XVIe–XVIIe–XVIIIe siècles.* Paris, 1988.

Bauman and Liedtke 1992
Bauman, Guy C., and Walter A. Liedtke. *Flemish Paintings in America: A Survey of Early Netherlandish and Flemish Paintings in the Public Collections of America.* Antwerp, 1992.

Bautier 1926–27
Bautier, Pierre. "Les tableaux de singeries attribués à Teniers." *Société Royale Archéologique de Bruxelles Annales* 32–33 (1926–27): 85–88.

Bautier 1941
_____. "Jean-Antoine van der Baren et les peintres de fleurs." In *Musées Royaux des Beaux-Arts de Belgiques, Conférences, 1940–41*, 11–19. Publications du Patrimoine des Musées Royaux des Beaux-Arts de Belgique. Brussels, [1941].

Bautier 1944
_____. *Les peintres Van Oost et la fin de l'école de Bruges.* Publications du Patrimoine des Musées Royaux des Beaux-Arts de Belgique. Brussels, [ca. 1944].

Becker 1984
Becker, J. "From Mythology to Merchandise: An Interpretation of the Engraved Title of van Mander's *Wtleggingh*." *Quaerendo* 14 (1984): 18–42.

Bedaux 1993
Bedaux, Jan Baptist. "In Search for Simplicity. Interpreting the Amsterdam Town Hall." In *Polyanthea: Essays on Art and Literature in Honor of William Sebastian Heckscher*, ed. Karl-Ludwig Selig, 37–41. The Hague, 1993.

Beebe 1980
Beebe, Lucie B. "Rhenish Stoneware of the Renaissance." *American Ceramic Circle Bulletin* 2 (1980): 125–40.

vanden Bemden 1976
vanden Bemden, Yvette. "Peintures sur verre representant l'histoire de Joseph." *Bulletin des Musées Royaux d'Art et d'Histoire, Brussels* 48 (1976): 85–100.

Bergevelt et al. 1993
Bergevelt, Ellinoor, Debora J. Meijers, and Mieke Rijnders, eds. *Verzamelen van rariteitenkabinet tot kunstmuseum.* Heerlen, 1993.

Bergevelt and Kistemaker 1992
Bergevelt, Ellinoor, and Renée Kistemaker, eds. *De wereld binnen handbereik: Nederlandse kunst- en rariteitenverzamelingen, 1585–1735.* Zwolle, 1992.

Bergström 1956
Bergström, Ingvar. *Dutch Still-Life Painting in the Seventeenth Century.* Translated by Christina Hedström and Gerald Taylor. New York, 1956.

van Berkel 1993
van Berkel, K. "Institutionele verzamelingen in de tijd van de wetenschappelijke revolutie (1600–1750)." In *Verzamelen van rariteitenkabinet tot kunstmuseum*, ed. Ellinoor Bergvelt et al., 189–204. Heerlen, 1993.

Berlin 1995
Berlin, Altes Museum. *"Von Allen Seiten Schöne": Bronzen der Renaissance und des Barock. Katalog der Sammlung.* Edited by Volker Krahn. Heidelberg, 1995.

Berryer 1957
Berryer, Anne-Marie. *La verrerie ancienne aux Musées Royaux d'Art et d'Histoire.* Brussels, 1957.

Berryer and Dresse de Lébioles 1974
Berryer, Anne-Marie, and Liliane Dresse de Lébioles. *La mesure du temps à travers les âges aux Musées Royaux des Beaux-Arts de Belgique.* 2nd ed., rev. Brussels, 1974.

van Beuningen 1975
van Beuningen, H.J.E. "Raeren en Lucas de Wael." In *Rotterdam Papers II: A Contribution to Medieval Archeology*, ed. J.G.N. Renaud, 1–4. Rotterdam, 1975.

Bimbenet-Privat 1994
Bimbenet-Privat, Michèle. "Rinceaux." In *The History of the Decorative Arts: The Renaissance and Mannerism in Europe*, ed. Alain Gruber, 113–89. New York, 1994.

den Blauwen 1979
den Blauwen, A.L. *Nederlands zilver, 1580–1830/Dutch Silver, 1580–1830.* 's Gravenhage, 1979.

Blunt 1940
Blunt, Anthony. *Artistic Theory in Italy.* Oxford, 1940.

Bond 1937
Bond, Harold Lewis. *An Encyclopedia of Antiques.* Boston, 1937.

Boston 1989
Boston, Museum of Fine Arts. *Italian Etchers of the Renaissance and Baroque.* Catalogue by Sue Welsh Reed and Richard Wallace. Boston, 1989.

Boston 1993
Boston, Museum of Fine Arts. *The Age of Rubens.* Catalogue by Peter C. Sutton. Boston, 1993.

Bowen 1996
Bowen, Karen. "The Moretuses Production of Illustrated Liturgical Texts." In *The Illustration of Books Published by the Moretuses*, ed. Dirk Imhof, 13–28. Antwerp, 1996.

Brenninkmeijer-de Rooij 1996
Brenninkmeijer-de Rooij, Beatrijs. *Roots of Seventeenth-Century Flower Painting: Miniatures, Plant Books, Paintings.* Leiden, 1996.

Briels 1997
Briels, Jan. *Peintres flamands au berceau du siècle d'or hollandais, 1585–1630.* Translated by M. Rosbach and M. Vincent. Antwerp, 1997.

Brown 1998
Brown, Christopher. "Rubens and the Archdukes." In *Albert & Isabella: Essays,* ed. Werner Thomas and Luc Duerloo, 121–28. Brussels, 1998.

Bruges 1993
Bruges, Stedelijke Musea. *Meesterwerken van de Brugse edelsmeedkunst.* Bruges, 1993.

Brussels 1963
Brussels, Musées Royaux des Beaux-Arts de Belgique. *Le siècle de Bruegel: La peinture en Belgique au XVIe siècle.* Brussels, 1963.

Brussels 1965
Brussels, Musées Royaux des Beaux-Arts de Belgique. *Le siècle de Rubens: La peinture en Belgique au XVIIe siècle.* 2nd ed. Brussels, 1965.

Brussels 1976
Brussels, Koninklijke Musea voor Schone Kunsten van België. *Het Brabantse landschap in de 17de eeuw: Van Brueghel de Jonge tot d'Arthois.* Brussels, 1976.

Brussels 1977a
Brussels, Musée d'Art Ancien. *La sculpture au siècle de Rubens dans les Pays-Bas méridionaux et la principauté de Liège.* Brussels, 1977.

Brussels 1977b
Brussels, Musées Royaux d'Art et d'Histoire. *Tapisseries bruxelloises au siècle de Rubens.* Edited by Rotraud Bauer and Guy Delmarcel. Brussels, 1977.

Brussels 1979
Brussels, Nationaal Bank van België. *Economische en financiele aspecten van de Brusselse geschiedenis.* Brussels, 1979.

Brussels 1980
Brussels, Palais des Beaux-Arts. *Bruegel: Une dynastie de peintres.* Catalogue by Robert de Smet et al. Brussels, 1980.

Brussels 1984
Brussels, Musées Royaux des Beaux-Arts de Belgique. *Départment d'art ancien: Catalogue inventaire de la peinture ancienne.* Catalogue by Matthias Winner. Brussels, 1984.

Brussels 1985
Brussels, Palais des Beaux-Arts. *Splendeurs d'Espagne et les villes belges, 1500–1700.* Vol. 1. Edited by Jean-Marie Duvosquel and Ignace Vandervivière. Brussels, 1985.

Brussels 1989a
Brussels, Generale Bank. *Zuid-nederlandse pronkmeubels: 16de–18de eeuw.* Catalogue by Ria Fabri. Brussels, 1989.

Brussels 1989b
Brussels, Musées Royaux d'Art et d'Histoire. *The Royal Museums of Art and History, Brussels: Europe.* Catalogue by Anne Cahen-Delhaye et al. Edited by Valentin Vermeersch and Jean-Marie Duvosquel. Brussels, 1989.

Brussels 1989c
Brussels, Musées Royaux des Beaux-Arts de Belgique. *Tableaux de fleurs du XVIIe siècle: Peinture et botaniques.* Brussels, 1989.

Brussels 1991
Brussels, Gemeentekrediet. *Stad in Vlaanderen: Cultuur en maatschappij, 1478–1787.* Edited by Jan van der Stock. Brussels, 1991.

Brussels 1993
Brussels, Musées Royaux des Beaux-Arts de Belgique. *Jacob Jordaens in de Koninklijke Musea voor Schone Kunsten van België/Jacob Jordaens aux Musées Royaux des Beaux-Arts de Belgique.* Brussels, 1993.

Brussels 1994a
Brussels, Musées Royaux des Beaux-Arts de Belgique. *Le Musée caché: À la découverte des réserves/Het verborgen museum: Ontdekkingstocht in de reserves.* Catalogue by Eliane de Wilde et al. Brussels, 1994.

Brussels 1994b
Brussels, Musées Royaux d'Art et d'Histoire. *S.O.S. Wandtapijten: Redding van 24 belangrijke kunstwerken/S.O.S. Tapisseries: 24 oeuvres majeures sauvées de la dégradation.* Brussels, 1994.

Brussels 1995
Brussels, Musées Royaux des Beaux-Arts de Belgique. *Divertimento: La musique dans l'art.* Brochure by Stefaan Hautekeete and Joost vander Auwera. Brussels, 1995.

Brussels 1996a
Brussels, Galerie du Crédit Communale de Belgique. *La peinture florale du XVIe au XXe siècle.* Brussels, 1996.

Brussels 1996b
Brussels, Musées Royaux des Beaux-Arts de Belgique. *The Royal Museums of Fine Arts of Belgium: A Guide to the Collections of Ancient Art and Modern Art.* Brussels, 1996.

Brussels 1996c
Brussels, Koninklijke Musea voor Kunst en Geschiedenis. *Museumstukken als Figuranten in een Stripverhaal.* Brussels, 1996.

Brussels 1998
Brussels, Koninklijke Musea voor Kunst en Geschiedenis. *Albrecht & Isabella, 1598–1621: Catalogus.* Edited by Luc Duerloo and Werner Thomas. Leuven, 1998.

de Bruyn 1985
de Bruyn, Jean-Pierre. "Voorstellingen van de Immaculata Conceptio in het oeuvre van Erasmus II Quellinus." In *Rubens and His World: Bijdragen–Études–Studies–Beiträge,* R.-A. d'Hulst, ed., 289–95. Antwerp, 1985.

van Bueren 1994
van Bueren, Truus. *Karel van Mander en de Haarlemse schilderkunst: 'De beste schilders van het gantsche Nederlandt'.* 's Gravenhage, 1994.

Bumpus 1928
Bumpus, T. Francis. *The Cathedrals and Churches of Belgium.* London, 1928.

Burk 1993
Burk, Peter. "Antwerp, A Metropolis in Comparative Perspective." In *Antwerp: Story of a Metropolis, 16th–17th Century,* ed. Jan van der Stock, 49–58. Ghent, 1993.

Burnby 1983
Burnby, Juanita G.L. *A Study of the English Apothecary from 1660 to 1760.* Medical History, Supplement No. 3. London, 1983.

Bussers 1985–88
Bussers, Helena. "Jan Baptist Bonnecroy: 17de-eeuws panoramaschilder." *Bulletin des Musées Royaux des Beaux-Arts de Belgique* 1–3 (1985–88): 161–80.

Bussers 1991
_____. *Vue de Bruxelles: J.B. Bonnecroy.* Brussels, 1991.

Caen 1990
Caen, Musée des Beaux-Arts. *Les vanités dans la peinture au XVIIe siècle: Méditations sur la richesse, le dénouement, et la rédemption.* Paris, 1990.

Cambridge 1981
Cambridge, Fogg Art Museum. *Fingerprints of the Artist: European Terracotta Sculpture from the Arthur M. Sackler Collections.* Introduction and catalogue by Charles Avery. Edited by Lois Katz. Cambridge, Mass., 1981.

Caviness 1978
Caviness, Madeline H. *Medieval and Renaissance Stained Glass from New England Collections.* Cambridge, Mass., 1978.

Charleston 1980
Charleston, Robert J. *Masterpieces of Glass: A World History from the Corning Museum of Glass.* New York, 1980.

Chartier 1989
Chartier, Roger, ed. *Passions of the Renaissance.* Vol. 3 of *A History of Private Life,* ed. Philippe Ariès and George Duby. Cambridge, Mass., 1989.

Chevallier 1996
Chevallier, Andrew. *The Encyclopedia of Medicinal Plants.* New York, 1996.

Chicago 1998
Chicago, The Art Institute of Chicago. *From the Sculptor's Hand: Italian Baroque Terracottas from the State Hermitage Museum.* Edited by Ian Wardropper. Chicago, 1998.

Chicorée 1972
La chicorée dans l'histoire de la médicine et dans la céramique pharmaceutique. Valenciennes, 1972.

Chong 1987
Chong, Alan. "The Market for Landscape Painting in Seventeenth-Century Holland." In *Masters of 17th-Century Dutch Landscape Painting,* ed. by Peter C. Sutton, 104–20. Boston, 1987.

Cocks 1978
Cocks, Anna Somers. "Mentmore Silver-Mounted Cabinet." *The Burlington Magazine* 120 (1978): 308–12.

van der Coelen 1996
van der Coelen, Peter. "Netherlandish Printmakers and the Old Testament." In *Patriarchs, Angels, & Prophets: The Old Testament in Netherlandish Printmaking from Lucas van Leyden to Rembrandt,* cat. Peter van der Coelen, 8–29. Amsterdam, 1996.

Collon-Gevaert 1951
Collon-Gevaert, Suzanne. *Histoire des arts du métal en Belgique.* Mémoires, Académie Royale de Belgique, Classe des beaux-arts, ser. 2, vol. 7. Brussels, 1951.

Cologne 1992
Cologne, Wallraf-Richartz-Museum. *Von Bruegel bis Rubens: Das goldene Jahrhundert der flämischen Malerei.* Edited by Ekkehard Mai and Hans Vlieghe. Cologne, 1992.

Cook 1974
Cook, L. "A 17th-Century Drug Account." *Pharmaceutical Historian* 4 (1974): 2–4.

Corning 1952
Corning, The Corning Museum of Glass. *The Glass Vessels in Dutch Painting of the 17th Century.* Corning, N. Y., 1952.

Davidson 1979
Davidson, Jane P. *David Teniers the Younger.* Boulder, Colo., 1979.

Deam 1998
Deam, Lisa. "Flemish Versus Netherlandish: A Discourse of Nationalism." *Renaissance Quarterly* 51(1998): 1–33.

Delft 1988
Delft, Stedelijk Museum Het Prinsenhof. *A Prosperous Past: The Sumptuous Still Life in the Netherlands 1600–1700.* Catalogue by Sam Segal. Edited by William B. Jordan. The Hague, 1988.

Delmarcel and Volckaert 1995
Delmarcel, Guy, and An Volckaert. *Flemish Tapestries: Five Centuries of Tradition.* Luxembourg, 1995.

Derveaux-van Ussel 1971–72
Derveaux-van Ussel, Ghislaine. "Twee zeventiende-eeuwse Antwerpse kunstkasten: Identificatie van de mythologische taferelen." *Bulletin des Musées Royaux d'Art et d'Histoire,* 6th ser., 43–44 (1971–72): 99–129.

Derveaux-van Ussel 1981
_____. *Mobilier: Gothique, renaissance, baroque.* Brussels, 1981.

Dictionary of Art 1996
The Dictionary of Art. Edited by Jane Turner. 34 vols. New York, 1996.

Dictionnaire des peintres 1995
Le dictionnaire des peintres belges du XIVe siècle à nos jours: Les premiers maîtres des anciens Pays-Bas méridionaux et de la Principauté de Liège jusqu'aux artistes contemporains. Preface by Eliane de Wilde. Brussels, 1995.

Dittrich and Dittrich 1995
Dittrich, Lothar, and Sigrid Dittrich. "Der Pferdeschädel als Symbol in der niederländischen Malerei des 17. Jahrhunderts." *Niederdeutsche Beiträge zur Kunstgeschichte* 34 (1995): 107–18.

Dohrn-van Rossum 1996
Dohrn-van Rossum, Gerhard. *History of the Hour: Clocks and Modern Temporal Orders.* Translated by Thomas Dunlap. Chicago, 1996.

Draper 1991–92
Draper, James David. "French Terracottas." *The Metropolitan Museum of Art Bulletin* 49 (1991–92): 4–57.

Drey 1978
Drey, Rudolf E.A. *Apothecary Jars, Pharmaceutical Pottery and Porcelain in Europe and the East, 1150–1850, with a Glossary of Terms Used in Apothecary Jar Inscriptions*. London, 1978.

Duerloo 1998
Duerloo, Luc. "Archducal Piety and Hapsburg Power." In *Albert & Isabella: Essays*, ed. Werner Thomas and Luc Duerloo, 267–84. Brussels, 1998.

Dumas 1994
Dumas, Charles, and Robert-Jan te Rijdt. *Kleur en raffinement: Tekeningen uit de Unicorno collectie*. Zwolle, 1994.

Düsseldorf 1979
Düsseldorf, Kunstmuseum. *P.P. Rubens & J. Jordaens: Handzeichnungen aus öffentlichen belgischen Sammlungen*. Catalogue by Wend von Kalnein. Düsseldorf, 1979.

Duverger 1988
Duverger, Erik. "The 16th Century: Tapestry and Textile Arts." In *Flemish Art: From the Beginning Till Now*, ed. Herman Liebars et al., 311–25. New York, 1988.

Ecouen 1989
Ecouen, Musée National de la Renaissance. *Catalogue de l'horlogerie et des instruments de précision du début du XVIe au milieu du XVIIe siècle*. Catalogue by Adolphe Chapiro et al. Paris, 1989.

Efland 1990
Efland, Arthur D. *A History of Art Education: Intellectual and Social Currents in Teaching the Visual Arts*. New York, 1990.

Eliens 1996
Eliens, Titus M. "De oorsprong van de stijlkamer." *Kunstschrift 1 [Openbaar Kunstbezit 40]* (1996): 39–41.

van der Elst 1994
van der Elst, E. *Collier de guilde malinois (XVIIe siècle)*. Brussels, [1994].

Engen 1989
Engen, Luc, ed. *Le verre en Belgique des origines à nos jours*. Antwerp, 1989.

Ertz 1979
Ertz, Klaus. *Jan Brueghel der Ältere (1568–1625). Die Gemälde mit kritischem Oeuvrekatalog*. Cologne, 1979.

Essen 1988
Essen, Kulturstiftung Ruhr, Villa Hügel. *Prag um 1600: Kunst und Kultur am Hofe Rudolfs II*. Freren, 1988.

Essen 1997
Essen, Kulturstiftung Ruhr, Villa Hügel. *Pieter Breughel der Jüngere–Jan Brueghel der Ältere: Flämische Malerei um 1600, Tradition und Fortschritt*. Edited by Klaus Ertz and Christa Nitzer-Ertz. Essen, 1997.

Evanston 1993
Evanston, Mary and Leigh Block Gallery, Northwestern University. *Graven Images: The Rise of Professional Printmakers in Antwerp and Haarlem 1540–1640*. Edited by Timothy Riggs and Larry Silver. Evanston, Ill., 1993.

Everett 1982
Everett, Thomas H. *The New York Botanical Garden Illustrated Encyclopedia of Horticulture*. 10 vols. New York, 1982.

Fabri 1982
Fabri, Ria. "Een zeventiende-eeuws Antwerps tafelcantoortje met getekende ivoren panelen: Iconografische identificatie." *Bulletin des Musées Royaux d'Art et d'Histoire* 53 (1982): 29–48.

Fabri 1988
_____. "The Seventeenth and Eighteenth Centuries: Furniture." In *Flemish Art: From the Beginning Till Now*, ed. Herman Liebars et al., 445–55. New York, 1988.

Fabri 1989
_____. "17th-Century Luxury Furniture in Antwerp Interiors." In *New Approaches to Living Patterns*, ed. R. Baetens and B. Blondé, 213–21. Antwerp, 1989.

Fabri 1991a
_____. "'De inwendighe wooninghe' ou la décoration intérieure des maisons." In *La ville en Flandre: Culture et société, 1478–1787*, ed. Jan van der Stock, 127–40. Brussels, 1991.

Fabri 1991b
_____. *De 17de-eeuwse Antwerpse kunstkast: Typologische en historische aspecten*. Koninklijke Academie voor Wetenschappen, Letteren en Schone Kunsten van Belgie, Klasse der Schone Kunsten, vol. 53, no. 53. Brussels, 1991.

Fabri 1993
_____. *De 17de-eeuwse Antwerpse kunstkast: Kunsthistorische aspecten*. Koninklijke Academie voor Wetenschappen, Letteren en Schone Kunsten van Belgie, Klasse der Schone Kunsten, vol. 55, no. 57. Brussels, 1993.

Farb and Armelagos 1980
Farb, Peter, and Serge Armelagos. *Consuming Passions: The Anthropology of Eating*. Boston, 1980.

Filedt Kok 1994
Filedt Kok, Jan Piet. "Jan Harmensz. Muller as Printmaker, I." *Print Quarterly* 11 (1994): 223–64.

Filedt Kok 1995
_____. "Jan Harmensz. Muller as Printmaker, III." *Print Quarterly* 12 (1995): 3–29.

Filedt Kok et al. 1994
Filedt Kok, Jan Piet et al. "Jan Harmensz. Muller as Printmaker, II." *Print Quarterly* 11 (1994): 351–78.

Flandrin 1989
Flandrin, Jean-Louis. "Distinction Through Taste." In *A History of Private Life*. Vol. 3. *Passions of the Renaissance*, ed. Roger Chartier, 265–307. Cambridge, Mass., 1989.

Flemish Art 1988
Flemish Art: From the Beginning Till Now. Edited by Herman Liebaers et al. Translated by John Cairns et al. New York, 1988.

Fock 1992
Fock, C. Willemijn. "Kunst en rariteiten in het Hollandse interior." In *De wereld binnen handbereik: Nederlandse kunst- en rariteitenverzamelingen, 1585–1735*, ed. Ellinoor Bergvelt and Renée Kistemaker, 70–91. Zwolle, 1992.

Fransolet 1942
Fransolet, Mariette. *François du Quesnoy: Sculpteur d'Urbain VIII, 1597–1643.* Mémoires, Académie Royale de Belgique, Classe des Beaux-Arts, ser. 2, vol. 9. Brussels, 1942.

Freedberg 1981
Freedberg, David. "The Origins and Rise of the Flemish Madonnas in Flower Garlands: Decoration and Devotion." *Münchner Jahrbuch der Bildenden Kunst* 32 (1981): 115–49.

Freedberg 1988
_____. *Iconoclasm and Painting in the Revolt of the Netherlands, 1566–1609.* New York, 1988.

Freedberg 1993
_____. "Painting and the Counter Reformation in the Age of Rubens." In *The Age of Rubens,* ed. Peter C. Sutton, 131–45. Boston, 1993.

Freedberg 1994
_____. "Van Dyck and Virginio Cesarini: A Contribution to the Study of van Dyck's Roman Sojourns." In *Van Dyck 350,* ed. Susan J. Barnes and Arthur K. Wheelock, Jr., 153–74. Washington, D.C., 1994.

Freemantle 1959
Freemantle, Katharine. *The Baroque Town Hall of Amsterdam.* Utrecht, 1959.

Freemantle 1961
_____. "Themes from Ripa and Rubens in the Royal Palace of Amsterdam." *The Burlington Magazine* 103 (1961): 258–64.

Fritz 1979
Fritz, Rolf. "Kokosnootbokalen, vervaardigd in de Nederlanden van de 15de tot de 18de eeuw." *Antiek* 13 (1979): 673–731.

Gabriels 1930
Gabriels, Juliane. *Artus Quellien, de Oude: Kunstrijke beeldhouwer.* Antwerp, 1930.

Gaimster 1997
Gaimster, David. *German Stoneware, 1200–1900: Archaeology and Cultural History.* London, 1997.

van Gelder 1993
van Gelder, Roelof. "Noordnederlandse verzamelingen in de zeventiende eeuw." In *Verzamelen van rariteitenkabinet tot kunstmuseum,* ed. Ellinoor Bergevelt et al., 123–44. Heerlen, 1993.

Geneva 1974
Geneva, Musée Rath. *De Genève à l'Ermitage: Les collections de François Tronchin.* Edited by Renée Locke. Geneva, 1974.

Genoa 1955
Genoa, Palazzo dell'Accademia. *100 Opere di van Dyck.* Genoa, 1955.

Gerson and ter Kuile 1960
Gerson, H., and E. H. ter Kuile. *Art and Architecture in Belgium, 1600 to 1800.* Harmondsworth, 1960.

Giltaij 1991
Giltaij, Jeroen. *Perspectives: Saenredam and the Architectural Painters of the 17th Century.* Rotterdam, 1991.

Glanville 1996
Glanville, Philippa, ed. *Silver.* London, 1996.

Gobert 1907
Gobert, T. "Banquets officiels aux XVIe et XVIIe siècles à Liège." *Bulletin de l'Institute Archéologique Liègeois* 37 (1907): 337–60.

Goodman 1995
Goodman, Elise. "'Les jeux innocents': French Rococo Birding and Fishing Scenes." *Simiolus* 23 (1995): 251–54.

Göttingen 1977
Göttingen, Universität Kunstsammlung. *Rubens in der Grafik.* Catalogue by Konrad Renger and Gerd Univerfehrt. Göttingen, 1977.

Grabske 1987
Grabske, Józef. "The Corsini Flagellation Group by Alessandro Algardi." *Artibus et Historiae* 16 (1987): 9–23.

Greindl 1956
Greindl, Edith. *Les peintres flamands de nature morte au XVIIe siècle.* Brussels, 1956.

Greindl et al. 1929
Greindl, Edith, et al. *XVIIe siècle: L'âge d'or de la peinture flamande.* Brussels, 1929.

Grieten 1993
Grieten, Jan. "Jan Baptist Bonnecroy." In *Antwerp: Story of a Metropolis, 16th–17th Century,* ed. Jan van der Stock, 162. Ghent, 1993.

Gruber 1994a
Gruber, Alain, ed. *The History of the Decorative Arts: The Renaissance and Mannerism in Europe.* New York, 1994.

Gruber 1994b
Gruber, Alain. "Introduction." In *The History of the Decorative Arts: The Renaissance and Mannerism in Europe,* ed. Alain Gruber, 13–19. New York, 1994.

Gutman 1940
Gutman, Elizabeth. "An Unknown Small Bronze by Frans Duquesnoy." *Art Quarterly* 3 (1940): 267–71.

Haarlem 1986
Haarlem, Frans Halsmuseum. *Portretten van echt en trouw. Huwelijk en gezin in de Nederlandse kunst van de zeventiende eeuw.* Catalogue by E. de Jongh. Zwolle, 1986.

Haarlem 1988
Haarlem, Frans Halsmuseum. *Schutters in Holland: Kracht en zenuwen van de stad.* Edited by M. Carasso-Kok and J. Levy-van Halm. Zwolle, 1988.

Hairs 1965
Hairs, Marie-Louise. *Les peintres flamands de fleurs au XVIIe siècle.* Paris, 1965.

Hairs 1977
_____. *"Dans le sillage de Rubens": Les peintres d'histoire anversois au XVIIe siècle.* Liège, 1977.

Hairs and Finet 1985
Hairs, Marie-Louise, and Dominique Finet. *Les peintres flamands de fleurs au XVIIe siècle.* Brussels, 1985.

Hall 1974
Hall, James. *Dictionary of Subjects and Symbols in Art.* Rev. ed. New York, 1974.

Hanover 1991
Hanover, Hood Art Museum, Dartmouth College. *The Age of the Marvelous.* Edited by Joy Kenseth. Hanover, N.H., 1991.

Hardyment 1992
Hardyment, Christina. *Home Comfort: A History of Domestic Arrangements*. London, 1992.

Hautekeete et al. 1991–92
Hautekeete, Stefaan et al. "Meester-werken op papier." *Openbaar Kunstbezit in Vlaanderen* 30 (1991–92), n.p.

Hayward 1964
Hayward, J.F. "The Mannerist Goldsmiths: 3: Antwerp." *Connoisseur* 156 (1964): 92–96; 165–70; 250–54.

Helbig and vanden Bemden 1974
Helbig, J., and Y. vanden Bemden. *Les vitraux de la première moitié du XVIe siècle conservés en Belgique: Brabant et Limbourg*. Ledeberg, 1974.

Held 1952
Held, Julius S. "The Burdens of Time: A Footnote on Abraham Janssens." *Bulletin des Musées Royaux des Beaux-Arts de Belgique* 1 (1952): 11–17.

Held 1959
_____. *Rubens: Selected Drawings*. 2 vols. London, 1959.

Held 1964
_____. "Two Drawings by Philip Fruytiers." *Art Quarterly* 27 (1964): 265–73.

Held 1967
_____. "Jan Boeckhorst as Draughtsman." *Bulletin des Musées Royaux des Beaux-Arts de Belgique* 16 (1967): 137–54.

Held 1980
_____. *The Oil Sketches of Peter Paul Rubens: A Critical Catalogue*. Kress Foundation Studies in the History of European Art, vol. 7. 2 vols. Princeton, 1980.

Held 1991
_____. "Notes on Flemish Seventeenth-Century Painting: Jacob van Oost and Theodor van Loon." *Art Quarterly* 18 (1991): 147–57.

Held 1993
_____. "Preface." In *Flemish Drawings in the Age of Rubens: Selected Works from American Collections*, ed. Anne-Marie S. Logan, 10–13. Wellesley, Mass., 1993.

Hellebrandt 1977
Hellebrandt, Heinrich. "Raerener Steinzeug." In *Steinzeug aus dem Raerener und Aachener Raum*, ed. Herbert Lepper, 9–170. Aachener Beiträge für Bauge-schichte und Heimatkunst, vol. 4. Aachen, 1977.

Henkel 1926–27
Henkel, M.D. "Illustrierte Ausgaben von Ovids *Metamorphosen* in XV., XVI., und XVII. Jahrhundert." *Vorträge der Bibliothek Warburg* 6 (1926–27): 58–144.

Henkes 1994
Henkes, Harold E. *Glas zoner glans: Vijf eeuwen gebruiksglas uit de bodem van de Lage Landen, 1300–1800/Glass without Gloss: Utility Glass from Five Centuries Excavated in the Low Countries, 1300–1800*. Rotterdam Papers 9. Rotterdam, 1994.

Holland 1978
Holland, Margaret. *Phaidon Guide to Silver*. Oxford, 1978.

Honig 1995
Honig, Elizabeth. "The Beholder as Work of Art: A Study in the Location of Value in Seventeenth-Century Flemish Painting." In *Beeld en zelfbeeld in de Nederlandse kunst, 1550–1750/Image and Self-Image in Netherlandish Art, 1550–1750*, ed. Reindert Falkenburg et al., 253–97. Netherlands Yearbook for the History of Art 1995, vol. 46. Zwolle, 1995.

Honig 1998
_____. *Painting and the Market in Early Modern Antwerp*. New Haven, 1998.

Hora 1981
Hora, Bayard. *The Oxford Encyclopedia of Trees of the World*. Oxford, 1981.

Hosten 1978
Hosten, A.-C. "Pierre-Paul Rubens: Les portraits des archducs Albert et Isabelle." *Brabant* 4 (1978): 2–11.

Houart 1982
Houart, V. *Antique Spoons: A Collector's Guide*. London, 1982.

Houston 1981
Houston, Sarah Campbell Blaffer Foundation Gallery, University of Houston. *A Golden Age of Painting: Dutch, Flemish, [and] German Painting [from the] Sixteenth [and] Seventeenth Centuries from the Collection of the Sarah Campbell Blaffer Foundation*. Catalogue by Christopher Wright. San Antonio, Tex., 1981.

Huemer 1985
Huemer, Frances. "Philip Rubens and His Brother the Painter." In *Rubens and His World: Bijdragen–Études–Studies–Beiträge*, ed. R.-A. d'Hulst, 123–28. Antwerp, 1985.

d'Hulst 1958a
d'Hulst, R.-A. "Antoine van Dyck: Portrait de sculpteur François Duquesnoy." In *Musées Royaux des Beaux-Arts de Bruxelles: Art Ancien* 64 (1958): no. 64.

d'Hulst 1958b
_____. "'Paul et Barnabe à Lystres' de Jacques Jordaens." *Bulletin des Musées Royaux des Beaux-Arts de Belgique* 2 (1958): 93–99.

d'Hulst 1967
_____. *Flemish Tapestries from the Fifteenth to the Eighteenth Century*. New York, 1967.

d'Hulst 1972
_____. *Flemish Drawings of the Seventeenth Century from the Collection of Frits Lugt*. Paris, 1972.

d'Hulst 1974
_____. *Jordaens Drawings*. 4 vols. London, 1974.

d'Hulst 1982
_____. *Jacob Jordaens*. Translated by R.S. Falla. Ithaca, N.Y., 1982.

Husband 1995
Husband, Timothy B. "Introduction." In *The Luminous Image: Painted Glass Roundels in the Lowlands, 1480–1560*, ed. Timothy B. Husband, 10–14. New York, 1995.

Imhof 1998
Imhof, Dirk. "Abraham Ortelius en het Plantijnse huis." In *De wereld in kaart: Abraham Ortelius (1527–1598) en de eerste atlas*, cat. Dirk Imhof, 13–21. Antwerp, 1998.

Israel 1982
Israel, Jonathan I. *The Dutch Republic and the Hispanic World, 1606–1661*. Oxford, 1982.

Israel 1995
_____. *The Dutch Republic: Its Rise, Greatness, and Fall, 1477–1806*. Oxford, 1995.

Israel 1997
_____. *Conflicts of Empires: Spain, the Low Countries, and the Struggle for World Supremacy, 1585–1713*. London, 1997.

Jaffé 1967
Jaffé, Michael. "Van Dyck's Sketches for his Portraits of Duquesnoy and of van Uffel." *Bulletin des Musées Royaux des Beaux-Arts de Belgique* 7 (1967): 155–62.

Jaffé 1997
_____. "Rubens's Portraits of the Archduke Albert and the Infanta Isabella." *The Burlington Magazine* 139 (1997): 194–95.

Janson 1952
Janson, H.W. *Apes and Ape Lore in the Middle Ages and the Renaissance*. London, 1952.

de Jongh 1968–69
de Jongh, E. "Erotica in vogelperspectief. De dubbelzinnigheid van een reeks 17de-eeuwse genrevoorstellingen." *Simiolus* 3 (1968/69): 22–74.

Kemp 1995
Kemp, Martin. "'Wrought by No Artist's Hand': The Natural, the Artificial, the Exotic, and the Scientific in some Artifacts from the Renaissance." In *Reframing the Renaissance: Visual Culture in Europe and Latin America, 1450–1650*, ed. Claire Farago, 176–96. New Haven, 1995.

Kenseth 1991
Kenseth, Joy. "The Age of the Marvelous: An Introduction." In *The Age of the Marvelous*, ed. Joy Kenseth, 25–59. Hanover, N.H., 1991.

King 1989
King, Catherine. "*Artes Liberales* and the Mural Decoration on the House of Frans Floris, Antwerp c. 1565." *Zeitschrift für Kunstgeschichte* 52 (1989): 139–56.

Klesse and Mayr 1987
Klesse, Brigitte, and Hans Mayr. *European Glass from 1500–1800: The Ernesto Wolf Collection*. Vienna, 1987.

Knipping 1974
Knipping, John. *Iconography of the Counter Reformation in the Netherlands*. 2 vols. Nieuwkoop, 1974.

Koeman 1964
Koeman, C[ornelius]. *The History of Abraham Ortelius and His Theatrum Orbis Terrarum*. New York, 1964.

Koeppe 1992
Koeppe, Wolfram. *Die Lemmers-Danforth-Sammlung Wetzlar*. Heidelberg, 1992.

von Kohnemann 1982
von Kohnemann, Michel. *Auflagen auf Raerener Steinzug: Ein Bildwerk*. Raeren, 1982.

Koldeweij 1991a
Koldeweij, Eloy. "Gilt Leather, Historical Developments." In *Ledertapeten*, 5–9. Essen, 1991.

Koldeweij 1991b
Koldeweij, Eloy. "Stylistic Developments." In *Ledertapeten*, 10–13. Essen, 1991.

Korf 1981
Korf, Dingeman. *Nederlandse majolica*. Bussum, 1981.

Koslow 1995
Koslow, Susan. *Frans Snyders*. Antwerp, 1995.

Kristeller 1951–52
Kristeller, Paul Oskar. "The Modern System of the Arts: A Study in the History of Aesthetics." *Journal of the History of Ideas* 12 (1951): 496–527; 13 (1952): 17–46.

van der Krogt 1993
van der Krogt, Peter. *Globi Neerlandici: The Production of Globes in the Low Countries*. Utrecht, 1993.

Laenen 1919–20
Laenen, J. *Histoire de l'église métropolitaine de Saint-Rombaut à Malines*. 2 vols. Malines, 1919–20.

Landau and Parshall 1994
Landau, David, and Peter Parshall. *The Renaissance Print, 1470–1550*. New Haven, 1994.

Landes 1983
Landes, David S. *Revolution in Time: Clocks and the Making of the Modern World*. Cambridge, Mass., 1983.

Lanoye 1998
Lanoye, Diederik. "Structure and Composition of the Household of the Archdukes." In *Albert & Isabella: Essays*, ed. Werner Thomas and Luc Duerloo, 107–20. Brussels, 1998.

Larsen 1980
Larsen, Erik. *L'opera completa di van Dyck*. Vol. 1: 1613–1626; vol. 2: 1626–1641. Milan, 1980.

Larsen 1988
_____. *The Paintings of Anthony van Dyck*. Lucca, 1988.

Laureyssens 1980
Laureyssens, Willy. "Jan van Kessel de Oude." In *Bruegel: Een dynastie van schilders*, ed. Robert de Smet et al., 313–15. Brussels, 1980.

Laureyssens 1989
_____. "De triptiek met de marteling van Sint Sebastiaan in de Sint-Martinus-kerk te Asse." *Ascania, Asse* 3–4 (1989): 101–14.

Lavin 1967
Lavin, Irvin. "Bozetti and Modelli." In *Stil und Überlieferung in der Kunst des Abendlandes*, vol. 3, *Theorien und Probleme*, 93–113. Akten des 21. Internationalen Kongresses für Kunst-geschichte in Bonn 1964. Berlin, 1967.

Legrand 1963
Legrand, F.-C. *Les peintres flamands de genre au XVIIe siècle*. Brussels, 1963.

Lemaire 1942
Lemaire, R. *Beknopte geschiedenis van de meubelkunst*. Antwerp, 1942.

van Lennep 1966
van Lennep, J. "L'alchemiste: origine et développement d'un thème de la peinture du dix-septième siècle." *Revue Belge d'Archéologie et d'Histoire de l'Art* 35 (1966): 149–68.

Leppert 1978
Leppert, Richard D. "Viols in Seventeenth-Century Flemish Paintings: The Iconography of Music Indoors and Out." *Journal of the Viola Da Gamba Society of America* 15 (1978): 5–40.

Leuven 1982
Leuven, Stedelijk Museum Vanderkelen-Mertens. *Inventaris Meubilair*. Catalogue by P. Demuynck. Kunstambachten, vol. 3. 9th ed. Leuven, 1982.

Levi d'Ancona 1957
Levi d'Ancona, Mirella. *The Iconography of the Immaculate Conception in the Middle Ages and Early Renaissance*. Monographs on Archaeology and Fine Arts, vol. 7. New York, 1957.

Leyva-Gutierrez 1998
Leyva-Gutierrez, Niria. "From Archduchess to Poor Clare: Rubens' Portrait of the Infanta Isabella Dressed in a Habit." Unpublished qualifying paper, Institute of Fine Arts, New York University, 1998.

Lille 1985
Lille, Musée des Beaux-Arts. *Au temps de Watteau, Fragonard, et Chardin: Les Pays-Bas et les peintres français au XVIIIe siècle*. Lille, 1985.

Limouze 1988
Limouze, Dorothy Anne. "Aegidius Sadeler (c. 1570–1629): Drawings, Prints, and the Development of an Art Theoretical Attitude." In *Prag um 1600: Beiträge zur Kunst und Kultur am Hofe Rudolfs II*, 183–92. Freren, 1988.

Limouze 1989
_____. "Aegidius Sadeler, Imperial Printmaker." *Philadelphia Museum of Art Bulletin* 85 (1989): 3–24.

Limouze 1993
_____. "Aegidius Sadeler (c. 1570–1629): Drawings, Prints, and Art Theory." Ph.D. diss., Princeton University, 1990. Ann Arbor, Mich., 1993.

Lind 1946
Lind, L.R. "The Latin Life of Peter Paul Rubens by His Nephew Philip: A Translation." *Art Quarterly* 9 (1946): 37–43.

Lockwood 1967
Lockwood, Luke Vincent. *The Furniture Collectors' Glossary*. New York, 1967.

Logan 1990
Logan, Anne-Marie S. "Jan Boeckhorst als Zeichner." In *Jan Boeckhorst, 1604–1668: Maler der Rubenszeit*, ed. Jochen Luckhardt and Hans Vlieghe, 118–32. Freren, 1990.

Logan 1993
_____. "Seventeenth-Century Flemish Drawings." In *Flemish Drawings in the Age of Rubens: Selected Works from American Collections*, ed. Anne-Marie S. Logan, 18–51. Wellesley, Mass., 1993.

London 1968
London, British Museum. *Masterpieces of Glass: A Selection*. Catalogue by D.B. Harden et al. London, 1968.

London 1970
London, National Gallery. *The Flemish School, circa 1600–circa 1900*. Catalogue by Gregory Martin. London, 1970.

London 1976
London, Wallace Collection. *Catalogue of Ceramics*. Vol. 1: *Pottery, Maiolica, Faience, Stoneware*. Catalogue by A.V. B. Norman. London, 1976.

London 1996
London, Victoria and Albert Museum. *Western Furniture 1350 to the Present Day in the Victoria and Albert Museum*. Edited by Christopher Wilk. London, 1996.

de Maere and Wabbes 1994
de Maere, J., and M. Wabbes. *Illustrated Dictionary of 17th-Century Flemish Painters*. Edited by Jennifer A. Martin. 2 vols. Brussels, 1994.

de Maeyer 1955
de Maeyer, Marcel. *Albrecht en Isabella en de schilderkunst: Bijdrage tot de geschiedenis van de XVIIe-eeuwse schilderkunst in de Zuidelijke Nederlanden*. Brussels, 1955.

Magurn 1991
Magurn, Ruth Saunders, trans. and ed. *The Letters of Peter Paul Rubens*. Evanston, Ill., 1991.

de Marchi and van Miegroet 1994
de Marchi, Neil, and Hans J. van Miegroet. "Art, Value, and Market Practices in the Netherlands in the Seventeenth Century," *Art Bulletin* 76 (1994): 451–64.

de Marchi and van Miegroet 1996
_____. "Pricing Invention: 'Originals,' 'Copies,' and their Relative Value in Seventeenth-Century Netherlandish Art Markets." In *Economics of the Arts: Selected Essays*, ed. Victor A. Ginsburgh and Pierre-Michel Menger, 27–70. Amsterdam, 1996.

Marlier 1964
Marlier, Georges. "C.N. Gysbrechts, l'illusioniste: Cornelius Norbertus, peintre flamand du XVIIe siècle passé maître en l'art du trompe-l'oeil fournisseur attitré du roi Christian V de Danemark." *Connaissance des arts* (March 1964): 96–105.

Martin 1972
Martin, John Rupert. *The Decorations for the Pompa Introitus Ferdinandi*. Corpus Rubenianum Ludwig Burchard, Part XVI. London, 1972.

Martín Gonzalez 1988
Martín Gonzalez, Juan J. "Bienes artisticas de don Rodrigo Calerón." *Bulletin del Seminario de Estudios de Arte y Arqueologia*, Universidad de Valladolid (1988): 267–92.

McGrath 1985
McGrath, Elizabeth. "An Allegory of the Netherlandish War by Hendrik de Clerck." In *Rubens and His World: Bijdragen–Études–Studies–Beiträge*, ed. R.-A. d'Hulst, 77–86. Antwerp, 1985.

Mechelen 1997
Mechelen, Stedelijk Museum Hof van Busleyden. *Lucas Faydherbe, 1617–1697: Mechels beeldhouwer and architect.* Catalogue by Heidi de Nijn et al. Mechelen, 1997.

van Meerbeeck 1965
van Meerbeeck, Luciennes. "Un officier lorrain au service de Pays-Bas: Paul-Bernard de Fontaine d'après des documents inédits (1596–1643)." *Revue internationale d'histoire militaire* 247 (1965): 302–20.

Mette 1995
Mette, Hanns-Ulrich. *Der Nautiluspokal: Wie Kunst und Natur miteinander Spielen.* Munich, 1995.

Metz 1993
Metz, Musée des Beaux-Arts. *La réalité magnifiée–Peinture flamande, 1550–1700.* Wielsbeke, 1993.

Meulemeester 1984
Meulemeester, Jan Luc. *Jacob van Oost de Oudere en het zeventiende-eeuwse Brugge.* Bruges, 1984.

Michel 1939
Michel, Edouard. *Flemish Painting in the XVIIth Century.* Paris, 1939.

Miedema 1989
Miedema, H. "Over vakonderwijs aan kunstschilders in de Nederlanden tot de zeventiende eeuw." In *Academies of Art Between the Renaissance and Romanticism,* ed. A.W.A. Boschloo et al., 268–82. The Hague, 1989.

de Mirimonde 1964
de Mirimonde, A.P. "Les concerts parodiques chez les maîtres du nord." *Gazette des Beaux-Arts,* 6th ser., 64 (1964): 253–84.

de Mirimonde 1971
_____. "Les peintres flamands de trompe l'oeil et de natures mortes au XVIIe siècles, et les sujets de musique." In *Jaarboek van het Koninklijk Museum voor Schone Kunsten Antwerpen 1971,* 223–72. Antwerp, 1971.

ter Molen 1976
ter Molen, J.R. "Decoration on Silver: The Application of Prints in the Work of Seventeenth-Century Dutch Silversmiths." *Connoisseur* 173 (1976): 94–103.

Moloney 1993
Moloney, Francis J. *Belief in the Word: Reading the Fourth Gospel, John 1–4.* Minneapolis, Minn., 1993.

Moloney 1998
_____. *The Gospel of St. John.* Sacra Pagina Series, vol. 4. Collegeville, Minn., 1998.

Montagu 1985
Montagu, Jennifer. *Alessandro Algardi.* New Haven, 1985.

Montagu 1986
_____. "Desegni, Bozetti, Legnetti and Modelli in Roman Seicento Sculpture." In *Entwurf und Ausführung in der Europäischen Barockplastik: Beiträge zum internationalen Kolloquium des Bayerischen Nationalmuseums und des Zentralinstituts für Kunstgeschichte,* ed. Peter Volk, 9–30. Munich, 1986.

Müller Hofstede 1971
Müller Hofstede, Justus. "Abraham Janssens: Zur Problematik des flämischen Caravaggismus." *Jahrbuch der Berliner Museen* 13 (1971): 208–65.

Muller, Jeffrey 1993
Muller, Jeffrey M. "Private Collections in the Spanish Netherlands: Ownership and Display of Paintings in Domestic Interiors." In *The Age of Rubens,* ed. Peter C. Sutton, 194–206. Boston, 1993.

Muller, Josy 1983
Muller, Josy. *Laiton dinanderie.* Brussels, 1983.

Munich 1982
Munich, Bayerischen Nationalmuseums. *Die Glassammlung des Bayerischen Nationalmuseums München.* Edited by Rainer Ruckert. 2 vols. Munich, 1982.

Munich 1989
Munich, Staatliche Graphische Sammlung München. *Niederländische Zeichnungen des 16. Jahrhunderts in der Staatlichen Graphischen Sammlungen, München.* Munich, 1989.

Murray and Murray 1996
Murray, Peter, and Linda Murray. *The Oxford Companion to Christian Art and Architecture.* Oxford, 1996.

Muylle 1991
Muylle, Jan. "Genre-iconografie en genreschilders in woord en beeld." In *Stad in Vlaanderen: Cultuur en maatschappij, 1477–1787,* ed. Jan van der Stock, 268–78. Brussels, 1991.

Namur 1998
Namur, Musée des Arts Anciens du Namurois. *Corporations de métiers à Namur au XVIIIe siècle.* Catalogue by Jacques Toussaint. Namur, 1998.

de Nave 1996
de Nave, Francine. "The Moretuses and the History of Books in Antwerp in the 17th and 18th Centuries." In *The Illustration of Books Published by the Moretuses,* ed. Dirk Imhof, 13–28. Antwerp, 1996.

Nelson 1986
Nelson, Kristi. "Jacob Jordaens' Drawings for Tapestry." *Master Drawings* 23–24 (1986): 214–28.

Neurdenburg 1948
Neurdenburg, Elisabeth. *De zeventiende-eeuwsche beeldhouwkunst in de Noordelijke Nederlanden: Hendrick de Keyser, Artus Quellinus, Rombout Verhulst en tijdgenooten.* Amsterdam, 1948.

New York 1991
New York, Pierpont Morgan Library. *Netherlandish Drawings of the Fifteenth and Sixteenth Centuries, Flemish Drawings of the Seventeenth and Eighteenth Centuries in the Pierpont Morgan Library.* Catalogue by Felice Stampfle. New York, 1991.

New York 1995
New York, Metropolitan Museum of Art. *The Luminous Image: Painted Glass Roundels in the Lowlands, 1480–1560.* Catalogue by Timothy B. Husband. New York, 1995.

Nijstad 1986
Nijstad, Jaap. "William Danielsz. van Tetrode." In *Renaissance en Reformatie en de kunst van de Noordelijke Nederlanden,* ed. Wouter Kloek et al, 259–79. Nederlands Kunsthistorisch Jaarboek, vol. 37. Weesp, 1986.

Noordegraaf and Wijsenbeek-Olthuis 1992
Noordegraaf, Leo, and Thera Wijsenbeek-Olthuis. "De wereld ontsloten: Aanvoer van rariteiten naar Nederland." In *De wereld binnen handbereik: Nederlandse kunst- en rariteitenverzamelingen, 1585–1735*, ed. Ellinoor Bergvelt and Renée Kistemaker, 39–50. Zwolle, 1992.

O' Connor 1958
O' Connor, Edward Dennis, ed. *The Dogma of the Immaculate Conception: History and Significance*. Notre Dame, Ind., 1958.

Oman 1963
Oman, Charles. *Medieval Silver Nefs*. Victoria and Albert Museum Monograph, no. 15. London, 1963.

Opgeruimd staat netjes 1997
Opgeruimd staat netjes: Bergmeubelen van eind 16de tot begin 20ste eeuw. Leuven, 1997.

Orenstein 1996
Orenstein, Nadine M. *Hendrick Hondius and the Business of Prints in Seventeenth-Century Holland*. Studies in Prints & Printmaking, vol. 1. Rotterdam, 1996.

Orenstein et al. 1993
Orenstein, Nadine, Huigen Leeflang, Ger Luijten, and Christiaan Schuckman. "Print Publishers in the Netherlands, 1580–1620." In *Dawn of the Golden Age: Northern Netherlandish Art, 1580–1620*, ed. Ger Luijten and Ariane van Suchtelen, 167–200. Translated by Michael Hoyle. Amsterdam, 1993.

Osaka 1990
Osaka, Nabio Museum of Art. *Flowers and Nature: Netherlandish Flower Painting of Four Centuries*. Catalogue by Sam Segal. The Hague, 1990.

Ostrow 1996
Ostrow, Steven F. "Cigoli's *Immacolata* and Galileo's Moon: Astronomy and the Virgin in Early Seicento Rome." *Art Bulletin* 78 (1996): 218–35.

Padrón 1995
Padrón, Matías Díaz. *El Siglo de Rubens en el Museo del Prado: Catálogo razonado de pintura flamenca del siglo XVII*. Madrid, 1995.

Padrón and Royo-Villanova 1992
Padrón, Matías Díaz, and Mercedes Royo-Villanova. *David Teniers, Jan Brueghel y los Gabinetes de Pinturas*. Madrid, 1992.

Pardailhé-Galabrun 1991
Pardailhé-Galabrun, Annik. *The Birth of Intimacy: Private and Domestic Life in Early Modern Paris*. Translated by Jocelyn Phelps. Philadelphia, 1991.

Paris 1972
Paris, Institut Néerlandais. *Flemish Drawings of the Seventeenth Century from the Collection of Frits Lugt, Institut Néerlandais, Paris*. Introduction by R.-A. d'Hulst. Paris, 1972.

Paris 1974
Paris, Institut Néerlandais. *Dessins flamands et hollandais du dix-septième siècle: Collections Musées de Belgique; Musée Boymans-Van Beuningen, Rotterdam; Institut Néerlandais, Paris*. Catalogue by A.W. F. M. Meij, J. Giltaij, M. van Berge, and C. van Hasselt. Paris, 1974.

Paris 1977
Paris, Grand Palais. *Le siècle de Rubens dans les collections publiques françaises*. Paris, 1977.

Parker 1977
Parker, Geoffrey. *The Dutch Revolt*. Ithaca, N.Y., 1977.

de Pauw-de Veen 1969
de Pauw-de Veen, L. *De begrippen "schilder," "schilderij," en "schilderen" in de zeventiende eeuw*. Brussels, 1969.

Payne 1996
Payne, Christopher, ed. *Sotheby's Concise Encyclopedia of Furniture*. New York, 1996.

Penny 1993
Penny, Nicholas. *The Materials of Sculpture*. New Haven, 1993.

Phillips 1981
Phillips, Phoebe, ed. *The Encyclopedia of Glass*. New York, 1981.

Pigler 1956
Pigler, A. *Barockthemen: Eine Auswahl von Verzeichnissen zur Ikonographie des 17. und 18. Jahrhunderts*. 2 vols. Budapest, 1956.

de Piles 1970
de Piles, Roger. *Conversations sur la connaissance de la peinture et sur le jugement qu'on doit faire des tableaux*. Geneva, reprint of 1672 text, 1970.

Pollitt 1965
Pollitt, J.J., ed. "Painting: Zeuxis of Herakleia." In *The Art of Greece, 1400–31 B.C.: Sources and Documents*, 154–55. New York, 1965.

de Poorter 1969
de Poorter, Nora. "Antoon van Dyck: Portret van Frans du Quesnoy(?)." *Openbaar Kunstbezit in Vlaanderen* 7 (1969): 17.

de Poorter 1988
————. "Rubens onder de wapenen." *Jaarboek van het Koninklijk Museum voor Schone Kunsten Antwerpen* (1988): 203–52.

Popham 1928
Popham, A.E. "Notes on Flemish Domestic Glass Painting, I." *Apollo* 7 (1928): 175–79.

Popham 1929
————. "Notes on Flemish Domestic Glass Painting, II." *Apollo* 9 (1929): 152–57.

Poskin and Stokart 1982
Poskin, G., and Ph. Stokart. *Orfèvres namurois*. Namur, 1982.

Prague 1997
Prague, Pražský hrad, Císařská konírna (Prague Castle Administration). *Rudolf II and Prague: The Imperial Court and Residential City as the Cultural and Spiritual Heart of Central Europe, 1550–1650*. Edited by Eliša Fučíková et al. London, 1997.

Princeton 1979
Princeton, The Art Museum, Princeton University. *Van Dyck as Religious Artist*. Catalogue by John Rupert Martin and Gail Feigenbaum. Princeton, 1979.

Providence 1979
Providence, Bell Gallery, List Art Building, Brown University. *Festivities: Ceremonies and Celebrations in Western Europe, 1500–1790*. Providence, R.I., 1979.

Put 1998
Put, Eddy. "Les archducs et la réforme catholique: Champs d'action et limites politique." In *Albert & Isabella: Essays*, ed. Werner Thomas and Luc Duerloo, 255–66. Brussels, 1998.

Ramsey 1969
Ramsey, L.G.G., ed. *The Complete Encyclopedia of Antiques*. New York, 1969.

Réau 1957
Réau, Louis. *Iconographie de l'art chrétien*. Paris, 1957.

Reineking von Bock 1989
Reineking von Bock, Gisela. "Steinzug in Raeren: Zum 25 jährigen Jubiläum des Topfereimuseums Raeren." *Keramos* 125 (1989): 87–106.

Remacle 1992
Remacle, Anne-Pascale. "Un souffle frais et novateur: la Renaissance et les rafraîchissoirs (17e s.)." *Confluent* (April 1992).

Renger 1975
Renger, Konrad. "Rubens Dedit Dedicavitque: Rubens' Beschäftigung mit der Reproduktionsgrafik. I. Teil: Der Kupferstich." *Jahrbuch der Berliner Museen* 16 (1974): 122–75.

Renger 1975
_____. "Rubens Dedit Dedicavitque: Rubens' Beschäftigung mit der Reproduktionsgrafik. II. Teil: Radierung und Holzschnitt–die Widmungen." *Jahrbuch der Berliner Museen* 17 (1975): 166–213.

Renger 1993
_____. "Flemish Genre Painting: Low Life–High Life–Daily Life." In *The Age of Rubens*, ed. Peter C. Sutton, 171–81. Boston, 1993.

van Riet and Kockelbergh 1997
van Riet, Sandra, and Iris Kockelbergh. "Lucas Faydherbe als beeldhouwer." In *Lucas Faydherbe, 1617–1697: Mechels beeldhouwer and architect*, 32–69. Mechelen, 1997.

Riggs 1993
Riggs, Timothy. "Graven Images: A Guide to the Exhibition." In *Graven Images: The Rise of Professional Printmakers in Antwerp and Haarlem, 1540–1640*, ed. Timothy Riggs and Larry Silver, 101–18. Evanston, Ill., 1993.

Ripa 1971
Ripa, Cesare. *Baroque and Rococo Pictorial Imagery*. Introduction, translations, and commentaries by Edward A. Maser. New York, 1971.

Robels 1989
Robels, Hella. *Frans Snyders: Stilleben-und Tiermaler, 1579–1657*. Munich, 1989.

Robinson 1981
Robinson, William W. "'This Passion for Prints': Collecting and Connoisseurship in Northern Europe during the Seventeenth Century." In *Printmaking in the Age of Rembrandt*, ed. Clifford S. Ackley, xxvii–xlviii. Boston, 1981.

Robinson and Wolff 1986
Robinson, William W., and Martha Wolff. "The Function of Drawings in the Netherlands in the Sixteenth Century." In *The Age of Bruegel: Netherlandish Drawings in the Sixteenth Century*, ed. J.O. Hand, 25–44. Washington, D.C., 1986.

Rooses 1909
Rooses, Max, ed. *Correspondance de Rubens et documents épistolaires concernant sa vie et ses oeuvres*. Vol. 6. Antwerp, 1909.

Roscoe 1981
Roscoe, Ingrid. "Mimic Without Words: *Singerie* in Northern Europe." *Apollo* 114 (1981): 96–103.

Salerno 1977–78
Salerno, Luigi. *Landscape Painters of the Seventeenth Century in Rome*. 3 vols. Translated by Clovis Whitfield and Catherine Enggass. Rome, 1977–78.

Salomon 1998
Salomon, Nanette. "From Sexuality to Civility: Vermeer's Women." In *Vermeer Studies*, ed. Ivan Gaskell and Michiel Jonker, 309–25. Studies in the History of Art, vol. 33. Washington, D.C., 1998.

Sellink 1996
Sellink, Manfred. "Illustrated Religious Publications of The Officina Plantiniana from the End of the 16th Century into the 17th." In *The Illustration of Books Published by the Moretuses*, ed. Dirk Imhof, 29–36. Antwerp, 1996.

Silver 1993
Silver, Larry. "Graven Images: Reproductive Engravings as Visual Models." In *Graven Images: The Rise of Professional Printmakers in Antwerp and Haarlem, 1540–1640*, ed. Timothy Riggs and Larry Silver, 1–45. Evanston, Ill., 1993.

Simón 1992
Simón, Maria del Carmen. "La théatricalité des repas royaux dans l'Espagne des xvie et xviie siècles." In *La sociabilité à table: Commensalité et convivialité à travers les âges*, ed. Martin Aurell et al., 159–68. Publications de l'Université de Rouen, no. 178. Rouen, 1992.

Sluijter 1988
Sluijter, Eric Jan. "'Een volmaekte schildery is also een spiegel van de natuer': Spiegel en spiegelbeeld in de Nederlandse schilderkunst van de zeventiende eeuw." In *Oog in oog met de spiegel*, 146–63. Amsterdam, 1988.

Sluijter 1990
_____. *De 'Heydensche fabulen' in de noordnederlandse schilderkunst, circa 1590–1670: Een proeve van beschrijving en interpretatie van schilderijen met verhalende onderwerpen uit de klassieke mythologie*. The Hague, 1990.

Sluijter 1991–92
_____. "Venus, Visus en Pictura." In *Goltzius-Studies, Nederlands Kunsthistorisch Jaarboek* 42–43 (1991–92): 337–96.

Smith 1968
Smith, Georgiana Reynolds. *Table Decoration Yesterday, Today, and Tomorrow*. Rutland, Vt., 1968.

Solon 1892
Solon, M.L. *The Ancient Art of Stoneware of the Low Countries and Germany*. 2 vols. London, 1892.

Stace 1991
Stace, Clive. *New Flora of the British Isles.* Cambridge, England, 1991.

Sterling 1952
Sterling, Charles. *La nature morte de l'antiquité à nos jours.* Paris, 1952.

van der Stighelen 1990
van der Stighelen, Katlijne. *De portretten van Cornelis de Vos (1584/5–1651): Een kritische catalogus.* Koninklijke Academie voor Wetenschappen, Letteren en Schone Kunsten van Belgie, Klasse der Schone Kunsten, vol. 50, no. 51. Brussels, 1990.

van der Stighelen 1994
————. Review of *De 17de-eeuwse Antwerpse kunstkast,* by Ria Fabri. *Bijdragen en mededelingen betreffende de geschiedenis der Nederlanden* 169 (1994): 80–82.

van der Stock 1998
van der Stock, Jan. *Printing Images in Antwerp.* Rotterdam, 1998.

van Straaten 1977
van Straaten, Evert. *Koud tot op het bot: De verbeelding van de winter in de zestiende en zeventiende eeuw in de Nederlanden.* 's Gravenhage, 1977.

Strasbourg 1978
Strasbourg, Musée Alsacien. *Grès traditionnels d'Alsace et d'ailleurs.* Catalogue by Jean Favière. Strasbourg, 1978.

Strauss 1978
Strauss, Walter L., ed. *The Illustrated Bartsch.* New York, 1978–.

Stuttgart 1997
Stuttgart, Staatsgalerie Graphische Sammlung. *'Der Welt Lauf': Allegorische Graphikserien des Manierismus.* Catalogue by Hans-Martin Kaulbach and Reinhart Schleier. Stuttgart, 1997.

Sullivan 1984
Sullivan, Scott A. *The Dutch Gamepiece.* Totawa, N.J., 1984.

Sutton 1993a
Sutton, Peter C., ed. *The Age of Rubens.* Boston, 1993.

Sutton 1993b
————. "Introduction: Painting in the Age of Rubens." In *The Age of Rubens,* ed. Peter C. Sutton, 12–105. Boston, 1993.

Sutton 1993c
————. "The Spanish Netherlands in the Age of Rubens." In *The Age of Rubens,* ed. Peter C. Sutton, 106–30. Boston, 1993.

Tempesta 1976
Tempesta, Antonio. *Metamorphoseon… Ovidianarum.* The Renaissance and the Gods: A Compre-hensive Collection of Renaissance Mythographies, Iconologies, and Icono-graphies, with a Selection of Works from the Enlightenment, vol. 19. New York, 1976.

Thiéry 1986
Thiéry, Yvonne. *Les peintres flamands de paysage au XVIIe siècle: Des précurseurs à Rubens.* Brussels, [1986].

Thijs 1993
Thijs, Alfons K.L. "Antwerp's Luxury Industries: The Pursuit of Profit and Artistic Sensitivity." In *Antwerp: Story of a Metropolis, 16th–17th Century,* ed. Jan van der Stock, 105–14. Ghent, 1993.

Thøfner 1998
Thøfner, Margit. "*Domina & Princeps proprietaria:* The Ideal of Sovereignty in the Joyous Entries of the Archduke Albert and the Infanta Isabella." In *Albert & Isabella: Essays,* ed. Werner Thomas and Luc Duerloo, 55–66. Brussels, 1998.

Thomas 1998
Thomas, Werner. "The Reign of Albert & Isabella in the Southern Netherlands, 1598–1621." In *Albert & Isabella: Essays,* ed. Werner Thomas and Luc Duerloo, 10–14. Brussels, 1998.

Thomas and Duerloo 1998
Thomas, Werner, and Luc Duerloo, eds. *Albert & Isabella: Essays.* Brussels, 1998.

Thornton 1978
Thornton, Peter. *Seventeenth-Century Interior Decoration in England, France, and Holland.* New Haven, 1978.

Thornton 1984
————. *Authentic Decor: The Domestic Interior, 1620–1920.* London, 1984.

Thurston 1998
Thurston, Bonnie. *Women in the New Testament: Questions and Commentary.* New York, 1998.

van Tichelen and Vlieghe 1990
van Tichelen, Isabelle, and Hans Vlieghe. "Jan Boeckhorst als Maler von Vorlagen für Bildteppiche." In *Jan Boeckhorst, 1604–1668: Maler der Rubenszeit,* ed. Jochen Luckhardt, 109–17. Freren, 1990.

Toussaint 1992
Toussaint, Jacques. "Les collections de la Société Archéologique de Namur." *Confluent* (April 1992).

Trail 1962
Trail, Richard R. "Physicians and Apothecaries in the 17th Century." *Pharmaceutical Journal* 188 (1962): 205–09.

Trevor-Roper 1991
Trevor-Roper, Hugh. *Princes and Artists: Patronage and Ideology at Four Hapsburg Courts, 1517–1633.* London, 1991.

Vandenbroeck 1990
Vandenbroeck, Paul. "De 'salette' of pronkkamer in het 17de-eeuwse Brabantse burgerhuis. Familie- en groepsportretten als icongrafische bron, omstreeks 1640–1680." *Monumenten en landschappen* 9 (1990): 41–64.

van der Veen 1992
van der Veen, Jaap. "Liefhebbers, handelaren en kunstenaars: Het verzamelen van schilderijen en papierkunst." In *De wereld binnen handbereik: Nederlandse kunst- en rariteitenverzamelingen, 1585–1735,* ed. Ellinoor Bergvelt and Renée Kistemaker, 117–34. Zwolle, 1992.

van der Veen 1993
————. "Galerij en kabinet, vorst en burger schilderijencollecties in de Nederlanden." In *Verzamelen van raiteit-enkabinet tot kunstmuseum,* ed. Ellinoor Bergvelt et al., 145–64. Heerlen, 1993.

Veldman 1977
Veldman, Ilja M. *Maarten van Heemskerck and Dutch Humanism in the Sixteenth Century*. Translated by Michael Hoyle. Maarssen, 1977.

Veldman 1993
_____. *Maarten van Heemskerck*. 2 vols. *The New Hollstein Dutch & Flemish Etchings, Engravings and Woodcuts, 1450–1700*. Roosendaal, 1993.

Veldman 1995
_____. "Characteristics of Iconography in the Lowlands During the Period of Humanism and the Reformation: 1480 to 1560." In *The Luminous Image: Painted Glass Roundels in the Lowlands, 1480–1560*, ed. Timothy B. Husband, 15–31. New York, 1995.

Verberckmoes 1998
Verberckmoes, Johan. "The Archdukes in Their Humour." In *Albert & Isabella: Essays*, ed. Werner Thomas and Luc Duerloo, 137–44. Brussels, 1998.

Vlieghe 1972a
Vlieghe, Hans. *Saints*. Vol. 1. Corpus Rubenianum Ludwig Burchard, Part VIII. London, 1972.

Vlieghe 1972b
_____. *Gaspar de Crayer, sa vie et ses oeuvres*. 2 vols. Monographies du "Nationaal Centrum voor de Plastische Kunsten van de XVIde en XVIIde Eeuw," vol. 4. Brussels, 1972.

Vlieghe 1979–80
_____. "Gasper de Crayer: Addenda et Corrigende." *Gentse bijdragen tot de kunstgeschiedenis* 24 (1979–80): 159–207.

Vlieghe 1985
_____. "Flemish Painting from the 15th to the 17th Century." In *The Royal Picture Gallery Mauritshuis*, ed. H.R. Hoetink, 102–16. Amsterdam, 1985.

Vlieghe 1987
_____. *Rubens Portraits of Identified Sitters Painted in Antwerp*. Vol. 2. Translated by P.S. Falla. Corpus Rubenianum Ludwig Burchard, Part XIX. London, 1987.

Vlieghe 1991
_____. "Maatwerk en Confectie." In *Stad in Vlaanderen: Cultuur en maatschappij 1477–1787*, ed. Jan van der Stock, 255–68. Brussels, 1991.

Vlieghe 1993
_____. "Rubens's Atelier and History Painting in Flanders: A Review of the Evidence." In *The Age of Rubens*, ed. Peter C. Sutton, 158–70. Boston, 1993.

Vlieghe 1997
_____. "Lucas Faydherbe en Rubens." In *Lucas Faydherbe, 1617–1697: Mechels beeldhouwer and architect*, cat. Heidi de Nijn et al., 24–27. Mechelen, 1997.

Vlieghe 1998
_____. *Flemish Art and Architecture, 1585–1700*. Translated by Alastair and Cora Weir in association with First Edition Translations, Ltd. New Haven, 1998.

Voet 1969
Voet, Leon. *The Golden Compasses: A History and Evaluation of the Printing and Publishing Activities of the Officina Plantiniana at Antwerp*. 2 vols. Amsterdam, 1969.

Voet 1973
_____. *Antwerp, The Golden Age: The Rise and Glory of the Metropolis in the Sixteenth Century*. Antwerp, 1973.

Washington 1976
Washington, D.C., Smithsonian Institution. *Antwerp Drawings and Prints, 16th–17th Centuries*. Catalogue by Leon Voet and Jeffrey Wortman. Washington, D.C. 1976.

Washington 1986
Washington, D.C., National Gallery of Art. *The Age of Bruegel: Netherlandish Drawings in the Sixteenth Century*. Edited by J. O. Hand. Washington, D.C., 1986.

Washington 1990
Washington, D.C., National Gallery of Art. *Anthony van Dyck*. Catalogue by Arthur K. Wheelock, Jr. et al. Washington, D.C., 1990.

Washington 1998a
Washington, D.C., National Gallery of Art. *A Collector's Cabinet*. Catalogue by Arthur K. Wheelock, Jr. Washington, D.C., 1998.

Washington 1998b
Washington, D.C., National Gallery of Art. *From Botany to Bouquets*. Catalogue by Arthur K. Wheelock, Jr. Washington, D.C., 1998.

Waterschoot 1983
Waterschoot, W. "Karel van Mander's *Schilder-boeck* (1604): A Description of the Book and its Setting." *Quaerendo* 13 (1983): 260–86.

Wauters 1912
Wauters, A.J. "Un peintre flamand oublié: Jean Antoine van der Baren." *Bulletin des Musées Royaux du Cinquantenaire* 11, no. 7 (1912): 49–50.

van der Wee and Materné 1993
van der Wee, Herman, and Jan Materné. "Antwerp in a World Market in the Sixteenth and Seventeenth Centuries." In *Antwerp: Story of a Metropolis, 16th–17th Century*, ed. Jan van der Stock, 19–32. Ghent, 1993.

Wellesley 1993
Wellesley, Mass., Davis Museum and Cultural Center. *Flemish Drawings in the Age of Rubens: Selected Works from American Collections*. Edited by Anne-Marie S. Logan. Wellesley, Mass., 1993.

Welu 1991
Welu, James A. "Strange New Worlds: Mapping the Heavens and Earth's Great Extent." In *The Age of the Marvelous*, ed. Joy Kenseth, 103–12. Hanover, N.H., 1991.

Wheaton 1983
Wheaton, Barbara Ketcham. *Savoring the Past: The French Kitchen and Table from 1300 to 1789*. Philadelphia, 1983.

Wheelock 1991
Wheelock, Arthur K., Jr., "*Trompe l'oeil* Painting: Visual Descriptions or Natural Truths?" In *The Age of the Marvelous*, ed. Joy Kenseth, 179–91. Hanover, N.H., 1991.

White 1987
White, Christopher. *Peter Paul Rubens: Man & Artist*. New Haven, 1987.

White 1998
_____. "Rubens and the Archduke." In *Albert & Isabella: Essays*, ed. Werner Thomas and Luc Duerloo, 10–14. Brussels, 1998.

Wieseman 1993
Wieseman, Marjorie E. "The Art of '*Conversatie*': Genre Portraiture in the Southern Netherlands in the Seventeenth Century." In *The Age of Rubens*, ed. Peter C. Sutton, 182–93. Boston, 1993.

Wilson 1973
Wilson, Anne. *Food and Drink in Britain*. London, 1973.

Winner 1961
Winner, Matthias. "Zeichnungen des älterer Jan Brueghel." *Jahrbuch der Berliner Museen* 3 (1961): 190–241.

Winner 1972
_____. "Neubestimmtes und Umbestimmtes im zeichnerischen Werk von Jan Brueghel D.Ä." *Jahrbuch der Berliner Museen* 14 (1972): 122–60.

Winner 1980
_____. "Jean Brueghel l'Âné, dessinateur." In *Bruegel: Une dynastie de peintres*, 209–12. Brussels, 1980.

Wittop Koning 1973–74
Wittop Koning, D.A. "Apothekerspotten uit Raeren." *Antiek* 8 (1973–74): 73–76.

Wittop Koning 1991
_____. *Apothekerspotten uit de Nederlanden*. Utrecht, 1991.

Woldbye 1985
Woldbye, V. "Scharloth's Curious Cabinet." *Furniture History* 21 (1985): 63–77.

Zeven eeuwen 1996
Zeven eeuwen Augustijnen. *Een kloostergemeenschap schrift geschiedenis*. Ghent, 1996.

Zilver op tafel 1984
"Zilver op tafel. Vlaams tafelzilver van de 16e tot de 18e eeuw." *Openbaar Kunstbezit in Vlaanderen* 22 (1984).